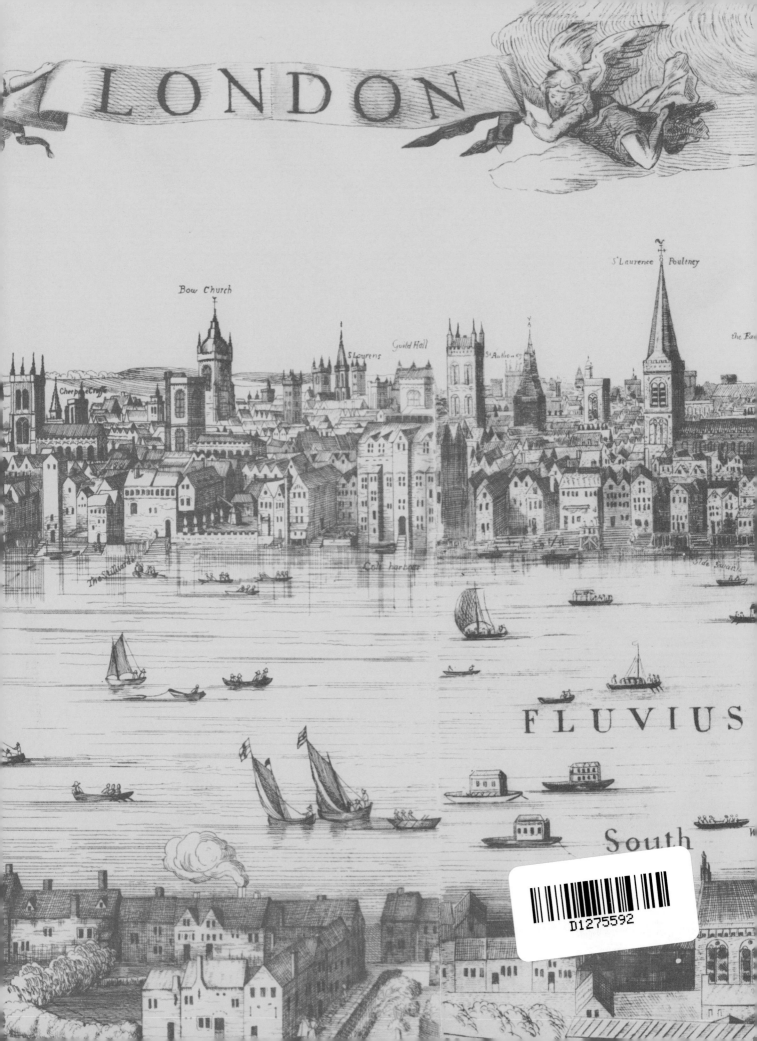

CATALOGUE OF THE
OIL PAINTINGS IN THE
LONDON MUSEUM

Frontispiece St. Pancras Hotel and Station from Pentonville Road by John O'Connor (Detail from No. 87)

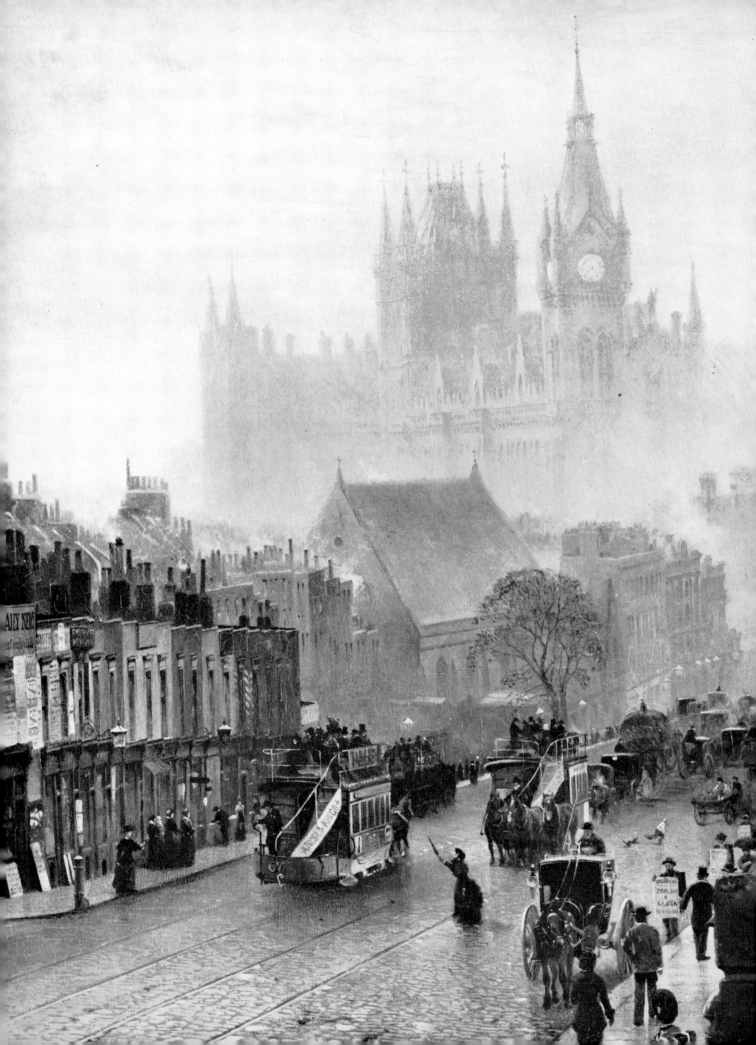

Catalogue of the

OIL PAINTINGS

in the London Museum

with an Introduction on Painters and the
London Scene from the Fifteenth Century

JOHN HAYES

LONDON: HER MAJESTY'S STATIONERY OFFICE 1970

© Crown copyright 1970

SBN 11 290061 5 *

Printed in England for Her Majesty's Stationery Office
by Eyre & Spottiswoode Ltd at Thanet Press Margate

FOR W. F. GRIMES

Contents

Preface

A Museum to be devoted entirely to the archaeology, history and life of the capital had long been a cherished idea of Reginald, 2nd Viscount Esher (1852-1930), who was a distinguished servant of the arts and a close friend of Queen Victoria and King Edward VII; and he proposed it formally in a memorandum to King George V in 1910. Following this initiative, the London Museum was founded by Lewis Harcourt, later 1st Viscount Harcourt (1863-1922) in 1911, with the active encouragement of Lord Esher, and of Queen Alexandra, King George V and Queen Mary. It was opened to the public on 8 April 1912; and became a National Museum under Treasury control in July 1913.

The first Keeper was (Sir) Guy Laking, son of one of the Household physicians. Laking, who had already published books on armour and the decorative arts, was an enthusiast, but somewhat undiscriminating in his choice of objects (understandably enough perhaps when there were many empty rooms to fill), and the pictures acquired in these early days were a great mixture both as regards quality and their relevance to London history. Requests for loans were sent to a number of owners who had lent pictures to the *Old London* exhibition at the Whitechapel Art Gallery in the winter of 1911, and some of the pictures borrowed at this time were afterwards converted into gifts, the large Deane of *Waterloo Bridge* (No. 33) being a notable example. Many pictures were also purchased, in particular a group submitted by Messrs. Leggatt in 1912, which included the magnificent Scott of *Covent Garden*, then attributed to Canaletto (No. 99).

Laking died in 1919, and during the Keepership of his successor, Harman Oates (1919-26), the picture collection was increased about equally by gift and purchase. The most outstanding gift was the splendid Marlow of *The Adelphi* (No. 74), and the happiest purchase the pair of Levins of *Covent Garden* and *Cremorne Gardens* (Nos. 67 and 68). Unfortunately, the records relating to accessions up to 1926 are often scanty, sometimes even non-existent, so that most of the information on matters of provenance and so on contained in the Catalogue which follows has been compiled from outside sources.

A more professional attitude towards administration was introduced by (Sir) Mortimer Wheeler (Keeper, 1926-44), and from 1927 the more usual practice was adopted of numbering accessions according to the year of acquisition. Though it was in Wheeler's Keepership that the first Treasury purchase grant was received (£200 for the year 1931-2), picture acquisitions were entirely by gift, the most important, and especially

the splendid Hondius of *The Frozen Thames* (No. 56), being acquired through the generosity of the National Art-Collections Fund.

Wheeler was succeeded by (Professor) W. F. Grimes (Keeper, 1945-7 and first Director, 1947-56), who brought a high degree of order into the heterogeneous collections and instituted a policy in regard to pictures in which the claims of aesthetic quality and archaeological accuracy or relevance should, wherever possible, be balanced, a policy which has remained in operation since I took over the Directorship in 1956. Up to 1959-60 the annual purchase grant received from the Treasury had never exceeded £375, and the Museum had been largely dependent on the Joicey Trust Fund (received in 1943), the Mackenzie Bell Trust Fund (received in 1956) and outside donations, for the purchase of exhibits, but in this year the Trustees received a substantially increased Treasury grant of £1,000, a sum increased to £2,000 in 1967-8 and £3,000 in 1969-70.

In the twenty years or so since the last war a number of significant purchases have been made, many of them, once again, with the aid of the ever sympathetic National Art-Collections Fund. These pictures include the Marlow of *Old London Bridge* (No. 73), the O'Connor of *St. Pancras Station from Pentonville Road* (No. 87), the Ritchie *Summer Day in Hyde Park* (No. 96), the great panorama of *The Fire of London* (No. 40), the Jacob Knyff view of *Chiswick from the River* (No. 61), and the early seventeenth century prospect of *London from Greenwich* (No. 43). In spite of the natural disinclination of donors to present pictures in a time of sharply rising prices, almost as many accessions have come in by gift as by purchase. Though most of these are perhaps of lesser importance, mention should be made of the group of Nevinsons (Nos. 77, 80, 81 and 82) and Joy's popular *Bayswater Omnibus* (No. 60), a long-standing loan converted.

In view of the comparatively recent date of the Museum's foundation, and the very small funds that have been available for purchase, it should not be expected that the collection would even begin to compete in importance with that of the Musée Carnavalet in Paris. There is no Hogarth; no Constable; no Turner; no Whistler; no Monet; and numerous other artists who spent part of their working lives painting the London scene are not represented either. But there is a handful of masterpieces, and a good many other works that are unique as records: the picture of *The Great Fire* can claim to be at the head of both categories.

This volume, the product of several years' careful research by Dr. John Hayes, Assistant Keeper since 1954 and now Director-elect, includes all paintings which entered the collection prior to 31 December 1967. Details in the entries have been revised up to the end of June 1969. It should perhaps be added that it has not been thought appropriate to over-burden the text with footnotes: the Museum will gladly supply the sources for statements made, or other information, on application.

The many people who have given such ready assistance to Dr. Hayes during his work on this Catalogue are listed in the Acknowledgements on page x, but a special word of thanks is due to Mr. J. L. Howgego, of the Guildhall Library, whose patience and goodwill under a barrage of enquiries have been tested more than most. Mr. P. H. Hulton, of the British Museum Print Room, very kindly read the Introduction;

and Messrs. Raymond Mander and Joe Mitchenson the entries for theatrical pictures, for which they provided much valuable information. Improvements were suggested by Mr. B. W. Spencer, Assistant Keeper, and Mrs. Miles Kington, the Museum's Librarian, who read the text in draft; and arguments for dating pictures on the evidence of costume have been provided by Mrs. Steven Jonas and Miss Zillah Halls, successively in charge of the Museum costume department. Most of the photographs have been taken specially for this catalogue, in the Museum studio, by Mr. A. S. Trotman and Mr. B. Gray. The Index was prepared by Miss Joan Pollard.

Kensington Palace
12 January 1970

D. B. HARDEN
Director

Acknowledgements

The author is indebted to a great many individuals and institutions for help of various kinds in the compilation of this Catalogue, and wishes to thank them for their assistance, particularly the following: Agnew's; Mr. J. Anatol; Mr. E. H. H. Archibald; Mr. Ellis Ashton; Mr. Hubert Bennett; Mr. P. A. Bezodis; British Museum Print and Reading Rooms; Mr. Nicholas Brown; Mr. M. de Burca; Mr. Martin Butlin; Mr. A. Cameron; Mr. T. D. Carpenter; Christie's; Mr. Bernard Coleman; Lieut-Col. R. W. G. Collins-Charlton; Mr. R. A. Cooper; Mr. E. F. Croft-Murray; Mr. R. O. Dennys; Miss Anne Donald; Dr. W. D. Donaldson; Mr. N. T. Downing; Mr. B. G. Downs; Miss Rhoda Edwards; Mr. Malcolm Fry; Professor Horst Gerson; Greater London Council; Mr. L. R. A. Grove; Guildhall Library; Mr. B. Fairfax Hall; Mr. K. C. Harrison; Mr. W. S. Haugh; Mr. J. L. Howgego; Mr. Felix Hull; Mr. P. H. Hulton; Mr. Geoffrey Inge; Mr. E. Jeffcott; Miss G. Johnson; Mr. Douglas Kennedy; Mr. John Kerslake; Mr. C. R. Kimber; London Library; Miss E. M. Loughran; Lady Lucas of Crudwell and Dingwall; Mr. N. H. MacMichael; Mr. W. R. Maidment; Mander and Mitchenson Theatre Collection; Paul Mellon Foundation for British Art; Mr. Oliver Millar; Professor Peter Murray; National Monuments Record; National Portrait Gallery; Mr. J. O. H. Norris; Miss Ann Pearce; Professor J. H. Plumb; Ministry of Public Building and Works; Miss Diana Rait Kerr; Rijksbureau voor Kunsthistorisches Documentatie; Mr. O. F. Rivers; Mr. Michael Robinson; Mr. Kenneth Sharpe; Mr. C. L. Shaw; Dr. F. H. W. Sheppard; Major-General H. D. W. Sitwell; Mr. R. J. D. Smith; Mrs. Pauline Staite; Dr. Roy Strong; Sir John Summerson; Tate Gallery; Mr. S. C. Tongue; Mr. Gilbert Turner; Victoria and Albert Museum Library and Print Rooms; Mr. Richard Walker; Mr. A. J. Ward; Westminster Bank; Westminster Public Libraries; Mr. James White; Mr. H. Whitwell; Witt Library; Mr. P. J. Wright.

PHOTOGRAPHS
All photographs are from official Museum negatives except the following: Pl. III (British Museum); Pls. IV, VII and IX, 40, 49, 61, 63, 93 and 102 (A. C. Cooper); Pls. I and II, and 180 (Courtauld Institute of Art); Pl. 8 (R. B. Fleming); Pl. X (Frick Collection); Pl. 41 (Greater London Council); Pl. 114 (Wallace Heaton); Pl. 121 (Edward Leigh); Pls. 31, 55, 98 and 134 (Messrs. Sloman and Pettitt); Pl. V (National Gallery); Pls. 29, 132, 136, 142, 145, 146, 165, 177 and 178 (National Maritime Museum); Pl. 74 (Paul Mellon Foundation for British Art); Pl. XI (Rhode Island School of Design); Pl. VI (Sir John Soane's Museum); Pls. VIII and XII (Tate Gallery).

List of Plates

2

xiv

Introduction

LONDON: ITS GROWTH AND APPEARANCE

One of the earliest surviving painted views of London is a longish panel, now in the Museum's collection, which was executed in about 1620-30 by an unidentified Flemish topographical and landscape painter (No. 43 and Pl. 1). The view is taken from above Greenwich (a favourite vantage point for London topographers until well into the nineteenth century), and shows the city in the far distance; Southwark Cathedral and Old St. Paul's are prominent landmarks, towering over the houses, and the general appearance of the capital from which Elizabeth had defied Spain and the early Stuarts asserted the dogma of Divine Right is unexpectedly like some pleasant cathedral town nestling in the depth of the shires, Hereford perhaps, or Worcester. For, though London then contained about a quarter of a million inhabitants, a vast population for any town at that date, it was not at all a large town in point of size. It is true that it had become linked with Westminster, via the palaces of the Strand, by at least the mid-sixteenth century,

Plate 1 Detail from the Prospect of London from above Greenwich, painted c. 1620-30 by an unidentified Flemish artist (Detail from No. 43)

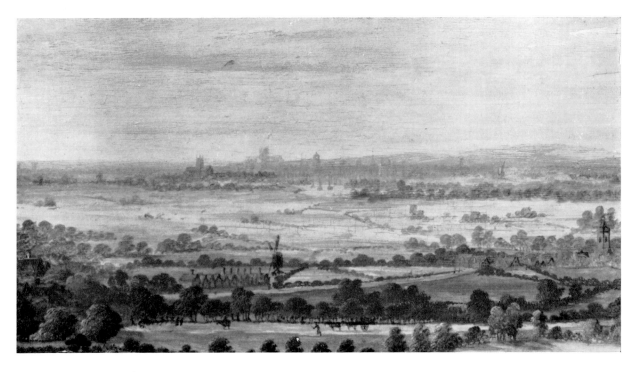

I

and that half the population now dwelt outside the walls, but many of these people lived in slum conditions though uncontrolled expansion without (and thus beyond the jurisdiction of the City Corporation) was penalised by law. The narrow, twisting streets and lanes of the old city must certainly have presented a spectacle of teeming human activity which would have gladdened Dr. Johnson's heart.

Charles I and his Surveyor of Works, Inigo Jones, had visions of transforming London into a truly Renaissance city, with spacious, regular streets and public buildings of architectural distinction; but their conceptions far outstripped the royal purse, and little emerged from the drawing-board save two great squares which, though rigorously supervised by Jones, were actually built under private enterprise, Covent Garden (Nos. 1 and 99) and Lincoln's Inn Fields; these, however, were significant for the future and lay at the roots of much subsequent development in London.

Then, suddenly, in four brief and terrifying days in September 1666, four-fifths of the city within the walls was totally destroyed by fire (Nos. 40 and 48). The great opportunity for profiting from this disaster and planning some systematic reconstruction, as envisaged by Wren and others, was rejected firmly, and the rebuilding followed the old street plan. But one effect of the Fire was to accelerate an inclination to move westwards, into the fashionable new squares (Bloomsbury and St. James's Squares were already in the course of development); and soon it was no longer considered smart actually to reside within the square mile of the City. Tradesmen and shopkeepers of course followed, and John Graunt wrote that 'did not the *Royal Exchange* and *London Bridge* stay the Trade, it would remove much faster'.

In the course of the eighteenth century the tentacles of the developers spread over the whole of what we now call the West End, reaching as far as Park Lane on the west side, and to the north, well beyond the Oxford Road. Grosvenor, Hanover and Berkeley Squares were among the earlier of the squares laid out, and attendant on them were numerous streets of simple greyish stock-brick houses, for the most part similar in design and uniform in height. So rapidly did building proceed that we find Boswell complaining, as early as 1772, that 'The increase of London is prodigious. It is really become too large . . . people live at such a distance from each other that it is very inconvenient for them to meet'. Yet the population had not grown appreciably. Rather less than three quarters of a million in 1700, it was not much above 850,000 when the first official census was taken in 1801.

Development continued non-stop during the Napoleonic Wars, and afterwards: the formation of Regent Street and the planning of Regent's Park, under the directing hand of John Nash, anticipated the parcelling out of estates in St. John's Wood and Islington, while the construction of new bridges over the Thames spurred on expansion south of the river; but still the unit was the square (or by now the crescent), with subsidiary streets surrounding, and building heights remained low. Between 1801 and the accession of Victoria in 1837 the population doubled, but largely under the disruptive impact of the Industrial Revolution. It was in this period that the East End of London, where many of the poorer newcomers settled, degenerated into slums, and that recurrent outbreaks of cholera forced the matter of public health urgently before Parliament.

2

The coming of the railways (Pl. VII) changed the whole character of London. The centre was enmeshed by railway lines, in the interstices of which there grew up further slums; but rapid communications, and cheap fares, meant that ordinary working people were no longer compelled to live close to the centre, and the new residential suburbs which fanned outwards from the railway stations (Pissarro's delightful view of Penge Station, painted in 1871 (Pl. II) illustrates the process well) took the built-up area of the metropolis deep into the countryside, engulfing villages like Dulwich and Croydon south of the river, Chiswick, Highgate and Ilford north of it. Stuccoed Georgian began to give way first to Italianate (No. 8) and then to Gothic, Jacobean, Dutch and Flemish Renaissance, and various hybrid styles. The release from classical architecture encouraged higher building, and the pinnacles and picturesque skyline of Whitehall Court, the Hyde Park Hotel or St. Pancras (No. 87) became symbols of Victorian London as surely as Hanover Square or Gower Street had been of Georgian. Dark red bricks producing a gloomy and sometimes claustrophobic effect, as in Cadogan Square, for instance, were now being used in place of the yellowish-grey stocks of the earlier part of the century; and with the increase in industry and density of population (which more than doubled again, from just under two to about four and a half millions, in the course of Victoria's reign) came a corresponding increase in smoke and fog and grime. It is certainly doubtful whether Wordsworth, if he could have stood on Westminster Bridge a century after 1802, would have marvelled then at the sight of London 'All bright and glittering in the smokeless air'. Rather let Henry James speak for the Victorian metropolis: 'The fogs, the smoke, the dirt, the darkness, the wet, the distances, the ugliness, the brutal size of the place, the horrible numerosity of society'.

Plate II Penge Station, painted in 1871 by Camille Pissarro (Courtauld Institute of Art)

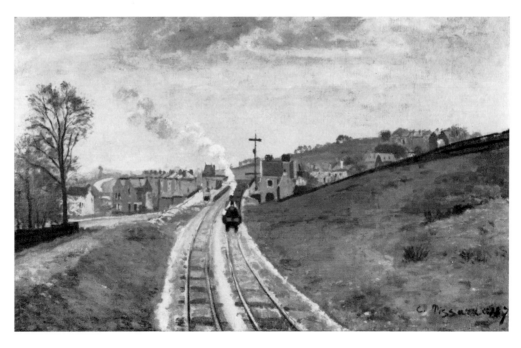

3

When the County of London was created in 1888, it must have been difficult to conceive of the metropolis growing much larger. Yet the boundaries were exceeded by suburban expansion almost before they were agreed upon, and by 1938 more Londoners lived outside the County than within it (where, in fact, the population was now in slow decline). The creation of a Green Belt round the city in 1935 did nothing to stop the rate of growth; estates of speculative mock-Tudor houses, neat as new pins, gathered round the underground termini, and a seemingly interminable suburbia stretched out further still along the arterial roads. This shift of population towards the perimeter has had its effect on central London, especially since the war. Communications (No. 36) have become of paramount importance, and though London has constantly renewed itself, never in the whole of its long history, save only after the Fire, has such rapid change occurred as within the last decade. The old has everywhere been torn down to make way for more profitable development, and whole districts have been altered both in appearance and their social composition. London has also become one more potential skyscraper city, insufficiently subject in this aspect of its growth to any logic or aesthetic, and dominated no longer by the massive, protective dome of Wren's St. Paul's but by the disturbing and brilliantly original upward-thrusting Post Office Tower.

Such, in outline, is the subject-matter of the Museum's collection, or, rather, its containing framework. What have the generations of painters who have lived and worked in London made of the scene around them?

THE EARLY TOWNSCAPES AND LONG VIEWS

It would be idle to expect much in the way of accurate representation from those few medieval artists who depicted London. Matthew Paris, in the mid-thirteenth century, marking London as the first stage in a pictorial map illustrating the journey to the Holy Land, drew a conventionalised river and walls, and within this schema inserted the Tower, Old St. Paul's and one or two other buildings as representative symbols. The draughtsman who illustrated a fourteenth century version of Geoffrey of Monmouth's *History* drew just a group of churches (among which Old St. Paul's can be distinguished). And as late as 1497 Wynkyn de Worde included a woodcut in his *Chronycle* which was no more than a formula of an archaic sort, an embodiment of the concept 'town' that bore no relation to the actual appearance of London at all: true, it was replaced in the 1510 edition by a woodcut recognisable as London, but this was no less formalised. On the other hand, the late fifteenth century miniaturist who had to supply an illustration of the Duke of Orleans imprisoned in the Tower for the *Poems of Charles, Duke of Orleans* (Pl. III) was to some extent influenced by the naturalistic tradition of contemporary Flemish painting, and composed a charming vignette of London which included the arcaded warehouses of Billingsgate and part of Old London Bridge, with the chapel of St. Thomas and its double row of houses (and the swell of water beneath the arches), as well as the Tower itself. Though the foreground was evidently conceived in terms of medieval narrative,

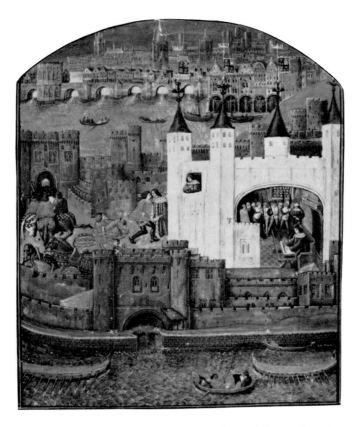

Plate III View of London from the Tower, miniature from the
Poems of Charles, Duke of Orleans, illuminated in the late
fifteenth century (British Museum)

and the artist, knowing little of perspective, organised his view into a succession of
receding planes, this miniature may be accepted as a good general impression of what
London looked like at the end of the Wars of the Roses.

Fifty years later, we are beginning to enter quite a different pictorial world. The
Renaissance eagerness to learn about the far corners of the world and the great voyages
of discovery of the sixteenth century (this was also the age when England itself was
first explored, by Leland) resulted in an extraordinary development of the science and
art of cartography. The early maps of London (the earliest dates from the mid-sixteenth
century) were nearly all semi-bird's-eye views, that is to say, the individual buildings
were actually represented, in summary fashion; and the impression given of showing
every building is what distinguishes them from Matthew Paris, who had drawn in much
the same style but whose attitude was conceptual not representational.

Allied to these pictorial maps were a series of prospects or 'long views', mostly taken
from a point in Southwark, the earliest and most famous of which was executed by the
Antwerp artist, Anthony van den Wyngaerde, in the latter part of Henry VIII's reign,
between 1539 and 1544. This view was not engraved, but fourteen large pen and ink

5

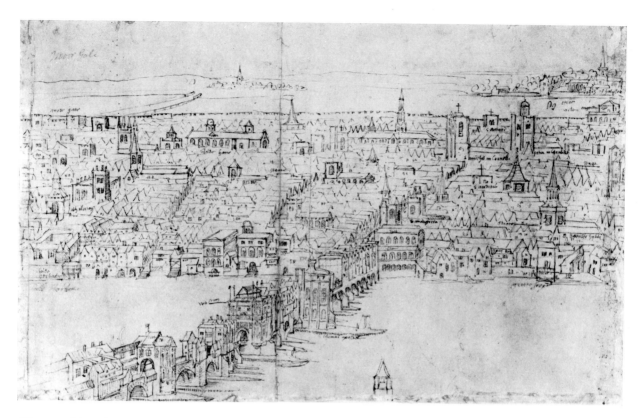

Plate IV Sheet from the Long View of London, drawn c. 1539-44 by Anthony van den Wyngaerde (Ashmolean Museum, Oxford)

sketches prepared by the artist are in the Ashmolean Museum, Oxford (Pl. IV) and constitute the earliest known attempt at a detailed topographical study of London – recording, incidentally, a number of monastic foundations which, as a consequence of the Dissolution, were shortly to be destroyed. Most of the later panoramas in the Wyngaerde tradition survive only in engraved form, the chief being those by Norden (published 1600), Visscher (also about 1600, and largely based on Norden), and, most notably, Hollar (published 1647).

Not all the early views of London were done simply as records, however. Townscapes had become a popular subject for schemes of decorative painting in Renaissance Italy – there is a well-known series in the Vatican – and views of the principal cities of the world were painted for Lord Burghley as part of the decoration at Theobalds. During the seventeenth century numerous general views of London were painted by visiting Dutch and Flemish artists, and some of these were certainly done for English patrons: Charles I owned a view of London 'done by Geldorp's man', and there was a continuing demand among connoisseurs – Evelyn, for example, purchasing a set of views of the London

6

riverside from Cornelis Bol in about 1660. But probably the greater number were painted for their own inexhaustible home market in the Netherlands, and these were often executed back in their own studios (and sometimes repeated over the years) from drawings originally made on the spot. These London views, as opposed to maps and engraved prospects, were doubtless regarded by the patrons of Ruisdael and de Hooch first and foremost as *pictures*, and though, obviously, they had to be reasonably plausible, there was probably little demand, in most cases, for detailed topographical accuracy.

One of the earliest painters to make the journey back and forth across the Channel was Claude de Jongh, who first came to London in 1615, and whose masterpiece, the view of *Old London Bridge* taken from the west side, signed and dated 1630, is now at Kenwood. This picture was executed from a detailed drawing made in April 1627, but nevertheless incorporates demonstrable errors, such as showing the arches of London Bridge to be rounded instead of pointed (pointed arches, one may note in parenthesis, were rare in Dutch bridges). Wenceslaus Hollar, the greatest of all London topographers, came to England in the suite of the Earl of Arundel in 1636, and except for the period 1644-52, remained in this country until his death in 1677. Hollar never actually *painted* a London view, so far as is known, but the numerous drawings and engravings he produced, skilled, detailed and exact, are fundamental for our knowledge of mid-seventeenth century London.

Among later seventeenth century Dutch and Flemish painters who specialised in topography and stayed in this country for varying periods were Danckerts, Jan Griffier, Jacob and Leonard Knyff, Siberechts, Vorsterman, and Thomas and Jan Wyck, most of whom were employed extensively by the Crown, Danckerts, for instance, being commissioned by Charles II to paint a series of views of royal palaces and seaports. Both Thomas Wyck and Griffier (see No. 48) painted the Great Fire, a subject for which there was considerable demand on the continent (fire paintings were a popular genre at this time); and Jacob Knyff was unusual in painting a long view of one of the Thames-side villages, Chiswick (No. 61), a canvas which, on the evidence of the church, may be accepted as an accurate representation, and thus a unique record of the appearance of the place before its total transformation in the eighteenth century. Leonard Knyff was mainly known for his bird's-eye views of noblemen's mansions and their surrounding parkland and estates; this work was very much in the cartographic tradition, and expressive of the seventeenth century taste for landscape which displayed an extensive and richly varied scene, 'diversityes of Cultivations and produce of the Earth . . . and Plaines and Rivers and great Woods, and little towns all in view', as Celia Fiennes, travelling about England in William III's reign, reported of an actual view she surveyed from the roof of Nottingham Castle. A series of Knyff's prospects, including one overlooking rural Chelsea and Kensington, was engraved by Kip, mainly for use in *Britannia Illustrata*, 1707.

The only artist of the front rank who came to England in the Restoration period and painted London was the as yet unidentified master who executed the incomparable panel of the Great Fire (No. 40). Sophisticated views like those Van der Heyden made of Amsterdam do not exist, let alone evocative paintings such as Ruisdael's bird's-eye view of Amsterdam or Vermeer's great prospect of the waterfront at Delft.

7

Plate v The Thames and the City from Richmond House, painted in 1747 by Antonio Canaletto (The Trustees of the Goodwood Collection)

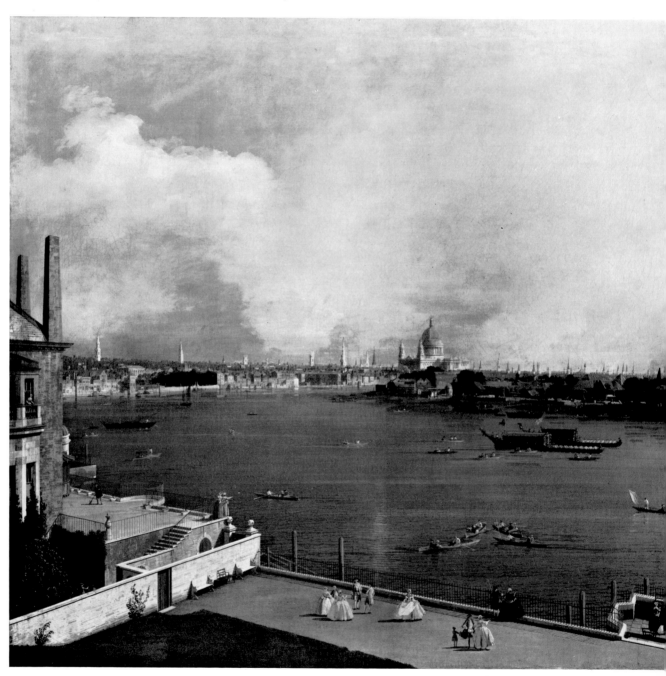

8

Long views taken from the Thames, and bird's-eye views of parts of London (notably, in the eighteenth century, the West End squares), were popular well into the nineteenth century, principally in engraved form. However, a type of prospect less related to the cartographic tradition than those of Knyff and his confrères, and more genuinely pictorial in every way, was popularised in the mid-eighteenth century by Canaletto, who should be ranked second only to Hollar as a London topographer. Canaletto arrived in London in May 1746, to see what 'prospects he might make of Views of the Thames', and in the event remained here for about a decade before his final return to Venice. His masterpieces were a pair of views from Richmond House, one of the Thames (Pl. v) and one of Whitehall, commissioned by the Duke of Richmond probably in 1747, and a second much larger view of Whitehall, this time done from Loudoun House, which was painted four or five years later. Quite apart from the strength of design and beauty of handling which give them their quality as pictures, these three great canvases are among the most accurate views of London ever painted; the treatment of the foreground detail is scrupulously exact (the last-named picture including a group of houses in course of construction), and the distances reliable in general disposition and silhouette.

Most of Canaletto's London views were of the riverside, and based on those strongly perspectival compositions he had learnt to use in drawing the canals of Venice, but he also painted Vauxhall and Ranelagh, the Horse Guards, Northumberland House, and Westminster Abbey, an interior view of which is in the collection (No. 27). Canaletto had a tendency to invest his views, especially his river views, with something of that exceptional clarity of atmosphere and sparkling light characteristic of his native Venice (though it must be remembered that the London atmosphere was purer in the eighteenth century); and he also painted a number of repetitions, which it is plain he regarded as commercial productions, and where his standards of accuracy were considerably relaxed. Many of his views were engraved, and they provoked a remarkable progeny; pictures of Northumberland House, for example, all depending from the 1753 engraving, three of which are in the Museum (Nos. 13, 129 and 164), continued to be produced for the best part of a century, John Paul being the latest and most industrious copyist. But the painter who really succeeded to the mantle of Canaletto was Samuel Scott.

Scott had begun his career in the 1730's, as a marine painter, and though to some extent active as a London topographer before Canaletto's arrival in this country, it was undoubtedly the latter's success in the genre that persuaded him to specialise in it to the exclusion of other kinds of painting. Certain of his compositions were directly inspired by Canaletto – the most obvious instances, perhaps, are those views of the Thames seen through an arch of Westminster Bridge – but, generally speaking, it was the essentials of his style that he absorbed, his strong pictorial construction, effective disposition of light and shade, and sense of emphasis. It should, of course, be noted that he also developed marked personal characteristics, for instance, a frequent use of boats in full sail as compositional accents. Like Canaletto, he was generally an exceptionally accurate topographer, and again like him, he concentrated upon the river, his finest view being

9

the prospect of the City waterfront from St. Paul's to the Tower, of which he executed a number of versions over a period of twenty years. Scenes done away from the river are comparatively rare, and the Museum is fortunate in possessing the magnificent view of *Covent Garden Market* (No. 99).

One subject that Scott never tired of painting was Westminster Bridge. This was the first new stone bridge to be constructed in the London area since London Bridge was built far back in the twelfth century, and as such was regarded almost as one of the seven wonders of the world. Scott painted it in various stages of construction, and several times after its completion, which leads us conveniently to a more general point. For despite the long-established tradition of the prospect, and the influence of Canaletto, the typical eighteenth century London view was a representation of a particular place, of an individual building or street. This new emphasis was to some extent due to a profound shift in patronage since the seventeenth century. Whereas in the earlier period patronage had emanated principally from the Court, in the eighteenth century there were patrons of the arts at all levels of society, and among ordinary London citizens plenty who were eager to buy engravings of recognisable, everyday scenes. Londoners were proud of their growing city, and its undoubted superiority to all others, and prints of any important new edifice, such as the Mansion House, or of popular resorts like Ranelagh or Vauxhall Gardens, were quick to appear, painted versions of the same or similar views being executed for wealthier patrons. Around 1800, influenced by the theatrical illusionism of de Loutherbourg, there was a fashion for cycloramas, vast circular panoramas of the capital being executed by Robert Barker, Girtin and others: not even fragments of any of these survive today, but Girtin's preparatory drawings for his *Eidometropolis* are in the British Museum.

Among the earliest paintings of single buildings of any quality were the roundels of London hospitals painted in the late 1740's for the embellishment of the new Foundling Hospital by some of the leading artists of the day, notably Wilson and the young Gainsborough; these still remain *in situ* in the Court Room of the Thomas Coram Foundation. Marlow's painting of the *Adelphi* (No. 74), a record of some importance both as to the appearance of the famous Royal Terrace, torn down in 1936, and the way in which it dominated the waterfront, is a combination of a detailed view of a new building in the course of construction and of a riverside panorama in the style of Scott, whose pupil he had been (the composition and effects of light are not unlike Scott's view of the *Tower*). But his picture of the *North End of Old London Bridge* (No. 73) is in a rather different class, a close-up view of a particular group of buildings, rendered with that loving care for exact verisimilitude and circumstantial detail characteristic of Canaletto and Scott.

The tradition of recording the more significant new buildings of the day later found more unified expression in Thomas Hosmer Shepherd's album of engravings of the finest buildings of the Regency entitled *Metropolitan Improvements;* and there is in the Museum a large, but not particularly distinguished, painting of a projected building which would certainly have been of major importance for the period had it been erected, the Leicester Square Opera House (No. 15). Views of the Houses of Parliament (Nos. 3

10

and 109) were among the more popular Victorian subjects, and continuing the tradition of depicting buildings in course of construction, the view of the Charing Cross Hotel under scaffolding (No. 22) may be mentioned. The oblique 'picturesque' kind of composition differentiates it from the more formal eighteenth century views, and this impression of being admitted to a real scene instead of being presented with a picture of one is typical of Victorian topography. Clifford's little view of houses in East Greenwich (No. 29) (actually from a slightly later date) is a good example of this informality of approach; while street scenes such as Niemann's *Buckingham Street, Strand* (No. 83) are almost as much genre paintings as they are views. On the other hand, the Scott tradition continued to flourish, and can be traced through Deane in 1821 (No. 33) and Pether in the 1840's (Nos. 90 and 91) as far as O'Connor in 1872 (No. 86).

Neither the eighteenth nor the nineteenth centuries were lacking in a healthy faith in the virtues of their own civilisation and their own architecture, and patrons and architects were not slow to pull down what their supposedly misguided forbears had built before them. But at the same time there was a growing body of antiquarian opinion, traceable to scholars like Stukeley and the poet Gray, which deplored the wanton destruction of our ancient buildings. John Carter, who undertook the first detailed study of the Palace of Westminster, was known as 'Antiquity's most resolute Friend', and T. H. Shepherd, who did the drawings for *Metropolitan Improvements*, also made innumerable and invaluable records of buildings that were about to disappear. Among the many later topographical artists who concentrated on work of this kind, the most devoted was undoubtedly Philip Norman, who also played a leading rôle in the work of various preservationist and antiquarian bodies, including the London Topographical Society, founded in 1898, and the London Survey, whose first volume was published in 1900. Two of Norman's oils are in the Museum (Nos. 84 and 85), one of them a view done immediately prior to demolition. During the last war, a number of artists were specially commissioned to record the bomb damage to London's buildings, and Piper's striking impression of the east end of Wren's Christchurch, Newgate Street, after gutting during a fire raid, is in the collection (No. 93).

SCENES OF LONDON LIFE

Some of the early maps and prospects of London are embellished with elaborately costumed figures, and the two spectators who appear in the foreground of the panorama of London and the Thames from above Greenwich (No. 43) evidently belong to this tradition. Most other early views with figures predominating depict particular events or ceremonies, such as the celebrated *Procession of Queen Elizabeth* set against a background formerly identified as Blackfriars. Not until later in the seventeenth century does one encounter any vividly observed scenes of the life of the times, and the Museum is fortunate in possessing the picture of the Great Fire and the two views by Hondius from the Restoration period. But to a large extent the figures even in views of this date

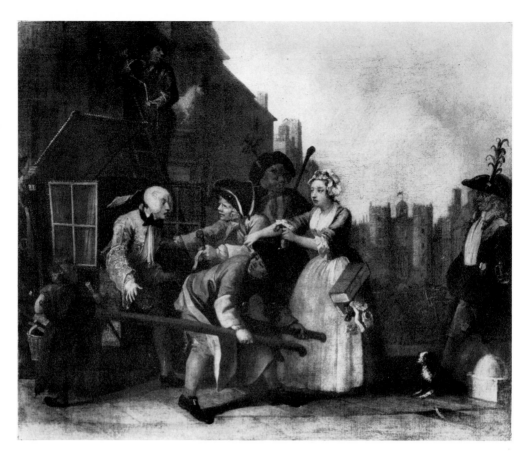

Plate VI Arrest for Debt, a scene from *The Rake's Progress*, painted c. 1731-5 by William Hogarth (Sir John Soane's Museum)

are only incidental. The refugees from the blazing City in the picture of the Great Fire (No. 40) are treated basically as an element in the composition, while the innumerable little figures disporting themselves on the ice in the scenes by Hondius (Nos. 56 and 57) are typical of Dutch *staffage*, the successors of the skaters who populate the winter scenes of Avercamp.

The painting of London life as a genre only really comes into its own with Hogarth, and it reflects the artistic mood of the second quarter of the eighteenth century, with its concern for naturalism and immediacy and preference for unpretentious everyday subjects. It was the age of the novel and of the conversation piece alike. It was also an age of moralising on the virtues of industry and sobriety, and Hogarth's moral purpose both sharpened his observation, and inclined him towards subjects which displayed the seamier side of London life. In *The Rake's Progress*, for instance, there are glimpses of the Fleet prison and of Bedlam, as well as of a tavern and a gaming house. Hogarth, in fact, supplies the necessary corrective to the Scott tradition of view painting, in which the streets of London were depicted as being rather wider and tidier and more seemly than they really

12

were. Southwark Fair and Covent Garden are included in the specific scenes he painted, and dining clubs, musical soirées, fashionable and not so fashionable drawing rooms among his other subjects. His gallery of characters included upper class dandies, City merchants, lawyers, clerics, watchmen, sedan chairmen, lamplighters, pickpockets, harlots and quack doctors – indeed, half of London passes before our eyes, and so irresistible was Hogarth's urge to portray, that, as in the *Arrest for Debt* (Pl. VI), he would include characters quite incidental to the story, who help to bring the London scene vividly alive for us. Hogarth's closest follower in the field of genre painting was Collet, and he provides us with another gallery of London types for a slightly later date, but observed without Hogarth's asperity: several familiar characters, among them the inevitable pickpocket, are included in his view of Covent Garden Market (No. 30). In the latter part of the century the sharpness of observation, especially of low life, is less evident still, and the figures in the scenes of Wheatley or Walton tend to be over sentimentalised: Wheatley's street-sellers in his famous series of *Cries of London* are an obvious example.

One of the most attractive features of the London scene in the late eighteenth and early nineteenth century was undoubtedly the coaching inn, with its comings and goings of elegant private, stage and mail coaches; but Pollard, who painted fine pictures of the *Elephant and Castle* and other inns, is unfortunately represented in the collections only by two of his later omnibus paintings (Nos. 94 and 95). Among other specialists were painters like Wolstenholme, who depicted the busy day-to-day scene at many of London's breweries (No. 111). Ceremonies and processions of various kinds were always, of course, popular subjects, the Mayday sweeps' procession (No. 26) being a particularly interesting and unusual example.

Victorian scenes of London life tended, on the whole, to follow the tradition of Wheatley rather than of Hogarth (Frith's moral series *The Race for Wealth*, with its last scene a prison yard, was evidently inspired by Hogarth but completely lacks his bite). The Victorians favoured a gentle, domesticised kind of art, and preferred triviality, anecdote and gaily costumed figures to any positive statement about the circumstances which surrounded and sustained their comfortable lives in Kensington or Belgravia. The enormous canvases of Frith and Hicks, of which *The Railway Station* (Pl. VII) and *The General Post Office: One Minute to Six* may serve as examples, were crammed to bursting with figures involved in the kind of incidents which were everyday occurrence, and they shone with the rich bright colours of the ladies' dresses. Ritchie's *Summer Day in Hyde Park* (No. 96) follows pleasantly in this tradition, making gentle fun of the couple up from the country and of stuffy upper middle-class parents. Phoebus Levin, now a completely forgotten painter, also worked in Frith's manner, and his views of *Covent Garden Market* and *Cremorne Gardens* (Nos. 67 and 68) are equally full of incident and colour; but they also reflect the Victorian desire to prettify and sentimentalise – Cremorne was a far rougher and seedier place than Levin would have us believe. This tendency is carried to a mawkish extreme in Mulready's paintings of street arabs (No. 76), who were not in fact the children of distressed gentlefolk but belonged to the submerged poor, a class of Londoner living constantly on the verge of starvation.

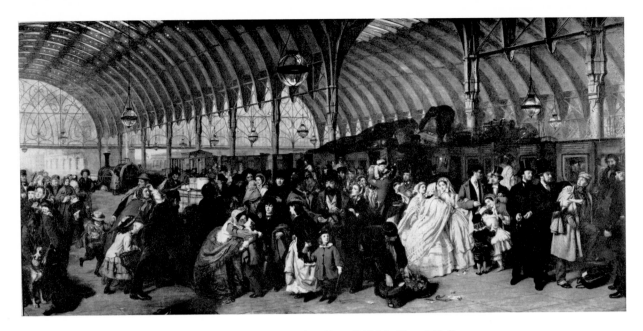

Plate VII Paddington Station, painted in 1862 by William Powell Frith (Royal Holloway College)

A more accurate impression of the London street sellers is to be found in the engravings in Mayhew's *London Life and the London Poor*, and the life of the poor was also illustrated, in graphic form, by Gustave Doré. In painting, the more sordid aspects of London life were treated in a less sentimental manner at this same period by Sir Luke Fildes, whose *Applicants for Admission to a Casual Ward* is painted in a range of subdued tones which contributes to the pathos of the scene.

Society life in London at the end of the nineteenth century, the balls and dinner-parties and private views at the Royal Academy, were painted with all the careful attention to detail of Frith by painters such as Tissot and Orchardson. Sickert, on the other hand, and later, the Camden Town school of painters, Bevan, Gilman, Ginner and Spencer Gore, who were the first to paint the streets of suburban London, Belsize Park (No. 8), Mornington Crescent and elsewhere, were beginning to give us a completely different gallery of Londoners: the devotees of the music hall (Pl. VIII), the ordinary tradespeople and working men and women, particularly those who lived in the inner suburbs, shown either going about the streets (Pl. IX), or at their jobs, or after hours in pub or café. This is a tradition still carried on in Ruskin Spear's Hammersmith scenes.

14

Plate IX The Angel, Islington, painted in 1914 by Charles Ginner
(B. Fairfax Hall, Esq.)

Plate VIII The New Bedford Music Hall, painted in 1915-6 by Walter
Sickert (Tate Gallery)

15

Up to now, we have discussed only the painters concerned principally with 'recording' London, those who focused their attention on the streets and buildings and people and events around them. But many artists, among them some who have best loved London, concentrated on more intangible qualities, the atmosphere, the flavour, the character of the city. Turner's great panorama of London from beyond Lambeth Marsh is quite different in intent from the panoramas of earlier painters; his subject was not the prospect, but the silhouette of the metropolis partially dissolved in the mistiness of a grey autumnal morning. Similarly, in a view of the Thames painted from Mortlake a quarter of a century later (Pl. x) he suggested the silvery, opalescent light of a morning in early summer – and the serenity and majesty of the river. Turner also painted two magnificent compositions derived from the burning of the Houses of Parliament, which are by far the most searing and dramatic impressions we possess of that extraordinary event.

During the Franco-Prussian War, several of the impressionists came to stay in London: Sisley did a number of views of the river near Hampton Court, Pissarro painted

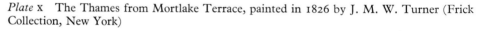

Plate x The Thames from Mortlake Terrace, painted in 1826 by J. M. W. Turner (Frick Collection, New York)

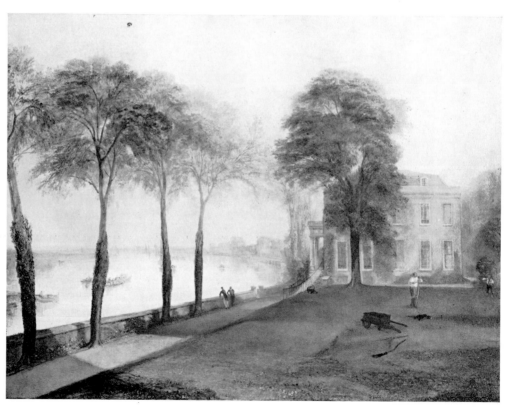

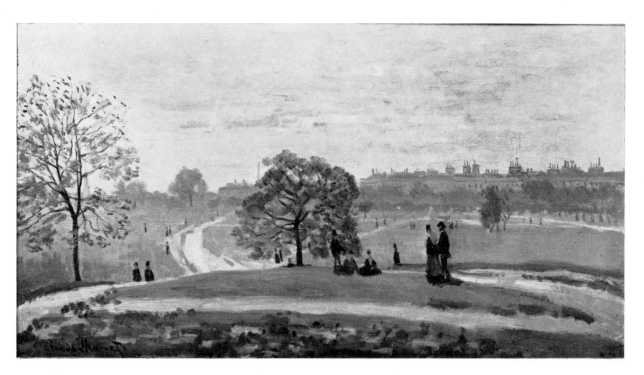

Plate XI View in Hyde Park, painted in 1871 by Claude Monet (Museum of Art, Rhode Island School of Design)

snow scenes in Norwood, and Monet produced a couple of pictures of Hyde Park (Pl. XI) incomparable in their sensitivity to the moisture and greyness of the London atmosphere. Fascinated by the unique quality of London's light and weather effects, Monet returned in later life, and between 1899 and 1904 executed some forty-five paintings of the Thames at Westminster, effects of sunlight, mist and fog. In some of these pictures, such as the view of the *Houses of Parliament* with sun coming through fog, where the buildings are rendered in bluish tints and the water blazes with the scarlets and oranges of the reflected sun, it is rather Turner that comes to mind than Monet.

The greyness of London's river, and the abstract shapes of boats and silhouetted buildings seen through mist, excited Whistler, who lived facing the river in Cheyne Walk, and his *Nocturnes* remain unrivalled as an evocation of the Thames in winter. Nevinson took up this theme, but in a less stylised manner (No. 77), and more recently David Tindle has produced similar impressions of the riverside in a broader, more vigorous style (No. 104). Kokoschka, on the other hand, equally excited by the Thames, to which he has returned as a subject again and again over the years, has always seen it in terms of continental light, as Canaletto had done, and painted it in a riot of brilliant, broken colour.

Aspects of London in which painters have delighted simply as painters are manifold: its skyline, the strange chiaroscuro of its courts and alleyways, the tracery of its trees in wintertime, decaying buildings, the human bustle, the scene by night. O'Connor's

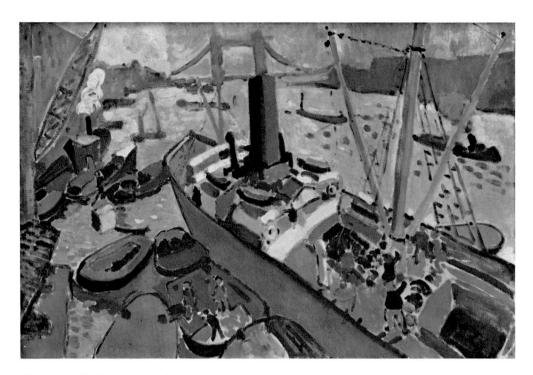

sunset view of the skyline of the St. Pancras Hotel seen from the Pentonville Road
(No. 87), Monet's various pictures of the Houses of Parliament, and Ginner's painting
of the Angel, Islington (Pl. IX) are examples of the first. Watson, who was also an etcher,
painted the chiaroscuro of Victorian London in his view of Drury Court (No. 107), and
this emphasis on contrasts and effects of tone became the special province of the New
English Art Club painters, who are represented in the collections by Atwood (No. 4:
significantly, perhaps, a subject etched by Whistler) and Forster (No. 44). Sutherland
and Piper (No. 93) were fascinated by the picturesque vistas and shapes left in the wake
of the bombs of 1940 and 1941. And among views of London by night, usually a pretext
for painting the soft, romantic effects produced by gaslight, especially under rain, are
Monet's impression of Leicester Square, unusual in his *oeuvre*, and on a lesser plane,
Forster's painting of the Regent Street quadrant (No. 44).

Finally, there are modern painters who have imposed pictorial style firmly upon
London, in a way not even Whistler had done before. Derain painted the Thames and
its barges in pure Fauvist style (Pl. XII); John Minton painted Rotherhithe in a semi-
Cubist manner; Buffet produced a series of London views in his own highly idio-
syncratic idiom; and Ceri Richards romanticised Trafalgar Square into a Matisse-like
composition of flat shapes and pure, bright colours. These are different interpretations
of the subject, London, from the medieval, but in a sense we are back where we began.

The Catalogue

The Catalogue which follows comprises all the oil paintings in the Museum with the exception of signboards etc., those done on paper (which are mounted as part of the collection of prints and drawings, and will be catalogued with the latter) and a small number not connected with the history of London 1. Martin van Valckenborgh's *The Tower of Babel*, painted on the back of the copper-plate map of Moorfields (62.75) 2. a group in the Tangye collection of Cromwelliana (46.78) 3. a portrait of *Prince Charles Edward Stuart* by an unknown artist (A 21821) 4. a park scene by Tibout Regters, signed and dated 1753, purchased as *Rosamond's Pond, St. James's Park*, but almost certainly a view in Holland (A 15448).

The Catalogue is divided into three parts: Topographical and Social Scenes; Portraits and Theatrical Pictures; and the Reserve Collection, the paintings in this group, which may be classed as copies, repetitions and works of inferior quality or marginal London interest, being listed in a more summary way. Within these three sections, the arrangement is alphabetically by artist, with unattributed pictures listed under schools and century e.g. 'British School, eighteenth century'. Accession numbers are noted after the titles of each picture. Measurements are given in inches, with centimetres in brackets; height precedes width.

Topographical and Social Scenes

JOSEPH VAN AKEN (c. 1699-1749)

Painter of market scenes, interiors and conversation pieces; but best known as drapery painter to most of the leading portraitists of the day. Born in Antwerp. His birthdate is unknown, but according to George Vertue, he died 'aged about 50' and 'had been 30 years or more in England'.

I COVENT GARDEN PIAZZA AND MARKET (A 7466)

Canvas. 38 × 40⅛ inches (96 × 100.6 cms.). Painted about 1726-30.

Provenance: B. T. Batsford; Batsford sale, Christie's, 20 December 1911 Lot 153 (as Hogarth) bt. Knoedler; purchased in 1912 (as after Hogarth).

A view of the piazza and market looking east, from beside the church of St. Paul's, Covent Garden. The piazza of Covent Garden, the very first London square ever to be planned, was laid out for Francis, 4th Earl of Bedford on the land behind his town house in the years immediately preceding the Civil War. He received his licence to build in 1631, and his architect was Inigo Jones. The houses, which were built by Isaac de Caux, were of regular width and height (something quite novel in early seventeenth century London), with classically treated façades, and the whole square was based upon the example of the Place des Vosges, a recent development that Jones would surely have made a point of seeing when he visited Paris in 1609. By a curious misnomer, it was the arcades at street level, not the whole square, that became known to Londoners as the 'piazzas' – and it was as the piazzas that they achieved notoriety during the eighteenth century as a meeting place for gallants and their *inamorata*. It may seem curious that what should have continued to be the most fashionable residential square in London for many a day should so soon have declined in reputation, but the explanation is probably to be sought in the growing nuisance of the market (see below) as much as in the tendency to move ever westwards, especially marked after the Great Fire. In the eighteenth century, Covent Garden was chiefly an artists' quarter, full of studios, coffee-houses and auction rooms. This picture gives a good impression of the original buildings; the eastern blocks of houses were demolished, and the northern blocks extensively remodelled, during the 1880's.

Covent Garden market originated in the mid 1650's and an interesting painting by an unknown artist dating from within a decade of this time, which, besides being one of the most useful illustrations of the architectural character of the square, shows a few street-sellers and their wares, is in the Earl of Pembroke's collection. The market was still a comparatively modest affair in the earlier part of the eighteenth century, though Strype referred to it in 1720 as 'a Market for Fruits, Herbs, Roots, and Flowers, every Tuesday,

Thursday, and Saturday; which is grown to a considerable Account, and well served with choice Goods, which makes it much resorted unto'. An excellent impression of the bustling activity at this time is provided by Peter Angillis's painting, signed and dated 1726, which was formerly with Knoedler: this shows the market before the sheds were built. The Museum picture was painted shortly after this date, by which time there was a single line of sheds on the south side of the square, of which the nearest, seen on the right, was Tom King's celebrated coffee house (seen also in Hogarth's *Four Times of the Day: Morning*), and another line of open stalls in the centre. The column supporting a sun-dial and gilt ball was erected in 1668 at the time the square was enclosed with wooden railings and gravelled in (it was later cobbled, as seen here). A number of people are seen buying in the market, mostly from vendors seated beside baskets of fruit and vegetables; a horse and trap is on the right, and a hackney carriage in the distance left.

The costume indicates a date of about 1720-30, and the inclusion of the sheds a date later than 1726.

A smaller but superior version of this picture, incorporating several of the figures included (notably the lady standing in the foreground beside the trap), which is signed in monogram by Joseph van Aken, was with Vicars Brothers in 1948.

Later views of Covent Garden, by Scott (No. 99), Collet (No. 30) and Levin (No. 67), are also in the collections.

ROBERT ALLEN (active second quarter of the nineteenth century)
Sign painter and amateur artist.

2 ALLEN'S TOBACCONIST SHOP, *THE WOODMAN*, 20 HART STREET, GROSVENOR SQUARE (39.45/1)
Canvas. 23⅞ × 20⅛ inches (57.8 × 50.25 cms.). Signed and dated bottom left: *Ro! Allen Feb^y 6. 1841.*

Provenance: Acquired in 1939, source unrecorded.

A view of the exterior of *The Woodman*, a tobacconist's shop at No. 20 Hart Street, Grosvenor Square, painted by the proprietor, Robert Allen; as advertised outside, Allen was also a writer and sign painter. The traditional trade signs of the tobacconist surmount the fascia, and various posters are seen outside the shop: a steamer service by the *William George* and *Royal Adelaide* is advertised as operating between London Bridge and Margate, Deal and Dover; and there are placards for a number of London theatres: Macready is billed as appearing at the Royal Haymarket on 2 July 1840 in *As You Like It,* and Madame Vestris at Covent Garden in *High Life Below Stairs.* Inside the open door can be made out part of Allen's shop sign (a copy of Thomas Barker's well-known picture, *The Woodman,* now in the Tate Gallery); this canvas, presumably executed by Allen, is also in the Museum's collections (39.45/2), but, as a signboard, is not included in the present catalogue.

22

Plate 1 Covent Garden Piazza and Market by Joseph van Aken. Painted about 1726-30

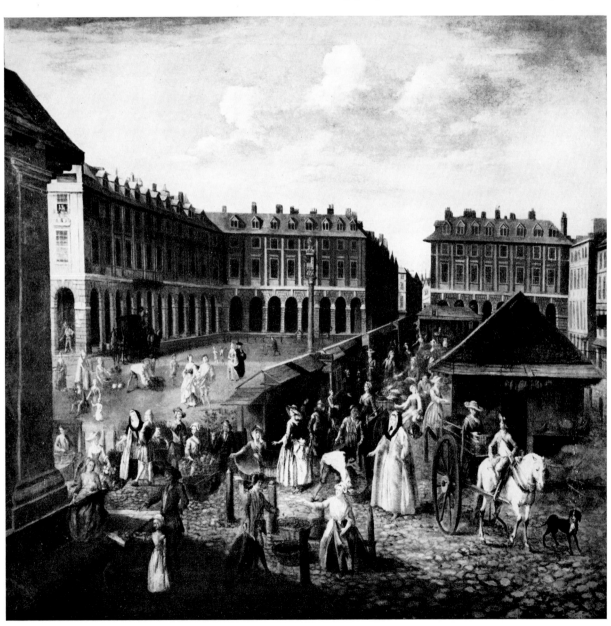

Hart and Brown Streets have now been replaced by Brown Hart Gardens, which is occupied by flats for four thousand artisans erected in 1886-8 by the Improved Industrial Dwellings Company on ground leased by the Duke of Westminster. Between the two sides of the street is the London Electricity Board generating station, on top of which are the Duke Street gardens.

JOHN ANDERSON (active 1858-84)

Topographical and landscape painter. Little is known about his life except that he exhibited at the Royal Academy and elsewhere, and that he lived in Walham Green and (after 1877) in Coventry. Painted several views of Westminster, of which two were exhibited at the British Institution.

3 WESTMINSTER BRIDGE, THE HOUSES OF PARLIAMENT AND WESTMINSTER ABBEY SEEN FROM THE RIVER (A 25910)

Canvas. $72\frac{1}{4} \times 42\frac{1}{4}$ inches (180.8 × 105.8 cms.). Signed and dated bottom left: *JOHN ANDERSON/1872*

Provenance: Presented by P. A. S. Phillips in 1923.

The disastrous fire of 1834 (see Nos. 72 and 97) destroyed almost the whole of the historic Palace of Westminster save Westminster Hall. New premises had to be built for the Houses of Parliament, and the terms of the competition held in 1835 required the designs to be either Gothic or Elizabethan; this was a revolutionary requirement at the time, since no public building had been erected in anything but the classical style for a couple of centuries and more. Ninety-seven designs were submitted, nearly all of them in the Gothic style, and the winner was Charles Barry. To him is due the planning and execution of the building, but the detailing, for which literally hundreds of drawings were prepared, was entirely the work of Augustus Pugin, whom Barry called in to help him. By the time the building was finished a quarter of a century later, in 1860, Gothic was the recognised language of all leading architects in England.

This view shows the Houses of Parliament from a point between the sites of the present County and Royal Festival Halls. The long river frontage, over three hundred yards, designed as a principal block with flanking towers and lower wings terminated by twin towers, is clearly seen, and behind this are the principal towers of the building: the Victoria Tower, completed in 1860, regarded at the time as a stupendous edifice, since it rose to no less than sixty feet higher than the top of the cross on the dome of St. Paul's; the Middle Tower, which rises above St. Stephen's Hall; and Big Ben, finished in 1858.

Westminster Bridge, seen in the foreground, which replaced the mid-eighteenth century structure (see No. 20), was built contemporaneously with the last stages of the Houses of Parliament, in 1854-62, and was designed by Thomas Page, engineer. Beyond the bridge, on the extreme left, is the spire of Holy Trinity, Bessborough Gardens, a church

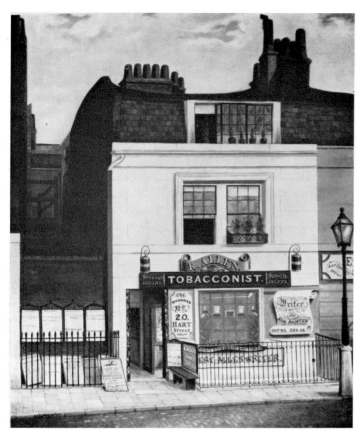

Plate 2 Allen's Tobacconist Shop, *The Woodman*, 20 Hart Street, Grosvenor Square by Robert Allen. Signed and dated 1841

Plate 3 Westminster Bridge, The Houses of Parliament and Westminster Abbey seen from the River by John Anderson. Signed and dated 1872

built by J. L. Pearson 1849-51, now destroyed; and on the right of the bridge are seen, from left to right, Westminster pier, the early Tudor parish church of St. Margaret's (incorrectly shown with pointed windows), Westminster Abbey, and part of the Embankment. The Victoria Embankment had only recently been completed at the date of this picture, and the works connected with the building of the floating bath (operative by 1876) are seen on the right. Behind this structure are the (then) offices of the Civil Service Commission (formerly the India Board of Control) and the south-west corner of Richmond Terrace; the St. Stephen's Club, which stood on the corner of Bridge Street, was not built until 1874. A steamboat is seen off Westminster pier, and a number of barges occupy the immediate foreground.

A smaller view by Anderson, taken from Vauxhall Bridge and showing St. Thomas's Hospital on the right, signed and dated 1873, was in an Anon. sale, Sotheby's, 15 January 1964 Lot 188.

A view of Westminster Bridge and the Houses of Parliament from a point further east, by Winkfield, is also in the collection (No. 109).

CLARE ATWOOD (1866-1962)

Painter of landscapes, portraits, interiors, and still lifes. Born in Richmond, the daughter of an architect. Studied at the Westminster School of Art and the Slade School. Member of the New English Art Club. Lived in Chelsea, Covent Garden and Tenterden, Kent.

4 INTERIOR OF THE COACH-WHEELWRIGHT'S SHOP AT 4½ MARSHALL STREET, SOHO (38.109/1)

Canvas. 16⅛ × 20 inches (40.6 × 50 cms.). Signed bottom left: *Clare Atwood*. Painted about 1897.
Exhibited: New English Art Club, November-December 1897 (76).

Provenance: Given to the donors' father (owner of the shop) by the artist; presented by the Misses Robson in 1938.

Five men are seen busily at work in the Marshall Street shop, but it is not clear from the picture exactly what tasks they are all engaged upon: the craftsman on the left is standing at a wheel-stool.

This workshop, owned by George Robson, supplied the wheels for the funeral car of the Duke of Wellington, the household carriages of Queen Victoria, and the state landau of Edward VII, all of which were designed and made by Hooper and Company. Hoopers' had their own small wheel shop in Chelsea, but wheels of greater size than usual were normally ordered from outside wheel makers, and Robson's name appears frequently in Hoopers' records as a maker and supplier (in this connection, notice the massive hub bottom left). The Marshall Street workshop began to lose its standing and clientèle when iron rimmed wheels were superseded first by solid rubber tyres, and then by pneumatic tyres, and it was finally closed down in 1906. The premises, until recently in use as warehouses, have now been demolished, and a prestige high rise building is in course of erection; but the carriage entrance still exists.

26

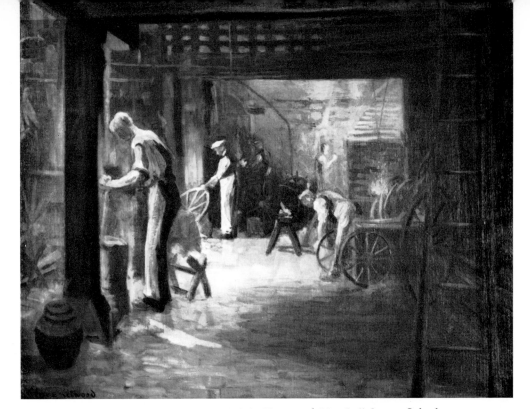

Plate 4 Interior of the Coach-Wheelwright's Shop at $4\frac{1}{2}$ Marshall Street, Soho by Clare Atwood. Painted about 1897

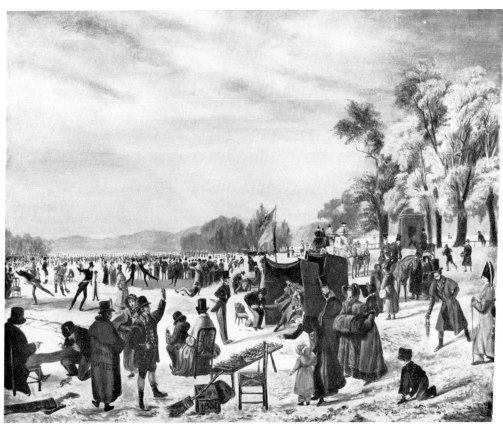

Plate 5 Skating on the Serpentine by J. Baber. Copy of a picture painted in 1823

J. BABER (active early nineteenth century)
Possibly the architect of this name who exhibited at the Royal Academy 1806-12.

5 SKATING ON THE SERPENTINE (A 8076)

Canvas: $18\frac{1}{8} \times 22\frac{1}{4}$ inches (45.3 × 55.5 cms.). Signed bottom left: *J Baber* and dated bottom centre: *1839.*

Provenance: Purchased from Leggatt Brothers in 1912.

A crowd of skaters are shown enjoying themselves on the frozen Serpentine, and a couple of coaches and three horseback riders are seen on the bank on the right. In the foreground is a low table with an array of skates, and three gentlemen, one of them seated in an improvised cabin, are seen being fitted up for skating. To their left is a man in an overcoat marked in large letters *ROYAL HUMANE SOCIETY.* This Society was founded in 1774, and the receiving house which it established in Hyde Park for the treatment of persons who met with accidents either in bathing or skating was built in 1834 (it was destroyed by enemy action in 1940). Skating on the Serpentine nowadays is only allowed when there is a uniform depth of about 5 inches of ice.

An unusual variety of costume is shown in this canvas, all of which indicates a date of about 1825, conflicting with the painter's clearly written date of 1839, and the picture is in fact an exact copy of John Chalon's *The Serpentine, Hyde Park, during the late frost,* formerly in the possession of Miss Cannan, which is signed and dated 1823 and was exhibited at the Royal Academy that year (457). Weather charts of the period record that the temperature was well below freezing-point (at midday) in mid and late January 1823, while neither 1838-9 nor 1839-40 were severe winters.

JOHN HENRY FREDERICK BACON (1865-1914)
Genre, ceremonial and portrait painter, best known for his painting of the Coronation of King George V and Queen Mary. Studied at the Royal Academy Schools. A.R.A. 1903. Lived in St. John's Wood and South Kensington.

6 INTERIOR OF WESTMINSTER ABBEY, SHOWING THE HIGH ALTAR (A 13264)

Canvas. $40 \times 49\frac{7}{8}$ inches (100 × 124.6 cms.). Stamped bottom right: *J.H.F.B./1914*

Provenance: J. H. F. Bacon Sale, Christie's, 27 April 1914 Lot 60 bt. London Museum.

An unfinished sketch for part of the large canvas of the Coronation of King George V and Queen Mary at Buckingham Palace. This view is taken from the Presbytery, and shows the High Altar. The Coronation took place on 22 June 1911.

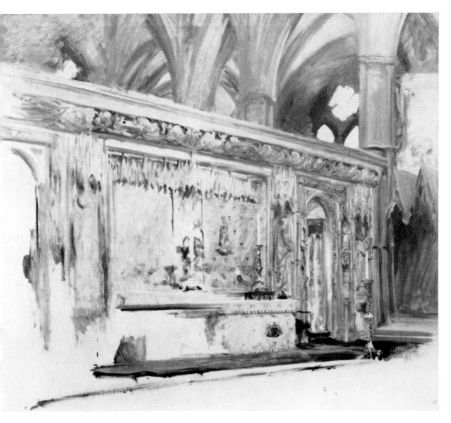

Plate 6 Interior of Westminster Abbey, showing the High Altar by J. H. F. Bacon. Painted in 1911

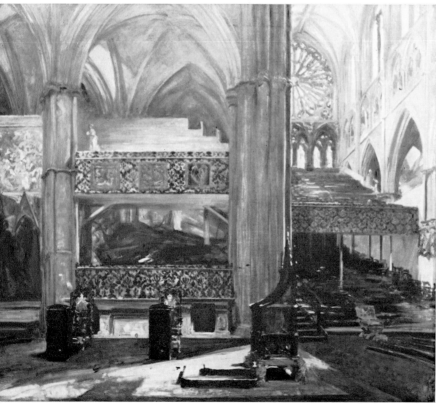

Plate 7 Interior of Westminster Abbey, looking into the South Transept by J. H. F. Bacon. Painted in 1911

29

7 INTERIOR OF WESTMINSTER ABBEY, LOOKING INTO THE SOUTH TRANSEPT (A 13265)

Canvas. 40 × 49⅞ inches (100 × 124.6 cms.). Stamped bottom right: *J.H.F.B./1914*

Provenance: J. H. F. Bacon sale, Christie's, 27 April 1914 Lot 60 bt. London Museum.

A sketch for another section of the canvas of the Coronation of King George V and Queen Mary at Buckingham Palace. This view is taken from the Presbytery, looking into the South Transept, which was used for the Royal Gallery, and shows the tiers of benches that were constructed for the ceremony. The Coronation Chair is seen on the right, and on the left are the Chairs of Estate upon which the King and Queen sat before the Service began.

ROBERT POLHILL BEVAN (1865-1925)

Painter of horses, landscapes, and London scenes. Born at Hove, Sussex. Pupil of Alfred Pearce and studied at the Westminster School of Art and the Académie Julian in Paris; worked in Pont Aven in 1893-4 at the same time as Gauguin. Settled in Hampstead in 1910. Original member of the Camden Town Group 1911, and the London Group 1913; member of the New English Art Club 1922.

8 A STREET SCENE IN BELSIZE PARK (61.78)

Canvas. 25 × 36⅛ inches (75 × 90.3 cms.). Signed bottom left: *Bevan*. Painted in 1917.

Provenance: the artist's family; purchased out of the Mackenzie Bell Trust Fund from Messrs. P. & D. Colnaghi in 1961.

Exhibited: London Group, Peintres Anglais Modernes, April 1917 (35); *Robert Bevan*, Arts Council, 1956 (27); *Robert Bevan*, Colnaghi's, March-April 1961 (19), repr. pl. IV in the Catalogue; *London Group Jubilee Exhibition*, Tate Gallery, July-August 1964 (3), repr. in the Catalogue; afterwards Arts Council Touring exhibition, August-October 1964 (Cardiff and Doncaster).

Reference: R. A. Bevan, *Robert Bevan*, London, 1965, pp. 21 and 27, repr. pl.59.

Also reproduced: The Daily Telegraph, 13 April 1961; *Hampstead and Highgate Express*, 12 November 1965.

Bevan lived in Belsize Park, and did a good many paintings of this neighbourhood. This view shows the fork of Buckland Crescent (left) and Belsize Park, and the large house in the centre is the building acquired by the Hall School in 1916, and used as a preparatory school; the artist's son was a pupil there up to 1913.

This part of Hampstead was developed in the middle years of the nineteenth century, in the stuccoed Italianate style popular also in Kensington, and, with the exception of the lamp posts, which have now been replaced, the scene represented in this painting remains quite unchanged (the modern flats in Belsize Park are on the sites of houses which would have appeared outside the canvas, on the right).

Plate 8 A Street Scene in Belsize Park by Robert Bevan. Painted in 1917

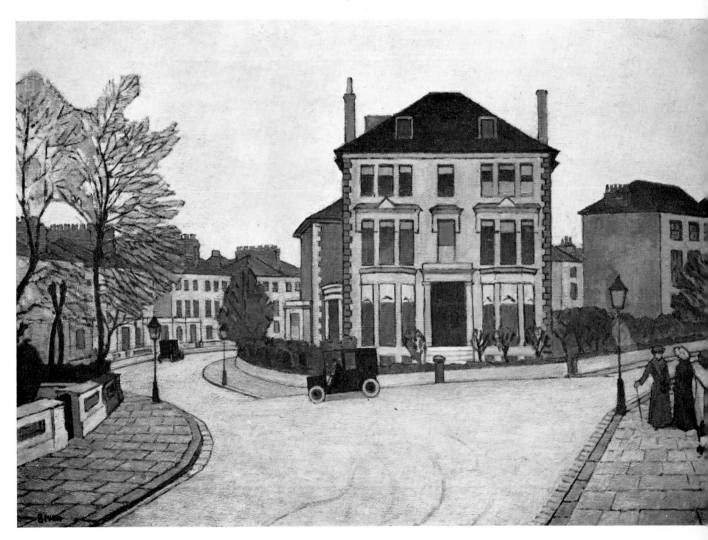

A. S. BISHOP (active 1874-89)

Nothing is known about this painter, and hardly any of his pictures are recorded: a portrait of the 4th Marquess of Salisbury on horseback, signed and dated 1874, is at Hatfield.

9 JAMES SELBY'S BRIGHTON COACH OUTSIDE THE NEW WHITE HORSE CELLAR, PICCADILLY (A 24298)

Canvas. 23⅞ × 36⅛ inches (59.8 × 90.3 cms.). Signed and dated bottom left: *A. S. Bishop./ 1888-9*

Provenance: M. W. H. Mackenzie; Mackenzie sale 1897 bt. E. K. Fownes; A. Baker; purchased in 1922.

A yellow and black stage-coach, with a coachman and a passenger on the box, and six other passengers outside, drawn by four brown horses, is shown standing outside the New White Horse Cellar, part of Hatchett's Hotel, 67-8 Piccadilly, on the corner of Dover Street. The vehicle is marked as owned by James Selby (d. 1888), the best known professional coachman of the period, and as plying between the White Horse Cellar and the Ship Hotel, Brighton, with intermediate stops at Croydon, Merstham, Horley and Handcross. A woman with a little girl, and a soldier, are seen on the left, and five more people, watching the departure of the coach, are standing on the right. It seems likely that the picture was painted to commemorate James Selby's famous drive from London to Brighton and back in under eight hours, an extraordinary achievement with a regular coach and four, and which he undertook (in 1888) for a wager of a thousand pounds.

Hatchett's Hotel, Coffee House and White Horse Cellar was founded by Abraham Hatchett in 1753, following the demise of the White Horse Inn or Cellar, kept by John Williams, which was situated on the south side of Piccadilly, between Duke Street and St. James's Street. The 'cellar' was for the reception of parcels and luggage for the western stages, and Hatchett's was also a starting point for the mail coaches, described by Hazlitt as 'the finest sight in the metropolis'.

The New White Horse Cellar attempted to revive the taste for coaching in the mid-Victorian period, and became the starting point for many short distance coaches, some of them driven by gentlemen (like James Selby) who were the proprietors of their own team; typical destinations were Dorking, Guildford, and Virginia Water. The premises shown here were probably built by Bailey and Thomas, who succeeded John Hatchett as proprietors in 1831. The hotel continued to be one of the foremost in London until its closure in 1896; Hatchett's restaurant still flourishes on the same site.

I. J. BORGNIS (active mid-nineteenth century)

Nothing is known about this painter, who was presumably an amateur.

10 THE METROPOLITAN BATHS, SHEPHERDESS WALK, HOXTON (A 28575)

Panel. 24¾ × 24⅞ inches (100.3 × 125.6 cms.). Signed bottom right: *I J Borgnis* Painted about 1845.

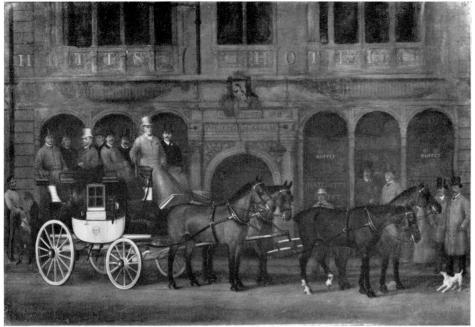

Plate 9 James Selby's Brighton Coach outside the New White Horse Cellar, Piccadilly by A. S. Bishop. Signed and dated 1888-9

Plate 10 The Metropolitan Baths, Shepherdess Walk, Hoxton by I. F. Borgnis. Painted about 1845

Provenance: Presented by Leggatt Brothers in 1912.

A view of the Metropolitan Baths at No. 23 Ashley Crescent (part of Shepherdess Walk), looking south down what was then known as Vaughan Terrace towards St. Luke's Workhouse, which is seen in the far distance. On the left is Shaftesbury Street, with the Royal Standard public house on the corner; the archway beyond, in front of which a number of people are gathered, seems to be the entrance to a Nonconformist Chapel; behind the trees is visible part of the façade of the Grecian Saloon (or theatre) attached to the celebrated Eagle Tavern (a stone eagle can be seen surmounting the parapet), shown as remodelled in 1837.

This part of London, which lies between the City Road and the Regent's Canal began to be developed at the end of the eighteenth century. By 1795 there was a row of houses at the southern end of Shepherdess Walk, the *Shepherd and Shepherdess* (later known as the Eagle Tavern) had been opened, and St. Luke's Workhouse constructed. Vaughan Terrace and Ashley Crescent were both finished in the early 1830's, and the houses seen here, two and three storey in height, partially stuccoed and with ironwork balconies, are typical of terraces of this period in the inner suburbs.

The Act enabling local authorities to establish public baths and wash-houses was passed in 1846, as part of a complex of sanitary legislation which resulted from the cholera scares of the 1840's. The Metropolitan Baths, described as a 'House with Cold, Tepid and private Baths, with Ante and Dressing Rooms and Boxes', was a more elegant private establishment opened in 1835 under the proprietorship of James Esdaile.

The costume indicates a date of about 1845.

A. DE BREE (active late nineteenth century)

Little is known about this artist except that he was Dutch in origin, that he was supposed to have been discovered in London by the 6th Earl of Mayo practically destitute, and employed by him as a copyist, that he painted animals and copies for King Edward VII (a painting of a horse executed in 1893 survives in the royal collection), and that he later married and returned to Holland.

II CHESTERFIELD HOUSE, BLACKHEATH (A 25323)

Canvas. 12⅛ × 17¹⁵⁄₁₆ inches (30.3 × 42.7 cms.). Signed and dated bottom right: *A de Bree/1884*

Provenance: Painted for Richard, 6th Earl of Mayo; presented by Dermot, 7th Earl of Mayo, in 1923.

A view of the front of Chesterfield House (later the Ranger's House) in Chesterfield Walk, Blackheath. The main block was built in the early eighteenth century, but the two wings, in yellow brick, were added by the 4th Earl of Chesterfield soon after he took the lease in 1753. The doorway and covered entrance seen here, which are probably Victorian (and of which this picture is the only visual record) were removed in about 1903; and the cupola surmounted by a weather vane, seen between the trees on the left, which

Plate 11 Chesterfield House, Blackheath by A. de Bree. Signed and dated 1884
Plate 12 Allegory of Summer (British School (?)). Painted in the late seventeenth century

stood on the roof of one of the buildings in the stable block, was taken down in 1943, as a result of war damage (it will, however, shortly be re-erected).

Blackheath became a popular district for establishing a country retreat close to London early in the eighteenth century, and Sir Gregory Page, the South Sea millionaire, built a vast Palladian mansion there in 1721; another notable house, which still stands, is Sir John Vanbrugh's villa, Vanbrugh Castle, built in 1717-26. Chesterfield House occupies a position of advantage at the summit of Shooter's Hill, and has a south-westerly aspect. The house was given to the donor's mother, a Lady of the Bedchamber, by Queen Victoria, and was acquired by the London County Council in 1900; part of it is now used as offices for the Greater London Council's Architect's Department, and the saloon is used occasionally for concerts, lectures and poetry-readings.

BRITISH SCHOOL (?), SEVENTEENTH CENTURY

12 ALLEGORY OF SUMMER (64.77)
Oil on plaster. 114 × 126 inches (285 × 315 cms.) (oval). Painted in the late seventeenth century.

Provenance: Part of the decoration of No. 15 Buckingham Street, Strand, removed from the premises at the time of its demolition in November 1961; presented by the Royal National Pension Fund for Nurses in 1964.

Reference: Survey of London, Vol. XVIII (The Strand), London, 1937, p. 65.

This ceiling painting, done directly on the plaster, and framed by a foliated decorative border executed in plasterwork in high relief, is one of two surviving that were painted for rooms in No. 15 Buckingham Street, Strand. Both were removed from their positions when the original house, built in the late seventeenth century, was pulled down in 1906, and replaced in first floor rooms of the new house designed by Paul Waterhouse in 1908. They were finally removed from Buckingham Street when the Waterhouse building was demolished in 1961. Both paintings had been much restored and overpainted.

The painting in the Museum is a good example of the kind of decorative work, deriving in type from the popular allegorical compositions of Verrio and Laguerre, that was common in London houses of the late seventeenth and early eighteenth centuries. It is rather inferior in quality to the style of Nicolas Heude (died 1703), an assistant of Verrio, who is known to have executed decorative work in London c. 1685-90; but closer to that of Pierre Berchet (1659-1720), a follower of Laguerre, who is also known to have worked in London subsequent to 1685, and whose ceiling paintings for the chapel of Trinity College, Oxford, c. 1694, are still extant. No. 15 Buckingham Street, one of the larger houses in the street, facing the river, was built between 1675 and 1680, and the decoration was probably carried out soon afterwards. The house was used as the Prize Office between 1704 and 1710, and a distinguished early resident was Sir John Colbatch, the physician, who lived there from 1717 until 1729.

36

The second painting is still in the possession of the donor, the Royal National Pension Fund for Nurses.

BRITISH SCHOOL, EIGHTEENTH CENTURY

13 CHARING CROSS AND NORTHUMBERLAND HOUSE FROM SPRING GARDENS (A 28576)

Canvas. 15 × 19⅝ inches (37.5 × 49.2 cms.). Painted in the late eighteenth century, after the original Canaletto executed in 1753.

Provenance: Purchased by an unknown buyer in Lisbon in 1872 (as Canaletto); date and source of acquisition unknown.

Northumberland House, which was known as Suffolk House in the earlier part of the seventeenth century, is seen in the centre of the picture. Built in 1605-9, it was until last century one of the principal monuments of Jacobean architecture in the metropolis, and stood on the south-east side of Charing Cross, between the Strand and Whitehall, with a garden stretching down to the river.

In 1749 the 2nd Earl (later the 1st Duke) of Northumberland, who had just succeeded to the title, and later commissioned Robert Adam to rebuild Syon House, began extensive alterations to the house, including the building of a fine new gallery; the modifications in the façade, seen here, comprised the building of the turrets with their lead cupolas, the erection of the Percy Lion above the parapet of the splendid frontispiece, and the replacement of the Jacobean window lights with Georgian sash windows. The house was destroyed in 1874 to make way for the formation of Northumberland Avenue, having been purchased by the Metropolitan Board of Works for just under half a million pounds; the Percy Lion was then removed to Syon House.

The monument on the right is the bronze equestrian statue of Charles I in armour by Hubert le Sueur, which was cast in 1633 for Lord Weston and intended for his garden in Roehampton. It later came into the possession of the Crown, and was set up at Charing Cross (on the site of the old Eleanor Cross, destroyed by the Parliamentarians in 1643) between 1675 and 1677, with a pedestal by Joshua Marshall. It still remains in the same position, facing down Whitehall.

Charing Cross was a noted shopping centre in the eighteenth century (as was the Strand, which can be seen in the distance), and among the shops seen on the left and right of this picture are jewellers, instrument makers, hosiers, trunkmakers and saddlers. The latter two were suitably located close to the Golden Cross Inn, whose sign appears on the left, and whose yard was one of the principal starting points for the mail coach services.

The composition (and certain of the figures) are derived from the painting by Canaletto executed for the Earl of Northumberland, which was engraved in 1753. A larger but far inferior version of this view is in the Museum (No. 129); and a variant of the composition is also in the collection (No. 164). Innumerable other versions exist.

14 LAMBETH PALACE FROM HORSEFERRY (C 352)

Canvas. 19⅜ × 27⅜ inches (48.4 × 68.4 cms.). Painted about 1745-50.

Provenance: B. T. Batsford ;Batsford sale, Christie's, 12 January 1901 Lot 12 (as Canaletto) bt. Agnew; lent by Mrs. C. W. Bischoffsheim in 1911 (as Boydell); by descent to Sir Arthur Fitzgerald, Knight of Kerry, who presented it in 1966.

Exhibited: Old London Exhibition, Whitechapel Art Gallery, November-December 1911 (119: Upper Gallery).

This view is taken from much the same viewpoint on Millbank Terrace as No. 49 and shows the scene some forty years later. Westminster Bridge, built between 1736 and 1750, is shown as completed, and a good deal of development has taken place on the fringe of Lambeth Marsh, between the bridge and the Palace. The barge-houses of the Archbishop of Canterbury are seen in the centre, and a tree lined walk has been laid out in front of Lambeth Palace. Lambeth stairs and St. Mary's church are seen to the right. St. Paul's still dominates the distance, but less commandingly than it used to do. Some passengers are being ferried across the river in the foreground, and a ceremonial barge can be seen in the middle distance.

The picture is crudely painted, and not to be relied upon for detailed accuracy. In composition it is based upon an engraving after John Maurer published in 1745, and the costume of the figures indicates a date not later than about 1750.

Versions of this picture, with different figures and boats, are in the collection of Bernard Bevan and of Associated Portland Cement Manufacturers Ltd.; others were with Agnew in 1921, with Knoedler in 1931, in a sale at Parke-Bernet, 21-2 September 1962 Lot 223, and in the Rockley sale, Christie's, 22 November 1963 Lot 32.

15 LEICESTER SQUARE, WITH THE DESIGN FOR A PROPOSED NEW OPERA HOUSE (A 28577)

Canvas. 59¼ × 94 inches (148.2 × 235 cms.). Painted about 1790.

Provenance: Mrs. Sligo de Porthonier; Porthonier sale, Christie's, 26 February 1917 Lot 85 (as Canaletto) bt. Knoedler; Anon. sale, Christie's, 8 December 1919 Lot 114 bt. Scott; purchased from George de Pyre in 1920.

References: Country Life, 24 March 1917, p. 287 (repr.); *The Connoisseur,* July 1920, p. 170 (repr.); *Survey of London,* Vol. XXXIV (The Parish of St. Anne Soho), London, 1966, p. 457 (repr. pl. 28b).

In the nineteenth century Leicester Square was principally noted for its hotels and places of entertainment, but it had previously been a fashionable residential district. Strype, writing in 1720, called it 'a very handsome open Square, railed about, and gravelled within,' adding that 'the Buildings are very good, and well inhabited, and frequented by the Gentry'. Some of the original houses built on the east side of the square are seen in this view.

The north side of the square, which included Leicester House, was pulled down in 1789, and the land was purchased by R. B. O'Reilly in January 1790 for the construction

Plate 13 Charing Cross and Northumberland House from Spring Gardens (British School). Painted in the late eighteenth century

Plate 14 Lambeth Palace from Horseferry (British School). Painted about 1745-50

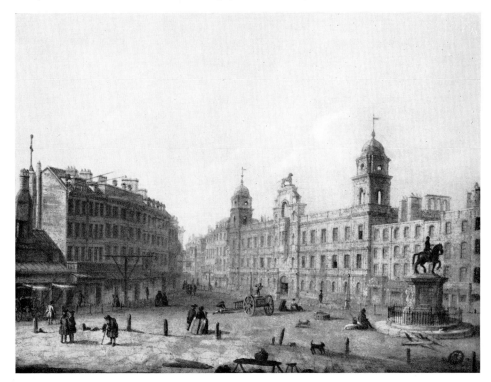

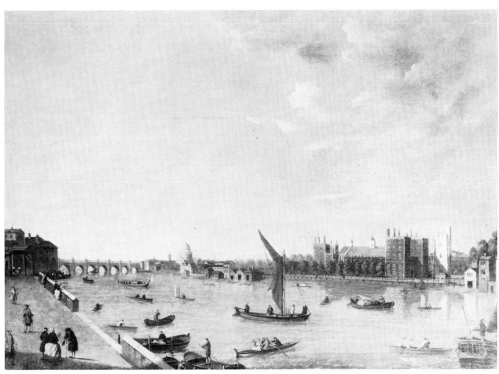

of a magnificent new opera house, intended to replace the Haymarket Opera House, burnt down on 17 June 1789. This new theatre was to stretch from Leicester Street on the west to a new street formed out of Cranbourn Alley on the east, and from the foot-pavement of Leicester Square on the south to Gerrard Street on the north.

The scheme came to nothing as the promised Patent was never granted, and O'Reilly took a lease of the Pantheon for the performance of Italian opera, but designs for the building had been drawn up by Victor Louis, architect of the new theatre in the Palais Royal, which O'Reilly had admired on his visit to Paris; by Sir John Soane, who was to have been the supervising architect; and by O'Reilly himself. One of Louis's designs may be recorded in a drawing of a front elevation, by Thomas Sandby, in the Royal Library; this seems certainly to be the work of a French architect, but does not fit O'Reilly's remark that Louis's plan was 'upon a scale nearly as large as the Colloseum at Rome, to which it is similar in its form'. Other designs were made by Sir John Soane in 1791 and are included in a portfolio of drawings in the Soane Museum. The Museum picture most probably represents O'Reilly's own plan, as a contemporary source describes this as including a 'piazza' (or arcade) on every side, and grand fronts to north and south 'each with a superb Ionic portico'. The elevations shown here are, however, consistent with a ground plan by Soane (which does not fit any of his own designs) in the Soane Museum portfolio. In character, the design curiously anticipates Nash's work of twenty or thirty years later.

The lead equestrian statue of George I by John Nost, which originally stood at Canons, the seat of the 1st Duke of Chandos, was erected in Leicester Square by Frederick, Prince of Wales (who lived at Leicester House) in 1748. It remained *in situ* until 1851, when it was taken down at the time of the building of Wyld's Great Globe. This edifice was designed by James Wyld, the geographer, for the display of geographical and historical dioramas, and achieved some success with the public for about ten years. The Globe was demolished in 1862, and the statue again set up in the centre of the square; it was finally sold in 1872, and later destroyed.

The gardens are planted with trees and flowers in the informal, colourful taste of William Mason and fashionable contemporary gardening.

16 MILLBANK WITH A DISTANT VIEW OF LAMBETH (A 8088)

Canvas. $22\frac{1}{4} \times 34\frac{1}{4}$ inches (55.6 × 85.6 cms.). Painted about 1785-90.

Provenance: Purchased from Leggatt Brothers in 1912.

This view shows Sullivan's boat-building yard and the group of houses at Millbank stairs, whence a ferry operated to Vauxhall. At this date, Millbank was a pleasant river-side walk, extending almost as far as Chelsea Hospital. The marshy area of Tothill Fields behind was still totally undeveloped, and the most southerly house in built-up Westminster was Belgrave House, the riverside home of Earl Grosvenor, which was pulled down in 1809 to make way for the Millbank Penitentiary (in its turn destroyed,

Plate 15 Leicester Square, with the Design for a proposed new Opera House (British School). Painted about 1790

Plate 16 Millbank with a distant View of Lambeth (British School). Painted about 1785-90

in 1890, for the building of the Tate Gallery). On the Surrey shore, houses now stretched as far as Vauxhall, and in the distance is Lambeth Palace, with the dome of St. Paul's beyond.

The costume indicates a date of about 1785-90.

Another view by the same hand, depicting the Red House at Battersea, was recently with Spink and attributed to Thomas Priest.

17 PUTNEY AND THE THAMES FROM PUTNEY BRIDGE (42.50/1)
Canvas. $13\frac{3}{4} \times 40$ inches (34.4 × 100 cms.). Painted about 1750.

Provenance: Bequeathed by Marcus R. Samuel in 1942 (as Boydell).

Exhibited: Views of the Thames from Greenwich to Windsor, Marble Hill House, July-September 1968 (21).

A view looking up the river from Putney Bridge, and showing the riverside village of Putney on the left. The first Putney bridge, connecting Putney and Fulham, of which only a fragment is seen here, was a wooden structure built in 1729 by Thomas Phillips, carpenter to George II (see also No. 18). This remained in place until the present stone bridge was built in 1882-6.

At this date, Putney was only a small village, a few streets surrounding the church, but it was already noted for the beauty of its villas, and also for its orchards and market gardens. With the exception of the 15th century tower, seen prominently in this view, the parish church of St. Mary's was rebuilt in 1836.

The Museum picture corresponds exactly, save for the disposition of the boats, with Boydell's engraving published in 1749, and was presumably copied from it. Another version was with Knoedler in 1928.

18 PUTNEY BRIDGE AND VILLAGE FROM FULHAM (42.50/2)
Canvas. $24\frac{5}{8} \times 40\frac{1}{8}$ inches (61.6 × 100.2 cms.). Painted about 1750.

Provenance: Bequeathed by Marcus R. Samuel in 1942.

Exhibited: The Thames in Art, Arts Council (Henley and Cheltenham), June-July 1967 (6).

The old wooden bridge at Putney was designed by Thomas Ripley and constructed by Thomas Phillips, carpenter to George II, and stood from 1729 until the late nineteenth century, the present stone bridge being built in 1882-6 by Sir Joseph Bazalgette. The charge for crossing was a penny for foot-passengers, and up to two shillings for vehicles, and as this was the only bridge above London Bridge in the vicinity of London until the opening of Westminster Bridge in 1750, the proprietors who subscribed towards its cost made a not inconsiderable income from it. The main toll-house, or Bridge House, seen here, was situated at the Fulham end, and included a residence for the manager; under the roof is seen the bell used to warn of approaching highwaymen. A similar but smaller

Plate 17 Putney and the Thames from Putney Bridge (British School). Painted about 1750

Plate 18 Putney Bridge and Village from Fulham (British School). Painted about 1750

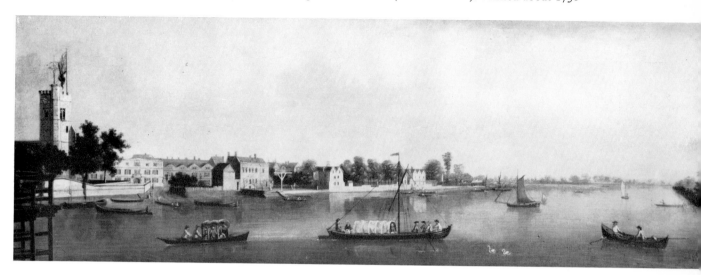

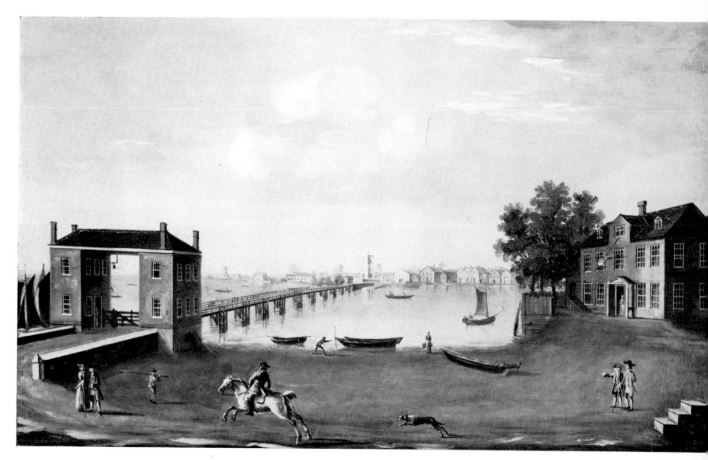

brick toll-house was built on the Putney side after 1850. Across the river are the riverside houses of Putney grouped round the parish church of St. Mary's, which adjoined the approach to the bridge; the windmill was situated on the extremity of the village on the verge of North Fields. On the right is the Swan Inn, where the Bridge Commissioners held their first meeting on 26 July 1726; some mounting steps are in the foreground.

The Museum picture is crudely painted, and the distant buildings are no more than generalised. The painter may have based his canvas on the engraving after Chatelain published in 1750, which depicts the view from precisely the same viewpoint, and the costume indicates a date of about 1750.

A larger version, in which the huntsman and hound and the two figures on the right also appear, was with Sabin Galleries in 1962; and a version with different staffage is in the collection of Sir R. G. Leon.

19 VIEW OF WESTMINSTER AND WESTMINSTER BRIDGE
FROM YORK STAIRS (A 8083)
Panel. $11\frac{3}{4} \times 17\frac{5}{8}$ inches (29.4 × 44.1 cms.). Painted about 1780-5.

Provenance: Purchased from Leggatt Brothers in 1912 (as Vanderstein).

In the foreground is York Stairs, with the York Water Gate, which was then the means of egress to the river from the terrace of York Buildings. Behind are the tower and chimneys of the York Buildings Waterworks Company, founded at the end of the seventeenth century to supply the streets of houses recently built on the sites of the old riverside mansions of the nobility, and, on the right, the Salt Office, once the residence of Samuel Pepys (1688-1701) and Robert Harley, Earl of Oxford (1702-14). In the distance is Westminster Bridge, first opened to traffic in 1750, and the riverfront of Westminster and Whitehall, with the towers of Westminster Abbey and the roof of the Banqueting House visible over the tops of the houses.

The extensive foreshore at low tide, so evident here, which was the hunting ground of mudlarks in search of nails and other small objects they could sell for a few pence, effectively disappeared with the construction of the Embankment in the 1860's; the York Water Gate also became isolated in the Embankment Gardens some hundred and fifty yards away from the river.

The costume of the figures indicates a date of about 1780-5.

20 WESTMINSTER BRIDGE FROM THE RIVER, LOOKING
SOUTH (A 8079)
Canvas. $14\frac{3}{4} \times 35\frac{5}{8}$ inches (36.9 × 89.9 cms.). Painted about 1750.

Provenance: Purchased from Leggatt Brothers in 1912.

Until the mid-eighteenth century the only bridge over the Thames in the metropolis was London Bridge. A better system of communications between London and the Surrey shore was urgently needed, and despite the opposition of the City authorities (who

Plate 19 View of Westminster and Westminster Bridge from York Stairs (British School). Painted about 1780-5

Plate 20 Westminster Bridge from the River, looking South (British School). Painted about 1750

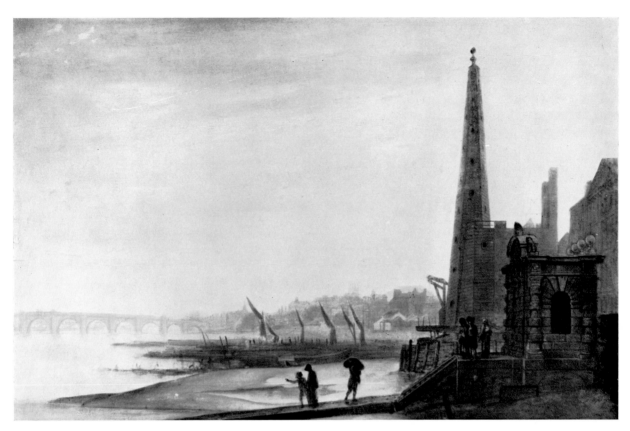

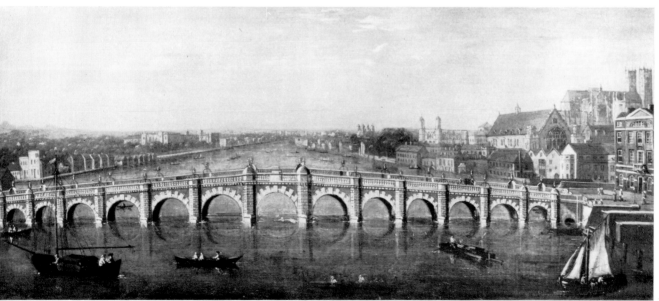

stood to lose their monopoly) and of the Company of Watermen, an Act for building a bridge at Westminster was finally passed through Parliament in 1736. A Swiss engineer, Charles Labelye, was entrusted with the design, and after a temporary setback, when one of the piers subsided in 1748, the bridge was opened to traffic in 1750. Notice the stone alcoves, each with lamps on top, in which pedestrians could shelter in showery weather, and the broad approaches to the bridge at both ends.

Beyond the bridge can be seen, from left to right, the barge houses of the Archbishop of Canterbury, Lambeth Palace, the last houses on Millbank (Mill Bank Row), the church of St. John's Smith Square, St. Stephen's Chapel (meeting place of the House of Commons until its destruction by fire in 1834), Westminster Hall and Westminster Abbey.

The picture is crudely painted, and not to be relied upon for detailed accuracy; and is probably derived from one of the many engravings of this view.

Innumerable versions of this composition exist, the prime source being Canaletto's painting of 1747, now in the collection of Mr. and Mrs. Paul Mellon, which also depicts the Lord Mayor's procession.

21 WESTMINSTER BRIDGE AND WHITEHALL FROM THE LAMBETH SHORE (A 28583)

Canvas. 14⅛ × 24 inches (35.65 × 72 cms.). Painted about 1775.

Provenance: Unknown.

A view of Westminster and the Whitehall riverfront looking south-westwards from one of the timber yards on the Surrey shore. Westminster Bridge, seen on the left, was the first stone bridge to be built over the Thames in the London area since the construction of London Bridge in the twelfth century (see No. 20), and stood for about a century. The present Westminster Bridge (see No. 3) was built in 1854-62, after it was found that the arches of the old bridge were showing signs of collapse. Beyond the bridge are Westminster Hall and Westminster Abbey, the latter with the two west towers designed by Hawksmoor, which had been completed in 1745.

The buildings recognisable north of Westminster Bridge, none of which survives today, are, from left to right: Dorset Court, a mid-eighteenth century residential block (beneath the towers of the Abbey); Richmond House (above the rowing boat); Montagu House (the pedimented mansion in the centre of the picture); the Duchess of Portland's house, where the celebrated Portland Museum was brought together; the long range of red brick buildings comprising the houses occupied by Andrew Stone (and after 1773 by his widow) and by members of the Bentinck family; Pembroke House, with its two bay windows and water-gate, as altered by Sir William Chambers in 1757; Viscountess Townshend's house; Sir Thomas Robinson's house; and Grantham House. The trees of Whitehall Yard are seen on the extreme right, and Whitehall stairs appears in front of Sir Thomas Robinson's house; the Banqueting House and the cupola of the Horse Guards are visible behind.

46

Plate 21 Westminster Bridge and Whitehall from the Lambeth Shore (British School).
Painted about 1775

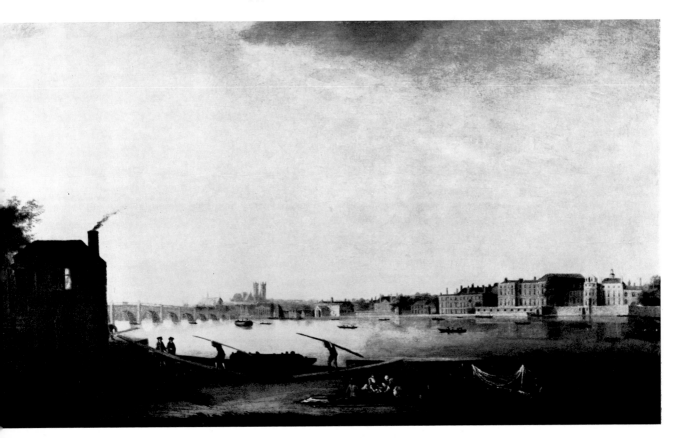

Members of the nobility had occupied mansions along the Thames since medieval times, frequently with pleasant gardens running down to the water's edge, and some continued to do so until well into the nineteenth century. The houses occupied by the Dukes of Richmond and Montagu were among the grander of these town residences; and new Montagu House (built 1859-62) remained a private residence (of the Dukes of Buccleuch) until 1917.

In the foreground, fishermen are active, two women are sorting fish, and some planks of timber are being carried ashore. The Surrey waterfront, from Westminster Bridge to the Old Barge House Stairs opposite the Temple, was largely composed of timber yards and wharves, the storehouse of London's flourishing building trade.

The costume indicates a date of about 1775.

BRITISH SCHOOL, NINETEENTH CENTURY

22 THE CONSTRUCTION OF THE CHARING CROSS STATION HOTEL (61.7/2)

Canvas. 15⅞ × 23⅞ inches (39.65 × 59.8 cms.). Painted about 1863-4.

Provenance: F. Halls; Halls sale, Christie's, 19 February 1960 Lot 116 (as C. R. W. Nevinson) bt. Meatyard; purchased from Abbott and Holder in 1961.

Exhibited: Victorian Painting 1837-1887, Agnew's, November-December 1961 (88); *Nineteenth Century English Art*, New Metropole Arts Centre, Folkestone, May-June 1965 (95).

Reproduced: The Illustrated London News, 22 May 1965, p. 26.

Charing Cross Station, the terminus of the South-Eastern Railway, was built on the site of Hungerford Market in 1863, and the Station Hotel, seen here under scaffolding, was constructed in 1863-4 to the designs of E. M. Barry. Barry's original skyline with its red roofs and pinnacles, has now been replaced by two quite regular extra storeys.

The top of the Nelson Monument, designed by William Railton, with the statue by Edward Hodges Baily, can be seen over the West Strand block (now destroyed). To the right of this, in the distance, is the front of the National Gallery; the cab rank in Duncannon Street, outside St. Martin-in-the-Fields, is visible in the middle distance; and, on the extreme right, are Nos. 448 and 449 Strand. The West Strand improvements, which included the last mentioned buildings and Charing Cross Hospital, were carried out in the early 1830's at the same time as the formation of Trafalgar Square.

The handling of this picture is not unlike the style of Edward Henry Corbould (1815-1905), a series of whose wash drawings of London buildings done for *The Illustrated London News* in 1852 is in the Museum (63.100).

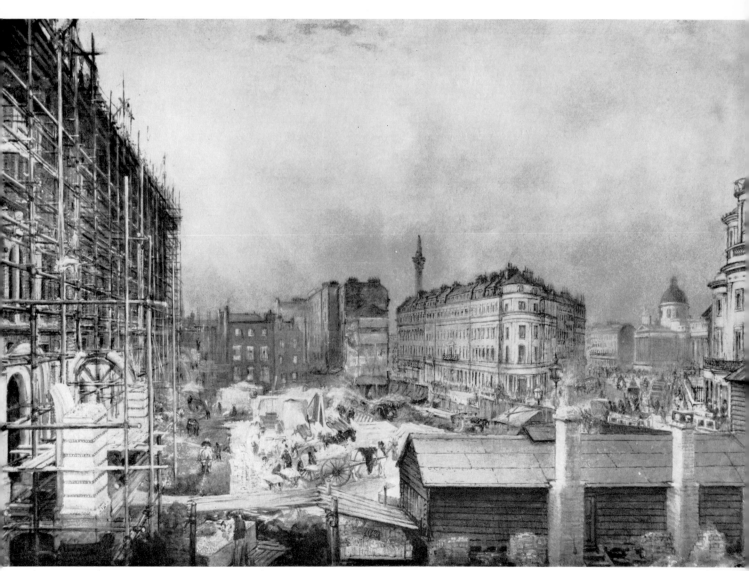

23 THE CORONATION BANQUET OF GEORGE IV IN WESTMINSTER HALL, 1821 (38.292)

Canvas. 39⅞ × 49⅞ inches (99.8 × 124.5 cms.). Painted about 1821.

Provenance: Presented by Bernard, 8th Earl of Granard in 1938.

The coronation ceremony was, until 1821, customarily followed by a banquet in Westminster Hall, attended by the nobility and gentry. Between the first and second courses, the King's Champion, in full armour and on horseback, approached and challenged any comer to deny the King's right to the Crown; his fee was the armour and horse with which he was provided, and a bowl of wine proffered by the sovereign. By tradition, the office of Champion was vested in the Dymoke family, Lords of the Manor of Scrivelsby, and in this picture Henry Dymoke, deputising for his father, who was a clergyman, is seen riding up the hall between the Deputy Earl Marshal (Lord Howard of Effingham) and the Lord High Constable (the Duke of Wellington). This was the last occasion upon which the ceremony of the challenge was performed.

The two rows of tables on either side of the Hall were occupied by the peers. The peeresses and gentry were seated in the two tiers above, and did not partake of the banquet itself. At the far end of the Hall sat the King, still wearing the Crown. The coronation of George IV was one of the most lavish and extravagant ever known, and cost over a quarter of a million pounds; the expenses of the banquet alone were more than twenty-five thousand pounds. William IV made radical economies in 1831.

The Museum possesses the suit of Greenwich armour worn and retained by John Dymoke as King's Champion at the coronation of George III (34.121).

A watercolour by Denis Dighton showing Henry Dymoke in the act of issuing his challenge is in the Royal Library, Windsor Castle.

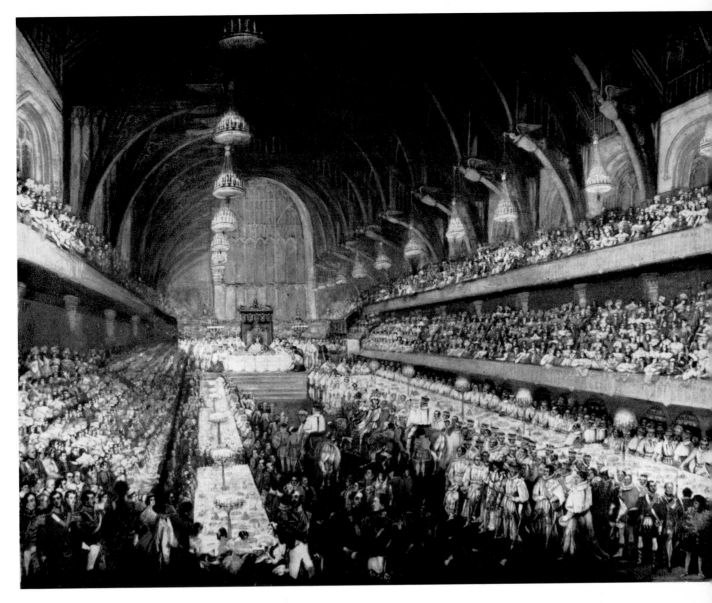

Plate 23 The Coronation Banquet of George IV in Westminster Hall, 1821 (British School).
Painted about 1821

24 RAT-CATCHING AT THE BLUE ANCHOR TAVERN, BUNHILL ROW, FINSBURY (A 19092)

Canvas. 16⅞ × 21 inches (42.2 × 52.5 cms.). Painted about 1850-2.

Provenance: Presented by Norman J. Byers in 1917.

Cockpits were used not only for cock-fighting, but for numerous sadistic diversions of a similar kind; a fight between a bull-dog and a prize monkey, for instance, is recorded as having taken place in a cockpit in 1822, and dog-fights were quite common at this date. These events were watched by many of the leading sportsmen of the day, and bets were placed on the contestants. By the mid-nineteenth century, dog-fights were on the wane and the main sport was rat-catching, which attained the popularity once accorded only to cock-fighting. The dogs employed were always terriers, and one celebrated animal, later stuffed and exhibited at the Seven Bells in St. Giles's, killed a hundred rats in five minutes.

In the scene shown here, a terrier called 'Tiny the Wonder' is attempting to kill two hundred barn rats in under an hour, a feat which he accomplished, apparently, on two separate occasions, on 28 March 1848 and 27 March 1849; the enclosure is rather more primitive than the better known London cockpits. Count D'Orsay (1801-52), formerly one of the Regency dandies, is among the audience, and can be seen fourth from the left, wearing a brown coat; the figure in the centre is holding a watch in his hand, and is evidently the timekeeper. Notice the gas-lamps.

The costume indicates a date of about 1850-5, and since Count D'Orsay is included, the picture must have been executed before 1852.

25 ST. MARY'S CHURCH, WILLESDEN (A 17004)

Canvas. 22⅛ × 23½ inches (55.2 × 58.75 cms.). Painted about 1815-24.

Provenance: Inscribed on the back as purchased at Bath in 1824 as Richard Wilson; T. Humphry Ward; Red Cross sale, Christie's, 23 April 1915 Lot 1510 (presented by T. H. Ward as Wilson) bt. Sir Guy Laking for the Museum.

A view taken from the north west showing the original thirteenth century nave and tower before the alterations of the nineteenth century, when the south aisle was built, battlements added to the tower and the cupola removed. Some cottages are seen on the right, and through the trees on the left is a larger house, which stood on the site of the present Vicarage garden (none of these buildings survive). At this date, Willesden was only a tiny village, with fewer than a hundred houses. The church is now surrounded by streets of late nineteenth century terrace houses in the Gothic taste.

This picture must have been painted after 1815, as it shows against the church the tomb of John Methley, who died on 9 January 1815 (the monument to the left is the tomb of the Mercelin family), and before 1824, the date of its purchase in Bath.

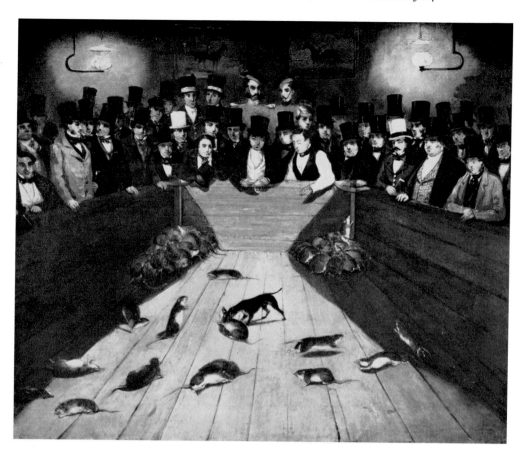

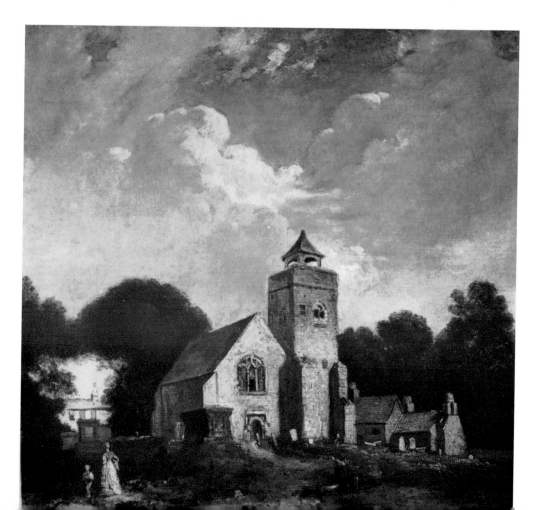

26 UPPER LISSON STREET, PADDINGTON, FROM CHAPEL STREET (66.68)

Canvas. 15 × 18¼ inches (37.5 × 45.6 cms.). Painted about 1837-47.

Provenance: Anon. sale, Christie's, 25 March 1966 Lot 150 bt. Patten; purchased out of the Joicey Trust Fund from Richard Green (Fine Paintings) Ltd. in 1966.

The fields north of the New Road (Marylebone Road) and east of the Edgware Road were developed in the third quarter of the eighteenth century, and Chapel and Upper Lisson Streets were formed at this time. The east side of Upper Lisson Street remained open fields, however, until after the manor of Lisson Green was sold in 1792, and was not finally built up until 1809-12.

Upper Lisson and Chapel Streets were largely shopping streets, and among the premises identifiable here are, from left to right, those of Richard Hickman, ironmonger, on the corner at No. 11 Chapel Street; William Lamburn, grocer, a few doors up at No. 22 Upper Lisson Street (this shop was moved to No. 4 Union Street between 1844 and 1847); the *Noah's Ark* public house at No. 16 Upper Lisson Street (the tallest building seen); and on the extreme right Charles Simpson, grocer and tea dealer, at No. 10 Chapel Street. A butcher's shop, a boot and shoe repairer's, and a hairdressing and shaving saloon can also be seen on the right, a greengrocer's cart is being unloaded, and in front of this there is a hot potato seller. Notice also the firemark over Hickman's shop, and the tea-canisters (a grocer's trade sign) over those of Lamburn and Simpson.

A small crowd has gathered to watch a Jack-in-the-Green procession, which is seen in the centre foreground, and a number of boy chimney sweeps are collecting money. Jack-in-the-Green was a greenwood Mayday folk-figure, normally attended by Robin Hood and Maid Marian, once generally common throughout the country. By the second half of the eighteenth century this pageant had been appropriated by the chimney sweeps, and in London Mayday was often known as 'Sweeps' Day'. Jack-in-the-Green was then accompanied by a 'lord' and 'lady', the former wearing a cross between full court dress and footman's attire with a huge cocked hat, and the latter also wearing mock court dress and holding a long brass ladle with which to catch the coins. In the picture the pair are seen commencing their dance, which they performed on either side of the garland, and which began as a minuet and quickened into something faster, before a collection was finally invited. In 1825 a clown à-la-Grimaldi (seen here) was first added to the traditional group in order to attract passers-by. Jack-in-the-Green began to decline in the latter part of the nineteenth century, though one was seen as late as 1917.

With the exception of No. 11 Chapel Street, which still stands and is now a dental surgery, the street has since been rebuilt and, more recently, bisected by the arterial road connecting Marylebone Road with the west via the flyover over Edgware Road. The southern end of Lisson Street has now been renamed Transept Street.

The picture must have been painted between 1837, when the *Noah's Ark* was established, and 1847, by which date William Lamburn was at No. 4 Union Street.

54

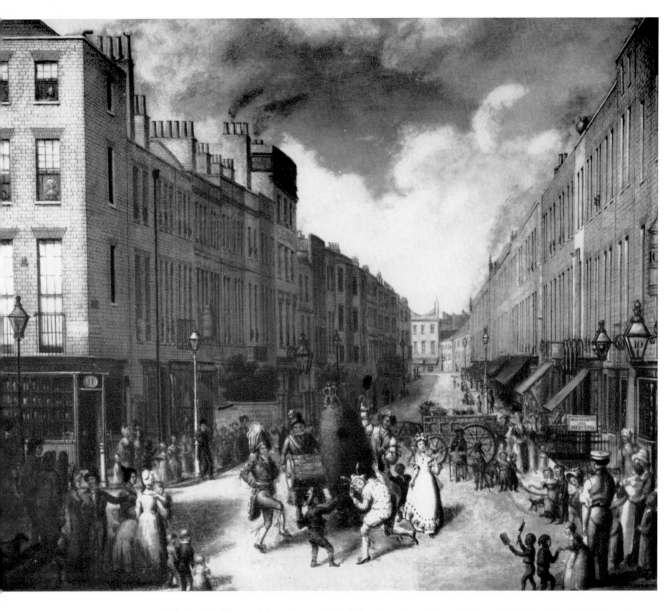

Plate 26 Upper Lisson Street, Paddington, from Chapel Street (British School). Painted about 1837-47

GIOVANNI ANTONIO CANAL called CANALETTO (1697-1768)

Landscape and topographical painter and etcher; best known for his views of Venice. Born in Venice. Trained as a scene painter with his father, but, under the influence of Carlevaris, soon turned to topographical painting. Worked chiefly for visiting Englishmen on the Grand Tour, and for Joseph Smith, the English Consul in Venice, who sold his large collection of Canalettos to George III in 1762. Visited London 1746-55, and the subjects he painted there were much imitated by English artists over the following decades. Member of the Venetian Academy of Painting 1763.

27 INTERIOR OF HENRY VII'S CHAPEL, WESTMINSTER ABBEY (A 20964)

Canvas (laid down on panel). 28 × 23⅛ inches (65 × 57.75 cms.). Painted about 1750.

Provenance: Sir Ralph Wilmot, Bt.; Wilmot sale, Christie's, 28 February 1913 Lot 111 bt. McKay; presented by Cecil B. Harmsworth in 1919, through the National Art-Collections Fund.

Exhibited: Canaletto in England, Guildhall Art Gallery, June-July 1959 (16).

References: 16th Annual Report of the National Art-Collections Fund 1919, London, 1920, p. 36, repr. facing; Hilda F. Finberg, 'Canaletto in England' (*Walpole Society,* Vol. 9, Oxford, 1921) pp. 35 and 69, repr. pl. XXI; *Twenty-five Years of the National Art-Collections Fund,* Glasgow, 1928, p. 39 and 67; W. G. Constable, *Canaletto,* Oxford, 1962, Vol. 2, pp. 391-2.

Also reproduced: The Illustrated London News, Christmas Number 1965, p. 33 (colour).

This canvas is one of Canaletto's very rare interior subjects, King's College Chapel, the Rotunda at Ranelagh and San Marco being other examples. The view is taken looking eastwards, and the tomb of Henry VII, with its surrounding grille, the work of Pietro Torrigiano, is seen in the centre. To the left, in the side-chapel, is the tomb of John Sheffield, 1st Duke of Buckingham (1648-1721), by Plumier, Scheemakers and Delvaux. The banners above the stalls are those of the companions of the Order of the Bath, an order of chivalry which had been established for political reasons in 1725 (an almost identical view of the chapel, done before 1725, and showing the stalls without the banners, was drawn and engraved by T. Schijnvoet).

Apart from some generalising of the complicated fan-vaulting of the roof, and one or two other discrepancies (e.g. the arches behind the stalls cannot be seen so clearly from the viewpoint chosen), this painting gives an accurate impression of the appearance of the chapel. A number of changes have been made since Canaletto's time: an extra row of stalls (usually assumed to have been carved in 1725) has been added on each side to make the number up to the requisite thirty-eight for the Knights of the Bath; the screens to the side-chapels were destroyed or mutilated to make way for the extra stalls and as a result of the seating arrangements at Installation ceremonies; the tomb of Henry VII has been re-orientated and a step added; an altar was built in front of the tomb in 1935; and the chapel at the east end has been converted into the Royal Air Force Chapel (consecrated 1947).

Another version of this subject by Canaletto, which gives an oblique view of the chapel, is in the collection of Mr. Ernest G. Kleinwort, and Professor Constable

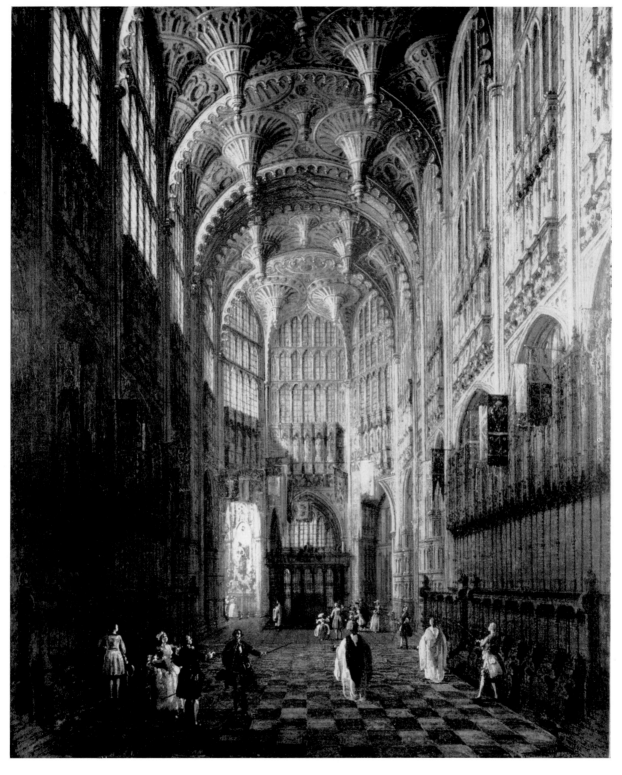

Plate 27 Interior of Henry VII's Chapel, Westminster Abbey by Antonio Canaletto. Painted about 1750

(op. cit.) describes the Museum picture as: 'Improbably by Canaletto. Neither the handling of the architecture nor of the figures is like his.' The canvas is not in good condition, having been rubbed severely, probably when laid on its present support, but close comparison with other Canalettos of the London period does not support the conjecture that it is an imitation; it is known, moreover, that the artist was accustomed to producing replicas of a popular subject, so that, in the absence of more positive evidence to the contrary, the attribution should be allowed to stand.

The costume indicates a date of about 1750.

A mid-eighteenth century view in the style of Canaletto in the possession of the Dean and Chapter of Westminster is taken from closer to the centre of the chapel, and may represent a lost version by Canaletto.

HENRY CHARLES CLIFFORD (1861-1947)

Landscape and topographical painter, best known for his views of disappearing London. Born in Greenwich, the son of an engineer. Studied in Paris under Bouguereau, Fleury and Benjamin Constant. Lived in Chelsea and Kensington; retired to Pulborough.

28 NO. 8 CLIFFORD'S INN, WITH PART OF THE HALL (A 23976)
Canvas board. 9¼ × 6⅞ inches (23.1 × 17.2 cms.). Signed bottom left: *H Charles Clifford* and dated and inscribed bottom right: *1903 Cliffords Inn*

Provenance: Purchased in 1921, source unrecorded.

An impression of one of the staircases of Clifford's Inn, an Inn of Chancery which was founded in 1344 by the widow of Robert de Clifford, and situated just north of Fleet Street (between what are now Chancery and Fetter Lanes). Part of the south elevation of the Hall (built in 1767 in the Gothic style) is seen on the left, and opposite stands the north wall of the church of St. Dunstan-in-the-West. The painting is inaccurate in detail, as may be seen by comparing it with F. L. Griggs's careful etching of the same subject, executed in 1908. Clifford's Inn was demolished in 1935, and a block of flats (the Clifford's Inn Club) was put up in its place the following year.

29 A SCENE IN EAST GREENWICH (A 24289)
Board. 7⅞ × 11⁷⁄₁₆ inches (19.7 × 28.6 cms.). Signed bottom left: *H Charles Clifford* and inscribed and dated bottom right: *Old Houses, East Greenwich 1903* Inscribed, signed and dated on the back: *On River front close to Trinity Alms House/Greenwich 1902/H Charles Clifford*

Provenance: Purchased in 1922, source unrecorded.

A view on the river front a little to the east of the Royal Naval College. Two or three old houses, since demolished, form the subject of the picture; several figures are represented, and two men are shown carrying oars down to their boats. On the left is the garden wall of the Trinity Alms Houses, founded by the Earl of Northampton in 1613, and administered by the Mercers' Company. The Alms Houses, rebuilt in the early nineteenth century in the Gothic style, still stand, but sandwiched between an enormous power station on the east side and blocks of Council flats on the side seen here. This whole area originally adjoined the fifteenth century royal palace of Placentia (see No. 43).

58

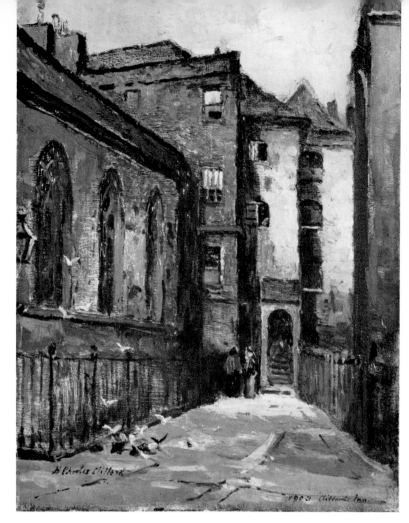

Plate 28 No. 8 Clifford's Inn, with part of the Hall by H. C. Clifford. Signed and dated 1903

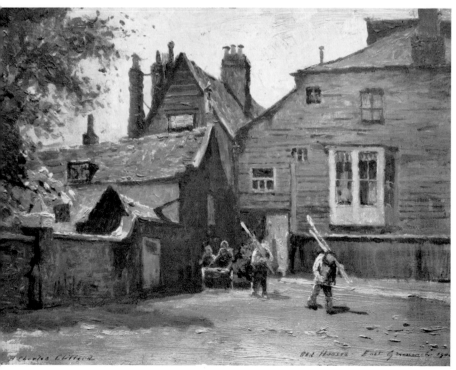

Plate 29 A Scene in East Greenwich by H. C. Clifford Signed and dated 1903

59

JOHN COLLET (1725-80)
Painter of narrative, genre and London views, best known for his scenes of London life, especially low life, derived from Hogarth. Born in London, the son of an official. Studied at the St. Martin's Lane Academy. Lived in Chelsea. There was a considerable demand for his genre pictures, and many of them were engraved.

30 COVENT GARDEN PIAZZA AND MARKET (55.72)
Canvas. 53½ × 75¾ inches (133.75 × 189.5 cms.). Painted about 1770-80.

Provenance: Ernest E. Cook, by whom it was bequeathed, through the National Art-Collections Fund, in 1955.

Reproduced: Country Life, 12 October 1967.

Exhibited: Canaletto and his Influence on London Artists, Guildhall Art Gallery, June-July 1965 (4); *Mr. Boswell*, Edinburgh Festival (Scottish National Portrait Gallery) and National Portrait Gallery, August-November 1967 (60 and repr. opposite).

This picture, taken from the east side and looking towards the church of St. Paul's, Covent Garden, is almost identical in composition and lighting with Scott's view of Covent Garden done twenty years before (see No. 99, also for discussion of the subject matter). It includes, however, considerably more of the south side of the square, and shows the full range of sheds and two-storeyed market buildings. Carts line the roadway on the north side of the market, and under the 'piazzas' are a number of sedan chairs. The picture is full of human activity, as one would expect from an admirer and imitator of Hogarth, and such familiar denizens of the capital as the street musician, the pick-pocket, and the chair mender are seen in the right foreground.

The architectural detail is not as accurate as in the Scott view, and St. Paul's Covent Garden has been given quite wrong proportions. The spire of James Gibbs's church of St. Martin-in-the-Fields is visible in the distance.

The costume indicates a date of about 1770-80.

J. CORDREY (active 1799-1822)
Coaching and sporting painter; specialised in 'portraits' of stage coaches, with landscape setting, and his *oeuvre* provides useful visual documentation of the network of services in England in the early nineteenth century.

31 THE LONDON TO DARTFORD STAGE COACH (A 20710)
Canvas. 20 × 30 inches. Signed and dated bottom left: *Cordrey Pinx/1813*

Provenance: Presented by an anonymous donor in 1919.

A stage coach drawn by four brown horses is shown in the foreground, with open country behind. A milestone on the left records *VII/Miles/from/London*. The coach is marked as

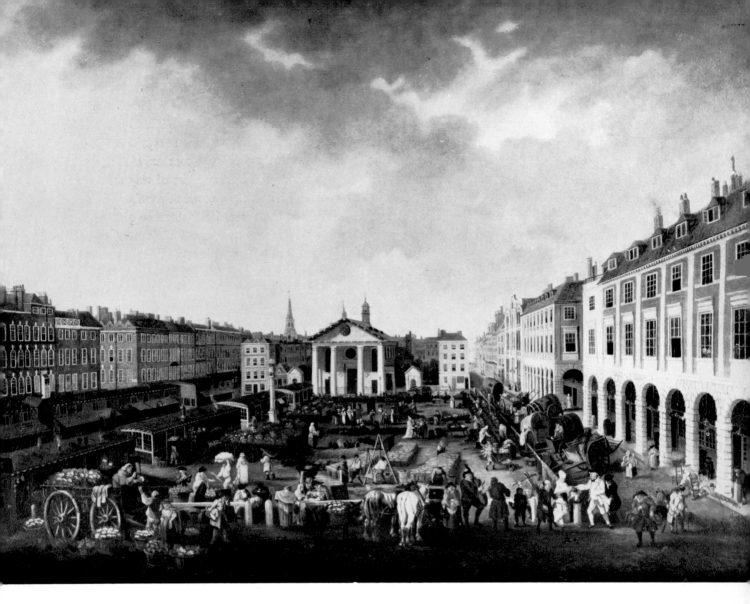

Plate 30 Covent Garden Piazza and Market by John Collet. Painted about 1770-80

61

plying between the Spur Inn, Borough and the Black Boy, Dartford, with stops at Bexley and Crayford; Thomas Mellin's name appears on the bottom of the window frame as owner, and under the footboard of the box seat is the legend *LICENC'D/To Carry/ 6 INSIDE/12 OUT*. A full complement of passengers can be seen seated outside.

Mail coaches were the fastest and most elegantly appointed coaches, and enjoyed the privileges of paying no tolls, running untaxed, and having right of way on the road. Unlike mail coaches, ordinary stage coaches had names instead of numbers, and these were usually painted on the panel behind the back seat. Long distance coaches of any repute always carried a guard, whose bugle or horn announced the coach's arrival to toll-gate keepers along the road; this would not be considered necessary on a short journey. As a result of the vast improvement in the condition of the roads since the seventeenth century, largely due to the turnpike system, journeys were two or three times as quick by 1813 as they had been a century earlier, and a whole network of services was available at frequent intervals. So efficient were the early nineteenth century coaches, indeed, that for a long time railways were thought to be impractical, at any rate in so far as passenger traffic was concerned.

CHARLES ERNEST CUNDALL (born 1890)

Topographical and townscape painter. Born at Stretford, Lancashire. Began designing pottery and stained glass for Pilkington's Pottery Company. Studied at the Manchester School of Art, obtaining a scholarship to the Royal College of Art in 1912; returned to the Royal College in 1918 after war service, studied at the Slade School 1919-20, and afterwards in Paris. Member of the New English Art Club 1924; A.R.A. 1937; R.A. 1944. Official War Artist with the Royal Navy and Royal Air Force 1940-5. Lives in Chelsea.

32 A STIRLING BOMBER ON EXHIBITION IN THE CITY DURING 'WINGS FOR VICTORY' WEEK, 1943 (47.26/5)
Canvas. 24 × 37⅞ inches (60 × 94.75 cms.). Signed and dated bottom right: *Charles Cundall 1943*

Provenance: Commissioned by the War Artists Advisory Committee; presented by H.M. Government, through the Imperial War Museum, in 1947.

Exhibited: Cartwright Memorial Hall, Bradford, spring 1945 (279).

A Stirling bomber is shown in the foreground centre, surrounded by a crowd of spectators, and with ruined buildings behind. This whole area, between Cheapside and Cannon Street, just to the east of St. Paul's Cathedral, was completely devastated by aerial bombardment during the Second World War, mainly in the raids of 29 December 1940 and the nights following. Most of the City churches were gutted, though St. Paul's, miraculously, survived almost totally unharmed. The shells of many of the churches remained (see No. 93), and in the distance on the left can be seen the spire of St. Vedast's, Foster Lane and on the right the tower and spire of St. Mary-le-Bow.

This district is now occupied by huge neo-Georgian office buildings.

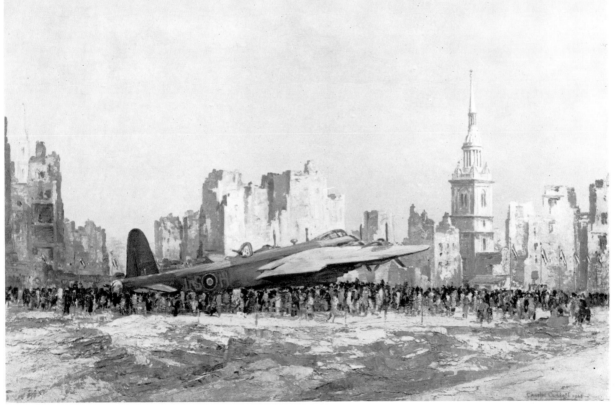

Plate 31 The London to Dartford Stage Coach by J. Cordrey. Signed and dated 1813

Plate 32 A Stirling Bomber on Exhibition in the City during 'Wings for Victory' Week, 1943 by Charles Cundall. Signed and dated 1943

CHARLES DEANE (active 1815-51)
Topographical and landscape painter, best known for his views of the Thames in and around London. Lived chiefly in St. Marylebone.

33 WATERLOO BRIDGE AND THE LAMBETH WATERFRONT FROM WESTMINSTER STAIRS (C 355)

Canvas. 44 × 73⅞ inches (110 × 184.75 cms.). Signed and dated bottom left: *C Deane 1821*

Provenance: Lent by A. L. Nicholson in 1911; afterwards presented, through the National Art-Collections Fund, in 1928.

Exhibited: British Institution, 1822 (206); *Old London Exhibition*, Whitechapel Art Gallery, November-December 1911 (129: Upper Gallery).

Reference: 25th Annual Report of the National Art-Collections Fund 1928, London, 1929, p. 42 (repr.).

Waterloo Bridge (originally called Strand Bridge) was built between 1811 and 1817 to the designs of John Rennie. It was opened by the Prince Regent on the second anniversary of the battle of Waterloo, and this picture shows it only a few years after completion. In 1924 it was found that one of the arches had become seriously weakened, and after prolonged discussion as to whether the bridge should be restored or not, it was finally decided to pull it down. This took place in 1936. Sir Giles Gilbert Scott's new Waterloo Bridge, completed in 1945, is fortunately a worthy successor to Rennie's fine structure.

Beyond Waterloo Bridge can be seen, from left to right, the spire of St. Mary-le-Strand, Somerset House before the construction of the west wing, and the towers and spires of St. Clement Danes, St. Andrew's Holborn, St. Sepulchre's and St. Bride's. On the right is the Lambeth waterfront, still largely composed of timber yards and wharves; the most prominent buildings are the slightly tapering tower of the Lambeth Waterworks in Belvedere Road, which operated from 1785 to 1853, and the square tower of the Patent Shot Manufactory east of Waterloo Bridge, erected in about 1789 and destroyed in 1937 (the more familiar round shot tower, pulled down as recently as April 1962, to make way for the extensions to the Royal Festival Hall, was not built until 1826). Beyond is the dominating mass of St. Paul's Cathedral, with, on the extreme right, the spires of (apparently) St. Swithin's and St. Mary Abchurch, and the tower of St. Michael's, Cornhill.

A number of barges are moored in the river, and in the foreground a Thames waterman in brown uniform is about to ferry a group of passengers across to Lambeth. Within a decade of the painting of this picture, the ferryboats which plied from Westminster stairs (there were landing stages adjoining Westminster Bridge on both the north and south sides) were replaced by steamboat services, and the stairs (eventually) by Westminster Pier.

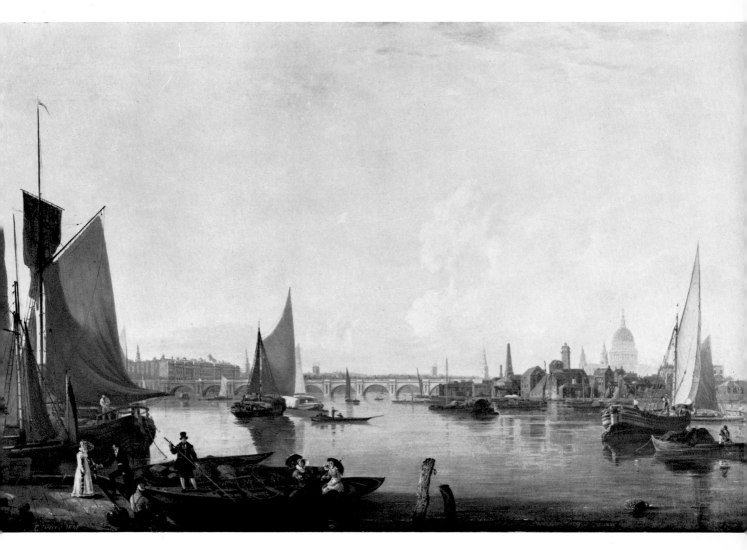

Plate 33 Waterloo Bridge and the Lambeth Waterfront from Westminster Stairs by Charles Deane. Signed and dated 1821

THOMAS COLMAN DIBDIN (1810-93)

Topographical and scene painter, and book illustrator, best known for his watercolours and pencil drawings of London views. Born in Betchworth, Surrey. At first apprenticed to a chemist, he secured an appointment in the Post Office at the age of sixteen. Apparently self-taught in painting and drawing. Worked as a scene painter for the Olympic and City Theatres, and at Sadler's Wells. Lived in various parts of London.

34 THE OPENING OF THE GREAT EXHIBITION OF 1851
 SEEN FROM BEYOND THE SERPENTINE (61.121)

Canvas. $27\frac{1}{4} \times 41\frac{3}{8}$ inches (68.25 × 103.5 cms.). Signed and dated bottom right: *Hyde PARK 1 May 1851/T C. Dibdin.*

Provenance: With Pulitzer Gallery in 1959; purchased from Michael Harvard in 1961.

The Great Exhibition of 1851, the first international exhibition ever held, was at first intended to be simply the most important of a series of annual exhibitions of manufactures promoted by the Royal Society of Arts from 1847 onwards. It was the Prince Consort, President of the Society, who proposed that it should 'embrace foreign productions', and Henry Cole, the organiser of the exhibitions, who suggested Hyde Park as the site. From this moment, the unusual nature of the project was apparent. A Royal Commission was set up to supervise the scheme, with the Prince Consort as Chairman, and the revolutionary design for the exhibition building submitted by Joseph Paxton, then superintendent of the gardens at Chatsworth, was accepted. The 'Crystal Palace', as it was christened by *Punch*, was a gigantic structure of iron and glass, derived from Paxton's experience in conservatory design. Something of its vast extent, 1,848 feet, stretching from the site of the present bowling green to opposite the former Hyde Park Barracks riding school, can be gauged from this view, which only shows half its length.

The Exhibition was opened by Queen Victoria on 1 May 1851, exactly the day that had been decided upon sixteen months before; and the Queen wrote in her Journal that 'the Green Park and Hyde Park were one mass of densely crowded human beings, in the highest good humour and most enthusiastic . . . A little rain fell, just as we started, but before we neared the Crystal Palace, the sun shone and gleamed upon the gigantic edifice, upon which the flags of every nation were flying. We drove up Rotten Row and got out of our carriages at the entrance on that side'. The plumes of the Royal Horse Guards and the canopy in front of the north transept, where the Queen entered the building, can be seen in the middle distance, across the Serpentine.

The Crystal Palace was dismantled in 1852, but purchased by a private company and rebuilt in Sydenham; opened there on 10 June 1854, it became a centre for various forms of entertainment, notably music festivals and displays of fireworks. It was totally destroyed by fire on the night of 30 November 1936.

66

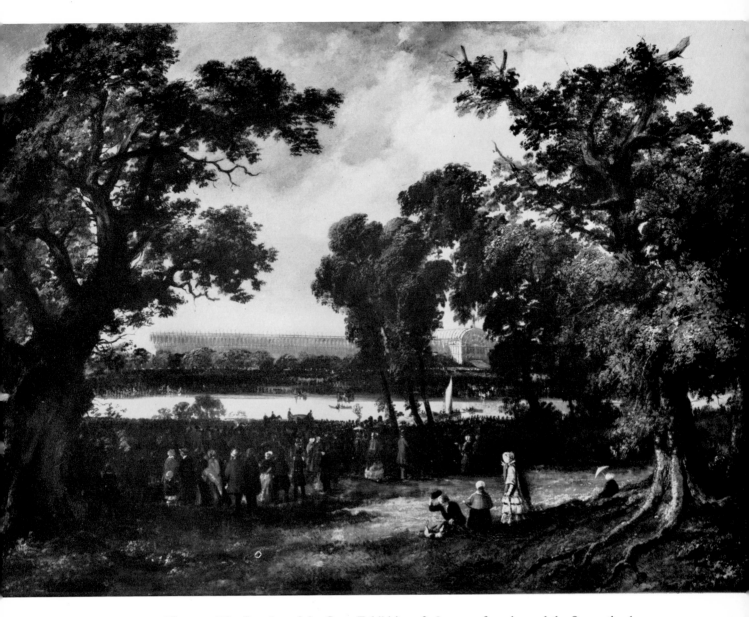

Plate 34 The Opening of the Great Exhibition of 1851 seen from beyond the Serpentine by T. C. Dibdin. Signed and dated 1851

JOHN CHARLES DOLLMAN (1851-1934)
Genre and animal painter. Born in Hove, the son of a bookseller. Studied at the South Kensington and Royal Academy Schools. Lived in Bedford Park.

35 A LONDON CAB STAND (28.35)
Canvas. $62\frac{1}{8} \times 38\frac{3}{4}$ inches (155.3 × 96.9 cms.). Signed and dated bottom right: *J. C. Dollman 1888*

Provenance: Presented by John Scrimgeour in 1928.

Exhibited: Royal Academy, 1888 (630) under the title *Les Miserables.*

Reproduced: Henry Blackburn, *Academy Notes*, 1888, London, 1888, p. 81.

Seven cabs, hansoms and 'growlers', are shown in the foreground, with a cab shelter behind on the left; a policeman is standing in the middle distance right, and some buildings are seen indistinctly beyond; the weather is wintry, with snow and slush on the ground.

The hansom cab was named after J. A. Hansom (1803-82), the architect, who designed and registered his 'patent safety cab' in 1834, subsequently disposing of his rights to a company for £10,000 (none of which he ever received). The main innovations in the cabs as developed were the large wheels and the placing of the driver at the rear of the vehicle (see also No. 101). The 'growler' was introduced in 1835 in competition with the hansoms; this was a much improved four-wheel cab with a luggage rack on the roof, initially accommodating only two people but later planned to hold four inside and one out. The law regarding cabs was regulated in 1853, when, among other provisions, it was required that a table of fares should be displayed inside all vehicles plying for hire.

BERNARD DUNSTAN (born 1920)
Painter of figures, interiors and townscenes. Studied at the Byam Shaw and Slade Schools. Born in London, the son of a scientist. A.R.A. 1959. Lives in Kew.

36 CONSTRUCTION WORK ON THE UNDERPASS AT HYDE
PARK CORNER, 1961 (62.118)
Hardboard. $42\frac{1}{8} \times 34\frac{3}{4}$ inches (105.5 × 86.75 cms.). Signed with initials bottom left: *BD* Painted in 1961.

Provenance: Purchased from the artist in 1962.

Exhibited: Summer Exhibition, Royal Academy, 1962 (421).

The underpass at Hyde Park Corner, which connects Knightsbridge with Piccadilly, was opened in 1962, the first improvement of this kind constructed in London to be

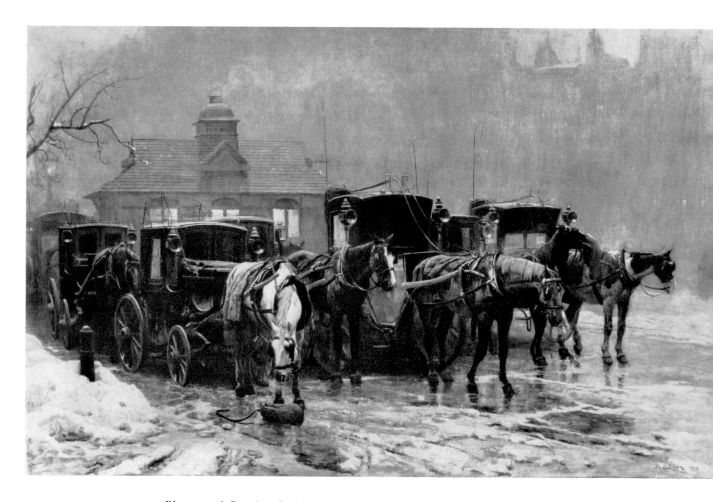

Plate 35 A London Cab Stand by J. C. Dollman. Signed and dated 1888

planned as an integral part of the street system (the subway under the Strand which connected Kingsway and the Thames Embankment, built in the 1900's, having been designed solely for tramways). It formed part of the Marble Arch – Park Lane – Hyde Park Corner improvements, themselves only an element in a concerted programme for easing the traffic congestion which was choking the arteries of central London, initiated by Mr. Ernest Marples, then Minister of Transport. The introduction of parking meters in business areas to restrict the number of private vehicles brought into town, and of one way streets to facilitate the flow of traffic, were other features of an energetic policy which has had successful results wherever it has been applied, making it possible for vehicles to move reasonably freely in the central area.

The view is taken looking eastwards, and beyond the massive girders and the group of cranes and lorries, can be seen the Hyde Park Corner screen and Apsley House (see also No. 53).

MARY EDITH DURHAM (1863-1944)
Portrait, genre and topographical painter, and book illustrator. Born in London, the daughter of a surgeon. Studied at the Royal Academy Schools. Lived in various parts of London.

37 QUEEN VICTORIA'S DIAMOND JUBILEE: A VIEW OF THE PROCESSIONAL ROUTE FROM BOROUGH ROAD (A 24382)
Panel. $10\frac{5}{8} \times 8\frac{3}{8}$ inches (26.6 × 20.95 cms.). Signed and dated bottom left: *ME Durham 97*

Provenance: Presented by the artist in 1922.

An impression of the decorations along the processional route for Queen Victoria's Diamond Jubilee, 22 June 1897, taken from Borough Road, Lambeth, and looking westwards towards St. George's Circus. Examples of the type of stands erected in front of the buildings along the route can be seen on the left, and Life Guards and other troops are shown lining the road, awaiting the procession.

Unlike the Golden Jubilee, to which the crowned heads of Europe were all invited, the Diamond Jubilee was essentially an Imperial occasion. Every Dominion and colony sent a detachment of troops, and, as in 1887, the opportunity was taken to hold an Imperial Conference: this was attended by fifteen premiers under the presidency of Joseph Chamberlain. The procession, in which Queen Victoria rode in an open landau, travelled from Buckingham Palace to St. Paul's Cathedral for an open air Thanksgiving Service, and thence past the Mansion House, over London Bridge, and back to the Palace through Southwark and Lambeth.

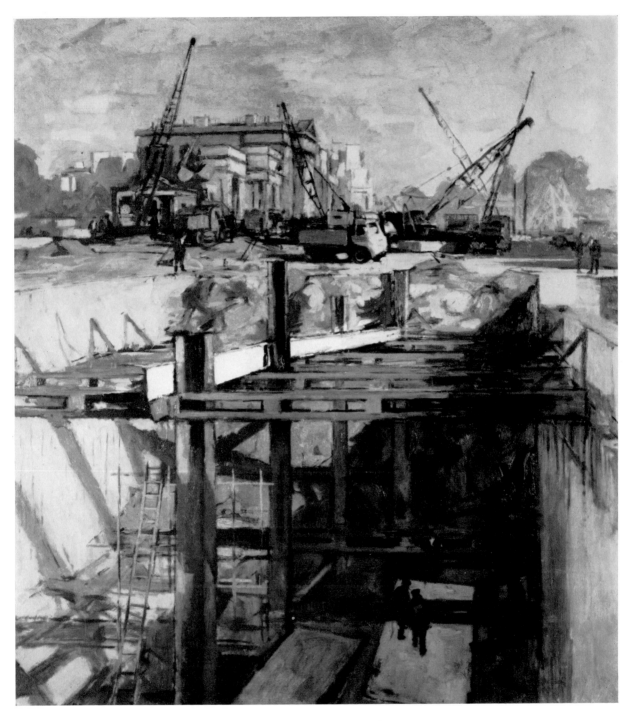

Plate 36 Construction Work on the Underpass at Hyde Park Corner, 1961 by Bernard Dunstan. Painted in 1961

38 THE FUNERAL PROCESSION OF QUEEN VICTORIA PASSING THROUGH HYDE PARK (A 24383)

Panel. $10\frac{3}{4} \times 8\frac{1}{8}$ inches (26.9 × 20.3 cms.). Signed and partially dated bottom left: *Feb^y ME Durham* Painted in February 1901.

Provenance: Presented by the artist in 1922.

Queen Victoria died at Osborne House on 22 January 1901, aged eighty-one, having reigned for over sixty-three years. Her body was brought to Gosport on Friday the 1st February, and by train to London the following morning. The processional route through the metropolis, from Victoria Station to Paddington, en route for Windsor, passed Buckingham Palace, went down the Mall to St. James's Palace, up St. James's Street, along Piccadilly to Hyde Park, through the Park to Marble Arch, along Edgware Road and across Praed Street.

This picture was sketched from the roof of a house in Park Lane, and shows the crowds that watched the procession passing through Hyde Park on this February Saturday morning. The gun carriage carrying the body, which was drawn by eight cream-coloured horses, can be seen in the middle distance; the coffin was covered by a pall of white satin and the Royal Standard, upon which rested the Crown, the Regalia and the Insignia of the Order of the Garter.

39 NEWGATE PRISON FROM THE GARDEN OF ST. SEPULCHRE'S CHURCH (A 24381)

Canvas. $18\frac{1}{8} \times 24\frac{1}{4}$ inches (45.25 × 60.75 cms.). Signed and dated bottom left: *ME. Durham 1901*

Provenance: Presented by the artist in 1922.

The old Newgate Prison, a gaol for debtors (up to 1815) and for felons, had become so insanitary by the mid-eighteenth century that it was condemned, and the building seen here was designed by George Dance the Younger in 1770-8. It was his first major assignment after succeeding to his father's post as Clerk of the City Works in 1768, and perhaps his greatest work in architecture. The massiveness of the rusticated walls, and motifs such as the aedicules set in arched niches, were evidently based on Giulio Romano, whose buildings he would have studied during his sojourn in Italy. The prison was badly damaged during the Gordon Riots of 1780, but repaired and altered. The first execution held within its walls took place in December 1783, a month after the last to be held at Tyburn. Newgate was demolished in 1902, shortly after this picture was painted, and Mountford's neo-baroque Central Criminal Court (the Old Bailey) was built on the site.

Newgate stood at the intersection of Giltspur Street, Newgate Street (left), Old Bailey and Skinner Street (right), but little of the busy traffic usual at this City cross-roads is suggested in the picture; traffic congestion was a problem much in the minds of the authorities in these last years of the horse-drawn vehicle. Two omnibuses of the garden-seat type, the top deck still open to the elements, are seen on the left, and hansom cabs, covered carts and a hay cart are amongst other vehicles. The dome of St. Paul's is seen beyond Newgate, and on the left are a couple of early telegraph poles: the monopoly of the telegraph system was acquired by the Post Office in 1870.

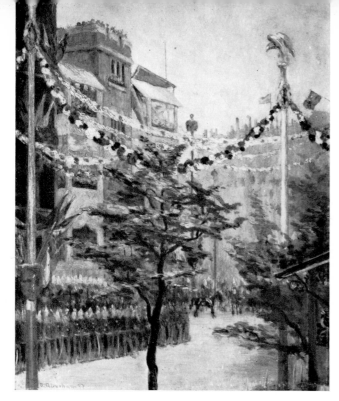

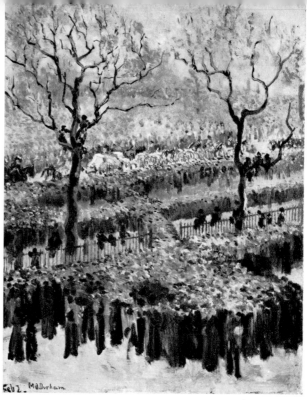

Plate 37 Queen Victoria's Diamond Jubilee: A View of the Processional Route from Borough Road by M. E. Durham. Signed and dated 1897

Plate 38 The Funeral Procession of Queen Victoria passing through Hyde Park by M. E. Durham. Painted in 1901

Plate 39 Newgate Prison from the Garden of St. Sepulchre's Church by M. E. Durham. Signed and dated 1901

7

40 THE GREAT FIRE OF LONDON, 1666 (57.54)
Panel. $35\frac{7}{8} \times 60\frac{5}{8}$ inches (89.7 × 151.6 cms.). Painted about 1666.

Provenance: Silvertop collection, Minster Acres, near Hexham, Northumberland; Charles Silvertop sale, Anderson and Garland, Newcastle, 22 January 1957 Lot 47 (as de Loutherbourg) bt. W. M. Sabin; purchased from Edward Speelman, partly out of the Joicey Trust Fund and with the aid of contributions from an anonymous donor and the National Art-Collections Fund, in 1957.

Exhibited: The Age of Charles II, Royal Academy of Arts, Winter Exhibition, 1960-1 (239); *The Growth of London*, Victoria and Albert Museum, July-August 1964 (E19 and repr. in the catalogue, pl. IX); *1666 and other London Fires*, Guildhall Art Gallery, August-September 1966 (23 and repr. in the catalogue, facing p. 16).

References: Brian Spencer, 'A View of the Great Fire', *Museums Journal*, August 1957, pp. 124-6 (repr.); *54th Annual Report of the National Art-Collections Fund 1957*, London, 1958, p. 13 (repr. pl. VI); Martin Holmes, 'Two views of the Great Fire', *The Connoisseur*, August 1962, pp. 244-5 (repr.).

Also reproduced: The Times, 31 May 1957; *The Illustrated London News*, 8 June 1957; P. G. M. Dickson, *The Sun Insurance Office 1710-1960*, London, 1960 (colour frontispiece); Arthur Bryant, *Restoration England*, London, 1960, facing page 41 (detail); *The Illustrated London News*, 10 December 1960; *The Royal Borough of Kensington* (handbook and guide), Cheltenham, n.d. (=1961), p. 40; Winston S. Churchill, *The Island Race*, London, 1964, pp. 182-3 (colour); John Bedford, *London's Burning*, London, 1966, p. 125; Chris Sutton, 'The Great Fire 1666', *St. Mary's Hospital Gazette*, May 1966; *The Listener*, 25 August 1966; *London Life*, 10 September 1966; *The Observer*, 21 August 1966 (colour); *Irish Independent*, 16 October 1966; John Hayes, *London: A Pictorial History*, London, 1969, pl. 41 (detail); J. L. Howgego, *The City of London through Artists' Eyes*, London, 1969, p. 21; various educational publications.

The Fire is here seen as it would have appeared from a boat in the vicinity of Tower Wharf, and the buildings shown are, from left to right: Old London Bridge, with, on it, the block of medieval buildings to the right of the Great Stone Gateway, the drawbridge, the block of medieval buildings flanked at the south end by Nonesuch House and at the north end by the Chapel House, the wooden parapet ordered to be put up in 1635 after a fire had destroyed the houses on this part of the bridge in 1632-3, and the three-storey tenement block erected in 1645-9; St. Dunstan-in-the-West and St. Bride's (immediately to the left of the tenement block); All Hallow's the Great, Old St. Paul's, St. Magnus the Martyr, St. Lawrence Pountney (with its spire), St. Mary-le-Bow, St. Dunstan-in-the-East (with its spire destroyed and smoke pouring from the top of the tower), and the Tower of London. Our knowledge of the topography of mid-seventeenth century London is not sufficiently detailed to enable the remainder of the churches depicted to be identified with certainty (the oblique view making it impossible to chart them).

The Great Fire started in a baker's shop in Pudding Lane in the early hours of Sunday morning, 2 September, and raged for four successive days. The strong and relentless

Plate 40 The Great Fire of London, 1666 (Dutch School). Painted about 1666

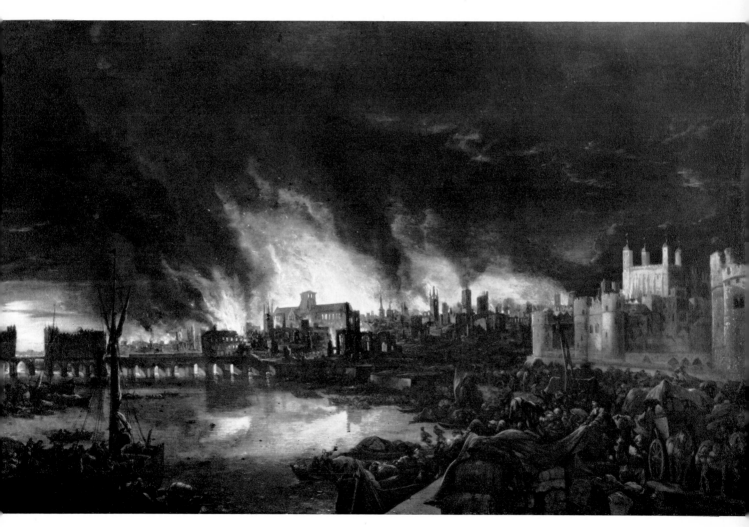

east wind, which was so largely responsible for the rapid spreading of the Fire, is most vividly shown fanning the flames, and London is seen as it appeared between eight and nine o'clock on the evening of Tuesday 4 September, when the flames finally began to reach Old St. Paul's but before the roof had collapsed.

In so far as it is possible to judge, both the detail and the disposition of the buildings are exceptionally accurate. The detail is notably accurate, in addition, at points where other seventeenth century topographers have consistently misrepresented; the arches of Old London Bridge are shown pointed and of irregular width (where Claude de Jongh had painted them as rounded), and the north-east turret of the White Tower is correctly represented as the one circular in shape (where Hollar has the north-west tower as rounded). Errors and omissions, however, there are. Old London Bridge has been given too many arches, and the burning of the tenement block on the bridge should not have been included, as this was destroyed at a much earlier stage of the conflagration (Sunday morning); the south transept of St. Paul's is seen without its pinnacles; the apse of the Chapel of St. John has been omitted from the south-east corner of the White Tower, and the outer bastions of the Tower are no more than approximations of the appearance of these buildings, St. Thomas's Tower being foreshortened and its gateway omitted, and the complex of buildings round the Byward Tower left out; finally, the foreground wharf, seen on the right, which provides a stage for the human drama so poignantly suggested, never existed and must be interpreted as artistic licence.

The accuracy of certain detail which could not have been rendered so by recourse to other pictures or engravings of contemporary London, and the unusual viewpoint (all the pre-Fire general views of London were taken either from the south bank, or from the west, looking directly towards London Bridge, and are not oblique), demonstrate that the artist knew London at first-hand. The viewpoint selected, which would have been both the best and the safest one for sketching the Fire, and such authentic observation as the live brands and sparks scattered high over the city, suggest, further, that the artist was actually an eye-witness of the event.

As a picture, the scene is in the tradition of Egbert van der Poel (1621-64), who specialised in conflagrations, some of them by moonlight, and painted the explosion at Delft in 1654. But the identity of the artist has proved a perplexing problem. An attribution to Lieve Verschuier (c. 1630-86) was proposed before the painting came into the Museum's possession on the basis of the similar canvas of the Fire signed by Verschuier, now in the Museum of Fine Arts, Budapest (Cat. No. 380), which is almost the same size and taken from the same viewpoint. The complete unreliability of the topography in this latter picture, however, rules out of court the possibility that the two works were executed by the same hand; while the handling is quite different. The similarity in tone, and the liveliness of the painting of the flames and the reflections in the water, as well as the closeness of the composition (down to details such as the boat on the left, which has its mast in much the same position) suggest certainly, however, that Verschuier was familiar with the London Museum picture; evidently he was interested only in the pictorial possibilities of this subject, not at all in delineating London as it actually was.

76

Plate 40 (Detail 1)

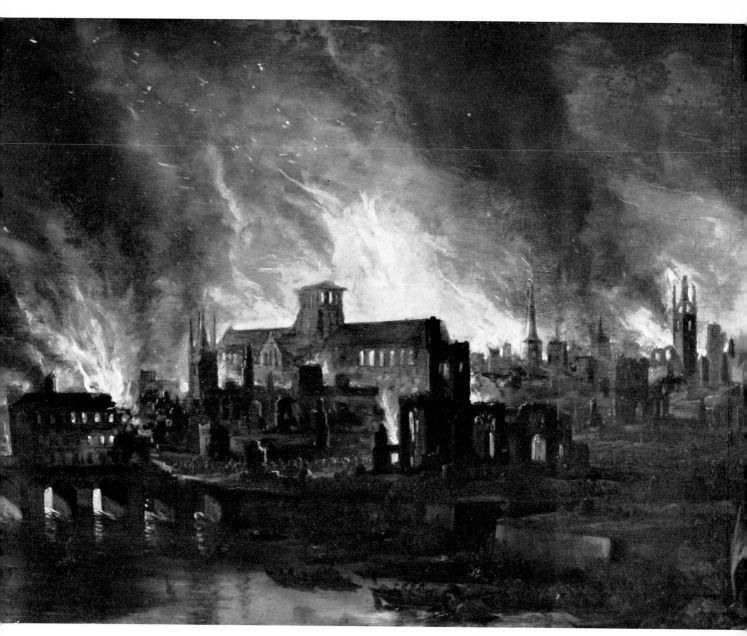

Other artists who are known to have painted the Fire are Jan Griffier the elder (?1645-1718), Waggoner (active c. 1666-85), and Thomas Wyck (c. 1616-77). The numerous prints of the subject which were produced, for the most part in Holland, were based on contemporary engravings of London, mainly Hollar's Long View of 1647, with the addition of the appropriate flames and smoke, and clearly have no value as representations of the event. For Griffier see the entry under No. 48. George Vertue records Waggoner's view at Painter-Stainers' Hall (*Vertue Notebooks*, Walpole Society, Vol. 20, 1932, p. 30), which was engraved in Pennant's *Some Account of London*, 1790, facing p. 324; but unfortunately, this picture was destroyed during the blitz, and no photographs of it were ever taken. Vertue also notes that 'Mr Wyke painted the View of the fire of the City of London several times very well' (*Vertue Notebooks*, Walpole Society, Vol. 18, 1930, p. 106), and Richard Gough tells us further that a certain 'Mr. Granger saw in Berkshire an excellent view of London on fire by Thomas Wych' (*British Topography*, 1780, Vol. 1, p. 705); a signed canvas by Wyck is in the collection of the Duke of Beaufort. Both Waggoner's and Wyck's views, which are broadly similar to each other in composition, were taken from the west. Neither of these, nor Griffier's view, have the detailed accuracy of the London Museum painting, or indeed any similarities of technique that would make an attribution of the latter to any of these painters plausible.

None of the many other topographical and landscape painters who worked in England in the second half of the seventeenth century has proved any likelier as a candidate; but one artist who settled in England in 1672 has much better claims, and that is the great marine painter, William van de Velde the younger. Van de Velde is not known to have painted the Fire, but he did paint other events than battles at sea, he was painstakingly careful over detail and yet at the same time capable of the breadth and drama characteristic of the Museum picture; his handling of paint, however, seems rarely to have reached this degree of brilliance, and if an attribution to him could be sustained, the panel of the Great Fire would certainly stand among his masterpieces.

Mr. Michael Robinson, of the National Maritime Museum, who has pointed out that some of the boats do not sit in the water as convincingly as one would expect of van de Velde, has suggested that the Budapest version may not be by Verschuier, and if the signature and attribution of this picture are questioned, the possibility that the Museum painting is by Verschuier is re-opened; certainly the handling of the flames, the foreground figures, and the bales and drapes, as well as the *contre-jour* effects, are comparable with certain works by this artist.

A smaller version of the Museum painting (size $31\frac{5}{8} \times 43\frac{3}{4}$ inches, unsigned, and painted on canvas not panel) is in the possession of the Worshipful Company of Goldsmiths at Goldsmiths' Hall. As Holmes rightly observes (op. cit.), elements of St. Paul's (specifically the south transept) are more correctly rendered in this version; but at almost every other point, for instance, the blocks of medieval houses on London Bridge, and the churches of St. Mary-le-Bow and St. Magnus the Martyr, it is more generalised and summary in its topography, while the three-storey block of tenements on London Bridge (interpreted by Holmes as Fishmongers' Hall) has been reduced to two storeys,

Plate 40 (Detail 2)

79

and the churches of St. Dunstan-in-the-West and St. Bride's omitted altogether. The absence of any of the painterly qualities characteristic of the Museum painting also suggests that the Goldsmiths' canvas is not by the same hand and perhaps somewhat later in date; the detail of the south transept of St. Paul's could have been corrected from Hollar's engravings. Holmes's contention that this, rather than the Museum painting, is 'an eye-witness impression', and 'the more accurate of the two in point of naturalism in general and London topography in particular' has little to recommend it.

A view of the Fire derived from this composition (panel, size $18\frac{3}{4} \times 29\frac{1}{2}$ inches) is at present on loan to the National Maritime Museum; this painting, though either near contemporary or eighteenth century in date, has little archaeological accuracy, and was probably executed by a Dutch artist unfamiliar with London itself.

ENGLISH SCHOOL, FIFTEENTH OR SIXTEENTH CENTURY

41 SAINT PETER AND A KNEELING CLERIC (56.167)
Distemper on plaster. $117\frac{1}{2} \times 38$ to $44\frac{1}{2}$ inches (293.75×95 to 111.25 cms.) (width irregular). Painted in the late fifteenth century or early sixteenth century.

Provenance: Part of the decoration of the chapel of Brooke House, Hackney; presented by the London County Council in 1956, at the time of the demolition of Brooke House.

References: Survey of London, Vol. XXVIII (Brooke House), London, 1960, pp. 20-2, 55 and 67-8, Fig. 8, Pls. 30-3, and colour frontispiece; Edward Croft-Murray, *Decorative Painting in England 1537-1837*, London, 1962, p. 175.

This fragment was the only major part of the decoration of the chapel of Brooke House, Hackney, uncovered at the time of demolishing the house in 1956, which was sufficiently complete and well preserved to be worthy of retention. It was accordingly removed from the plaster and transferred to linen. Originally the fragment had stood in the north-east corner of the chapel, on the north wall, to the right of a doorway, and, like the rest of the decoration, had been covered over with linewhite, presumably at the time of the Reformation.

The principal figure depicted is evidently St. Peter (though he has also been identified as the Patriarch of Jerusalem: cf. Croft-Murray, op. cit., p. 175). He is shown wearing a red cope and a spherical headdress surmounted by a cross, with his right hand upraised and in his left a double transomed cross and staff, and the crossed keys which are the attributes of St. Peter. At his feet, on the scale and in the place traditionally associated with donors, kneels a tonsured figure in black clerical dress. The figures are painted on a red and white tiled floor, and set against a red and white diapered background, in several of the interstices of which are Tudor roses in black and white. The inscription in black letter on a level with St. Peter's shoulders is fragmentary and cannot be interpreted with certainty; in the interstices below this occur the letter 'T' in the form of the Tau cross. At the top is a frieze with the coat of arms of the Radclyffe family, flanked on either side

Plate 41 Saint Peter and a kneeling Cleric (English School). Painted in the late fifteenth century or early sixteenth century

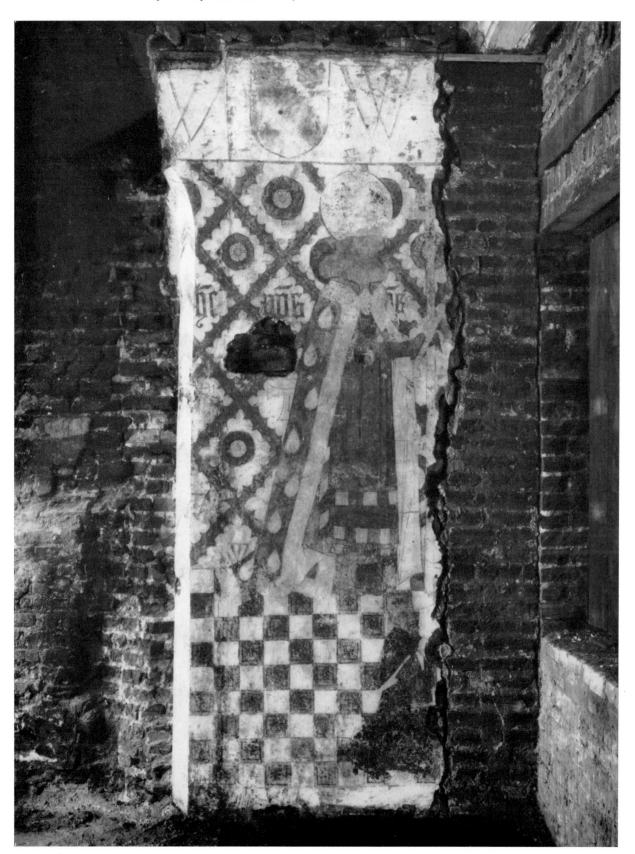

by the letter 'W'. Brooke House was built by William Worsley, later Dean of St. Paul's, shortly after 1476, and the letters 'W' are presumably his initials. The presence of the Radclyffe arms is accounted for by the fact that Roger Radclyffe was Worsley's steward. It has been suggested tentatively (*Survey of London*, op. cit., p. 68) that the kneeling figure may represent Worsley himself.

The date of the decoration of the chapel must be after 1485 (on account of the Tudor rose) and before 1532, when the house and estate had come into the possession of Henry, 6th Earl of Northumberland. The fragment in the Museum cannot be regarded as of much artistic merit, but no doubt represents the general level of decorative painting at the time, and is of particular interest as being the only surviving example of wall painting executed in the London area, which dates from the early Tudor period.

ENGLISH SCHOOL, SIXTEENTH CENTURY

42 JONAH CAST OVERBOARD AND SWALLOWED BY A WHALE (A 7928)

Distemper on plaster. $37\frac{3}{4} \times 73\frac{1}{4}$ inches (94.3 × 183.1 cms.). Painted in the mid or late sixteenth century.

Provenance: Part of the decoration of a house on the south side of High Bridge Street, Waltham Abbey, discovered in 1892 at the time of its demolition; presented by Charles Welch in 1912.

References: Transactions of the Essex Archaeological Society, New Series, Vol. 4, 1893, p. 300; Charles Welch, 'Descriptive Notes on a Wall-Painting', representing 'Jonah and the Whale', discovered at Waltham Abbey', *Transactions of the London and Middlesex Archaeological Society, New Series*, Vol. 2, 1913, pp. 111-8 (repr. facing p. 111); Francis W. Reader, 'Tudor Domestic Wall-Paintings', *The Archaeological Journal*, 1935, pp. 255-6 and repr. in colour from a drawing by the author on Pl. 5; Edward Croft-Murray, *Decorative Painting in England 1537-1837*, London, 1962, p. 187.

This wall painting was discovered behind the Jacobean wainscoting of a partition between two rooms on the upper storey of a house on the south side of High Bridge Street, Waltham Abbey, at the time of demolishing the building (and four other houses adjoining) in the autumn of 1892.

The scene is taken from the Book of Jonah, ch. 1. Jonah had been commanded by the Lord to go to Nineveh and preach against the evils rampant in that city. Instead, he fled by sea to Tarshish. In his wrath, the Almighty created so violent a storm that the safety of the boat was endangered. Realising that he was the cause of this storm, Jonah besought the mariners to throw him to the waves, whereupon 'the sea ceased from her raging'. God had prepared a great fish to swallow up Jonah, and he remained in its belly three whole days and nights.

In this representation, four seamen are shown throwing Jonah overboard, while one remains at the lookout and another at the stern-paddle; the whale occupies the right foreground, and part of the ship's cargo can be seen adrift in heavy seas. Another vessel

Plate 42 Jonah cast overboard and swallowed by a Whale (English School). Painted in the mid or late sixteenth century.

is seen in the middle distance left, and the whole picture is enclosed in a painted frame.

At this period painting directly on the plaster was a normal way of adorning a wall in smaller houses and the lesser rooms of great houses, tapestry being the usual decoration commissioned or purchased by important patrons. This painting may be regarded as an excellent example of the kind of work executed by members of the Painter-Stainers' Company and their confrères outside London; it is boldly conceived, well balanced in composition, and vigorously, though crudely, executed. The adoption of Scriptural subject-matter of this dramatic kind for domestic wall-painting may have been prompted by the example of Elizabethan playwrights. The inclusion of a stern-paddle rather than a rudder (which was an invention of the early Middle Ages) indicates that the artist made some attempt to recreate the kind of ship that might have been used in Biblical times; the boat on the left, however, is flying the flag of St. George. The whale is depicted as a purely fanciful sea-monster.

FLEMISH SCHOOL, SEVENTEENTH CENTURY

43 PROSPECT OF LONDON AND THE THAMES FROM ABOVE GREENWICH (64.52)

Panel. $11\frac{3}{4} \times 36\frac{1}{2}$ inches (29.4 × 92.25 cms.). Painted about 1620-30.

Provenance: Janet, Countess of Eglinton (d. 1923); Sir Bruce Ingram; Ingram sale, Sotheby's, 11 March 1964 Lot 12 (as English School, seventeenth century) bt. Colnaghi on behalf of the Museum; purchased out of the Mackenzie Bell Trust Fund, with the aid of contributions from an anonymous donor and the National Art-Collections Fund.

Exhibited: Seventeenth Century Art in Europe, Royal Academy of Arts, Winter Exhibition, January-March 1938 (26); *Wenceslaus Hollar*, City of Manchester Art Gallery, September-November 1963 (Works by other Artists 2); *The Growth of London*, Victoria and Albert Museum July-August 1964 (E4 and repr. in the catalogue, pl. VII (detail)); *The Origins of Landscape Painting in England*, Iveagh Bequest, Kenwood, June-August 1967 (6).

References: George H. Chettle, *The Queen's House, Greenwich* (14th Monograph of the London Survey Committee), London, n.d., p. 31 (repr. pl. 8 (detail)); Ellis Waterhouse, *Painting in Britain 1530 to 1790*, London, 1953, p. 42 (repr. pl. 41); *61st Annual Report of the National Art-Collections Fund 1964*, London, 1965, p. 18; Beryl Platts, 'The Oldest Road in London?', *Country Life*, 17 November 1966, p. 1262, repr. Fig. 1.

Also reproduced: The Illustrated London News, 1 January 1938; John Hayes, *London: A Pictorial History*, London, 1969, pls. 31-2 (details); Olive and Nigel Hamilton, *Royal Greenwich*, London, 1969, repr. p. 220 (with detail).

The earliest painted view of London from a distance, showing its setting in the landscape, and taken from a viewpoint close to that used by Anthony van der Wyngaerde in 1558. The extent to which Southwark Cathedral and Old St. Paul's dominated the skyline is dramatically displayed (see especially Pl. 1); the steeples of St. Mary-le-Bow and St. Dunstan-in-the-East, and the Tower of London, are also visible, and beyond the city

Plate 43 Prospect of London and the Thames from above Greenwich (Flemish School).
Painted about 1620-30

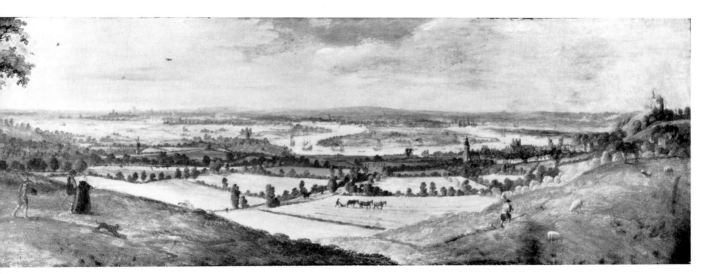

are the northern heights of Hampstead and Highgate. Though London already had a population of some quarter of a million, nearly ten times that of Bristol or Norwich, which were then the most important provincial towns, it was still quite small in size, and hardly exceeded twice the area of the original walled city.

In the middle distance left and centre are the two villages of Deptford, and the Isle of Dogs. On the right is Greenwich, a village that had grown up round the royal Palace, one of the favourite residences of the Tudors and the early Stuarts. From left to right are seen the medieval parish church of St. Alfege's, pulled down after the roof caved in in 1710, and replaced by the present church, designed by Hawksmoor and Jones; the Palace or 'manor of Plesaunce' (called Placentia) built by Humphrey, Duke of Gloucester after 1426, and later added to by Queen Margaret, Edward IV and Henry VIII, with the hall, the gatehouse and the twin towers of Henry VIII's Tilt Yard predominant; the Queen's House; and, on the hill, the castle originally built by Humphrey, Duke of Gloucester in the early fifteenth century, later rebuilt by Henry VIII, and destroyed in Charles II's reign, so that the Royal Observatory could be erected on its site. The hill in front of the Castle is Croom's Hill, showing the house known as the Paternoster Croft. The Queen's House, an H-plan with a bridge spanning the roadway, is shown here as it was left by Inigo Jones in 1618; it was later completed by him for Henrietta Maria in 1630-5, the additions which converted it into the square building we know today being designed by John Webb shortly after the Restoration, in 1661. In the distance right are two villages, with church towers distinct, that may represent Barking and East Ham.

The attribution and exact date of this painting have long been uncertain. The matter of date is crucial to the attribution, and should be discussed first. There are two clues, the costume, and the Queen's House. According to Miss Anne Buck (cited in the Hollar Exhibition catalogue, op. cit.), the costume of the figures is nearer to the French or Flemish fashion than to English, and to be dated about 1625-35; the inclusion of the Queen's House gives a date certainly after 1616, when that building was begun. From this evidence, it emerges that the painter was probably a French or Netherlandish artist, who visited London after 1616 and before 1640 at the outside. The style of painting is Flemish, and has close affinities with Joos de Momper and the Rubens circle. The figures, however, are rather Dutch than Flemish, deriving from Esaias van de Velde and Jan van Goyen. Waterhouse has suggested (op. cit.) that 'if we knew that Hollar ever practised in oil, an attribution to him would hardly be wide of the mark'; and Grossmann, compiling the entry for the Hollar Exhibition catalogue, does not reject this hypothesis, though observing that 'there are weaknesses and some coarseness of execution which make one hesitate to attribute the painting to him'. Certainly, the picture is in the tradition of Hollar's panoramic views, but by the date of Hollar's arrival in England, late in 1636 or early in 1637, the Queen's House had been finished; while some explanation would have to be offered for the earlier picture in the National Maritime Museum noted below. Another possible candidate is Claude de Jongh, who was certainly in England during the spring of 1627, and amongst other places, sketched Rochester Castle and the fort of Gravesend; he also did drawings of English scenes in 1615, 1625 and 1628. Although the earliest important painting from his hand, the view of *Old London Bridge*

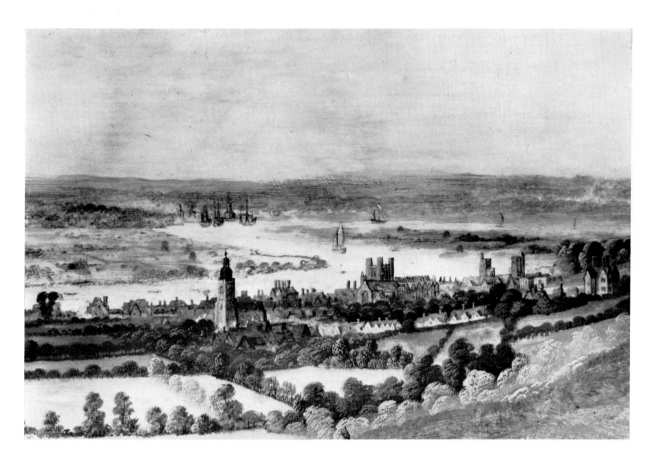

Plate 43 (Detail)

at Kenwood, signed and dated 1630, is entirely in the current Haarlem style represented by van Goyen and unrelated to the Museum picture, it is conceivable, especially since he was in fact a master in Utrecht, that his work of five to ten years earlier was quite different in character.

The rainbow visible in earlier photographs proved to be a later addition, and was removed during the restoration carried out by Mr. Stephen Rees-Jones in 1964-5.

A similar view of London from above Greenwich but with a viewpoint further east, which is by the same hand though considerably less mature and probably dating from some years earlier, is in the National Maritime Museum.

FRANCIS L. M. FORSTER (died 1916)
Painter of landscapes, portraits, genre and theatrical scenes. Pupil of Sickert. Member of the New English Art Club. Lived in Chelsea and Belgravia.

44 THE REGENT STREET QUADRANT AT NIGHT (A 28578)
Canvas. $36\frac{1}{8} \times 54\frac{1}{8}$ inches (90.25 × 110.25 cms.). Painted about 1897-8.

Provenance: Presented by the artist's sister, Miss Evelyn Forster, in 1926.

Exhibited: New English Art Club, April-May 1898 (131).

Reproduced: Steen Eiler Rasmussen, *London: The Unique City*, London, 1937, p. 285 (p. 269 in the original Danish edition, 1934).

This view of the Quadrant, which was taken from just below Glasshouse Street, looking southwards towards Piccadilly Circus, and with the entrance to Swallow Street visible in the distance, was painted only a few years before the whole character of Regent Street was drastically altered.

The Quadrant, which was built in 1818-20, was one of the most impressive features of the 'Royal Mile' designed by John Nash to link the Prince Regent's palace of Carlton House with Regent's Park. Its purpose was to connect Lower Regent Street, which was cut northwards from the façade of Carlton House, with Regent Street proper, which, for practical reasons, could not be planned quite in alignment. It was the only part of the street actually built by Nash himself (so important did he consider it), and the stately sweep of this uniformly designed block, contrasting with the variety and picturesque skyline of the remainder of Regent Street, constituted the essence of its architectural character. This sweep was effectively shattered in 1905-8 by the intrusion of a grandiose Edwardian façade, that of Norman Shaw's Piccadilly Hotel, and only partially restored

Plate 44 The Regent Street Quadrant at Night by Francis Forster. Painted about 1897-8

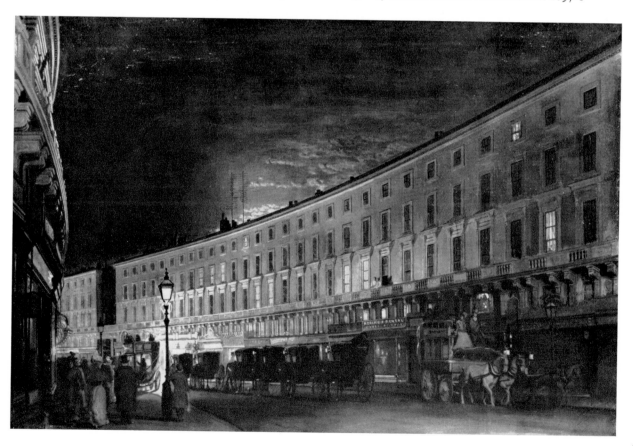

in the 1920's by the rebuilding of the entire length of the Quadrant with façades in stylistic keeping with the new hotel.

Three typical late Victorian omnibuses of the garden seat variety can be seen passing by, and six hansom cabs are waiting at a cab stand in the centre of the street.

WILLIAM E. FOX (active early twentieth century)
Flower and topographical painter. Lived in Kensington.

45 NO. 15 CHEYNE WALK, CHELSEA (A 17452)
Canvas. 22 × 15$\frac{15}{16}$ inches (55 × 37.75 cms.). Signed bottom left: *W. E. Fox*

Provenance: Presented by Miss M. C. Ford Smith in 1916.

Exhibited: Royal Academy, 1915 (852).

A view of the façade of No. 15 Cheyne Walk (at one time called Carlton House), built in 1717, from Chelsea Embankment gardens. An excellent example of the London terrace house of the Queen Anne period, with arched window heads and the first floor emphasised, the wrought iron work in the gate and railings of exceptional distinction. The first occupant of the house was Admiral Sir John Balchen (1670-1744); in 1869 it was tenanted by William Lawson, whose son, Cecil Gordon Lawson (1851-82), was a well-known Victorian landscape painter, specialising in Chelsea views. The house on the left, only partially visible, is Queen's House, one of the finest in Cheyne Walk, and formerly the home of Dante Gabriel Rossetti.

HENRY GREAVES (1844-1904)
Topographical painter, best known for his views of Chelsea. Born in Chelsea, the son of a waterman and boat-builder. Pupil and studio assistant of Whistler from about 1863. Lived in Chelsea.

46 CHEYNE WALK AND CHELSEA OLD CHURCH (60.58/2)
Cardboard. 9$\frac{9}{16}$ × 13$\frac{3}{4}$ inches (23.75 × 34.35 cms.). Signed and dated bottom centre: *H Greaves 1857* Inscribed in pencil on the back: *Cheyne Walk/Old Chelsea/1857*

Provenance: Purchased from Messrs. P. & D. Colnaghi in 1960.

A view of the west end of Cheyne Walk before the construction of the Chelsea Embankment in 1871, and the replacement of all but the furthest two houses by the Chelsea Hospital for Children and Carlyle Mansions.

Plate 45 No. 15 Cheyne Walk, Chelsea by W. E. Fox. Painted about 1915

Plate 46 Cheyne Walk and Chelsea Old Church by Henry Greaves. Painted about 1875-80

Cheyne Walk, named after Charles Cheyne, a former lord of the manor of Chelsea, who died in 1698, was a residential street of considerable distinction from the moment its first houses were built in the late seventeenth century. Though there were several coffee houses, of which Don Saltero's, opened in 1695, was the best known, there were no shops in the street until the nineteenth century: one is seen on the right of this picture. The Cricketers' public house was famous for having a signboard attributed to George Morland, which was still in existence in 1824. Notice that the Royal Humane Society's drags (or grapples) were available at the Thames Coffee House (see also No. 5); beyond the coffee house, and on the other side of Lawrence Street, is the row of five late seventeenth century houses in Prospect Place (formerly called Church Row).

In the middle distance is the church of All Saints, better known as Chelsea Old Church, which was the parish church of Chelsea until the building of St. Luke's in 1819. Erected at the end of the thirteenth century, it was rebuilt in 1669-72, the tower being finished in 1674. This view shows the church after the removal of the cupola in 1815 (which can be seen in Rowlandson's watercolour of Cheyne Walk in the Museum, No. 28 in the Catalogue published in 1960), but the weather vane that surmounted the cupola remained. The east window is early nineteenth century in date. The church was badly damaged during the second World War, but afterwards rebuilt. Beyond the church are the houses and wharves of Lombard Street, now part of Cheyne Walk.

This view cannot have been painted in 1857, when the artist was only thirteen; it is known, moreover, that the brothers Greaves were accustomed to putting early, incorrect dates on their pictures. The style is identical with No. 47, and the painting is probably of the same date, about 1875-80.

WALTER GREAVES (1846-1930)
Topographical, genre, and portrait painter, best known for his views of Chelsea. Born in Chelsea, the son of a waterman and boat-builder. Pupil and studio assistant of Whistler from about 1863. Lived in Chelsea.

47 THE WATERSIDE ENTRANCE TO CREMORNE GARDENS
(60.58/3)
Cardboard. $9\frac{15}{16} \times 15$ inches (22.75 × 37.5 cms.). Signed and dated bottom left: *W. Greaves 1859* Inscribed in pencil on the back: *Waterside Entrance/Cremorne Gardens Chelsea*

Provenance: Purchased from Messrs. P. & D. Colnaghi in 1960.

Exhibited: Walter Greaves, Leighton House, January 1967 (33).

A view of the south-east entrance to Cremorne Gardens from Cremorne Road, close to the Pier, part of which, with the City flag flying above it (this was one of the piers used by the City Steamship Company), is seen in the background.

Cremorne House, one of Chelsea's finest riverside mansions (situated just to the north of the present Lot's Road Power Station), was sold at the end of the 1820's. For a number of years it was used as a sports club, known as the Stadium, an early predecessor

Plate 47 The Waterside Entrance to Cremorne Gardens by Walter Greaves. Painted about 1876-9

of Hurlingham. This venture not succeeding, however, Cremorne was turned into a pleasure garden by Renton Nicholson (see also No. 155) in 1843; under the management of Thomas Bartlett Simpson, the grounds were laid out on the model of Vauxhall at the cost of five thousand pounds, and opened to the public in this form in 1846. One of the most notorious of the London pleasure gardens (see also No. 68), Cremorne was finally closed in 1877 following repeated complaints from the neighbourhood about the noise and rowdiness.

The gardens were situated a little to the west of Battersea Bridge, between Ashburnham House and World's End Passage, north of what is now Lots Road; today the area is covered with streets of houses, the names of Cremorne Road and Stadium Street preserving memories of the past.

Notice the hansom cab, a vehicle first introduced on the London streets in 1835 (see also Nos. 35 and 101).

The costume indicates a date of about 1876-9, conflicting with the clearly written date of 1859 (see also No. 46).

A watercolour of this subject by Walter Greaves is in the local collection of the Royal Borough of Kensington and Chelsea; Greaves also executed a number of etchings of Cremorne Gardens, which date from 1870 and 1871.

AFTER JAN GRIFFIER THE ELDER (c. 1646 or 1652-1718)

48 THE GREAT FIRE OF LONDON, 1666 (51.53)
Canvas. 29⅝ × 46⅛ inches (74.2 × 115.3 cms.). Date uncertain.

Provenance: Miss Brougham Thompson; Thompson sale, Christie's, 2 August 1951 Lot 101 (as Jan Griffier) bt. National Art-Collections Fund, by whom it was presented.

Exhibited: Historic Fires, Stadsmuseum, Stockholm, April-June 1969.

This view of the Fire is intended to represent the scene as it would have appeared from just beyond the westernmost gates of the City. The identifiable buildings are St. Paul's Cathedral and St. Mary-le-Bow, and the orientation of St. Paul's indicates that the gateway on the left is Newgate and that on the right Ludgate, with the tower of St. Martin's Ludgate behind. So far as is known, this is the only pictorial record of what these medieval gates may have looked like (though see below).

Beyond a general impression of desolation and of the flames being carried westwards by the relentless wind, this view cannot be accepted as of much value as a record of the Fire, and it was evidently not studied at first-hand. In the first place, St. Mary-le-Bow could not possibly have been seen from the viewpoint chosen, since it lay well to the east of St. Paul's and would actually have been hidden from view by the towers of Newgate; and secondly, the detail of St. Paul's is very casually painted – in particular, the north transept is given far too many windows. These facts suggest that the artist was probably unfamiliar with London itself at the time of producing this composition, and certainly uninterested in topographical accuracy (which, in so far as St. Paul's was concerned, anyway, he could easily have achieved from secondary sources).

94

Plate 48 The Great Fire of London, 1666 (after Jan Griffier the Elder). Date uncertain

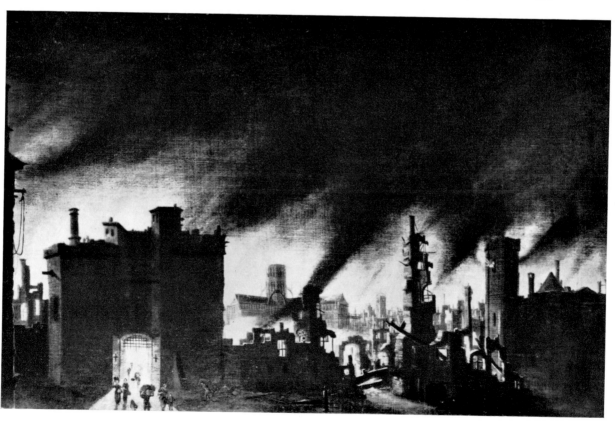

This painting is identical in all but the smallest particulars with what is probably the original of this subject, now lost, but recorded as in the possession of a Mr. Lawrence of High Timber Street, Queenhithe (and later, Mrs. Lawrence of Thames Street) at the time it was engraved for Wilkinson's *Londina Illustrata*, 7 August 1811, and there described as being 'on a comparatively small scale'. No attribution is given by Wilkinson, but an undated early nineteenth century lithograph after an original painting in the possession of Robert Golden, which is very similar in composition but not in detail (St. Paul's is differently orientated, too, and seen from Ludgate, while the church which appears in the position of St. Mary-le-Bow bears no resemblance to any London church), includes the signature *J GRIFFIER* on some masonry to the right. The tradition that the Museum view was painted by Jan Griffier the Elder may stem from this version. George Vertue records of Griffier that 'the Grandson of him. told me he had heard His Grandfather came into England. soon after the Fire of London 1666 and that he had painted some views of London about that Time. representing the Citty on Fire' (*Vertue Notebooks*, Walpole Society, Vol. 26, 1938, p. 69). But none of these views is certainly identifiable.

There are two other versions of this composition in the Museum's collection (see Nos. 151 and 152), which suggests that the original was regarded at the time as a work of some importance.

49 THE THAMES AT HORSEFERRY, WITH LAMBETH PALACE AND A DISTANT VIEW OF THE CITY (54.96)

Canvas. $24\frac{1}{4} \times 43\frac{1}{2}$ inches (60.63 \times 108.75 cms.). Painted about 1706-10.

Provenance: A. J. Pidduck; Pidduck sale, Christie's, 19 December 1908 Lot 79 (as Hayman) bt. in; with M. Bernard; Anon. sale, Christie's, 13 June 1952 Lot 127 (as Scott) bt. J. Mitchell; purchased out of the Joicey Trust Fund from the Parker Gallery in 1954.

Exhibited: The Growth of London, Victoria and Albert Museum, July-August 1964 (F33); *The Thames in Art*, Arts Council (Henley and Cheltenham), June-July 1967 (5).

Reproduced: John Hayes, *London: A Pictorial History*, London, 1969, pl. 70 (detail); J. L. Howgego, *The City of London through Artists' Eyes*, London, 1969, p. 23 (colour).

The horseferry, which plied on the site of the present Lambeth Bridge and is still recalled in the name Horseferry Road, was, until the building of Westminster Bridge in 1736-50, the only point along the entire waterfront of the capital west of London Bridge where coaches could be taken across the river. The ferry rights belonged to the See of Canterbury, but were usually leased out; at the date of this painting, they were in the possession of a Mr. Leventhorp, who was accused by the parishioners of St. Margaret's, Westminster of 'usurping the whole profits of the horseferry, and neglecting to repair the roads leading thereto'. The ferry rights lapsed after the opening of Westminster Bridge.

In this picture a coach and pair are shown being punted across the Thames, while a naval barge close by fires a friendly salute. In the foreground left is Millbank Terrace,

Plate 49 The Thames at Horseferry, with Lambeth Palace and a distant View of the City
(after Jan Griffier the Elder). Painted about 1706-10

with a Mayday procession: a milkmaid, with the traditional Mayday garland of pots and pans, and three other figures are dancing outside the White Hart tavern to the accompaniment of a fiddler and concertina player. Other figures, including a royal bargeman in his scarlet coat and a Thames waterman in blue uniform, are seated on benches smoking and drinking; and three youths are bathing from a nearby punt. Beyond are Westminster Abbey and what is intended to be the tower of St. Margaret's, Westminster and, in the distance, the City waterfront, dominated by the spires of Wren's churches and the great mass of St. Paul's Cathedral. In the middle distance are Lambeth Marsh and Lambeth Palace, where, from left to right, are visible Laud's Tower, the Great Hall, the gatehouse (Morton's Tower), Lambeth stairs, the tower of St. Mary's church, and the ramp of a barge-house.

The treatment of the architectural detail is very summary, and this picture is a generalised and abbreviated copy of the signed Griffier in the Galleria Sabauda, Turin, with fewer ships and figures, but with those that are included for the most part painted in much the same positions and poses. The costume in both suggests a date of about 1700-20. They were clearly painted either during or after the completion of the west front of St. Paul's, the towers having been built in 1705-8, and the ball and cross surmounting the lantern being paid for in October 1708. But the ensign flying on the naval barge is that in use before the Union with Scotland, 1707. Either the artist showed St. Paul's during completion, but without the scaffolding, as it would have been seen when finished; or else an outmoded ensign. A bracket of 1706-10 is the closest acceptable dating.

CHRISTOPHER HALL (born 1930)

Landscape and topographical painter. Studied at the Slade School 1950-4. Lives in Newbury.

50 TOLMERS SQUARE, ST. PANCRAS (65.93)

Fibreboard. $25\frac{3}{4} \times 17\frac{1}{16}$ inches (64.25 × 42.65 cms.). Signed and dated bottom left: *C. Hall/ May/1954.*

Provenance: Purchased out of the Mackenzie Bell Trust Fund from the artist in 1965.

Tolmers Square, a small square just north of the Euston Road, between Hampstead Road and Gower Street, now much dilapidated, was developed in the early 1860's on the site of the reservoir belonging to the New River Company, which had been removed in 1860, and was built up with four storey Italianate terrace houses. The Congregational Church opened in 1863, which occupied the whole of the centre of the square, was converted into the Tolmer cinema in the 1920's.

This view is taken looking south, and shows Nos. 14 and 15; on the left is the alleyway which leads into Gower Street, and on the right the back of the Tolmer cinema. Since this picture was painted, the tall block of RTB House on the corner of Gower Street and Euston Road has been erected, and would dominate the background. The whole area west of Tolmers Square has now been cleared for improvement, and high rise buildings are in course of erection along the Euston Road.

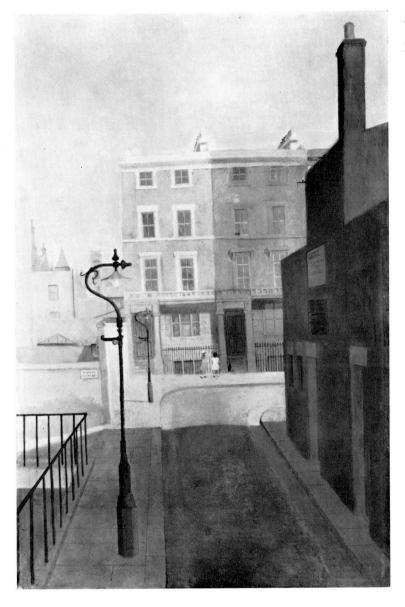

Plate 50 Tolmers Square, St. Pancras by Christopher Hall. Signed and dated 1954

51 A SCENE IN SOUTHAM STREET, NORTH KENSINGTON
(61.62)

Fibreboard. 20½ × 16 inches (51.25 × 40 cms.). Signed and dated bottom right: *C. Hall 1959*

Provenance: Purchased from the Arthur Jeffress Gallery in 1961.

Exhibited: Christopher Hall, Arthur Jeffress Gallery, February-March 1961 (4).

This neighbourhood, between the Grand Union Canal and what was then the Great Western Railway was first laid out with streets of small terrace houses shortly after 1860. Southam Street itself was under construction in 1865, and the name was approved in 1867. This whole district was known as Kensal New Town, and acres of farmland (including Portobello Farm) then lay between the new streets and the main built up area of west London. By the mid-1870's, however, the whole of the Portobello Estate had been developed in a similar way. The main artery of North Kensington, Ladbroke Grove, lies a little to the west of Southam Street.

During and after the Second World war, these streets became very run down and dilapidated, and this view shows a group of people outside a house with peeling stucco, next door to a site undeveloped since war destruction. The area has since enjoyed some of the prosperity which has come to Little Venice, a mile or so down the canal, as a result of the greatly increased demand for houses of a reasonable price within easy distance of central London, but large tracts of north-west London still remain un-reclaimed.

CLIFFORD ERIC HALL (born 1904)
Painter of landscapes, townscapes, interiors and portraits. Born in London, the son of a newspaper manager. Studied at the Royal Academy Schools 1925-8, and with André Lhote in Paris, 1928. Lives in Paddington.

52 THE CALEDONIAN MARKET, COPENHAGEN FIELDS (51.55)
Canvas. 28¼ × 36¼ inches (70.6 × 90.6 cms.). Signed and dated bottom right: *Clifford Hall/ 1933.*

Provenance: Purchased out of the Joicey Trust Fund from the artist in 1951.

Exhibited: National Society 8th Annual Exhibition, Royal Institute Galleries, February-March 1937 (351).

Reproduced: The Tatler, 16 June 1937.

This view of the Caledonian market was taken from the tall central clock tower, looking south-east towards Pedlar's Way and the White Horse Tavern. The gabled warehouses are not part of the premises but belong to Caledonian Road railway station, which adjoins the market.

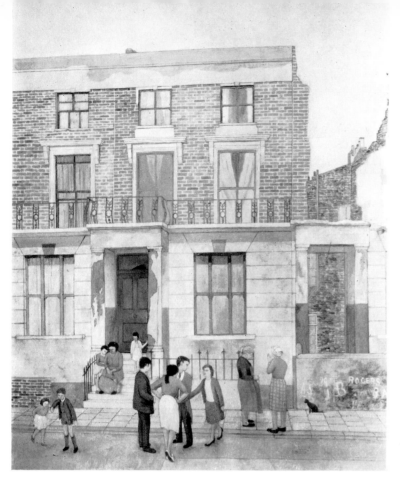

Plate 51 A Scene in Southam Street, North Kensington by Christopher Hall. Signed and dated 1959

Plate 52 The Caledonian Market, Copenhagen Fields by Clifford Hall. Signed and dated 1933

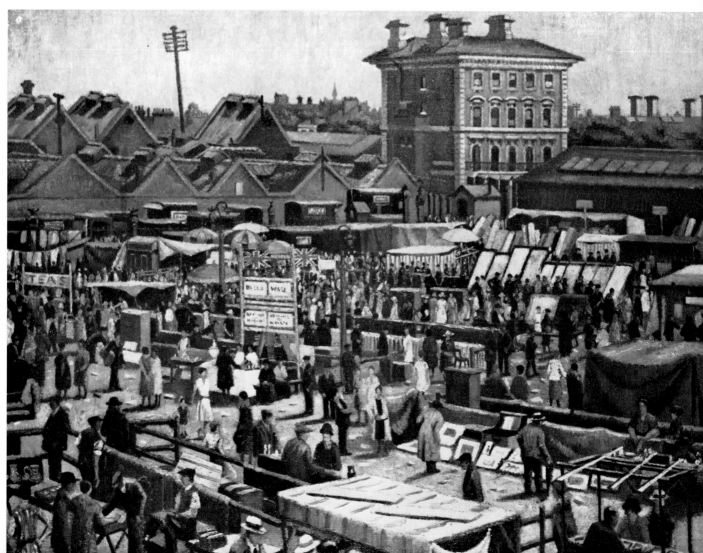

The buildings were originally designed by John Bunning, the architect of the Coal Exchange, for use as the Metropolitan Cattle Market, the live-stock market at Smithfield having been demolished in 1851. It was completed in 1855, and officially opened by the Prince Consort. Covering an area of fifteen acres, it provided accommodation for some 44,000 animals. The central tower, built on the site of Copenhagen House (a celebrated London tea garden), contained twelve banks and a telegraph office. Two large taverns were erected on the north side of the market, on either side of a fountain, and four smaller taverns at each corner, all in a sober style uncharacteristic of contemporary public house architecture, and perhaps, as Professor Henry-Russell Hitchcock suggests, piously 'intended to influence for the better the deportment of hard-drinking cattle dealers'.

The cattle market was not a commercial success, however, and by the beginning of the present century its premises were being used as a vast second-hand market, the equivalent of the *marché aux puces* in Paris. Some impression of its popularity and the variety of stalls is given here. Closed during the second World War and never re-opened, its activities are now carried on in Bermondsey Square. The area is now being developed with blocks of flats, and Market Estate has been completed on the north side; but the central clock tower still stands, and three of the four corner taverns remain in business.

JAMES HOLLAND (1800-70)
Flower and topographical painter, best known for his views of Venice; painted several views of Greenwich. Born at Burslem, Staffordshire. Worked for seven years as a flower painter at the Davenport porcelain factory, where his father and other members of his family were employed, before coming to London in 1819, and continued to exhibit flower paintings at the Royal Academy until 1838. Lived in various parts of London.

53 HYDE PARK CORNER AND CONSTITUTION ARCH (c 1004)
Canvas. 21¼ × 35½ inches (53.2 × 88.75 cms.). Painted about 1829-34.

Provenance: Miss Emily J. Wood, who presented it to the National Gallery in 1888; transferred to the Tate Gallery in 1897; lent by the Tate Gallery in 1912, and transferred in 1957.

Exhibited: Victorian Painting 1837-1887, Agnew's, November-December 1961 (6).

References: Mary Chamot, *British School* (Tate Gallery Concise Catalogue), 1953, p. 99.

This view shows Constitution Arch and the entrance screen to Hyde Park in alignment, as they were until the Arch was moved to its present position at the top of Constitution Hill in 1883. Several schemes for composing an entry into London at Hyde Park Corner in the grandest architectural style had been proposed in the second half of the eighteenth century, but proved abortive. In the end, the idea was turned upside down, as it were, and the grand arches actually built were not an entry into London at all, but on a totally different axis, and intended as an entrance to Nash's new Buckingham Palace, on the

Plate 53 Hyde Park Corner and Constitution Arch by James Holland. Painted about 1829-34

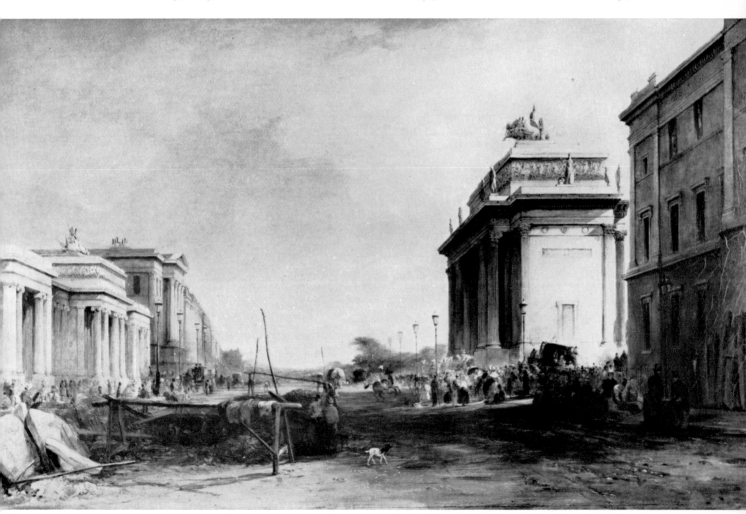

south (a similar triumphal entrance to the Constitution Arch, the Marble Arch, was designed by Nash for the forecourt of the Palace, and stood there until 1851). Both the Hyde Park Corner screen and the Royal Entrance (Constitution Arch) were designed by Decimus Burton, and built in 1825-8. The sculptured figure of a Victory in a quadriga or four-horsed chariot surmounting the Arch was replaced by a bronze equestrian statue of the Duke of Wellington by Matthew Cotes Wyatt in 1846; this in its turn was replaced, in 1912, by the bronze Victory group by Adrian Jones that still remains there.

Apsley House, No. 1 London, originally an Adam house of 1771-8, is seen here as it was remodelled for the Duke of Wellington by Benjamin and Philip Wyatt in 1828-9; beyond is Piccadilly. On the right is part of St. George's Hospital, built by William Wilkins in 1828-9. Road-mending operations are in progress in the foreground, and a crowd is watching a troop of lancers as it passes through Constitution Arch. Amongst the vehicles depicted are a town or dress coach, with two footmen on the platform behind, emerging from Hyde Park, a row of waggons in Piccadilly, and a dress chariot passing Constitution Arch.

The costume indicates a date of about 1829-34.

SIR CHARLES JOHN HOLMES (1868-1936)

Painter and etcher of landscapes, topography and industrial scenes. Born at Preston, Lancashire. Self-taught in painting, but studied etching under William Strang. Member of the New English Art Club 1904. Slade Professor at Oxford 1904-10. Director of the National Portrait Gallery 1909-16. Director of the National Gallery 1916-28. Lived in Kensington.

54 THE WOOD LANE POWER STATION (37.205)

Canvas. $17\frac{7}{8} \times 32$ inches (44.7 × 80 cms.). Signed with initials and dated bottom centre: *CJH 07.* Inscribed on the back: *THE POWER STATION. LADBROKE GROVE. 1907.*

Provenance: Presented by Lady Holmes in 1937.

Exhibited: Pictures and Drawings by Professor C. J. Holmes, Carfax and Co., January 1909 (20).

Reference: C. J. Holmes, *Self & Partners,* London, 1936, p. 253.

A view of the power station in Wood Lane, Shepherd's Bush over the roof tops from the artist's house, 73 Ladbroke Grove. The artist described this painting as his 'first elaborate effort at an Industrial subject', and it was executed at the beginning of what he considered his 'best period', from 1907 to 1913.

Wood Lane Power Station, which supplied electricity to the Kensington area (it was built for the Kensington and Knightsbridge, and the Notting Hill, Electric Light

Plate 54 The Wood Lane Power Station by Sir Charles Holmes. Signed and dated 1907

Companies), started operation in 1900, and, as the earliest generating plant to provide high-voltage, three-phase generation and transmission in this country, has a place of particular importance in the development of the industry. It was closed down in 1928.

E. F. HOLT (active 1853-60).
Hardly anything is known about this artist, except that he exhibited pictures in differing genres during the 1850's, and sent in from addresses in various parts of London.

55 THE DRESS CARRIAGE OF VISCOUNT EVERSLEY IN
HYDE PARK (A 20709)
Canvas. 23⅞ × 36⅛ inches (59.7 × 90.3 cms.). Signed and dated bottom centre: *E. F. HOLT. 1856*; and inscribed: *No. 71.*

Provenance: Presented by Oliver, 3rd Viscount Esher in 1919.

This picture is a 'portrait' of the dress carriage owned by Viscount Eversley, which is shown passing the Achilles monument in the Ring Road of Hyde Park. Charles Shaw-Lefevre (1794-1888), Speaker of the House of Commons from 1839 to 1857, was raised to the peerage as Viscount Eversley of Heckfield on his retirement from office; the carriage may have been ordered at this time, in which case the artist dated his picture wrongly, or it may have been the vehicle Lord Eversley used as Speaker, in which case the armorial bearings were added to the canvas later.

The bodywork of the carriage is painted in two colours, black on the upper part, green with gold stripes on the lower, with the Eversley coat of arms on the door panel; the window is closed, with the blind up. On the hammer cloth covered box sits a coachman in ivory and blue livery, wearing a tricorne hat; two footmen in similar liveries, but wearing the customary cocked hats, stand on the platform between the rear springs, carrying staves which were relics of the necessity to deal with highwaymen or anyone else who might attempt to molest the vehicle. The carriage is drawn by two black thoroughbred horses.

Elegant dress carriages of this kind, with elaborate decorations and livery, were more common in London in the early years of Queen Victoria's reign than at any other period, and the year of the coronation, 1838, marked the peak of dress coachbuilding by London makers. By the time this picture was painted, the dress carriage was beginning to be replaced in popularity by the brougham and the landau, and the travelling carriage by the railways.

The statue of Achilles, a monument to the Duke of Wellington and his troops, was cast in bronze by Sir Richard Westmacott, from cannon taken in the battles of Salamanca, Vittoria, Toulouse and Waterloo, and erected in 1822. The sheet of paper in the foreground is inscribed: *GOING TO/TAKE UP/REGULATIONS;* a soldier and his lass are seen in the park in the middle distance left.

106

Plate 55 The Dress Carriage of Viscount Eversley in Hyde Park by E. F. Holt. Signed
and dated 1856

ABRAHAM HONDIUS (c. 1625/30-91)

Painter of religious, mythological and topographical subjects, interiors and hunting scenes, but specialised in animals and birds. Born in Rotterdam, the son of the city stonemason. Settled in England by 1674. Lived first on Ludgate Hill, and later in the parish of St. Dunstan-in-the-West.

56 THE FROZEN THAMES, LOOKING EASTWARDS TOWARDS OLD LONDON BRIDGE (35.190)

Canvas. 43⅛ × 70¼ inches (107.8 × 175.6 cms.). Signed and dated lower left: *Abraham Hondius/Aᵒ 1677*

Provenance: Sir James Rawlins, Syston Court, Mangotsfield, Bristol; J. E. Rawlins sale, Norfolk and Prior, 21 May 1935 Lot 183 (repr.); purchased from Spink by the National Art-Collections Fund, with the aid of a contribution from Owen H. Smith, and presented to the Museum.

Exhibited: The Age of Charles II, Royal Academy of Arts, Winter Exhibition, 1960-1 (234), repr. in the Souvenir, p. 18; *London Bridge in Art*, Guildhall Art Gallery, June-July 1969 (5).

References: The Times, 17 April 1935 (repr.) and 26 April, 1 May and 13 May, 1935; C. E. Britton, 'The Cold Winter of 1676-1677', *Journal of the Royal Meteorological Society*, Vol. 61, 1935, pp. 390-1; *32nd Annual Report of the National Art-Collections Fund 1935*, London, 1936, p. 54, repr. facing; H. Gerson, 'Dutch Landscape', *The Burlington Magazine*, February 1953, p. 47 Note 1; Margaret Whinney and Oliver Millar, *English Art 1625-1714*, Oxford, 1957, p. 263; Alfred Hentzen, 'Abraham Hondius', *Jahrbuch der Hamburger Kunstsammlungen*, Vol 8, 1963, pp. 45 and 53 (Cat. No. 66), repr. pl. 18.

Also reproduced: The Illustrated London News, 18 May 1935; *Twenty-Five Years of the London Museum*, London, 1937, pl. LVI; Arthur Bryant, *Restoration England*, London, 1960, facing p. 41 (detail); *The Illustrated London News*, 28 May 1960 and 10 December 1960; R. G. Veryard, 'The Changing Climate', *Discovery*, January 1962, Fig. 5; J. L. Howgego, *The City of London through Artists' Eyes*, London, 1969, p. 19 (colour).

Numerous figures are shown amusing themselves on the frozen river, skating, sliding, snowballing and even shooting. Old London Bridge is seen in the middle distance, with beyond it, part of the tower of St. Olave's Tooley Street (rebuilt by Flitcroft 1738, after it had fallen into serious disrepair) and Southwark Cathedral (not Westminster Abbey, as stated in Hentzen, op. cit.). In common with most other seventeenth century painters, Hondius has drawn the pointed arches of Old London Bridge incorrectly, as almost rounded and of more or less equal width; and the block of houses seen on the left, which replaced those burnt in the fire of 1632-3, should be of greater height. The stairs in the left foreground greatly exaggerate the height even of those along the City waterfront, and are presumably imaginary.

The frost depicted is evidently that of December 1676, which began to break on 3 January, and the date of the scene shown here must, therefore, be the very beginning of January 1677 (since the picture is dated that year). Hondius has depicted the state of the ice with great accuracy. The tall floes with almost sheer sides, separated by narrow channels, are characteristic of an accumulation of snow on a basis of thin ice, and this was exactly the sequence of events in 1676. A covering of thin ice had formed by 12

Plate 56 The Frozen Thames, looking eastwards towards Old London Bridge by Abraham
Hondius. Signed and dated 1677

December, when there was a heavy fall of snow (Evelyn called it 'so greate a snow, as I remember not to have ever seene the like'), followed by another on 19 December. People first began to cross the ice on 31 December, and it is recorded that on 1 January 'hundreds passed over the Thames'. The ice was not thick enough, however, for any sustained activity of the kind that occurred in 1683-4 (see No. 57).

The last occasions on which the Thames froze were in 1813-4 and 1895 (see No. 137), and it was partly as a result of the dangers to which Old London Bridge became subject from the pressure of the ice in the freeze of 1813-4 that the bridge was finally pulled down. The new London Bridge was designed so that its arches did not impede the flow of water in the way that the arches of the old bridge had always done.

57 A FROST FAIR ON THE THAMES AT TEMPLE STAIRS (49.80)
Canvas. 26¾ × 44¾ inches (66.9 × 111.9 cms.). Painted about 1684.

Provenance: Purchased out of the Joicey Trust Fund from Philip Moore and Spooner, Hove, in 1949 (without attribution).

Reproduced: Arthur Bryant, *Restoration England*, London, 1960, between pp. 40 and 41 (detail); *The Illustrated London News*, 28 May 1960 and 6 January 1962; Ivor Brown, *London*, London, 1965, pl. 69.

The Thames was frequently frozen over during severe winters, in the years before Old London Bridge was pulled down and the flow of the river thereby improved; but the frost of 1683-4 was unparalleled in London's history. It lasted from the beginning of December 1683 until 4 February 1684, and the ice was thicker than had ever been known. There were also exceptionally bad fogs. As Evelyn tells us in his Diary, by New Year's Day 'streetes of Boothes were set up upon the Thames,' which were like a 'Continual faire, all sorts of Trades & shops furnished, & full of Commodities, even to a Printing presse, where the People & Ladys tooke a fansy to have their names Printed & the day & yeare set downe, when printed on the *Thames*'. Many woodcuts of the scene were also sold as souvenirs.

In this picture the principal line of booths, which extended from Temple Stairs to the Old King's Barge-House, is shown in the centre, coaches, sledges and sedan-chairs are plying on the ice, and citizens are strolling on the frozen river; a game of ninepins is seen in progress in the foreground centre, and nearby there is a gaping hole in the ice. The buildings represented in the background are, from left to right, St. Clement Danes (before the addition of Gibbs's steeple in 1719) with Arundel Street in front of it, Essex Buildings (Nicholas Barbon's first speculative enterprise in this district) with Essex stairs in front, Middle Temple Hall, Temple Stairs, Crown Office Row (partly hidden by the trees), the Temple church, the hall of Serjeant's Inn with, in front of it, the predecessor of Paper Buildings, and, on the extreme right, King's Bench Walk.

On the evidence of the booths, the date of the scene depicted is January or the beginning of February 1684. Though there seems no reason to discount an attribution to Hondius, the painting is not of the quality of No. 56.

Plate 57 A Frost Fair on the Thames at Temple Stairs by Abraham Hondius. Painted about
1684

A version of this picture, differing only slightly (in the disposition of the clouds, and in some of the figures), was with Leggatt Brothers in 1926.

CHARLES HUNT (active 1870-96)
Genre painter; worked in the style of R. W. Buss. Lived in various parts of London.

58 A COFFEE STALL (53.28)

Canvas. 24 × 35⅞ inches (60 × 89.7 cms.). Signed and dated bottom left: *C HUNT 1881*

Provenance: Robert Frank; purchased out of the Joicey Trust Fund from M. Newman in 1953.

Exhibited: British Life, Arts Council Coronation Exhibition, May-July 1953 (109); *Victorian Painting 1837-1887*, Agnew's, November-December 1961 (93).

Reference: Graham Reynolds, *Painters of the Victorian Scene*, London, 1953, p. 92 (repr. fig. 81).

Among the many thousand street sellers of all descriptions who thronged Victorian London, the coffee stall proprietor was one of the most welcome. A baker's man, a boy wearing a City of London badge and seated in a wheelbarrow, and a young lady carrying a band-box are shown with cups of coffee, while the proprietress is washing up. On the left is a ragged girl with a broom, evidently a crossing sweeper, and a woman with a basket on her head.

The costume depicted is of the period 1858-60, so that the picture represents a scene some twenty odd years earlier than the date of painting.

JULIUS CAESAR IBBETSON (1759-1817)
Painter of landscapes, topographical subjects, portraits and genre. Born at Farnley Moor, Yorkshire, the son of a cloth merchant. Apprenticed to John Fletcher, a ship painter in Hull, in about 1771; broke his articles and ran away to London in 1777, where he worked for a picture restorer. Lived in London until 1798, chiefly in Kilburn and Paddington; then moved to the north, finally settling in Masham in 1805.

59 THE ASCENT OF LUNARDI'S BALLOON FROM ST. GEORGE'S FIELDS (A. 15491)

Canvas. 20 × 24¼ inches (50 × 60.6 cms.). Painted about 1788-90.

Provenance: Purchased from Willson Brothers in 1915 (without attribution).

Exhibited: Julius Caesar Ibbetson, Iveagh Bequest, Kenwood, June-September, 1957 (4).

Reference: Rotha Mary Clay, *Julius Caesar Ibbetson 1759-1817*, London, 1948, p. 11.

Reproduced: J. E. Hodgson, *The History of Aeronautics in Great Britain*, London, 1924, fig 23 (colour).

In 1784, Vincenzo Lunardi, secretary to the Neapolitan Ambassador in England, made aeronautical history with his successful ascent in a hydrogen-filled balloon, when he took off from the Honourable Artillery Company's ground in Moorfields and landed at Ware.

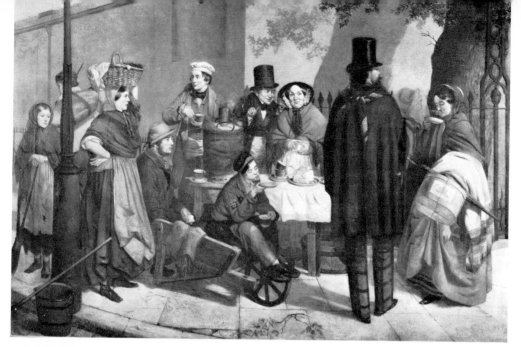

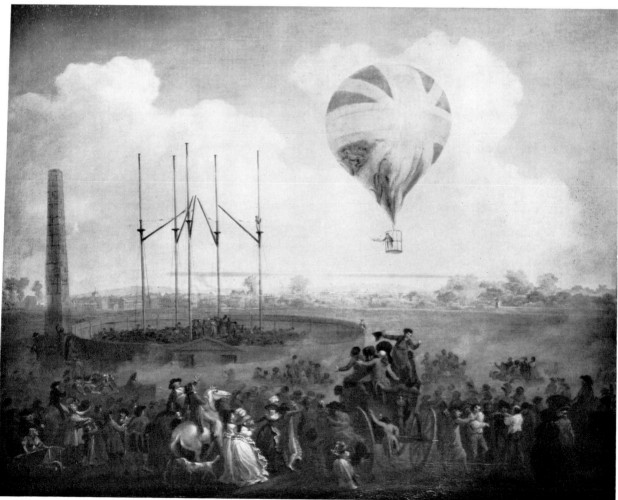

Plate 58 A Coffee Stall by Charles Hunt. Signed and dated 1881
Plate 59 The Ascent of Lunardi's Balloon from St. George's Fields by J. C. Ibbetson.
Painted about 1788-90

113

Ibbetson's canvas is a record of the third ascent of Lunardi's balloon, from St. George's Fields, Newington, on 29 June 1785. Tickets were sold for the event, and some idea of the crowd present is suggested in the foreground of the picture. Lunardi had intended to pilot the flight, and take four companions with him, but the balloon failed to rise; he decided to forgo the excitement himself, two other aeronauts had also to be disappointed, and the 'eagle's nest' was occupied only by his patron George Biggin and by Mrs. Letitia Anne Sage (omitted in this picture). Though Biggin had no experience in piloting, and had left behind the oars used to help control the rate of ascent and descent, this flight was as successful as the first, and after floating over the Thames and Westminster, and being watched by the King from St. James's Palace, the balloon eventually came down in a common field near Harrow School.

St. George's Fields was still largely undeveloped at this time, although the new road from Blackfriars Bridge, approved by Parliament in 1769, had already been constructed, and the obelisk (seen here) at the junction of this road with those from London and Westminster Bridges at St. George's Circus, had been raised in 1771. In this picture, Ibbetson has left out any indication of the roads which radiated from the Circus. Next to the obelisk (which was removed to the nearby Geraldine Mary Harmsworth Park, Lambeth, in 1905) is the Royal George Rotunda, the enclosure from which the preparations for the balloon ascent were made. In the distance is Newington Butts, with the church tower of St. Mary's Newington visible on the left, and beyond, the hills of south London.

In 1788 Ibbetson exhibited a painting of this subject at the Royal Academy; this picture, now in the collection of Arthur Kauffman, was reproduced as the frontispiece to Clay (op. cit.). Except for the omission of Mrs. Sage, the Museum picture is an exact replica.

GEORGE WILLIAM JOY (1844-1925)

Painter of historical and religious subjects, portraits, fancy pictures, nudes and genre. Born in Dublin, the son of a doctor. Studied under Millais, Leighton and Watts, at the Royal College of Art and the Royal Academy Schools, and in Paris with Jalabert and at the Atelier Bonnat. Lived in Bayswater.

60 THE BAYSWATER OMNIBUS (29.166)
Canvas. 48¼ × 69 inches (120.6 × 172.5 cms.). Painted in 1895.

Provenance: Lent by the artist's widow in 1929; presented by his daughter, Miss Rosalind B. Joy, in 1966.

Exhibited: Royal Academy, 1895 (524); Paris Salon, 1896 (1098); *Paintings and Drawings by Victorian Artists in England*, The National Gallery of Canada, Ottawa, March-April 1965 (68).

References: The Work of George W. Joy, London, 1904, pp. 24-5 and 47, repr. pl. 10 (colour); Graham Reynolds, *Painters of the Victorian Scene*, London, 1953, p. 95 (repr. fig. 86); Jeremy Maas, *Victorian Painters*, London, 1969, p. 239 and repr. p. 240.

Plate 60 The Bayswater Omnibus by G. W. Joy. Painted in 1895

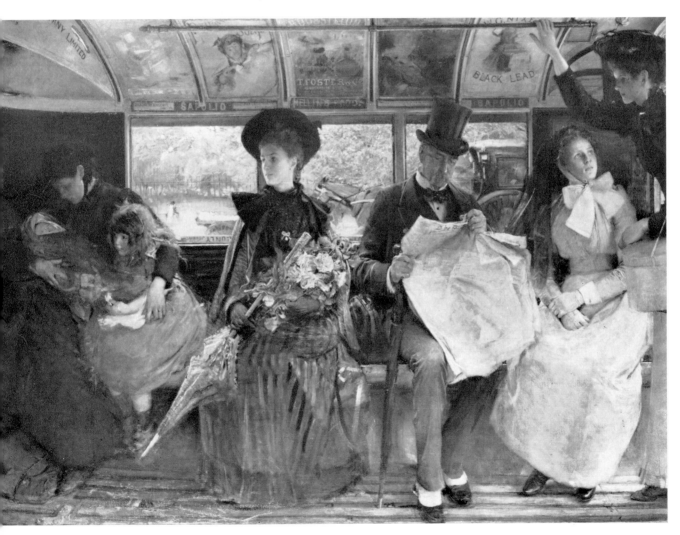

Also reproduced: Henry Blackburn, *The Academy Notes*, London, 1895, p. 101; Charles E. Lee, *The Horse Bus as a Vehicle*, British Transport Commission, London, 1962, p. 23.

A typical anecdotal picture of the late Victorian period, showing a group of passengers inside an omnibus; among the advertisements above the windows is one for *Pears' Soap*. The artist described the characters as follows: 'In the farthest corner sits a poor anxious mother of children, her foot propped on an untidy bundle; beside her, full of kindly thoughts about her, sits a fashionable young woman; next to her the City man, absorbed in his paper; whilst a little milliner, band-box in hand, presses past the blue-eyed, wholesome-looking nurse in the doorway.' The sitters were the artist's wife (the young mother) and their daughter Rosalind, the donor of the picture (the small girl); a policeman's baby; Miss L'Amy, a friend (the fashionable young woman); Colonel Moutray Read, a cousin (the City man); and the same professional model for the nurse and milliner. Joy also recorded that he borrowed an omnibus from the London General Omnibus Company during his work on the painting. A hansom cab appears in the background, and the 'bus is evidently passing Hyde Park or Kensington Gardens.

JACOB KNYFF (1639-81)

Topographical painter. Born in Haarlem, the son of Wouter Knyff, the painter. Studied with his father. Travelled to Paris in 1672, and working in England by 1673.

61 CHISWICK FROM THE RIVER (62.32)

Canvas. $32\frac{3}{4} \times 63\frac{3}{4}$ inches (81.9 × 159.4 cms.). Painted about 1675-80.

Provenance: Purchased out of the Joicey Trust Fund, with the aid of a contribution from the National Art-Collections Fund, from Frank T. Sabin in 1962 (as Jan Wyck).

Exhibited: English Paintings, Frank T. Sabin, 1962 (4) and repr. in the catalogue.

Reference: 59th Annual Report of the National Art-Collections Fund 1962, London, 1963, p. 22 and repr. pl. IX.

Reproduced: The Times, 31 March 1962; *The Daily Telegraph*, 2 April 1962; C. Brooke Coles, *A Guide to Chiswick Parish Church*, Saffron Walden, n.d. (=1965), p. 4; John Hayes, *London: A Pictorial History*, London, 1969, pl. 34 (detail).

The earliest known view of Chiswick, showing, from left to right, Old Corney House, a property acquired by John Russell, 1st Earl of Bedford, in 1542 (the gazebo at the foot of the garden probably being late Elizabethan or Jacobean); the parish church of St. Nicholas, surrounded by a cluster of sixteenth century houses; and Chiswick Eyot, with some larger Tudor houses on the waterfront beyond. A chariot has drawn up on the left, and a group of people are watching two fishermen dragging nets. A fishing boat is close by, and a barge laden with merchandise is stationary beyond; another craft is sailing past, and on the right a barge bearing the arms of the City Corporation, and flying its flag and pennant, is firing a salute.

Plate 61 Chiswick from the River by Jacob Knyff. Painted about 1675-80

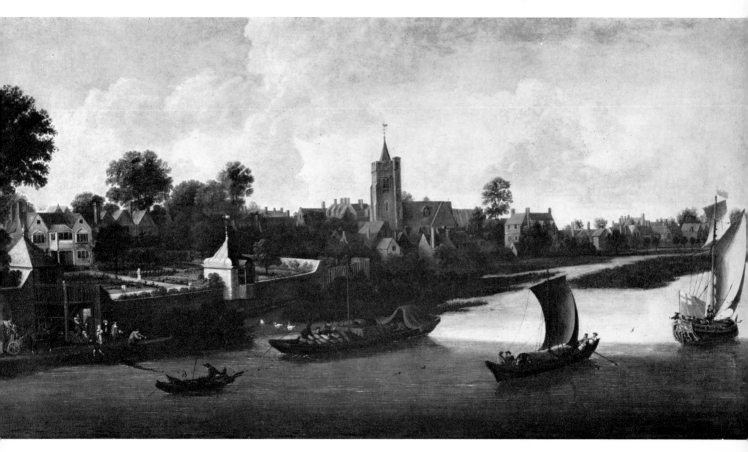

An engraving published 29 September 1750, by J. Roberts after Chatelain, shows the extent to which Chiswick had already changed since Knyff's painting; Old Corney House had been replaced by New Corney House, an early Georgian mansion, and the houses beyond the Eyot had been pulled down for the formation of the Mall (many of the fine Georgian houses built along the Mall still survive there, and the name Bedford House preserves the memory of the owners of Corney House). The church was rebuilt and the tower restored and altered in 1836; timber yards and warehouses stand upon the site of Corney House; and the Eyot is covered with thick bushes. So that hardly anything remains now of the topography recorded in this view.

The attribution of this painting to Jacob Knyff is due to Mr. Oliver Millar, and rests on its close similarity in style to the view of Durdans House, Epsom, signed and dated 1673, at Berkeley Castle: the darkness of tone and feeling for chiaroscuro, the coarseness of touch generally, and the minutiae of handling, are exactly alike in both works. The costume of the figures on the left indicates a date of about 1675-80.

IMITATOR OF LEONARD KNYFF (1650-1722)

62 LAMBETH PALACE WITH A DISTANT VIEW OF WESTMINSTER AND THE STRAND (52.137)

Canvas. 25 × 30⅛ inches (62.5 × 75.3 cms.). Painted about 1682-7.

Provenance: Henry, 2nd Baron Melchett; purchased out of the Joicey Trust Fund from the Parker Gallery in 1952 (as Leonard Knyff).

Engraved: Early nineteenth century as from Hollar, about 1670 (the engraving is not in reverse, cuts the composition slightly both left and right, and generalises the background detail.)

In the foreground is Lambeth Palace, showing, from left to right, Lambeth Stairs, the rectory of St. Mary's, the gatehouse (Morton's Tower), the parish church of St. Mary's, the great hall, the kitchen block, and, on the extreme right, the stables. Behind the buildings are the trees which formed the limits of the park walks, and to the right, the orchard; further beyond is Lambeth Marsh, at this date hardly built upon. On the north bank of the Thames, a good many buildings can be identified, from left to right, St. Stephen's Chapel, the rooves of Westminster Hall, Westminster Abbey, and the Banqueting House, the cupola of the old Horse Guards, and the roof of the great hall of Whitehall Palace; further east are the great private palaces of the Strand, Northumberland House rising immediately above the tower of St. Mary's, York House, Durham House, Salisbury House, Exeter House, Worcester House and the Savoy (with between them the spire of St. Giles-in-the-Fields), old Somerset House (with the spire of St. Clement Danes prominent to its east), and, on the far right, the house built for Sir Thomas Fitch on the corner of the Fleet Canal. The viewpoint is that of Hollar's *Prospect of London and Westminster taken from Lambeth*, but omitting the foreground buildings included there.

The rendering of one of the most prominent features, Morton's Tower, with twice as many windows as there should be (and as appear in Knyff and Kip's view of 1697),

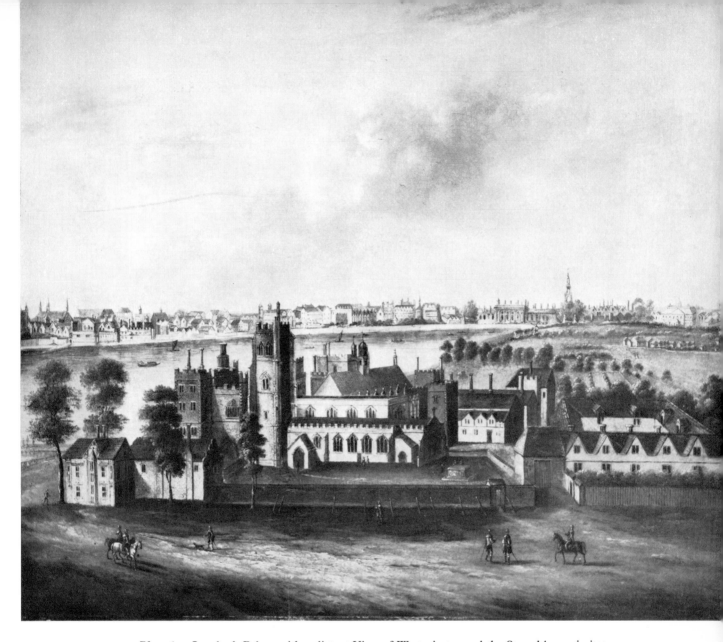

Plate 62 Lambeth Palace with a distant View of Westminster and the Strand by an imitator of Leonard Knyff. Painted about 1682-7

does not suggest that the painting is very careful as regards detail, but the disposition of the various buildings is correct, and the picture is of considerable interest in showing the general appearance of this part of London towards the end of the seventeenth century. The view must date after 1682 (since it shows the steeple of St. Clement Danes, completed in that year) and before 1687 (since it does not show the alterations to Whitehall Palace which were made by Wren in 1687-8). The costume indicates a date of about 1685.

The traditional attribution to Hollar (*vide* the early nineteenth century engraving) was presumably based on the similarity to the latter's prospect (see above). The later ascription to Leonard Knyff is presumably based on the facts that he came to England in 1681, lived in Westminster, and made prospects of the London scene. There is nothing in the handling of the Museum painting, however, suggestive of Knyff's technique, nor is the carelessness in the drawing of architectural detail characteristic of his work.

E. F. LAMBERT (active 1823-1846)
Painter of portraits and literary subjects. Lived in various parts of London.

63 THE ANNUAL FÊTE OF THE LICENSED VICTUALLERS' SCHOOL (60.90)

Panel. 23⅝ × 37½ inches (59.1 × 93.75 cms.). Signed and dated bottom right: *E. F. Lambert/ 1831*

Provenance: Purchased out of the Mackenzie Bell Trust Fund from Leger Galleries in 1960.

Engraved: George Hunt, republished by J. Moore, 1 May 1846.

In 1803 the Friendly Society of Licensed Victuallers acquired Kennington House, on the south side of Kennington Lane, close to the Oval, which it opened as a school for orphans and other destitute children of members of the Society. The venture was evidently successful, and a new building was planned in the early 1830's, the foundation stone being laid by the Prime Minister in 1836. These premises still stand, but are now in use as the Navy, Army and Air Force Institutes, the Licensed Victuallers' School having moved out to Slough in 1921.

The annual fête of the Licensed Victuallers' School was always an occasion for considerable junketing, and in 1837, when the event took place at Highbury Barn, no fewer than four thousand people sat down to dinner. The Museum picture represents the fête of 1830, which took place on 24 June at the Eyre Arms Tavern, St. John's Wood (where the rehearsals for the Eglinton Tournament took place in 1839). According to *The Morning Advertiser* (the organ of the Licensed Victuallers), nearly two thousand people were present on this occasion, being accommodated partly in the guest room and partly in a tent in the grounds some two hundred feet long. The company was entertained throughout by the Duke of Gloucester's band, and the dinner was followed by a brilliant display of fireworks.

120

Plate 63 The Annual Fête of the Licensed Victuallers' School by E. F. Lambert. Signed and dated 1831

The large marquee is seen here in the middle distance, and a crowd of people are shown feasting and drinking at the tables there and in the foreground; other people are strolling about the grounds, and in the distance there are arbours, swings and people dancing. In front of the marquee is seen a procession of the children in their school uniforms, preceded by a military band.

GEORGE LAMBERT (1700-65)

Landscape and topographical painter. Born in Kent. Became a scene painter first at Lincoln's Inn Theatre, and then, from 1736, at Covent Garden. Collaborated with Samuel Scott in 1732 on a series of views of the East Indies Settlements for the old East India House in Leadenhall Street. Member of the Society of Artists of Great Britain, but in company with other artists, left this in 1765 to form the Incorporated Society of Artists, of which he became the first President.

64 ST. JAMES'S PARK FROM THE TERRACE OF
NO. 10 DOWNING STREET (A 20760)

Canvas. $35\frac{3}{4} \times 57\frac{1}{8}$ inches (89.4 × 142.8 cms.). Painted about 1736-40.

Provenance: B. C. Creasy; Creasy sale, Christie's, 30 November 1917 Lot 13 (as Laroon) bt. London Museum.

St. James's Park, which was formerly meadowland dotted with trees and ponds, was laid out in the contemporary French style, but in rather disjointed fashion, shortly after the Restoration. A mall for playing pall-mall, some quarter of a mile long, on the site of the present thoroughfare still called the Mall, was constructed immediately south of the grounds of St. James's Palace, and flanked with fine avenues of trees; the path shown on the right led to the east end of this mall. Also running the entire length of the park, and flanked by a double row of trees, was a long canal, which is seen on the left with some people beside it; at the further end of this sheet of water was Rosamond's Pond, connected to it by a sluice. A formal garden was laid out north of the mall on the site of what is now Marlborough House and Carlton House Terrace. Over the tops of the trees on the right can be seen the spire of St. James's Piccadilly. The park was completely remodelled in the 'picturesque' taste by John Nash in 1828, and the canal was then replaced by the present serpentine lake.

In the foreground is the garden of No. 10 Downing Street, surrounded by a high brick wall; two gardeners are shown at work, one of them rolling the gravel path, the other tidying the edge of the grass with a pair of shears. On the terrace are two figures, which, according to a nineteenth century label on the back of the frame, are portraits of Sir Robert Walpole (1676-1745), 'Prime Minister' from 1722 to 1742, and George Pitt, 1st Baron Rivers (1722?-1803). The figure on the left, who is wearing the sash of the Order of the Garter, is definitely not Walpole, but, judging from the portraits of him by Kneller, might well be intended to be Spencer Compton, 1st Earl of Wilmington (1673?-1743), who succeeded Walpole as First Lord of the Treasury in 1742; there is no reason to

Plate 64 St. James's Park from the Terrace of No. 10 Downing Street by George Lambert.
Painted about 1736-40

exclude the identification of the figure in profile as George Pitt, who was elected M.P. for Shaftesbury in 1742. No. 10 Downing Street, now the official residence of the Prime Minister, was built for the Earl of Lichfield in 1676-7; it was substantially remodelled by William Kent in the early 1730's, and the land for the garden was acquired, and the grounds laid out, in 1736.

Formerly attributed to Wilson and Hogarth, and afterwards to Marcellus Laroon, this canvas can be ascribed with confidence to George Lambert, whose views of, for example, Wotton Place, are identical in style and technique.

The costume indicates a date of about 1735-45, and the inclusion of the garden a date subsequent to 1736. If the principal figure could be established as Lord Wilmington, the date could be narrowed to 1742-3.

E. L. LAURIE (active late nineteenth century)
Nothing is known about this artist.

65 THE COLDSTREAM GUARDS MARCHING OUT OF THE TOWER OF LONDON, 3 APRIL 1875 (A 25332)
Canvas. 28⅛ × 40½ inches (66.3 × 101.25 cms.). Painted in 1875.

Provenance: Purchased in 1923.

A battalion of the Coldstream Guards, preceded by the regimental band and a detachment of pioneers (the latter distinguished by their beards and axes), is shown leaving the Tower of London for Wellington Barracks after a spell of guard duty. The shadows indicate that the time is about 4 o'clock, the viewpoint is outside the Queen's House, and the troops are seen passing St. Thomas's Tower. From left to right are visible the Bloody Tower, the Wakefield Tower (where the Crown Jewels are kept) and St. Thomas's Tower; the latter was converted into a residence for the Keeper of the Jewel House by Anthony Salvin in the 1860's, and the arch connecting it with the Wakefield Tower was also built at this time. The scene has changed little since the date of this picture.

SIR JOHN LAVERY (1856-1941)
Portrait, genre and landscape painter; London views are exceptional. Born in Belfast. Studied at the Haldane Academy in Glasgow, Heatherley's School in London, and from 1881 at the Académie Julian and the Atelier Colarossi in Paris. Settled in London 1896, and lived in South Kensington. A.R.A. 1911; R.A. 1921.

66 ST. JOHN'S, HAMPSTEAD, FROM CHURCH ROW (60.114/1)
Panel. 9½ × 12 inches (23.75 × 30 cms.). Painted about 1900-10.

Provenance: Babington; anon. sale, Sotheby's, 27 July 1960 Lot 141 bt. Colnaghi on behalf of the Museum.

An impressionistic sketch showing the parish church of St. John's, Hampstead, built by

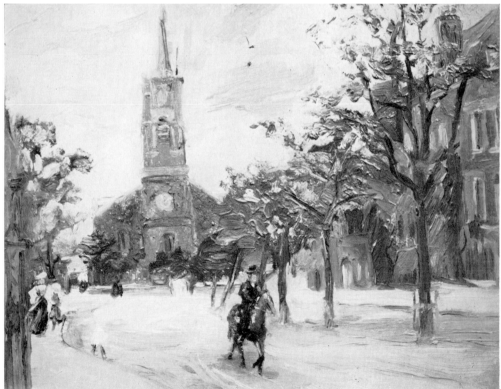

Plate 65 The Coldstream Guards marching out of the Tower of London, 3 April 1875 by E. L. Laurie. Painted in 1875
Plate 66 St. John's Hampstead from Church Row by Sir John Lavery. Painted about 1900-10

John Sanderson in 1745-7, after the reconstruction of 1878. A peculiar feature of the design of this church is that the tower is at the east end, and at the time of planning the alterations of 1878, it was proposed to remove it; this was fortunately opposed by an influential body of opinion, on the grounds that the tower provided an incomparable focal point at the end of Church Row.

Church Row is one of the very few streets in London which is still almost entirely early eighteenth century in character. The houses on the south side are complete, and date from about 1720; those on the north side (some of which are seen here) are less regular in design, and vary a little more in date.

The costume indicates a date of about 1900-10, and there seems no reason to doubt the attribution.

PHOEBUS LEVIN (active 1855-74)
Painter of historical and religious subjects, and genre. Born in Berlin. Studied at the Berlin Academy 1836-44. Worked in Rome 1845-7, and settled in London 1855-78. Lived first in Bond Street, and afterwards in Kensington.

67 COVENT GARDEN MARKET FROM JAMES STREET (A 25328)
Canvas. 26⅛ × 43 inches (55.3 × 107.5 cms.). Signed and dated bottom right: *P. Levin./1864*

Provenance: Jules Singer; Singer sale, Christie's, 1 May 1899 Lot 64 bt. Hamilton; G. W. Boorman; Boorman sale, Christie's, 11 December 1922 Lot 83 bt. Potter; purchased in 1923.

Exhibited: 19th Century English Art, New Metropole Arts Centre, Folkestone, May-June 1965 (47) and repr. in the Catalogue.

During the course of the eighteenth century the number of sheds and stalls in use at Covent Garden continued to grow steadily, as may be seen by comparing van Aken's view of about 1726-30 (No. 1) with Collet's view, painted some fifty years later (No. 30). As a result of this profitable expansion, John, 6th Duke of Bedford obtained an Act to have the whole place cleared and rebuilt. Charles Fowler, who had designed Hungerford Market, was called in as architect, and the new premises were built in 1828-31. His sturdily designed gateways (the motto *Che Sara Sara* is that of the Dukes of Bedford) and Tuscan colonnades were a perfect match for the piazza itself, and especially for the church. Behind this classical exterior were two large market halls divided by a long glass-roofed arcade and flanked on either side by shops. Notice that the high glass roofs which now cover both the market halls had not yet been constructed. The Floral Hall, of glass and cast iron, was added in 1859 by E. M. Barry (the architect of the Royal Opera House, next door). The cupola of St. Paul's, Covent Garden has since been removed.

This picture gives a good idea of the early morning bustle of Covent Garden (the church clock is shown at five o'clock). Since Victorian times, the situation has become

Plate 67 Covent Garden Market from James Street by Phoebus Levin. Signed and dated 1864

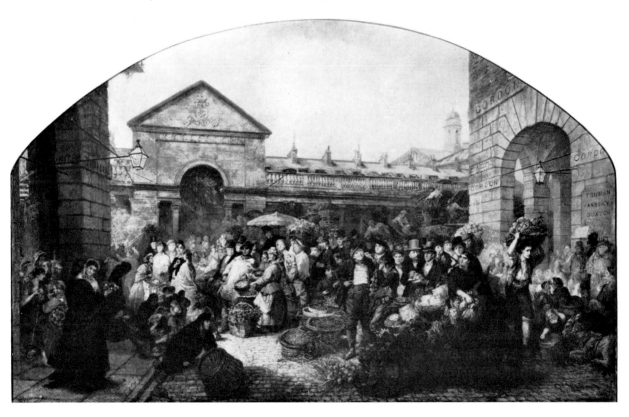

almost intolerable with motorised traffic congesting the narrow streets and with the increased demands of London's ever growing population, and it is now planned to move the market right away from the heart of the city, as has happened already to Les Halles in Paris. Something of the social decline of the square since Inigo Jones designed it in 1631 may be gauged from the two buildings partially shown. The Tavistock Hotel marks the site of the house once owned by Sir Peter Lely, which was later occupied by Richard Wilson, and subsequently became auction rooms; the house opposite had become a public house – and jellied eels are advertised as well as gin and stout. Both buildings are now the premises of fruit salesmen.

68 THE DANCING PLATFORM AT CREMORNE GARDENS (A 25327)

Canvas. 26½ × 43 inches (66.25 × 107.5 cms.). Signed and dated bottom right: *P. Levin 1864*

Provenance: Jules Singer; Singer sale, Christie's, 1 May 1899 Lot 64 bt. Hamilton; G. W. Boorman; Boorman sale, Christie's, 11 December 1922 Lot 83 bt. Potter; purchased in 1923.

Exhibited: Victorian Painting 1837-1887, Agnew's, November-December 1961 (74); *19th Century English Art*, New Metropole Arts Centre, Folkestone, May-June 1965 (45).

Reference: Jeremy Maas, *Victorian Painters*, London, 1969, p. 117 and repr. p. 118 (colour).

Also reproduced: The Illustrated London News, 22 May 1965, p. 27.

After the sale of Cremorne House in the 1820's, the mansion and grounds were used first as a sports club, known as the Stadium, and then for occasional fêtes and balloon ascents (see also No. 47). It was not until 1846 that the grounds were laid out as pleasure gardens, at a cost of £5,000. The model, both as regards amenities and design, was Vauxhall, though the ironwork is typically early Victorian and it was perhaps more comparable with the Tivoli Gardens in Copenhagen, which had been opened in 1843; fireworks, balloon ascents, vocal and instrumental concerts, vaudeville, marionettes and dancing were the principal amusements, and the charge for entrance one shilling.

This painting, which shows the crowd on a typical summer's evening, represents the south west corner of the gardens, with the dancing platform and its central pagoda, where the dance orchestra played, as the main subject. Some of the tables and chairs which were set among trees round the platform can be seen in the foreground, and in the distance are the double tiers of supper boxes.

Cremorne was never patronised by fashionable society, as Vauxhall and Ranelagh had been in the eighteenth century, and was frequented more by what were termed 'the lower orders'; something of the raffish character of its clientèle is apparent in many of the figures here. A number of riots occurred in the 1860's, and as a result of the general rowdiness there was considerable opposition to the Gardens from the Chelsea Vestry and the Principal of St. Mark's Training College opposite; finally, after a libel action in May 1877, the proprietor decided not to renew his licence.

128

Plate 68 The Dancing Platform at Cremorne Gardens by Phoebus Levin. Signed and dated
1864

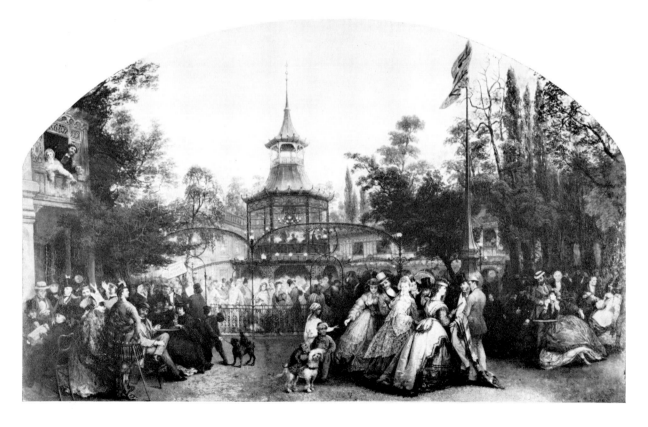

JOHN LINNELL (1792-1882)

Painter of landscapes, portraits and religious subjects. Born in London, the son of a carver and gilder. Studied with John Varley and at the Royal Academy Schools, 1805-6. Became an intimate friend of William Blake. Lived in Bloomsbury, Bayswater, Hampstead and (from 1851) Redhill.

69　COLLINS'S FARM, NORTH END, HAMPSTEAD (63.62)

Panel. $9\frac{3}{8} \times 15$ inches (15.4 × 37.5 cms.). Inscribed on the back: *Collin(s's) Farm/North End/ Hampstead Heath/Painted by John Linnell senr 1831.*

Provenance: Purchased out of the Joicey Trust Fund from Maas Gallery in 1963.

Collins's Farm (now called Wyldes Farm, from the name of the old estate) is a small weatherboarded house in North End, situated on the east side of Hampstead Way. At this date North End was no more than a cluster of houses at the foot of Hampstead Hill, on either side of the road (North End Road) which led from Jack Straw's Castle to Golders Green. Part of the hill can be seen on the right, and in the distance are open fields stretching away to the horizon, on ground that is now Hampstead Garden Suburb and the built-up area of north-west London.

Linnell lived at Collins's Farm from March 1824 until April 1828, when he moved back to Bayswater, and painted a good many views of the immediate vicinity. For a short period in 1837 Charles Dickens lived at Collins's Farm, and a distinguished later occupant was Raymond Unwin, the town planner, who was responsible for the layout of Hampstead Garden Suburb.

This picture is not included in the list of Linnell's works which Alfred T. Story appended to his *Life*, published in 1892.

THOMAS LUNY (1759-1837)

Marine painter; painted a number of London river scenes in the style of Marlow, which are dated between 1793 and 1806. Born in London. Studied under Francis Holman. Served at sea for varying periods up to 1810. Lived in Ratcliffe and the City, but retired to Teignmouth in 1810, where he lived as an invalid.

70　THE POOL OF LONDON (A 8070)

Canvas. $16\frac{5}{8} \times 25\frac{1}{4}$ inches (41.6 × 63.1 cms.). Signed bottom left: *Luny*. Painted about 1801-10.

Provenance: Purchased from Leggatt Brothers in 1912.

Numerous merchantmen are shown anchored near the legal quays, which stretched from the Tower to Old London Bridge. Part of the bridge is visible, and the great central arch formed by removing one of the piers which was built at the time of the reconstruction work in 1756-62 (see No. 73) is seen on the left. Behind are St. Paul's and

130

St. Magnus the Martyr; the spire of St. Mary-le-Bow and the Monument appear in the centre, and, on the right, are the spires of St. Dunstan-in-the-East and St. Margaret Pattens.

Until the very end of the eighteenth century the City maintained a stranglehold on London's trade through its monopoly of quayside rights and customs facilities. But the value of the trade handled in the Pool had nearly trebled since 1700, and the increasing congestion of shipping in the 1790's resulted in the setting up of a Parliamentary Committee of inquiry in 1796. The establishment of an entirely new system of docks was approved by Parliament, and the first to be built was the West India Dock, opened in 1802.

The Union Jacks flying on several of the vessels indicate that the picture was painted after the Act of Union with Ireland was passed in 1801, but the types of ship suggest that it was painted probably before 1810. One version of this picture, differing in the shipping, is in the collection of Mr. and Mrs. Paul Mellon (signed and dated 1798) and another is in the collection of the Earl of Inchcape (signed and dated 1803).

71 THE BURNING OF DRURY LANE THEATRE FROM WESTMINSTER BRIDGE (59.105/1)
Canvas. 21⅜ × 30 inches (53.4 × 75 cms.). Painted about 1809.

Provenance: Miss Gertrude Elbourne; Elbourne sale, Christie's, 10 March 1950 Lot 44 (without attribution) bt. in; purchased from Stanley Crowe in 1959.

Exhibited: 1666 and other London Fires, Guildhall Art Gallery, August-September 1966 (91).

The present Drury Lane theatre, built in 1810-2 by Benjamin Wyatt, is the fourth to stand on the site. The first was destroyed by fire in 1672. Wren's building was pulled down in 1791. And the third, Henry Holland's magnificent theatre, which opened in 1794, was burnt down on the night of 24 February 1809.

Holland's Drury Lane theatre had been constructed primarily of wood, with bricks used only for filling in this framework, so that when the fire started, just after eleven o'clock on a Friday in Lent when there was no performance or rehearsal in progress, and the theatre was empty, it took less than a quarter of an hour to engulf the entire building. A vivid impression of the fantastic pillar of fire, and of the glow cast over the whole metropolis, is provided by the Museum picture. The view is taken from Westminster Bridge, and spectators can be seen in one of the alcoves and on the balustrade, while three firemen equipped with hatchets are also to be seen. The fire services were not then a metropolitan brigade, but organised by the various insurance companies, and the firemen seen here, in top hats and green, red and buff uniforms respectively, have the badges of their companies on their left arms (in 1833 the ten leading insurance companies joined together to form the London Fire Engine Establishment). The spires of St. Martin-in-the-Fields, St. Giles-in-the-Fields, St. Mary-le-Strand and St. Clement Danes, with the tower of the York Buildings Waterworks Company, are seen dominating

132

Plate 70 The Pool of London by Thomas Luny. Painted about 1801-10

Plate 71 The Burning of Drury Lane Theatre from Westminster Bridge by Thomas Luny. Painted about 1809

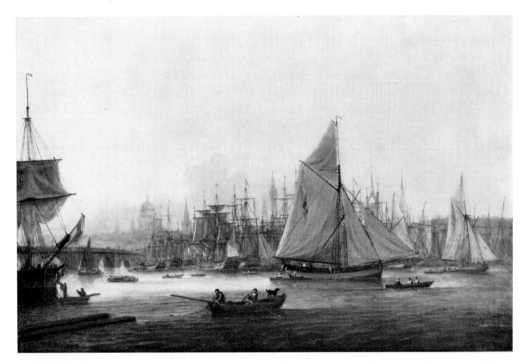

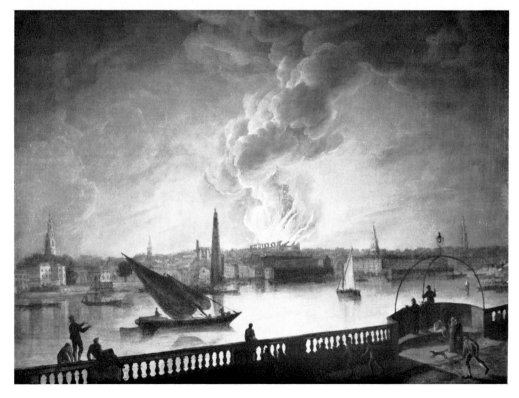

the skyline, and the long façades of the Royal Terrace, Adelphi and Somerset House are also visible; part of the Lambeth shore appears on the extreme right.

A drawing by Whichelo, also made on Westminster Bridge, which gives much the same impression of the blaze, was engraved and published on 7 August 1811 for Wilkinson's *Londina Illustrata*.

This picture formed part of a considerable collection of views of fires, chiefly by Dutch artists, owned by Miss Gertrude Elbourne.

72 WESTMINSTER BRIDGE AND THE BURNING OF THE HOUSES OF PARLIAMENT FROM LAMBETH (A 8072)

Canvas. 20¼ × 27⅛ inches (50.6 × 67.8 cms.). Signed and dated bottom left: *T Luny 1835*

Provenance: Rev. Anson Cartwright, Brimley House, Teignmouth in 1887 (presumably by descent from his grandfather, William Cartwright, who was Luny's executor); purchased from Leggatt Brothers in 1912.

Exhibited: 1666 and other London Fires, Guildhall Art Gallery, August-September 1966 (65).

Reference: Robert Dymond, 'Thomas Luny, Marine Painter, Part II', *Transactions of the Devonshire Association for the Advancement of Science, Literature and Art*, Vol. XIX, 1887, p. 117.

An impression of the fire which destroyed most of the Palace of Westminster during the night of 16 October 1834 (see also No. 97). The strong south-westerly wind which fanned the flames is very evident, billowing the smoke over Westminster. The buildings destroyed by the blaze, and some of the spectators who watched the scene from boats on the river, are seen through the arches of Westminster Bridge. To the right are Westminster Hall and Westminster Abbey, both untouched by the flames, and the blocks of houses at the south end of Bridge Street which were built as part of the Westminster Bridge improvements scheme following the Act of 1736: the Bridge itself, over which coaches are shown passing, was replaced twenty years after this picture was painted. In the foreground is the Lambeth shore.

Since Luny retired to Teignmouth in 1810, and suffered from a paralysis of the legs which obliged him to use a wheel-chair, it is extremely unlikely that he was actually an eye-witness of the event, and the painting was presumably executed from prints depicting the scene.

WILLIAM MARLOW (1740-1813)

Landscape and topographical painter; painted a number of views of the Thames in and around London. Born in Southwark. Pupil of Samuel Scott from about 1756 to 1761. Travelled in France and Italy 1765-8. Member of the Society of Artists of Great Britain, of which he became Vice-President in 1778. Lived in Leicester Square until about 1783, when he retired to Twickenham.

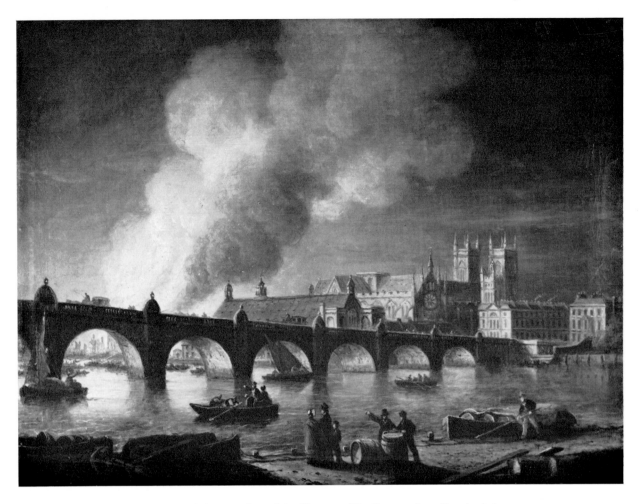

Plate 72 Westminster Bridge and the Burning of the Houses of Parliament from Lambeth by
Thomas Luny. Signed and dated 1835

73 THE NORTH END OF OLD LONDON BRIDGE FROM FRESH WHARF (50.31)

Canvas. 39¼ × 49⅞ inches (99.1 × 128.7 cms.). Painted about 1762.

Provenance: Possibly Sir William Chambers, and Chambers sale, Christie's, 6 April 1799 Lot 97 bt. Taylor; Mrs. Wauchope of Niddrie; Wauchope Settlement Trust Sale, Christie's, 12 May 1950 Lot 58 bt. London Museum (purchased out of the Joicey Trust Fund).

Exhibited: Possibly Society of Artists, 1762 (56); *William Marlow*, Guildhall Art Gallery, June-July 1956 (7); *Canaletto and his Influence on London Artists*, Guildhall Art Gallery, June-July 1965 (7); *London Bridge in Art*, Guildhall Art Gallery, June-July 1969 (82).

This picture was taken from Fresh Wharf, the most westerly of the quays between the Tower and London Bridge constructed after the Fire to facilitate the activities of the Port (one of the most significant improvements incorporated in the rebuilding). Some barrels and bales of merchandise are being checked, and a dray with three horses is seen behind (notice also the Spanish olive jar on the left).

Old London Bridge is seen shorn of its superstructure of shops and houses, which had long been a public nuisance and obstructed the flow of traffic. The demolition, alterations and widening were carried out under the supervision of George Dance the Elder, Clerk of the City Works, and Sir Robert Taylor, in 1756-62, the east side of the bridge being completed by 1761, and all the houses removed by 1762. Scaffolding and fencing is seen at the north end of the bridge and in front of the church of St. Magnus the Martyr; the west ends of the aisles of the church were set back and openings cut through the arches of the tower to make a passage-way, as part of the bridge approach widening operations, and the work was begun in 1762 and finished in June 1763. Beyond the Bridge (immediately beneath St. Paul's) is Fishmongers' Hall, designed by Edward Jerman, which was replaced by the present building in 1831-3. The dome of St. Paul's and the tower of St. Michael's, Cornhill, appear in the distance.

Marlow served his apprenticeship with Samuel Scott, and the standards of accuracy he maintained in his topographical painting were comparatively high; nevertheless, Fishmongers' Hall has been painted here with single windows (instead of three) in the side bays, St. Michael's Cornhill could never have been seen from this viewpoint, and the water-wheels of the Bridge Waterworks have been omitted.

There are two other versions of this composition, one in the Lucas collection, originally painted for Lord Hardwicke, in which more activity is shown in the foreground left, and one in the royal collection, which is closer in detail to the Museum picture but incorrectly gives Fishmongers' Hall four windows in the central bay and includes two buildings not shown in either this or the Lucas version, namely, the spire of St. Antholin's (a church pulled down in 1874) and a large pedimented building in Fish Street Hill which appears never to have been erected. Either the Museum painting or one of these versions is likely to have been the picture exhibited at the Society of Artists in 1762. An upright variant is in the possession of Mrs. M. L'Estrange Malone at Scampston Hall; and a watercolour copy by John Thirtle, with some alterations in the foreground detail, is in the Victoria and Albert Museum (No. 1272-1871).

136

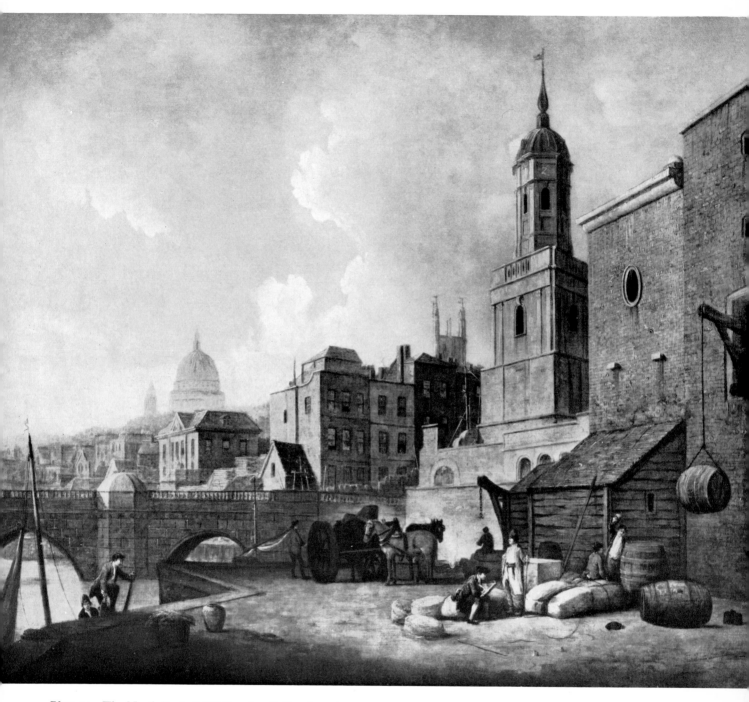

Plate 73 The North End of Old London Bridge from Fresh Wharf by William Marlow.
Painted about 1762

137

74 THE LONDON RIVERFRONT FROM WESTMINSTER TO THE ADELPHI (A 25874)

Canvas. 54⅛ × 76 inches (135.3 × 190 cms.). Signed with initials on the stern of a boat on the right: *WM*. Painted about 1771-2.

Provenance: Possibly Thomas Parnell, 2 Royal Terrace, Adelphi, and his sale, Foster's, 12 June 1829 Lot 40 bt. Colnaghi (see below); with Leggatt Brothers, from whom it was purchased by J. Pierpont Morgan Jr. and presented in 1923.

Reproduced: John Hayes, *London: A Pictorial History*, London, 1969, pl. 79 (detail).

A view of the riverfront from the site of the present Waterloo Bridge showing, from left to right, part of Westminster Bridge, Westminster Hall, Westminster Abbey, the Whitehall waterfront (better seen in No. 21), the Banqueting House, the cupola of the Horse Guards, the tower and chimneys of the York Buildings Waterworks Company, the Salt Office (once the residence of Samuel Pepys, 1688-1701, and of Robert Harley, Earl of Oxford, 1702-14), the house at the south-east corner of Buckingham Street owned by Sir Philip Botelier 1740-63, and, principally, the Adelphi.

The Adelphi was a highly imaginative, but in the event financially disastrous, development by the brothers Adam. These architects took a lease of the site of Durham House in 1768, and obtained an Act of Parliament which enabled them to reclaim part of the river (a shallow bay) at this point. They then built, over a vast substructure of brick vaults, which served as foundations, a superb terrace of private houses fronting the river, the Royal Terrace, conceived as an architectural unity with pilasters accenting the centre and ends, together with a number of subsidiary streets, four of which were called after their own names, Robert, John, James and William.

In this picture the Royal Terrace is shown completed (some of the houses were ready for occupation by 1772, and David Garrick had moved in to No. 5 by April of that year) and so is Adam Street (the street at right angles to the Terrace terminated by a house with a pediment), houses in this street being let in 1771. But the companion street to Adam Street on the west side of the Terrace, Robert Street, was not yet built – two of the houses were noted as 'not being quite finished' in 1773 – nor was the Adelphi wharf. Heaps of stone and more carefully piled stacks of timber are distributed about the site; a jetty has been constructed for rubbish disposal (the rubble would be dropped into waiting craft); and a number of barges and rowing boats are drawn up on the foreshore. Barges and rowing boats are also seen on the left. On the extreme right is Salisbury Street, rebuilt by James Paine in 1765-9.

The whole of the Adelphi buildings (except for No. 7 Adam Street and one or two others) were destroyed in 1936, and Colcutt and Hamp's massive office block, Adelphi House, built in 1936-8, now occupies the site.

Versions of this canvas, of approximately the same size, and differing only very slightly in detail, are in the possession of the Earl of Iveagh and of the Westminster Bank. Another view by Marlow, showing the Adelphi under construction, but from the opposite side, is in the collection of Lord Rosebery at Mentmore. One of these pictures may be identified with the 'View of the Royal Terrace, Adelph, in 1771, just before its

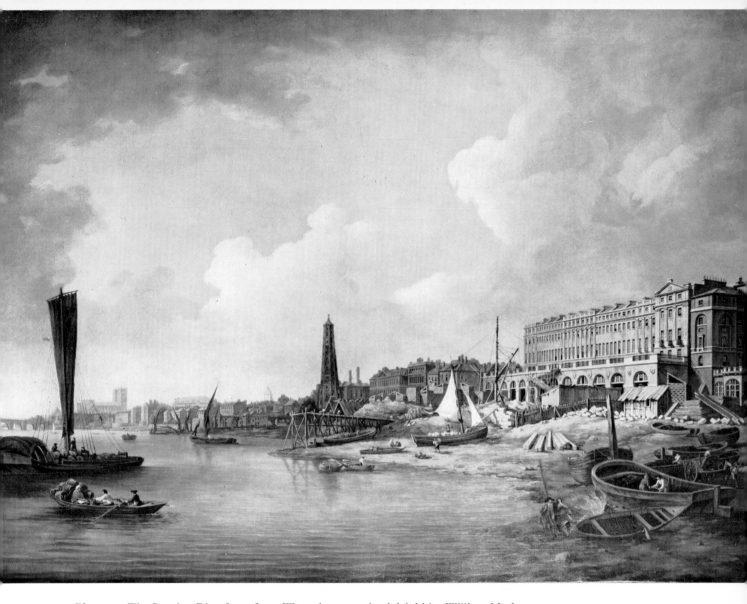

Plate 74 The London Riverfront from Westminster to the Adelphi by William Marlow.
Painted about 1771-2

completion' by Marlow, which was in Thomas Parnell's sale at Foster's, 12 June 1829.

The Museum picture must date from about 1771-2, when the Royal Terrace and Adam Street were built, but Robert Street was not. Two rough preparatory sketches in pen and brown ink, and a more detailed study in pencil, all for the right half of the composition, are in the British Museum.

HENRY MILBOURNE (active 1797-1823)
Landscape, topographical, marine and animal painter. Lived in various parts of North London.

75 THE FAIRLOP OAK, HAINAULT FOREST (59.39)

Canvas. $16\frac{7}{8} \times 20\frac{3}{4}$ inches (42.1 × 51.8 cms.). Signed with initials and dated on the trunk of the oak: *H.M/1816*

Provenance: Purchased from Alfred Werner in 1959 (without attribution).

A view of the Fairlop Oak, in Hainault Forest, near Ilford, which boasted a trunk 36 feet in circumference and was reputed to be nearly 2000 years old. A figure with a parcel over his left shoulder is pointing out the Oak to a horseman in the foreground left, and on the right some figures are grouped around a camp fire.

In the nineteenth century, the Oak was noted for the fair which used to be held there every year on the first Friday in July. This originated in an annual dinner which Daniel Day (1683-1767), an engine and pump-maker who had an estate nearby, used to give to some of his neighbours under the shade of the old oak. By 1725, other groups had begun to gather on the same day, booths were erected, and a regular fair was in operation (it was customary to celebrate fairs and festivals beneath oak trees in many parts of England). Rowlandson is the best known artist who has left us impressions of the Fairlop Fair during its heyday; but there is also an attractive watercolour by S. H. Grimm in the Victoria and Albert Museum (P.65-1921), which is signed and dated 1774.

In 1805, as a result of the practice of lighting fires in the cavity of the trunk, the Oak was burnt, and in February 1820 it finally collapsed during a heavy gale. The Fair, however, continued to be held on the site until some time after Hainault was disafforested by the Government in 1851, and went on in other parts of Ilford until the end of the century.

AUGUSTUS E. MULREADY (active 1872-99)
Genre painter; specialised in London characters. Lived in various parts of London.

76 A LONDON CROSSING SWEEPER AND FLOWER GIRL (61.7/1)

Canvas. $27\frac{1}{8} \times 20$ inches (97.8 × 50 cms.). Signed and dated bottom left: *A. E. Mulready./ 1884.* Inscribed on the back of the canvas: *London Flower Girl and Street Arab/Mutually giving and receiving aid,/They set each other off like light and shade./A. E. Mulready/1884.*

Provenance: Purchased from Abbott and Holder in 1961.

Reproduced: Jeremy Maas, *Victorian Painters,* London, 1969, p. 255 (colour).

The occupation which absorbed the highest proportion of the London poor in Victorian times was undoubtedly crossing-sweeping. It required no capital outlay or risk, and

Plate 75 The Fairlop Oak, Hainault Forest by Henry Milbourne. Signed and dated 1816

provided ample opportunity for begging. Most adult crossing sweepers had a regular pitch, for a 'monopoly' of which they sought the protection of the police, and the advantage of this was that they became well known to those who frequented the district. According to Henry Mayhew, in his classic survey of *London Labour and the London Poor*, published in 1861, the average takings at this date were between eightpence and a shilling a day. Many children also set up as crossing sweepers, but they did not normally have a regular pitch and usually moved around after an hour or so in one place.

Flower sellers were mostly female, and mainly girls between the ages of six and twenty. On a Sunday, which was the best day for trade, four or five hundred girls would be about the streets selling violets, wallflowers, lavender, pinks, roses, or mignonette, according to season. Some flower girls, who sold only in the evenings, were also prostitutes.

In this picture, which over-sentimentalises the London street urchins, and suggests nothing of their actual poverty and degradation, the boy who is resting for a bite to eat, seems also to be engaged in selling matches. The girl has a basket of roses, pinks and carnations. The scene is the north end of Blackfriars Bridge, and part of the City waterfront can be seen in the background.

Mulready painted a number of London genre scenes of a similar size, mostly pointing a moral in more or less overt form; and he used the same model in a similar pose for a picture of a flower girl dated 1885 which was in an Anon. sale, Christie's, 11 July 1969 Lot 63.

CHRISTOPHER RICHARD WYNNE NEVINSON (1889-1946)

Landscape, topographical, genre and figure painter, etcher and lithographer; best known for his war paintings and townscapes. Born in Hampstead, the son of the journalist and essayist Henry Woodd Nevinson. Studied at the St. John's Wood School of Art, the Slade School 1908-12, and in Paris at the Académie Julian and the *Cercle Russe* 1912-3, sharing a studio with Modigliani. Foundation member of the London Group 1913. Associated with the Futurist Movement, and published the manifesto *Vital English Art* with Marinetti 1914. Became an official war artist in 1917. Member of the New English Art Club 1929. A.R.A. 1939.

77 CLEOPATRA'S NEEDLE AND HUNGERFORD BRIDGE FROM THE SAVOY (59.99/140)

Canvas. $18\frac{7}{8} \times 24$ inches (47.2 × 60 cms.). Signed bottom right: *C. R. W. Nevinson* Painted about 1924.

Provenance: Purchased from the Leicester Galleries by A. D. Power in 1924; bequeathed by him through the National Art-Collections Fund in 1959.

Exhibited: Paintings and Water-colours by C. R. W. Nevinson, The Leicester Galleries, March-April 1924 (115).

Reference: 56th Annual Report of the National Art-Collections Fund 1959, London, 1960, p. 37.

A winter's view of the river looking south-west from an upper window at the Savoy Hotel. In the foreground is Cleopatra's Needle, the obelisk that formerly stood in front of the Temple of Heliopolis, which was shipped from Alexandria at a cost of £10,000

Plate 76 A London Crossing Sweeper and Flower Girl by A. E. Mulready. Signed and dated 1884

Plate 77 Cleopatra's Needle and Hungerford Bridge from the Savoy by C. R. W. Nevinson. Painted about 1924

and re-erected on the Victoria Embankment in 1878. On the right are the Victoria Embankment Gardens, first opened to the public in 1872. Beyond the Embankment trains are seen crossing the Charing Cross Railway Bridge (popularly known as Hungerford Bridge), an iron girder bridge built in 1863-6, which replaced Brunel's Hungerford Suspension Bridge (see No. 83). The silhouettes of Westminster Bridge, the Houses of Parliament and Whitehall Court are visible in the background.

78 THE CITY FROM THE SOUTH END OF WATERLOO BRIDGE (28.160)

Tempera on board. $29\frac{1}{2} \times 19\frac{1}{2}$ inches (73.75 × 48.75 cms.). Signed bottom right: *C. R. W. Nevinson.* Painted about 1928.

Provenance: Purchased from the Leicester Galleries by R. Just Boyd in 1928 and presented through the National Art-Collections Fund.

Exhibited: Paintings and Water-colours by C. R. W. Nevinson, The Leicester Galleries, October 1928 (41) as *London, Winter; Memorial Exhibition of pictures by C. R. W. Nevinson, A.R.A.,* The Leicester Galleries, May-June 1947 (29).

References: Kineton Parkes, 'Nevinson', *Apollo,* November 1928, pp. 262 and 264, repr. p. 259; *25th Annual Report of the National Art-Collections Fund 1928,* London, 1929, p. 53.

The foreground is dominated by seagulls, barges, and the cranes of the warehouses which lined the Lambeth riverfront east of Waterloo Bridge; in the middle distance is the square shot tower built in about 1789 by Messrs. Watts. Part of the City can be seen in the distance left, with St. Bride's, the City of London School for Boys (built by Davis and Emmanuel in 1881-2), St. Paul's, the Monument (which should be seen much further to the east) and Blackfriars Bridge clearly visible. The picture is painted in the semi-abstract style deriving ultimately from Cubism that is characteristic of Nevinson's work of the 1920's.

79 AMONGST THE NERVES OF THE WORLD (30.167)

Canvas. $30\frac{1}{8} \times 20$ inches (75.3 × 50 cms.). Signed bottom right: *C. R. W. NEVINSON* Painted about 1930.

Provenance: Purchased from the Leicester Galleries in 1930 and presented by an anonymous donor.

Exhibited: Paintings, Etchings and Lithographs by C. R. W. Nevinson, The Leicester Galleries, October 1930 (43); *Memorial Exhibition of pictures by C. R. W. Nevinson, A.R.A.,* The Leicester Galleries, May-June, 1947 (35).

Reference: C. R. W. Nevinson, *Paint and Prejudice,* London, 1937, p. 191 and repr. pl. 15.

Also reproduced: J. L. Howgego, *The City of London through Artists' Eyes,* London, 1969, p. 63.

144

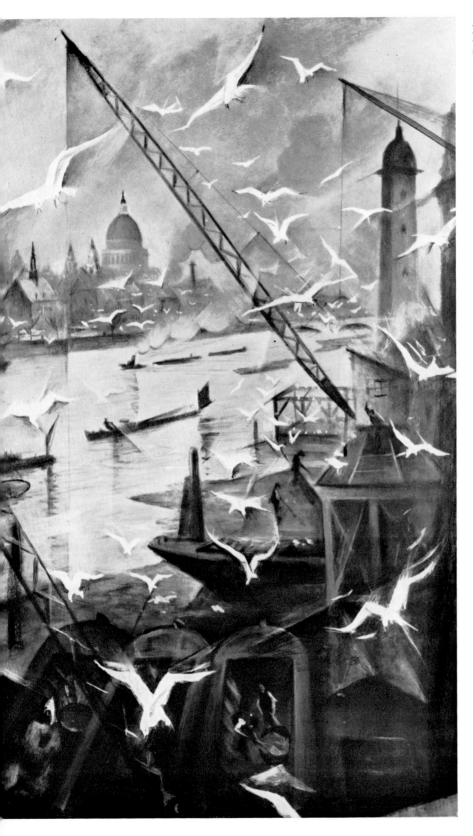

Plate 78 The City from the South
End of Waterloo Bridge by
C. R. W. Nevinson. Painted about
1928

A view of Fleet Street from an upper storey window, looking east and showing the street crowded with traffic and pedestrians: the 'buses are seen with the covered tops first introduced in 1925. In the middle distance a passenger train is shown crossing the Ludgate Hill railway bridge towards Holborn Viaduct Station. Beyond are Wren's church of St. Martin's Ludgate, with its tall lead spire, and the dome and west towers of St. Paul's Cathedral. In this picture Nevinson has used telegraph wires and the perspective lines of pavement and ledges as a basis for a system of criss-crossing lines that break up the composition into facets, a method of painting characteristic of the artist's later work that can be studied also in such pictures as his view of New York through Brooklyn Bridge, painted in 1920.

80 THE SOUTHWARK RIVERFRONT NEAR BLACKFRIARS BRIDGE (59.99/143)
Panel. $11\frac{7}{8} \times 16$ inches (29.7 \times 40 cms.). Signed bottom right: *C. R. W. Nevinson.* Painted in 1938.

Provenance: A. D. Power; bequeathed by him through the National Art-Collections Fund in 1959.

Exhibited: Memorial Exhibition of pictures by C. R. W. Nevinson, A.R.A., The Leicester Galleries, May-June 1947 (37).

Reference: 56th Annual Report of the National Art-Collections Fund, 1959, London, 1960, p. 37.

A view of the warehouses of Bankside from Southwark Bridge. Over their tops can be seen, from left to right, the hulk of Waterloo Station, the shot tower built by D. R. Roper in 1826, which stood until recently (April 1962) on the west side of Waterloo Bridge, and the 'Oxo' tower. The iron girder railway bridge which was built in the early 1860's immediately next to Blackfriars Bridge to take the London, Chatham and Dover Railway to its new termini on the north bank (first Ludgate Hill, then Holborn Viaduct) is seen to the right, and beyond are Big Ben and some of the buildings fronting the Embankment east of Charing Cross, Shell Mex House being the most prominent; the tip of Nelson's column and of the spire of St. Martin-in-the-Fields can just be distinguished. A tug and a number of barges are seen on the river.

81 THE TEMPORARY WATERLOO BRIDGE, WITH PART OF THE SOUTH BANK (59.99/144)
Panel. $16 \times 11\frac{7}{8}$ inches (40 \times 29.7 cms.). Signed bottom right: *C. R. W. NEVINSON* Painted in 1938.

Provenance: Purchased from the Leicester Galleries by A. D. Power; bequeathed by him through the National Art-Collections Fund in 1959.

Reference: 56th Annual Report of the National Art-Collections Fund 1959, London, 1960, p. 37

Plate 79 Amongst the Nerves of
the World by C. R. W. Nevinson.
Painted about 1930

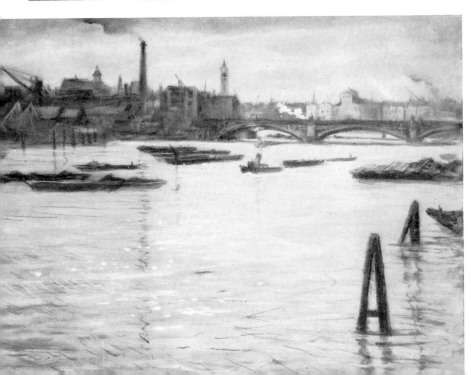

Plate 80 The Southwark
Riverfront near Blackfriars Bridge
by C. R. W. Nevinson.
Painted in 1938

A view of the temporary iron bridge which was erected to replace Rennie's Waterloo Bridge, destroyed in 1936 (see No. 33), pending the construction of the new concrete bridge by Sir Giles Gilbert Scott, finished in 1945. Beyond can be seen the shot tower on the South Bank, pulled down in 1962, the Victoria Tower, Hungerford Bridge and Big Ben. A barge is being manoeuvred in the foreground.

82 VIEW OF THE THAMES AT DEPTFORD (59.99/145)

Panel. 14⅜ × 18⅜ inches (35.9 × 45.9 cms.). Signed bottom right: *C. R. W. Nevinson* Painted in 1939.

Provenance: A. D. Power; bequeathed by him through the National Art-Collections Fund, 1959.

Exhibited: The Recent Paintings of C. W. Nevinson, The Leicester Galleries, February 1939 (36); *Memorial Exhibition of pictures by C. R. W. Nevinson, A.R.A.*, The Leicester Galleries, May-June 1947 (40).

Reference: 56th Annual Report of the National Art-Collections Fund 1959, London, 1960, p. 37.

An impressionistic view of the Deptford riverside looking westwards from Greenwich pier, in front of the present berth of the *Cutty Sark*. The opening of Deptford creek is seen on the left, and in the middle distance is the parish church of St. Nicholas's Deptford, destroyed during the Second World War, and the chimneys of Deptford power station (this now has three chimneys). On the right is part of a warehouse, with a crane, which still stands on the north shore, the Isle of Dogs. A number of barges are seen on the river.

EDMUND JOHN NIEMANN (1813-76)

Landscape and topographical painter. Born in Islington, the son of an underwriter at Lloyd's. A clerk at Lloyd's from the age of thirteen, he did not take up painting until 1839. Lived at High Wycombe, and afterwards in various parts of London.

83 BUCKINGHAM STREET, STRAND (64.150)

Canvas. 44⅛ × 35 inches (110.3 × 87.5 cms.). Signed, dated and inscribed bottom right: *Buckingham St^t Strand/Niemann 1854*

Provenance: Purchased out of the Mackenzie Bell Trust Fund from Richard Green (Fine Paintings) Ltd., in 1964.

Reproduced: John Hayes, *London: A Pictorial History*, London, 1969, pl. 117.

Buckingham Street was built up in the 1670's, the whole street being complete by 1680; some of the original houses are seen here, for example, on the extreme right, but others have the set back windows of the early eighteenth century, and were clearly built later. This view appears to be taken from the top of the street, looking south, and York Place, an alleyway known until shortly before this date as Of Alley, runs off to the west a little way down. The topography is puzzling, however, as York Place also ran off to the east,

Plate 81 The temporary
Waterloo Bridge, with part of the
South Bank by C. R. W. Nevinson.
Painted in 1938

Plate 82 View of the Thames at
Deptford by C. R. W. Nevinson.
Painted in 1939

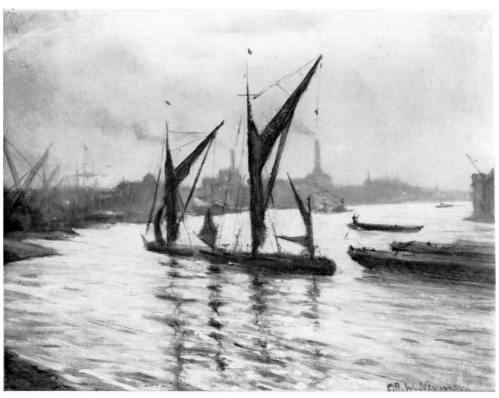

149

and the opening of Duke Street (now John Adam Street) should be visible further down.

At the foot of the street is the York Water Gate which, after the construction of the Victoria Embankment, was to be stranded some hundred and fifty yards from the river. Beyond can be seen part of the Hungerford Suspension Bridge, an elegant footbridge designed by Brunel and finished in 1845, but which was demolished not long after completion, in 1859-60, so that the Charing Cross Railway Bridge could be built (the chains of the old bridge were used for the Clifton Suspension Bridge at Bristol).

On the left are the premises of Richard Stone, tallow chandler, at Nos. 27 and 28, and William Crocker, boot maker, at No. 26; on the right is the Prince's Head Tavern, and the shops of James Lilly, fruiterer, at No. 4, and J. C. Fisher, butcher, at No. 5. The premises further down the street were still in use either as private residences, or as the offices of solicitors, civil engineers, and other professional people. Among the figures represented is a hurdy-gurdy player; notice also the cobbles and absence of raised pavements still characteristic of London's side streets.

PHILIP NORMAN (1842-1931)

Watercolour painter, principally of London buildings. Born in Bromley, the son of the Governor of the Bank of England (G. W. Norman). Studied at the Slade School from 1872. Vice President of the London Topographical Society 1906-31. Lived in South Kensington.

84 DRURY COURT WITH THE CHURCH OF ST. MARY-LE-STRAND (c 358)

Canvas. 20⅞ × 18¼ inches (58.2 × 45.6 cms.). Signed in monogram bottom right: *PN* Inscribed on the back by the artist as painted in 1880.

Provenance: Lent by the artist in 1911, and afterwards purchased in 1914.

Exhibited: Summer Exhibition, The New Gallery, 1906 (72); *Old London Exhibition,* Whitechapel Art Gallery, November-December 1911 (362: Lower Gallery).

Drury Court, the continuation of Drury Lane southwards from Wych Street to the Strand, was one of a number of streets in this area cleared away for the Aldwych and Kingsway improvements, carried out in 1900-5. It was originally known as Maypole Lane, on account of its proximity to the Maypole in the Strand: the high Maypole put up shortly after the Restoration stood on the site of Gibbs's church of St. Mary-le-Strand, built in 1714-7, which is seen in the distance, and was taken away by Sir Isaac Newton.

This view is taken from Drury Lane proper, and part of Bates's British Coffee House, on the corner of Wych Street, is seen on the extreme left of the picture (see also No. 107). The seventeenth century house on the right, the premises of E. Crafter, watchmaker, and of Stockley, bookseller, at one time the Cock and Magpye Tavern, was said to have been the house where Nell Gwynn had lodgings, and where she was seen standing at the door by Pepys in 1667; both this and the house next door, the premises of J. Johnson, coal and coke merchant, which also dated from the seventeenth century,

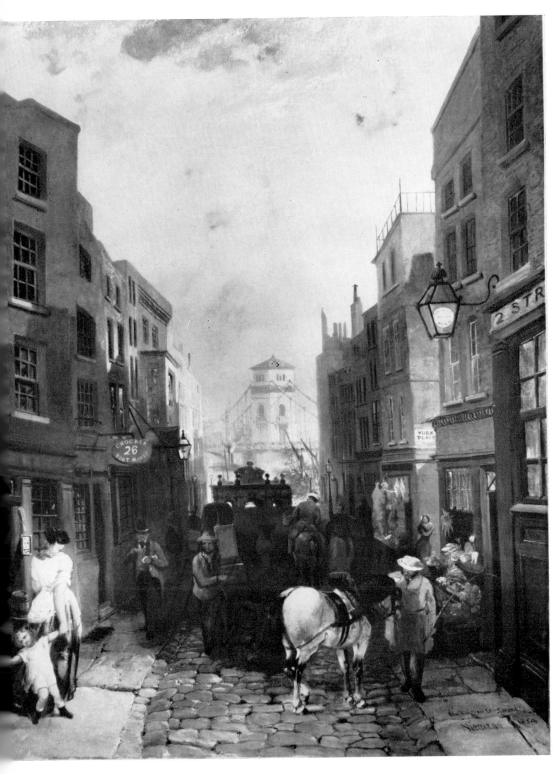

Plate 83 Buckingham Street, Strand by E. J. Niemann. Signed and dated 1854

151

were pulled down in 1890. A man is seen clearing snow and piling it into a cart which would subsequently be emptied into the river.

For most of the seventeenth century, Drury Court and Drury Lane had been streets of considerable distinction, with aristocratic residents, but by the beginning of the eighteenth century they had begun to acquire a more doubtful reputation. The whole district had become a seed-bed of crime and vice by the mid-Victorian period, Wych Street being notorious for its brothels, ostensibly cigar shops; and extensive clearance was started in the 1880's under the provisions of the Artisans' Dwellings Act.

Another view of the street, by C. J. Watson, is also in the Museum (No. 107).

85 THE BACK YARD OF THE QUEEN'S HEAD INN, NO. 105 BOROUGH HIGH STREET, SOUTHWARK (c 407)

Canvas. 15⅛ × 11⅛ inches (38.4 × 28.3 cms.). Signed bottom right: *P Norman* Painted about 1883.

Provenance: Lent by the artist in 1912, and afterwards purchased in 1914.

The Queen's Head Inn was originally called the Cross or Crowned Keys, and was probably renamed in the sixteenth century in honour of Queen Elizabeth. Amongst those who have held the lease of the inn was John Harvard, the founder of Harvard University. The entrance to the tap room is seen next to the seated figure; the main entrance to the yard itself was just to the right of this view. The inn was demolished in 1886.

Two other views of the inn by Philip Norman, both signed and dated 1883, and both in watercolour, are in the Victoria and Albert Museum: one (D17—1896) is identical with the Museum picture, the other (D16—1896) shows the main yard.

JOHN O'CONNOR (1830-89)

Topographical and scene painter. Born in Londonderry, and came from a family connected with the stage. Had no formal training, and as a boy assisted in scene painting at theatres in Belfast and Dublin; came to London in 1848, where he worked first at Drury Lane and later, as principal scene painter at the Haymarket Theatre 1863-78. Drawing master to the London and South-Western Literary and Scientific Institution, 1855-8. A.R.H.A. 1883. Drew numerous royal ceremonies, including the Jubilee service in Westminster Abbey, 1887. Lived chiefly in St. John's Wood.

86 YORK WATER GATE AND THE ADELPHI FROM THE RIVER (A 7545)

Canvas. 24 × 39⅞ inches (60 × 99.7 cms.). Painted in 1872.

Provenance: Anon. sale, Christie's, 2 April 1892 Lot 27 bt. Hoare; purchased in 1912, source unrecorded.

Exhibited: Royal Academy, 1872 (1019).

Plate 84 Drury Court
with the Church of
St. Mary-le-Strand by
Philip Norman. Painted
in 1880

Plate 85 The Backyard
of the Queen's Head
Inn, No. 105 Borough
High Street, Southwark
by Philip Norman.
Painted about 1883

A view of the Strand waterfront from the river, before the construction of the Embankment, looking north-eastwards and showing Somerset House and an arch of Waterloo Bridge in the distance. In the foreground is the York Water Gate, erected in 1626 by Nicholas Stone, to designs probably by Sir Balthasar Gerbier, as the stately riverside entrance to the Duke of Buckingham's mansion (built in 1626 and demolished fifty years later), and seen here in its original position fronting the Thames; since the construction of the Embankment, it has been stranded some distance inland. Behind is the terrace of York Buildings, with the steps leading up to Buckingham Street (see No. 83). To the right are the Adelphi wharves, with the Royal Terrace towering above.

The Adelphi scheme, an enterprise by the brothers Adam (see No. 74), was begun in 1768 and to a large extent completed by 1772. In 1872, just a century later, the Royal Terrace was subjected to a hideous Victorian facelift (a desecration that may have prompted the painting of the present picture), and in 1936 it was totally demolished. A Thames waterman, in the traditional red uniform with arm badge, is shown staring up at the Adams' masterpiece, and barges and other craft are seen on the river.

O'Connor used his watercolour of the York Water Gate and the buildings around it, now in the National Gallery of Ireland (No. 2220) which is signed and dated 1861, for the left half of the Museum picture, the details in both being identical down to the reflections in the water, with the exception of the figure smoking a pipe, who does not appear in the watercolour. Though the picture was painted in 1872, the entry in the Royal Academy catalogue noted that it represented the scene as it had been 'ten years ago'. A pencil sketch for the composition is in the possession of Dr. Michael King.

87 ST. PANCRAS HOTEL AND STATION FROM
PENTONVILLE ROAD: SUNSET (52.87)

Canvas. 36⅛ × 60⅛ inches (90.3 × 150.3 cms.). Signed in monogram and dated bottom centre: *JOC 1884.*

Provenance: Isaac Holden, 1887; purchased out of the Joicey Trust Fund from H. R. Cresner in 1952.

Exhibited: Royal Academy, 1884 (860); Royal Hibernian Academy, 1885 (39); Royal Jubilee Exhibition, Manchester, 1887 (Fine Arts section: 1); *Victorian Paintings 1837-1890*, Mappin Art Gallery, Sheffield, September-November 1968 (190).

References: Henry Blackburn, *Academy Notes 1884*, London, 1884, p. 65; Graham Reynolds, *Painters of the Victorian Scene*, London, 1953, p. 93 (repr. fig. 82).

Reproduced: John Gloag, *Victorian Comfort*, London, 1961, pl. 1; *The Times*, 17 September 1966; *The Weekend Telegraph*, 11 November 1966, pp. 44-5 (colour); John Hayes, *London: A Pictorial History*, London, 1969, pl. 133 (detail).

Though much exaggerated for the sake of pictorial effect, this picture gives an excellent impression of the varied skyline of Sir Gilbert Scott's St. Pancras Hotel, one of London's finest sights, as seen from the hill which leads down from the Angel, Islington. The

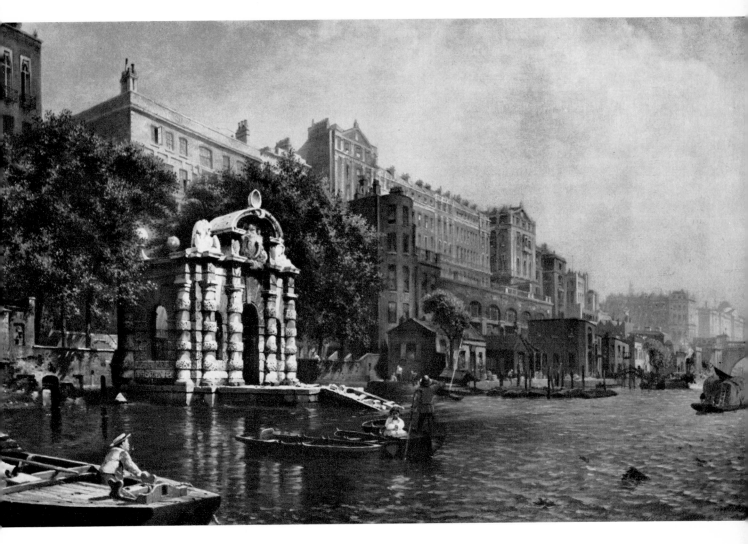

Plate 86 York Water Gate and the Adelphi from the River by John O'Connor.
Painted in 1872

155

viewpoint is a rooftop on the corner of Rodney Street and Pentonville Road (now the premises of the E.R. Engineering Company Ltd.); the turning on the left is Penton Rise.

St. Pancras Station, the terminus of the Midland Railway, was designed by W. H. Barlow and opened in 1868; in an age of great engineering achievement, it was remarkable for its daring construction, and the mighty barrel vault which roofed the platforms in a single span is clearly visible here. The St. Pancras Hotel, built in 1867-76, was one of the foremost Gothic buildings in London, and fully expressed the glamour and pride of railway travel (as did the Euston Arch, now unhappily destroyed).

Pentonville Road, partly composed of early Victorian terrace houses and shops, and partly of taller buildings dating from the third quarter of the nineteenth century, has changed considerably since the date of this picture. Some of the shops in the block on the left stood until recently, but have now been replaced by blocks of flats; a few of the buildings at the lower end of the street are still in use – even the tall lead cupola on the building at the junction of Pentonville and Gray's Inn Road survives intact. The church on the left is the Welsh Congregational Church, now hemmed in by a block of early twentieth century tenements, and that on the right St. James's, built by Aaron H. Hurst in the Adam style in 1787. At the foot of the hill is the clock tower of King's Cross Station, and on the left of the picture, in the distance, are the dome of University College and the tower (inspired by the Tower of the Winds in Athens) of the parish church of St. Pancras, built in 1819-22 by William and H. W. Inwood.

Numerous figures are introduced, including a policeman, a postman (notice the hexagonal pillarbox) and a number of sandwich-board men; and hansom cabs, a haycart, and horse-drawn 'buses and trams of the 'knife-board' variety (see also Nos. 94 and 95) are seen in the roadway. Trams were first introduced into London by G. F. Train, an American, in 1861, but it was not until the 1870's that lines began to proliferate, chiefly in north London (only small sections were ever allowed within the City itself). The line down Pentonville Road first came into operation in 1883, and the two trams seen here, which plied between the Angel and King's Cross, are numbered 67 and coloured red – notice that three horses were used in Pentonville Road on account of the steep ascent.

JOHN PAUL (1804-87)
Topographical painter, and copyist.

88 SOMERSET HOUSE AND THE ADELPHI FROM THE
 RIVER (C 2385)

Canvas. 27¾ × 36 inches (69.4 × 90 cms.). Painted about 1825.

Provenance: Bequeathed by J. G. Joicey in 1919.

Exhibited: Canaletto and his Influence on London Artists, Guildhall Art Gallery, June-July 1965 (27).

Somerset House, designed by Sir William Chambers as a public building to house a number of official and learned bodies, and begun in 1776, is seen here before the river

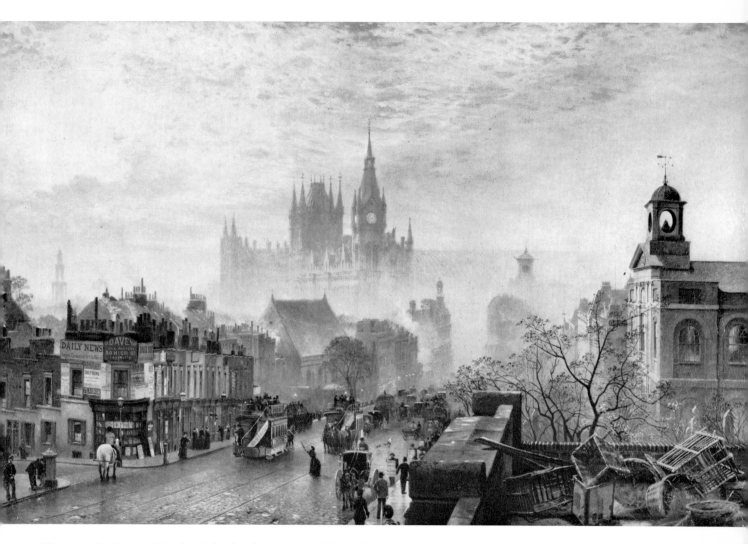

Plate 87 St. Pancras Hotel and Station from Pentonville Road: Sunset by John O'Connor.
Signed and dated 1884

157

frontage was completed by the building of King's College (to the designs of Sir Robert Smirke 1830-1), and before the arcades and watergate of its Piranesian substructure were masked by the Victoria Embankment. The Inland Revenue Office, which occupies the west wing, was added in the 1850's by Sir James Pennethorne. Beyond Somerset House is the spire of St. Martin-in-the-Fields, and next to it is the Adelphi, begun by the brothers Adam in 1768, and pulled down in 1936. On the left of the picture are seen the water tower of the York Buildings Waterworks Company, the house once owned by Samuel Pepys, and the York Water Gate.

John Paul was principally a copyist of eighteenth century topographical views, and this painting is identical in all but the smallest particulars with one of Farington's drawings, engraved by J. C. Stadler in 1791. That it was actually intended to pass for an original by Farington may be seen from the inscription *JF 1790* which appears (as in the Stadler print) on one of the logs in the left foreground. It certainly cannot be relied upon for detailed accuracy, especially as it was done at second hand – in the case of the York Water Gate, it is no more than perfunctory – but it does, nevertheless, give a useful impression of what the riverside south of the Strand looked like before Waterloo Bridge was built and when it was dominated by two of London's most dramatic eighteenth century buildings.

The costume indicates a date in the first quarter of the nineteenth century, and, since Paul was born in 1804, presumably towards the end of that period.

There are innumerable versions of this picture, of which one is in the possession of the Royal Scottish Corporation.

89 GREENWICH HOSPITAL FROM THE RIVER (A 13437)
Canvas. 25 × 30 inches (62.5 × 75 cms.). Painted about 1835.

Provenance: S. Girling; Girling sale, Christie's, 27 November 1909 Lot 56 (as *The Custom-House and Quay on the Thames*) bt. Saunders; presented by Theodore Lumley in 1914.

A view of the Greenwich waterfront from the old houses on the site of the Trafalgar Inn, built a year or two later in 1837. The principal features are the two riverside blocks of Greenwich Hospital (now the Royal Naval College), Queen Anne's Block, begun by Hawksmoor in 1696 and finished by Campbell and Ripley, and King Charles's Block, the first building of all, erected to John Webb's designs in 1662-9, but extended in later years by Hawksmoor in 1712, Stuart in 1769 and Yenn in 1811-4. One of the most important buildings of its age, the Hospital remains the grandest complex of baroque architecture in London. Beyond are the Ship Tavern and the houses in Maiden Row, facing the river. Several rowing boats and other craft are seen on the river, and some figures are grouped on the landing stage in the foreground.

The Museum picture is a copy of the painting by George Chambers in the royal collection, which is signed and dated 1832, probably done from the engraving by J. B.

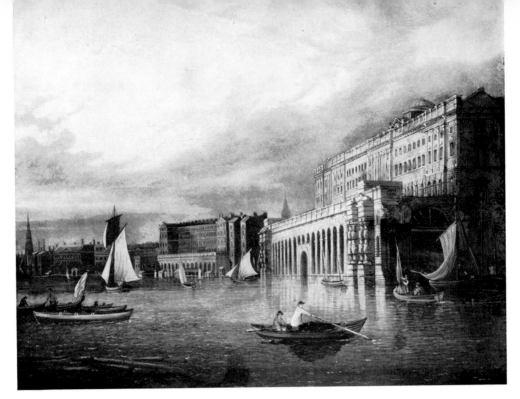

Plate 88 Somerset House and the Adelphi from the River by John Paul. Painted about 1825
Plate 89 Greenwich Hospital from the River by John Paul. Painted about 1835

Allen; the group of buildings in the middle distance has not, however, been very faithfully rendered, and the spire of St. Paul's, Deptford has been omitted. A variant of Chambers's painting, signed and dated 1835, now in the National Maritime Museum, includes the Dreadnought then anchored close to the waterfront, which served as a seamen's hospital. A watercolour of this subject by Chambers is in the Laing Art Gallery, Newcastle upon Tyne. A replica of the Museum picture, in which the boats and figures are also identical, is in the possession of the Royal Scottish Corporation.

The costume indicates a date of about 1835, and the view dates from before the building of the Trafalgar Inn in 1837.

HENRY PETHER (active 1828-65)
Topographical painter, best known for his moonlight pictures. Son of Abraham Pether, the painter. Lived in various parts of London.

90 CHELSEA OLD CHURCH AND CHEYNE WALK FROM THE
 RIVER, BY MOONLIGHT (57.68/1)

Canvas. 23½ × 36 inches (58.75 × 90 cms.). Signed bottom left: *Henry Pether*. Painted about 1850.

Provenance: Possibly John Rushout, 2nd Baron Northwick (1770-1859) and Thirlestane House sale, Phillips, 29 July 1859 Lot 311; Victor Bonney; presented by Mrs. Victor Bonney in 1957.

Exhibited: 19th Century English Art, New Metropole Arts Centre, Folkestone, May-June 1965 (94).

Reproduced: The Illustrated London News, 22 May 1965, p. 26.

A view of Cheyne Walk and the river looking eastwards from the foreshore just east of Battersea Bridge. In the foreground is the large house at the eastern end of Lombard Street through which was an archway joining this street with Cheyne Walk. Behind this building is Chelsea Old Church (see also No. 46), rebuilt in 1669-72, its tower dating from 1674. In the churchyard, fronting the river, stands Joseph Wilton's monument to Sir Hans Sloane (1660-1753), the distinguished naturalist whose collections are the foundation of the British Museum. Two Chelsea pensioners are standing next to the monument. Beyond the church is the row of five late-seventeenth century houses in Prospect Place (at one time called Church Row), now demolished, with Cheyne Walk extending into the distance.

In the middle distance is Cadogan pier, which a paddle steamer has just left: steamers were first introduced on the Thames in the 1820's, and by this period provided a regular service between Hammersmith and London Bridge, for a fare of only a few pence. In the far distance can be made out the buildings and chimneys of various works and manufactories on either side of Chelsea Reach; prominent among these is the engine house for the Southwark and Vauxhall waterworks, seen to the right of the paddle steamer.

The costume indicates a date of about 1845-50.

160

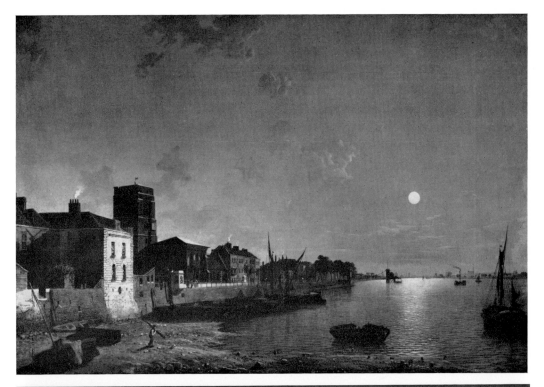

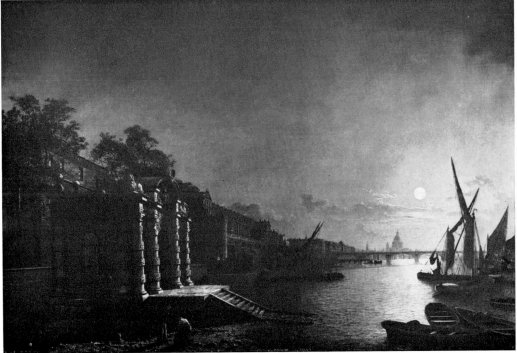

Plate 90 Chelsea Old Church and Cheyne Walk from the River by Moonlight by Henry Pether. Painted about 1845

Plate 91 York Water Gate and the Adelphi from the River by Moonlight by Henry Pether. Painted in the mid-nineteenth century

A version of similar size signed and dated 1850 on the reverse was in an Anon. sale, Sotheby's, 26 June 1968 Lot 106.

91 YORK WATER GATE AND THE ADELPHI FROM THE RIVER, BY MOONLIGHT (60.50)

Canvas. 23½ × 35⅝ inches (58.75 × 84.1 cms.). Signed bottom left: *Henry Pether.* Painted in the mid-nineteenth century.

Provenance: Purchased out of the Mackenzie Bell Trust Fund from the Parker Gallery in 1960.

Exhibited: 19th Century English Art, New Metropole Arts Centre, Folkestone, May-June 1965 (93).

A view of the Strand waterfront from the river, before the construction of the Embankment, looking north-eastwards and showing in the distance Somerset House, Waterloo Bridge, the spire of St. Bride's and St. Paul's Cathedral. In the foreground is the York Water Gate, with the Adelphi wharves and the Royal Terrace beyond (see Nos. 74 and 86). Waterloo Bridge (first called Strand Bridge) was erected between 1811 and 1817 to the designs of John Rennie; it was pulled down in 1936, as a result of the weakening of one of the arches, and the present bridge, by Sir Giles Gilbert Scott, was then built in its place.

Just this side of the bridge can be seen Waterloo pier, the scene of the explosion of the *Cricket* paddle steamer in 1847. A fare of one halfpenny to the City 'by the fast iron boats' was advertised at this landing stage. On the foreshore two mudlarks, as they were called, are seen gathering together what bits and pieces the tide might have washed up, coals, rope, old iron, or best of all, copper nails; these unfortunates, often aged little more than six or seven, could expect to average about threepence a day by selling their gains to the rag shops. A number of barges and rowing boats are seen in the foreground right.

92 NORTHUMBERLAND HOUSE AND WHITEHALL FROM THE NORTH SIDE OF TRAFALGAR SQUARE, BY MOONLIGHT (66.44)

Canvas. 24 × 36⅛ inches (60 × 90.3 cms.). Signed bottom right: *Henry Pether.* Painted between 1861 and 1867.

Provenance: Anon. sale, Bonham's, 5 May 1966 Lot 174 bt. Richard Green (Fine Paintings) Ltd., from whom it was purchased out of the Mackenzie Bell Trust Fund.

A moonlight view of Trafalgar Square from the balustrade on the north side, and looking south-eastwards down Whitehall; a number of figures are seen in the foreground, and there are two or three cabs in the distance left and right.

Trafalgar Square was formed on the site of the King's Mews, Charing Cross in connection with the improvements planned to link Pall Mall with St. Martin's Lane,

Plate 92 Northumberland House and Whitehall from the North Side of Trafalgar Square
by Moonlight by Henry Pether. Painted between 1861 and 1867

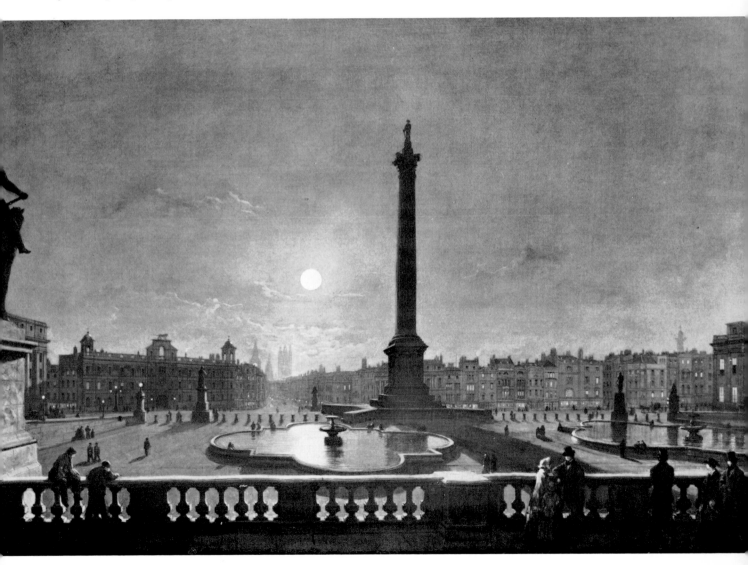

which followed the completion of Regent Street. Though the area was cleared soon after the passing of the Charing Cross Act in 1826, the layout, designed by Sir Charles Barry (but with subsequent modifications), was not finished until about 1850. The statue of Nelson by E. H. Baily was raised on its fluted Corinthian column (145 feet in height) in 1843; and the fountains and basins were in position by 1845 (these were remodelled in 1939). The four lions which now surround Nelson's column, cast from a model by Sir Edwin Landseer and set in position in January 1867, were evidently not finished at the time this picture was painted. The monuments in the square are, from left to right, George IV on horseback by Sir Francis Chantrey, put up in 1843 (this was originally intended for Marble Arch), General Havelock by W. Behnes, erected in 1861, and General Napier by G. G. Adams, erected in 1855-6; the statue seen at the far end of the western parapet wall is not known ever to have existed, and a lamp corresponding to that on the eastern parapet should occupy this position.

Beyond the square are seen, from left to right, part of Morley's Hotel, built by G. L. Taylor in 1830 and destroyed in 1936 to make way for South Africa House; Northumberland House (see also No. 13), purchased by the Metropolitan Board of Works from the Duke of Northumberland in 1874 for £500,000 and demolished for the construction of Northumberland Avenue; Whitehall, with Big Ben and the Victoria Tower in the distance, and Le Sueur's equestrian statue of Charles I; the offices and shops of Charing Cross and Cockspur Street; the top of the Duke of York's column, Carlton House Terrace; and the Union Club (later Canada House) built by Sir Robert Smirke in 1824-7.

JOHN PIPER (born 1903)

Landscape, topographical and abstract painter, and theatrical designer. Born at Epsom, the son of a solicitor. Student at the Richmond and Kingston Schools of Art, and the Royal College of Art, 1928-9. Member of the London Group 1933. Official War Artist 1940-2. Supervised the design of the Battersea Pleasure Gardens (with Osbert Lancaster) 1951. Lives near Henley.

93 CHRIST CHURCH, NEWGATE STREET, AFTER ITS DESTRUCTION IN 1940 (47.26/15)

Canvas. 30¼ × 25¼ inches (75.6 × 63.1 cms.). Signed bottom right: *John Piper* and inscribed and dated on the back: *Christ Church, Newgate Street, Jan. 1st 1941.*

Provenance: Commissioned by the War Artists Advisory Committee; presented by H.M. Government, through the Imperial War Museum, in 1947.

Exhibited: The Growth of London, Victoria and Albert Museum, July-August 1964 (H5); *British Artists of the Second World War,* Arts Council (Cambridge, King's Lynn, Huddersfield, Keighley, Cheltenham, Stafford, Plymouth, Eastbourne, Exeter and Colchester), February-November 1965 (49).

Reference: J. L. Howgego, *The City of London through Artists' Eyes,* London, 1969, p. 17 and repr. p. 64.

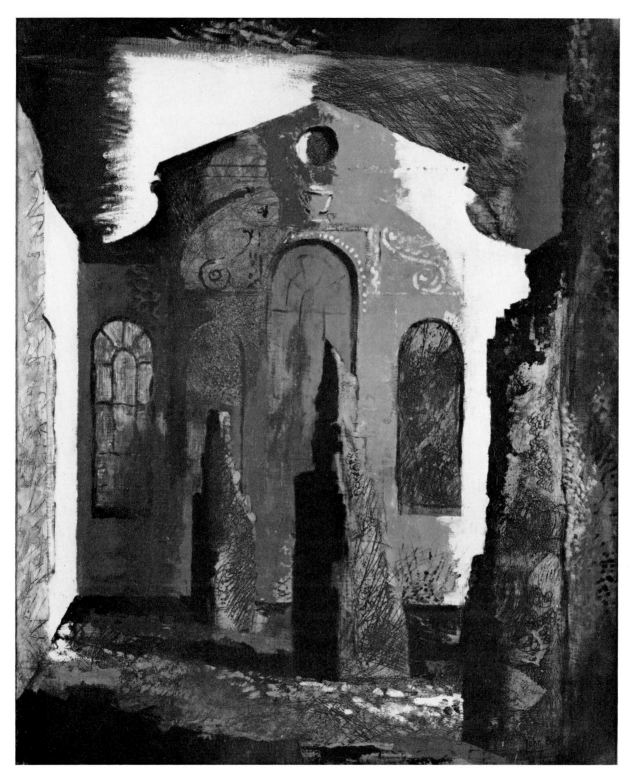

Plate 93 Christ Church Newgate Street after its Destruction in 1940
by John Piper. Signed and dated 1941

An impression of the east end of the church (built by Sir Christopher Wren 1677-87, on the site of the old Grey Friars church), as it looked from the nave, the morning after it had been gutted by incendiary bombs from a Nazi air attack. The first full scale night raid on London occurred on 29 December 1940, and much of the area north of St. Paul's was laid waste in the space of a few short hours. A long succession of night raids then followed, which devastated a great part of the historic City and gutted the majority of Wren's churches.

In accordance with the provisions of the Pastoral Reorganisation Measure 1949, a number of the City parishes were amalgamated, and Christ Church Newgate Street was merged with St. Sepulchre-without-Newgate, where services are now held. Though the steeple, which had also been seriously damaged, was re-erected in 1960 (and the opportunity taken to replace the twelve urns which had been removed as unsafe in the nineteenth century), the church was not restored, and apart from a thick undergrowth of weeds, ferns and bushes, remains much as John Piper saw it in 1941.

JAMES POLLARD (1792-1867)

Painter of coaching and sporting subjects, best known for his views of the famous London coaching inns. Born in London, the son of the engraver and publisher, Robert Pollard; little else is known about his life. Lived in Holloway.

94 A STREET SCENE WITH TWO OMNIBUSES (C 2399)

Fibreboard. 9¾ × 12¾ inches (24.4 × 31.9 cms.). Signed and dated bottom left: *J. Pollard. 1845*—An old label on the back bears the inscription: *E & J. Wilsons*: (*sic*) *omnibuss* (*sic*) *showing/his Visiter* (*sic*) *the way to Chelsea – /on St Patricks Day March 17th 1845*

Provenance: Lent by J. G. Joicey in 1917, and afterwards bequeathed in 1919.

Exhibited: Victorian Painting 1837-1887, Agnew's, November-December 1961 (68).

Reproduced: Charles E. Lee, *The Horse Bus as a Vehicle*, British Transport Commission, London, 1962, p. 5; T. C. Barker and Michael Robbins, *A History of London Transport*, Vol. 1, London, 1963, pl. 21.

Two early London omnibuses are shown against a background of four storey eighteenth century red brick terrace houses, probably situated in Holloway or Islington. The foremost omnibus, painted in *Favorite* green, is labelled as one of the *Favorite* fleet, and with the owners' names, E. and J. Wilson. Its terminus is marked as the Crown Inn, Holloway, and, according to the legend on a board fixed to a post above the 'bus, it plied between the Birmingham Railway (Euston) and Chelsea; intermediate points between Holloway, Euston and Chelsea are advertised on the side of the 'bus, Islington, New Road (Euston Road), Regent Street, and Knightsbridge. The second omnibus, also green in colour, is marked as plying between Holloway and Chelsea, with Oxford Street and Knightsbridge as intermediate points; but being further away, there was less opportunity in this case for the artist to include detailed lettering.

Plate 94 A Street Scene with Two Omnibuses by James Pollard. Signed and dated 1845

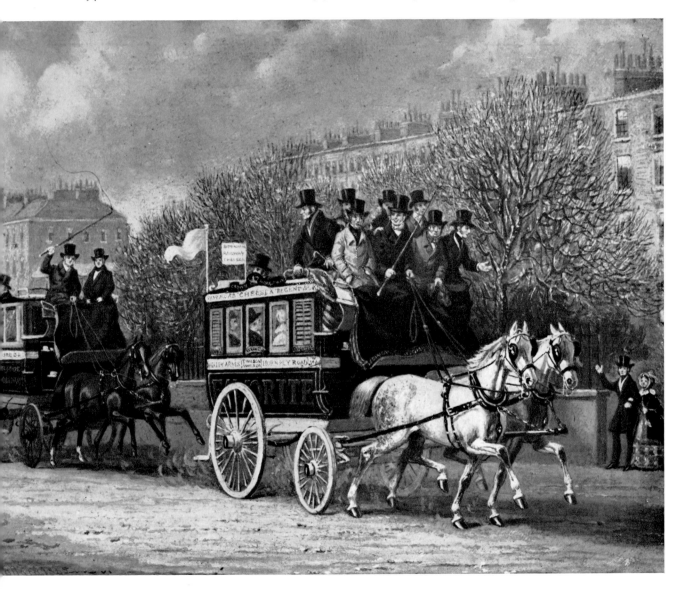

Both omnibuses are of the early single deck type introduced by George Shillibeer in 1829, which remained standard until the 1850's, when the crowds that came up to London for the Great Exhibition of 1851, and the rapidly increasing population of the metropolis itself, created a demand for more and much bigger 'buses. The earliest 'buses were drawn by three horses (these are drawn by two, which became normal), and the conductor stood on a plate at the back of the vehicle and held on by means of a strap; twelve seats were provided for passengers inside. Gradually, accommodation was provided on the roof as well, and at first two passengers were allowed outside, one on either side of the driver. By the mid-1840's, however, a second row of seats was often installed behind the driver, and this arrangement can be seen in the foremost 'bus here. The longitudinal roof seat (or 'knifeboard') characteristic of the 1850's and 1860's was first introduced in 1847.

At this date, there was no publicly owned transport system in London; numerous different companies operated, each with its own route and distinctive colour, and all were fiercely competitive. E. and J. Wilson, who had a licence to run eleven vehicles from Holloway, were among the leading proprietors; they also hired out horses and carriages, and their yard was called Wilson's Livery Stables. In 1855 two French speculators, Orsi and Foucauld, began to buy up the companies (the 48 omnibuses then owned by the Wilsons were taken over in January of that year), and out of their operations grew the London General Omnibus Company, the precursor of London Transport.

95 AN OMNIBUS PASSING THE *THREE COMPASSES* INN, CLAPTON (A 6392)
Canvas. 14 × 18 inches (35 × 45 cms.). Signed and dated bottom left: *J. Pollard/1850*

Provenance: Purchased in 1913.

A green and yellow omnibus of the early 'knifeboard' type, drawn by two horses, is shown passing the *Three Compasses* Inn, Clapton. Two passengers are seated on either side of the driver, and two along the 'knifeboard', or longitudinal seat (see No. 94); others are seated inside. The conductor is standing on the plate at the back of the 'bus and holding on by means of a strap; both the driver and the conductor are wearing badges and a buttonhole. This omnibus, owned by Thomas Kendall of Regent Street, ran along the following route: Clapton Square, Hackney, Islington, the Birmingham Railway station at Euston Square, and Oxford Street. Most early 'bus routes were planned to meet the needs of passengers using the railways.

The enormous expansion in London's 'bus services that occurred in these years was a direct result of the Great Exhibition of 1851; and the London General Omnibus Company, which amalgamated many existing businesses, was started in 1855 (see also No. 94). The inn in the background was leased by Truman, Hanbury and Buxton to W. Niblett, formerly of the King's Head, Clapton, and, like many public houses in the suburbs, had tea gardens at the rear of the premises.

Plate 95 An Omnibus passing the Three Compasses Inn, Clapton by James Pollard. Signed and dated 1850

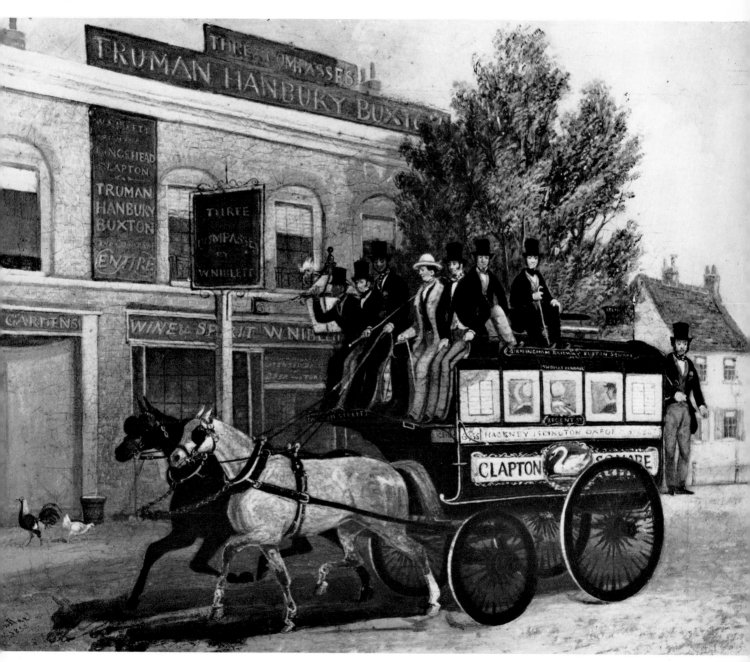

13

JOHN RITCHIE (active 1855-75)
Genre painter; hardly anything is known about his life. Lived in various parts of London.

96 A SUMMER DAY IN HYDE PARK (54.131)
Canvas. 30 × 51 inches (75 × 127.5 cms.). Signed and dated bottom right: *Jon Ritchie. 1858.*

Provenance: Purchased partly out of the Joicey Trust Fund, from Ian MacNicol in 1954.

Exhibited: British Institution 1858 (449) under the above title, and with a companion picture: *A Winter Day in St. James's Park* (281); *Victorian Painting 1837-1887*, Agnew's, November-December 1961 (84).

Reference: Jeremy Maas, *Victorian Painters*, London, 1969, p. 117 and repr. p. 119 (colour).

Also reproduced: The Illustrated London News, 27 November 1954 and 8 December 1962; *The Illustrated London News*, Christmas Number 1962, pp. 34-5 (colour).

This picture, crowded with characters, is in the tradition of Frith's large genre paintings, and shows an imaginary scene at the north-east corner of the Serpentine on a hot summer's afternoon. Amongst the figures shown are, from left to right, a gentleman reading a newspaper containing the latest report of the Indian Mutiny; a child in a perambulator; a soldier leaning over the back of a park bench and talking to the child's mother; a lady with her parasol up, sitting next to the mother and evidently severely censorious; a couple up from the country, also seated on the park bench, the man mopping his brow and with a map of London dropped in front of him; three children, one of them with a hoop; a gentleman talking to a lady holding a parasol; some poorer children, one of them seated on an improvised swing; a man fishing; and another pushing a rowing boat, in which his wife and daughter are seated, away from the shore.

Behind, in the Ring Road, a gentleman riding is seen raising his hat to a young lady seated in a passing landau, much to the annoyance of her parents; and other figures are grouped on the grass beyond. In the distance is Connaught Place, Marble Arch (originally designed by John Nash in 1828 as the gateway into the forecourt of Buckingham Palace, and removed to its present position in 1851), and Park Lane, with the Corinthian screen of the picture gallery attached to Grosvenor House (built by Thomas Cundy in 1827-8) prominent between the trees.

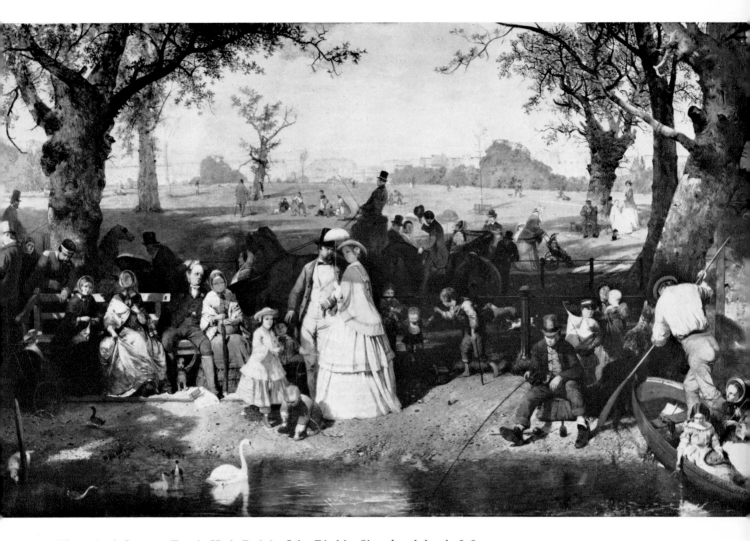

Plate 96 A Summer Day in Hyde Park by John Ritchie. Signed and dated 1858

DAVID ROBERTS (1796-1864)

Landscape and topographical painter; painted chiefly views in Western Europe, notably the interiors of cathedrals, and in the Middle East. Born in Stockbridge, Edinburgh, the son of a shoemaker. Apprenticed to a house painter, he afterwards became a scene painter, first in Glasgow and then in Edinburgh; appointed scene painter at Drury Lane 1822, and transferred to Covent Garden 1824. Travelled extensively on the Continent and in the Middle East. A.R.A. 1839; R.A. 1841. Lived mainly in Bloomsbury. Painted the inauguration ceremony at the Great Exhibition of 1851, and a series of views of London from the Thames 1862, which included views of the new Palace of Westminster.

97 THE PALACE OF WESTMINSTER FROM THE RIVER AFTER THE FIRE OF 1834 (63.61)

Canvas. $19\frac{1}{8} \times 25\frac{3}{4}$ inches (48.2 × 68.75 cms.). Painted in 1834.

Provenance: Purchased out of the Joicey Trust Fund from Oscar and Peter Johnson in 1963 (without attribution).

Exhibited: 1666 and other London Fires, Guildhall Art Gallery, August-September 1966 (64); *Historic Fires,* Stadsmuseum, Stockholm, April-June 1969.

Reproduced: The Times, 6 September 1966.

On the night of Thursday 16 October 1834, as a result of the overheating of a furnace under the House of Lords through the burning of a quantity of wooden Exchequer tallies, a fire was started that raced through the ancient and for the most part rotten timbers, fanned by a brisk south-westerly wind, and resulted in the almost total destruction of the historic Palace of Westminster. Crowds came from all over London to watch the blaze, amongst them artists such as Turner and Constable, both of whom recorded the scene; and in this picture several boats full of spectators are shown in the foreground, with two artists standing up sketching in one of them.

This view was similarly taken from a boat on the river and shows the still smouldering buildings, from left to right, a modern block containing Parliamentary offices, the thirteenth century Painted Chamber, the Library of the House of Commons, the residence of the Clerk of the House of Commons, St. Stephen's Chapel (built between 1292 and 1348, and since the mid-sixteenth century the meeting-place of the House of Commons), and the Speaker's residence. All these buildings were totally destroyed. Behind are seen Westminster Abbey and Westminster Hall, fortunately not touched by the flames. A view of the new Houses of Parliament, designed by Sir Charles Barry, painted by John Anderson a few years after their completion in 1860, is also in the collection (No. 3).

A signed and dated version of the Museum picture, which is rather more generalised, and differs in the boats and figures, is in the possession of the Chartered Insurance Institute; two other unsigned versions are owned by Sir Harry Legge-Bourke and the Ministry of Public Building and Works.

Another view of the burning of the Palace of Westminster, but taken from a more distant viewpoint, by Luny, is also in the collection (No. 72).

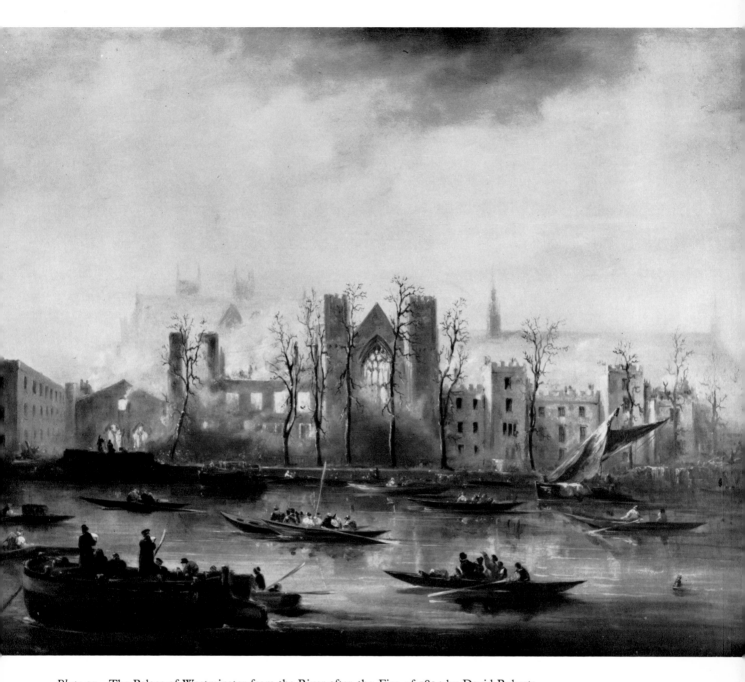

Plate 97 The Palace of Westminster from the River after the Fire of 1834 by David Roberts. Painted in 1834

173

JOHN NOST SARTORIUS (1759-1828)

Sporting painter. Born in London, the son of Francis Sartorius, also a sporting painter. Lived in Soho and Covent Garden.

98 THE DRESS CHARIOT OF THE SHERIFF OF THE CITY OF LONDON IN THE COURTYARD OF GUILDHALL (A 16492)

Canvas. 32⅞ × 44⅛ inches (82.2 × 88.3 cms.). Signed and dated bottom left: *JN Sartorius pinxt 1807.* and inscribed: *Sʳ Jonathan Miles's. Sheriff*

Provenance: Noel Fenwick, Hunstanton Lodge, King's Lynn; Fenwick sale, Christie's, 18 July 1892 Lot 48 bt. Toovey; Miss Toovey sale, Christie's, 3 June 1909 Lot 24 bt. Glen; with John Glen, from whom it was purchased by J. G. Joicey and presented in 1915.

This picture (an unusual genre for Sartorius) is a 'portrait' of the dress chariot used by Sir Jonathan Miles, when he was Sheriff of the City of London in 1806-7. The body is in black and chocolate brown, with the City's coat of arms painted on the door panel; the window is closed, with the yellow blind up. On the hammer cloth covered box sits a coachman in navy blue livery, with gold braid, and wearing a tricorne hat; two footmen in similar liveries, but wearing bicorne hats, stand on the platform between the rear springs. The chariot is drawn by four brown thoroughbred horses. Although there was only room for two occupants in a chariot, there being no seat facing backwards, it was a vehicle no less popular than the carriage for formal purposes, and indeed usually more elegant in design. Its heyday was much the same as that of the carriage, the first half of the nineteenth century, with 1838 the peak year.

In the background is the Gothic entrance front of Guildhall, built in 1788-9 by George Dance the Younger, Clerk of the City Works, together with the west wing flanking the courtyard, a range of plain brick buildings, also by George Dance and built in 1789. The picture is not to be relied upon for architectural accuracy (the parapets of the two blocks should actually be in alignment, the first floor windows of Guildhall should be less tall and those above the archway taller, the fluting of the buttresses does not stop short beneath the top storey, the pinnacles and castellation are quite misleading, and so on), so that the background should not be accepted as more than just a general impression.

174

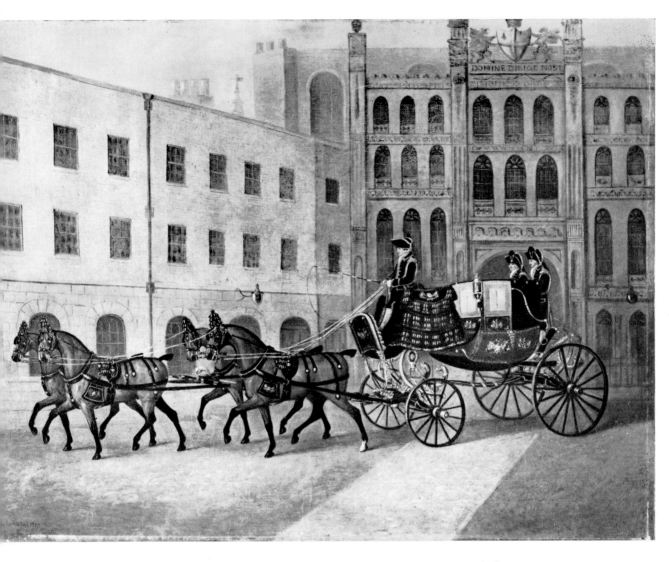

Plate 98 The Dress Chariot of the Sheriff of the City of London in the Courtyard of
Guildhall by J. N. Sartorius. Signed and dated 1807

SAMUEL SCOTT (1702?-72)

Marine and topographical painter; specialised in London views. Worked chiefly as a marine painter until the mid-1740's, when, as a result of the enhanced demand for London views stimulated by the arrival of Canaletto in this country in 1746, he added this genre to his other activities. Painted several versions of his most popular subjects, and was much copied. Lived in Covent Garden until 1758, when he retired to a house he had bought in Twickenham in 1748; left London in 1765 and spent his last years in Ludlow and Bath.

99 COVENT GARDEN PIAZZA AND MARKET (A 8078)

Canvas. 44 × 66⅝ inches (110 × 166.7 cms.). Painted about 1749-58.

Provenance: Purchased from Leggatt Brothers in 1912 (as attributed to Canaletto).

References: Hilda F. Finberg, 'Pictures of Covent Garden in the Duke of Bedford's Collection', *Country Life*, 10 September 1921, p. 329; ed. James Greig, *The Farington Diary*, Vol. 1, London, 1923, p. 158 Note.

A view of the piazza and market taken from a house on the east side close to the famous Bedford Coffee House, looking west towards the church of St. Paul's, Covent Garden and its symmetrically placed flanking gateways and houses. The story goes that when Inigo Jones laid out the square for Francis, 4th Earl of Bedford in 1631 (see No. 1), he was asked to make the church as simple as possible, 'not much better than a barn', in fact. His answer to this plea for economy was that the Earl should have 'the handsomest barn in Europe'; and he designed a plain but beautifully proportioned building, with a splendid portico of Tuscan columns, that cost nearly £5,000. Jones's church was burnt down in 1795, and the building that stands in its place today is an exact replica of the original by Thomas Hardwick.

The northern blocks of Jones's houses, with their stuccoed arcades, popularly called the 'piazzas', can be seen on the right. Beyond these is a mansion which must date from soon after the completion of the square (though it is not shown in Hollar's etching of Covent Garden, dating from about 1650), and was carefully integrated with it architecturally, as the string courses demonstrate. This house was converted into a hotel in 1774; it still stands, though completely refaced, and is now the offices of George Monro (Produce) Ltd.

The south side of the square was originally occupied by the boundary wall of Bedford House, but when Wriothesley, 2nd Duke of Bedford, decided to make Southampton House his London home, Bedford House was pulled down, in 1705-6, and Tavistock Row was built. Some of these early Queen Anne houses, none of which survives today, are seen on the left: note the wooden window frames flush with the brickwork – after the Building Act of 1709, they would have been required to be set back four inches, as an added safeguard against fire.

As may be seen by comparing this picture with Van Aken's view (No. 1), the market had expanded considerably in the space of thirty years. The line of sheds had been replaced by a row of two-storeyed buildings (the upper storeys even being used as

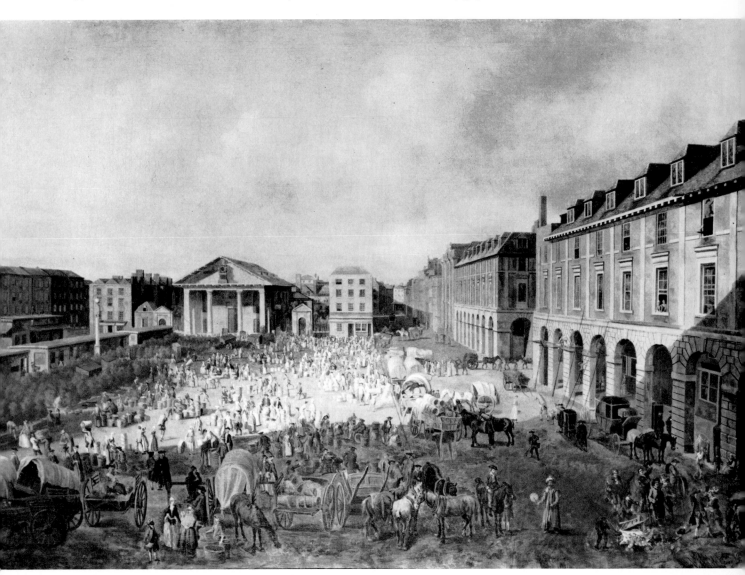

bedrooms), and the open stalls by a row of more permanent sheds. The clock points to half-past nine, and the market is still bustling with activity; numerous carts are shown outside the railings on the north and east sides of the square, a sedan chair is seen passing by on the right, and a coach and another sedan are waiting for custom nearby. An affray is taking place in the foreground as a result of an overturned vegetable barrow.

This painting is an unfinished version (the buildings, and the majority of the figures, have not been given Scott's detailed finish, and the cupola of St. Paul's and spire of St. Martin-in-the-Fields have not been painted in) of the canvas of almost identical size in the collection of the Duke of Bedford, once attributed to Canaletto but now recognised as the work of Scott, with the help of Sawrey Gilpin for the animals (see *The Farington Diary*, cited above) and as a commission for Lord Hardwicke. The animals were no doubt also put in by Gilpin in the Museum version as well, which would give a date of between 1749 and 1758, when Gilpin was apprenticed to Scott. The costume indicates a date of about 1750-60. Studies for the figures of the two ladies in the foreground left are in the Oppé collection. A preliminary oil sketch in which the essentials of the composition are already worked out is in the collection of Mr. and Mrs. Paul Mellon.

CHARLES SIMS (1873-1928)

Portrait, religious, figure, genre, landscape and decorative painter. Born in Islington, the son of a costume manufacturer. Studied at the Royal College of Art 1890, the Académie Julian, Paris, 1891-2, and the Royal Academy Schools 1892-5. A.R.A. 1908; R.A. 1915. Painted the large mural of *King John confronted by his Barons* for St. Stephen's Hall, Westminster, in 1924. Lived in various parts of London, and after 1906, at Fittleworth, Sussex.

100 VIEW IN KENSINGTON GARDENS (65.84)

Fibreboard. 9½ × 14½ inches (23.75 × 36.25 cms.). Signed bottom right: *SIMS* Painted about 1920-5.

Provenance: Presented by George Fraser in 1965.

Exhibited: Paddington Art Exhibition, Paddington, March 1949 (74).

A view in Kensington Gardens looking north-west, and taken from the path which leads diagonally from Queen's Gate to the Broad Walk. The magnificent avenue of elms, cut down in 1953-4, which formerly lined the Broad Walk, and masked Kensington Palace, is seen in the distance; on the right is the Round Pond. There are a number of scattered figures.

Kensington Gardens, as we now know them, were laid out between 1726 and 1733, chiefly to designs by Charles Bridgman. Though they have been much altered since, the Broad Walk, the Round Pond, and the avenues which radiate from the Round Pond, are all part of the original layout. The Gardens, which were, of course, the private grounds of Kensington Palace, were then enclosed by a high brick wall, and were open to the public only on Saturdays. From the beginning of the last century, however, they were opened every day, and the walls were gradually removed between 1826 and 1861

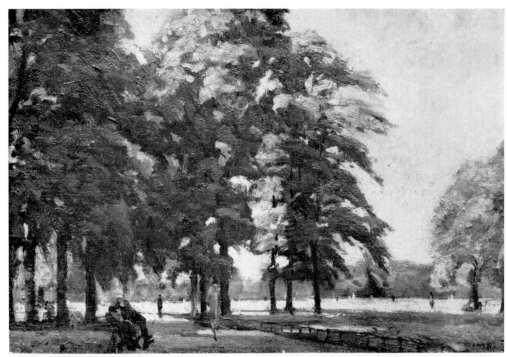

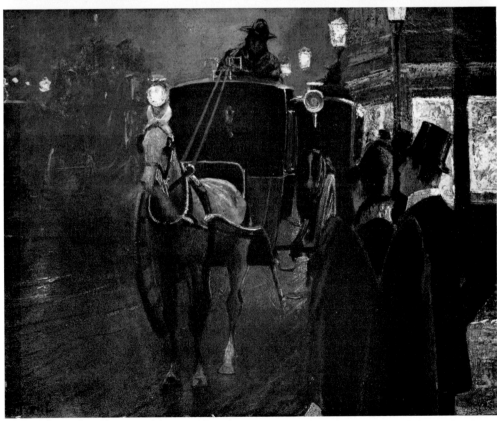

and replaced by low walls surmounted by iron railings. The Round Pond has been a favourite place for sailing model boats for fifty years and more. The shin railings seen in the picture, which formerly lined all the gravel paths, were removed during the Second World War (at the same time the iron railings surmounting the walls were taken down).

P. STAHL (active late nineteenth century)
Nothing is known about this artist.

101 A HANSOM CAB STAND (60.114/2)
Panel. 7⅞ × 10 inches (19.7 × 25 cms.). Signed bottom left: *P Stahl* (the PS in monogram). Painted about 1889-90.

Provenance: Babington; anon. sale, Sotheby's, 27 July 1960 Lot 142 bt. Colnaghi on behalf of the Museum.

A night scene with a couple in evening dress approaching the foremost of two hansom cabs drawn up at the kerbside of a brightly lit street. An omnibus is passing by in the opposite direction. Hansom cabs first appeared on the London streets in 1835, and this painting shows the two most characteristic features of these vehicles: the exceptionally large wheels, and the positioning of the driver's perch at the rear, features which ensured a high degree of balance and therefore safety. The first London taxicab, a Renault, made its début in 1907, and by the beginning of George V's reign, the hansom was in inevitable decline.
 The costume indicates a date of about 1889-90.

CALEB ROBERT STANLEY (c. 1790-1868)
Topographical and landscape painter. Lived in Mayfair.

102 THE STRAND, LOOKING EASTWARDS FROM
 EXETER CHANGE (60.171)
Canvas. 30 × 27⅛ inches (75 × 67.8 cms.). Signed bottom left: *C R Stanley* Painted about 1824.

Exhibited: British Institution, 1825 (309).

Provenance: Purchased out of the Joicey Trust Fund from M. Bernard in 1960.

A view of part of the Strand, looking eastwards towards St. Mary-le-Strand, built by James Gibbs in 1714-7, and St. Clement Danes, a Wren church of 1680-2 with a spire added by Gibbs in 1719. Savoy Street is on the extreme right, and the next turning, visible in the middle distance, is Wellington Street, which led to Waterloo Bridge.

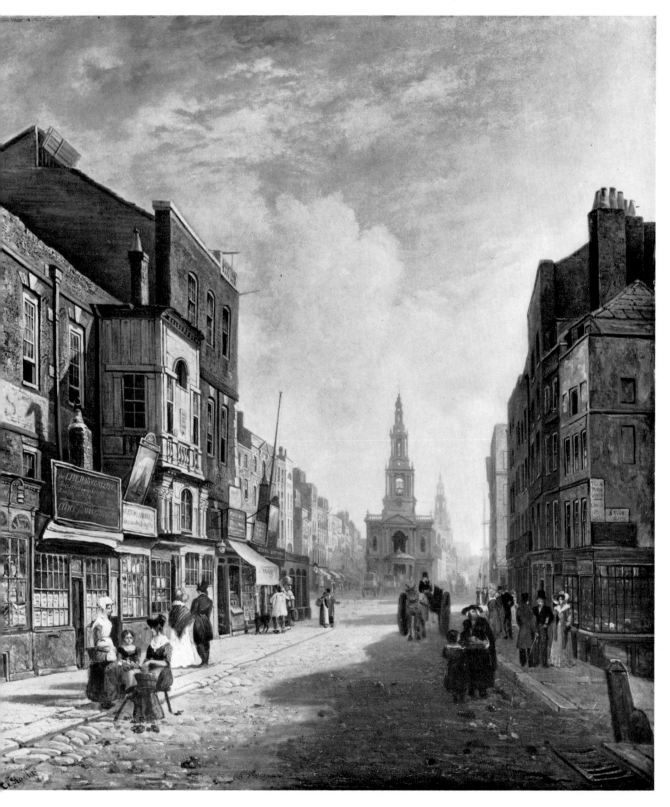

Exeter Change, from which the picture was taken, was an arcade of shops on two levels, built in 1676 and demolished at the time of the Strand improvements in 1829.

At this date, the Strand was still one of London's principal shopping streets, and the eighteenth century buildings seen here, with the shop windows divided into small panes of glass, were typical of the street's general appearance throughout its length. The shop on the extreme left, at No. 363 Strand, belonged to Mary Arthur, snuffman; next door, at No. 362, were the offices of *The Literary Gazette* (numerous newspaper offices were then situated in this area, notably in Catherine Street); and also in this block were the offices of two steam packet companies. The premises on the far right cannot be identified, though it is known that Thomas Gill, patent agent, had an office on one floor; Thomas Remnant, glover, was at No. 126, and the Globe and Travel Office at No. 127; premises further along included a boot and shoe maker and a tailor. Two street sellers are active on either side of the street; notice also the cobbled roadway, and the cab stand in front of St. Mary-le-Strand; this was the site of the first hackney carriage stand established in London, in 1634.

The picture was evidently painted about 1824, as by the following year (when it was exhibited) *The Literary Gazette* had moved from No. 362 Strand to No. 263.

W. THOMPSON (active early nineteenth century)
Genre painter; nothing is known about his life.

103 THE UPPER CONDEMNED CELL AT NEWGATE PRISON
ON THE MORNING OF THE EXECUTION OF
HENRY FAUNTLEROY (A 28580)

Canvas. $40\frac{1}{8} \times 50\frac{1}{4}$ inches (101.9 × 127.6 cms.). Signed and dated (on the chair) bottom right: *W. Thomson/1828.*

Provenance: Purchased from G. Harmsworth and Co. in 1914.

Henry Fauntleroy (1785-1824) was a partner in the banking firm of Marsh, Sibbald and Company, who was convicted of forgery in 1824 and condemned to death. Fauntleroy, while pleading guilty, declared that his actions had been forced upon him by the instability of the bank's position, and that all the sums he had raised had been used solely to improve its credit. His case aroused a great deal of sympathy, and it was said that over 100,000 people witnessed the execution on the morning of 30 November 1824.

In the scene shown here, Fauntleroy is depicted in the upper condemned cell at Newgate Prison, preparing to leave for his execution. He is seen framed against the doorway, with the executioner in the act of tying his hands. Another condemned prisoner is having his shackles removed prior to execution, and a third, with his hands already tied, is seated on the right. Among the other persons present who can be identified are the Ordinary of Newgate, the Rev. Mr. Cotton, fifth from the left; two friends of Faunt-

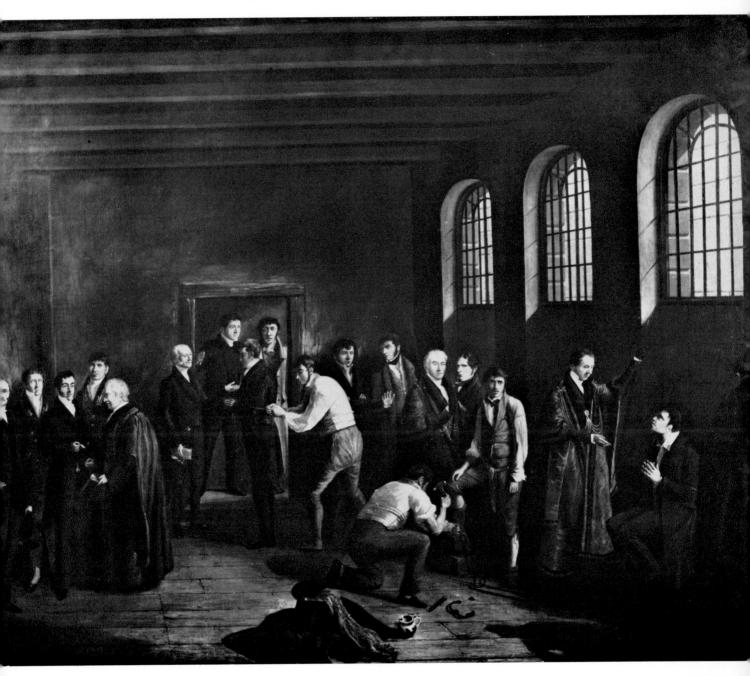

Plate 103 The Upper Condemned Cell at Newgate Prison on the Morning of the Execution of Henry Fauntleroy by W. Thompson. Signed and dated 1828

leroy's, the Rev. Mr. Springett and the Rev. Mr. Baker, who accompanied him to the scaffold (the former had sat with him all night), sixth and seventh from the left; Harris, the turnkey, who had been very kind to the prisoner, ninth from the left; and the Sheriffs of the City of London, Peter Laurie and G. Byrom Whittaker, third and sixth from the right respectively, who arrived at 7.45 a.m.

A painting by Thomson in the same genre, representing the last three pirates to be hanged receiving the death sentence from Sheriff Kelly, and signed and dated 1827, was in the possession of F. W. Wheeler in 1919, and a sketch for a later picture of prisoners being prepared for execution in the condemned cell at Newgate, dated 13 May 1828, is in the Guildhall Library.

DAVID TINDLE (born 1932)

Landscape, topographical and abstract painter. Born in Huddersfield. Studied at Coventry Art School. Teaches at Hornsey College of Art, and lives in Islington.

104 BATTERSEA REACH AND THE RAILWAY BRIDGE FROM BATTERSEA BRIDGE (63.145)

Canvas. 32 $\frac{9}{16}$ × 46$\frac{5}{8}$ inches (81.4 × 115.6 cms.). Signed and dated bottom right: *David Tindle 1956*

Provenance: Purchased from the Piccadilly Gallery in 1963.

A view of the river which conveys all the greyness of the London atmosphere on a winter's day. On the left are some of the Victorian warehouses that line the Battersea shore. In the distance is the railway bridge built for the Southern Railway, at the time of its construction the widest railway bridge in the world, with beyond this the Fulham power station. On the right is the Lots Road power station, used for the underground railways, situated just to the west of the Chelsea Flour Mills and at the extreme end of Cheyne Walk. A number of barges are seen on the river.

DANIEL TURNER (active 1782-1806)

Landscape, marine and portrait painter and engraver; best known for his views of London's riverside. Pupil of John Jones, the mezzotint engraver. Lived in Millbank. Sometimes known as David Turner.

105 THE TOWER OF LONDON FROM THE RIVER (A 8084)

Panel. 11$\frac{3}{4}$ × 16$\frac{3}{8}$ inches (29.4 × 40.9 cms.). Painted about 1790-1810.

Plate 104 Battersea Reach and the Railway Bridge from Battersea Bridge by
David Tindle. Signed and dated 1956

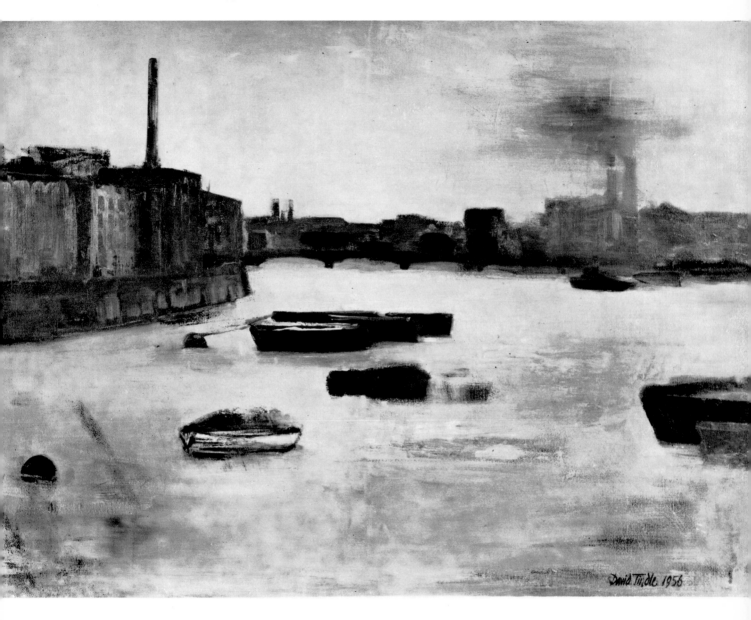

Provenance: With Obach and Co.; Obach sale, Christie's, 6 February 1909 Lot 126 (without attribution) bt. Leggatt; purchased from Leggatt Brothers in 1912.

A view which has for its principal subject the White Tower, but making the mistake, common among London topographers, of depicting the north-eastern tower as square instead of rounded. In front of the White Tower is St. Thomas's Tower, with the Traitors' Gate just visible, but the eastern bastion omitted; and behind it the Great Armoury or Storehouse, which was burnt out in a fire on 30 October 1841 (a barracks now occupies this position). On the right is one of the Ordnance buildings, a structure built at the end of George II's reign, in front of the old Horse Armoury.

Along the waterfront can be seen the easternmost part of the forty foot wide quayside that stretched past the Custom House to Queenhithe, one of the improvements carried out during the rebuilding of London after the Great Fire, replacing the clutter of wharves and warehouses that had so impeded the work of the Port. A number of sailing vessels and other craft are seen on the river.

The costume indicates a date of about 1790-1810.

CLAUDE ALFRED PENNINGTON WALKER (1862-c. 1925)

Picture restorer and topographical painter. Born in Cheltenham, the son of a mathematician. Studied at the South Kensington schools. Lived first in Primrose Hill and Belsize Park, and afterwards in Fulham.

106 THE VALE OF HEALTH, HAMPSTEAD HEATH (A 28581)

Canvas. 24⅛ × 29 inches (60.3 × 72.5 cms.). Signed bottom left: *C Walker*. Painted about 1910.

Provenance: Unknown.

This part of Hampstead Heath was marshland until the end of the eighteenth century, when it was drained and christened the Vale of Health. A number of tea gardens were soon established, and amongst famous people who had houses here were Leigh Hunt, Rowland Hill and Douglas Jerrold. Many of these early villas survive, but for the most part the Vale is now composed of Victorian terrace houses. As well as being a retreat, the Vale was also a centre for laundresses and sweeps in the earlier part of the nineteenth century. The Hampstead Bank Holiday Fair, perhaps the best known of all London's outdoor amusements, takes place annually outside the village.

This view is taken from a point on the heath below Jack Straw's Castle, looking east. The road that winds through the village is seen centre and right, and to its left is the walk that leads to the fairground. The Victorian villa whose gables and chimneys appear on the extreme right still stands, adjoining Villas-on-the-Heath, but the building behind has now disappeared: this was the Athenaeum, at first a club, but in use as a gymnasium at the time this picture was painted – it was demolished in 1958 and replaced by a block

Plate 105 The
Tower of London
from the River by
Daniel Turner.
Painted about 1790–
1810

Plate 106 The
Vale of Health,
Hampstead Heath
by Claude Walker.
Painted about 1910

187

of flats; the Vale of Health Hotel, seen in the centre, was pulled down in 1964.

A gouache drawing by the same artist, also done on Hampstead Heath (a panorama of London from Parliament Hill, signed and dated 1909), is also in the Museum (A 8089).

CHARLES JOHN WATSON (1846-1927)
Topographical painter, etcher and lithographer. Born in Norwich, the son of a printseller, carver and gilder. Prevented from studying in London by his father's death, and carried on the family business. Left Norwich in 1888, and lived first in Chelsea and afterwards in Hammersmith.

107 DRURY COURT WITH THE CHURCH OF ST. MARY-LE-STRAND (39.166/3)
Millboard. 18 × 12 inches (45 × 30 cms.). Signed and dated bottom left: *C. J. Watson/1886.*

Provenance: Mrs. C. J. Watson: S. H. Dowson, by whom it was presented in 1939.

Engraved: One of a set of six etchings (with frontispiece) published in January 1880 under the title of the *London Thoroughfare Series*, and signed and dated 1878 (*Catalogue of the Etched and Engraved Work of Charles J. Watson, R.E.*, privately printed, 1931, No. 25, repr. p. 11.)

This view is taken from a point slightly to the south of that used by Philip Norman in his painting of the same subject (see No. 84) and shows the beginning of Wych Street on the left, with part of the north frontage of Bates's British Coffee House. Some road works are in progress, workmen being seen in the foreground near a brazier and a couple of carts.

Drury Court was originally called Maypole Lane, on account of its proximity to the Maypole in the Strand; the great Maypole erected after the Restoration was removed by Sir Isaac Newton at the time of building the church of St. Mary-le-Strand in 1714-7 (the church is seen in the middle distance). Drury Court was one of the streets cleared at the time of the Aldwych and Kingsway improvements, 1900-5.

FREDERICK A. WINKFIELD (active 1873-1904)
Marine painter. Lived in Fulham.

108 THE RIVERSIDE AT LIMEHOUSE (53.29)
Canvas. 18 × 20 inches (40 × 50 cms.). Signed bottom left: *F. A. WINKFIELD* Painted about 1877-80.

Provenance: Purchased out of the Joicey Trust Fund from the Leicester Galleries in 1953.

A barge builder's yard is prominent among the wooden buildings characteristic of the

Plate 107 Drury Court with the Church of St. Mary-le-Strand by C. J. Watson.
Signed and dated 1886

189

Limehouse riverside which are seen on the right. Two barges are moored in the centre and, on the left, a tug is towing out a schooner. In the mid-nineteenth century Limehouse still possessed a very marked character of its own, commemorated in several of Dickens's books; but by the time this picture was painted, something of this individuality had been lost: Limehouse had become swallowed up in the street development of East London, and it was no longer possible to walk across the open fields to Bow Common.

The view is taken close to the Harbour Master's office, the headquarters of the Thames police, and the *Bunch of Grapes*, which can just be made out in the middle distance (the first-named has a flag flying), and shows the premises of George and William Lamb, mast makers, of No. 92 Narrow Street, Charles John Hartnoll, barge builder, at No. 94, and, on the extreme right, the *Two Brewers*.

The picture must date between 1877, when Surridge and Hartnoll moved to Narrow Street, and about 1880, when the partnership with Surridge had come to an end (his name has been obliterated on the fascia shown here).

109 WESTMINSTER BRIDGE AND THE HOUSES OF PARLIAMENT FROM THE RIVER (61.142/1)

Canvas. 14⅛ × 24 inches (35.3 × 60 cms.). Signed bottom left: *F. A. WINKFIELD* and inscribed bottom right: *OEO* Painted about 1890.

Provenance: J. G. Appleby sale, Christie's, 22 January 1960 bt. Nicholls; purchased from the Piccadilly Gallery in 1961.

Exhibited: The Thames, Piccadilly Gallery, August 1961 (20).

The Houses of Parliament, designed by Sir Charles Barry and Augustus Pugin in 1835 and built in 1840-60, are here viewed from the south-east, across the new Westminster Bridge, which was erected in 1854-62 to the designs of the engineer, Thomas Page. Dominating the skyline are the Victoria Tower, completed in 1860, and Big Ben, finished in 1858. Westminster Abbey can be seen in the distance beyond Big Ben, and on the extreme right is part of the Victoria Embankment, with the new St. Stephen's Club, built in 1874, on the corner of Bridge Street. A number of barges and tugs can be seen on the river.

A closer, and larger, view of the Houses of Parliament, by Anderson, is also in the collection (No. 3).

Plate 108 The Riverside at Limehouse by F. A. Winkfield. Painted about 1877-80

Plate 109 Westminster Bridge and the Houses of Parliament from the River by F. A. Winkfield. Painted about 1890

110 THE POOL OF LONDON (62.187)

Canvas. 14 × 24 inches (35 × 60 cms.). Signed bottom left: *F. A. WINKFIELD* and inscribed bottom right: *LIM* Painted about 1890.

Provenance: Anon. sale, Bonham's, 20 December 1962 Lot 244 bt. London Museum.

A view of the Pool from Southwark, looking westwards towards London Bridge. The buildings most clearly depicted are, from left to right, Cannon Street Station (built in 1865-6), the dome of St. Paul's, St. Magnus the Martyr, the Monument, the Customs House, the steeple of St. Dunstan-in-the-East and the spire of St. Margaret Pattens. A variety of craft are seen on the river.

IMITATOR OF DEAN WOLSTENHOLME THE YOUNGER (1798-1892)

111 BARCLAY AND PERKINS'S BREWERY, PARK STREET, SOUTHWARK (A 8069)

Canvas. 20⅛ × 25⅞ inches (50.3 × 64.7 cms.). Painted about 1832-40.

Provenance: Purchased from Leggatt Brothers in 1912 (as Shayer).

The Anchor Brewery, owned by Barclay and Perkins, vastly extended and modernised in the rebuilding after the fire of 1832, was, in the mid-nineteenth century, the largest brewery in the world and covered over 12 acres on either side of Park Street, Southwark, including the site of the Globe Playhouse, and with a wharf on Bankside. It was one of the recognised sights of London, and among eminent visitors at that time were Ibrahim Ali, son of the Pasha of Egypt, and Prince Louis Napoleon, later Napoleon III.

Brewing became an important industry in Southwark soon after the introduction of hop growing in Kent in the fifteenth century, and the first brewhouse on the site of Barclay and Perkins's premises was established by James Monger in about 1616. In the possession of the Thrales in the eighteenth century, the Brewery was sold in 1781 by the executors of Henry Thrale, one of whom was Dr. Johnson, and purchased by Robert Barclay, a member of the Quaker banking family. One of Barclay's first actions was to make Thrale's enterprising manager, John Perkins, a partner in the business, and the firm continued to flourish under this name until 1955 when it was taken over by Courage (Eastern) Ltd.

This view shows the entrance to the Brewery in Park Street, with the office block at the rear of the yard. To the right of this is the range that housed the fermenting vessels, and above the entrance wing the three windows of the head brewer's office. On the extreme right is the Great Brewhouse, with its eight huge windows, and the light suspension bridge that connected it with the buildings on the east side of the street. The Brewery presented much the same appearance until the reconstruction and modernisation of 1960.

192

Plate 110 The Pool of London by F. A. Winkfield. Painted about 1890

Plate 111 Barclay and Perkins's Brewery, Park Street, Southwark by an imitator of Dean Wolstenholme the Younger. Painted about 1832-40

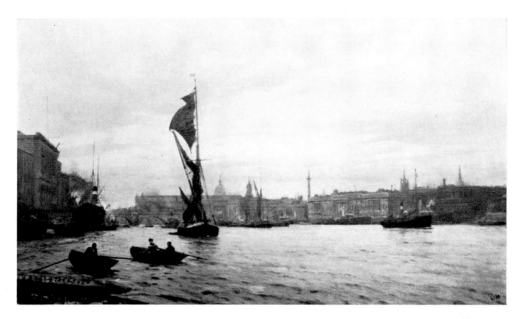

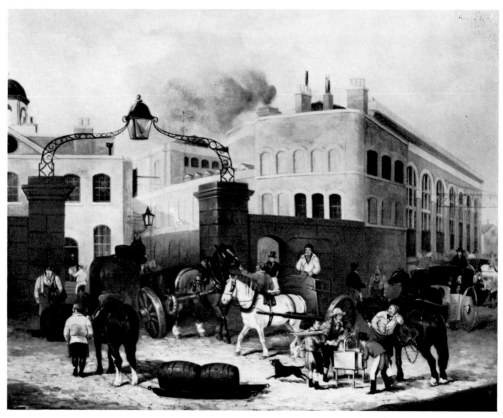

The picture is no less interesting for its incidental detail. A dray is seen emerging from the yard, and, to the left, other barrels are being carried on horse-drawn sleds (the sign of the anchor is clearly visible on the horses' harness). On the right a butcher's boy, carrying a wooden tray, together with another customer, have stopped at a baked potato stall. Beyond, and further to the right, two visitors are being driven to the Brewery in one of the newly introduced hansom cabs (distinguished from other vehicles by its single pair of big wheels, and the seating of the driver behind) (see also No. 101).

The costume indicates a date of about 1830-40, and the picture must have been painted later than 1832, when the rebuilding operations began after the fire.

IMITATOR OF JAN WYCK (c 1645-1700)

112 TITUS OATES IN THE PILLORY OUTSIDE WESTMINSTER HALL (34.54)

Canvas. 25 × 29⅞ inches (62.5 × 74.7 cms.). Painted about 1687.

Provenance: Purchased from Leger Galleries by the National Art-Collections Fund in 1934, and presented to the Museum.

Reference: 31st Annual Report of the National Art-Collections Fund, 1934, London, 1935, p. 40.

Reproduced: Twenty-Five Years of the London Museum, London, 1937, pl. LIX.

Titus Oates (1649-1705), perhaps the most infamous of all false informers in British history, was brought to trial for perjury in May 1685. He was condemned by Judge Jeffreys to imprisonment for life, and to stand in the pillory annually at certain specified places, sentences which, as David Ogg observes, were probably intended to be superfluous, since he was sentenced in addition to be flogged from Aldgate to Newgate, and two days later, from Newgate to Tyburn. Extraordinarily, Oates survived this ordeal, and the Museum picture shows him standing in the pillory in New Palace Yard in 1687. Westminster Hall appears on the left, with, beyond, a range of late Tudor buildings incorporating one of the towers of the Palace Gate which formerly stood at this point; and in the distance is the Palace Gate which opened on to King Street (not to be confused with the better known King Street gate of Whitehall Palace).

The viewpoint of the picture is identical with that adopted by Hollar for his etching of 1647, and it seems possible that the artist based his composition on Hollar's print, and that he was not actually familiar with London at all. Support for this theory comes from the inclusion of the Palace Gate in the distance, which appears in Hollar, but which had evidently been pulled down before William Morgan published his great map of London in 1682; and from the features of the many figures in the crowd, which are decidedly more Dutch than English.

Doubts have been expressed as to whether the picture represents Titus Oates (the traditional title of the picture, for which there is no known authority). There is no other

194

Plate 112 Titus Oates in the Pillory outside Westminster Hall by an imitator of Jan Wyck.
Painted about 1687

195

portrait of him with which the head painted here may be compared; but it should not be assumed, anyway, that the latter was necessarily a good likeness of the pilloried man, or indeed a likeness at all. However, the costume of the numerous figures points in all particulars to a date of about 1685; there was no other case of the period in which such crowds could have been expected to congregate and special boxes to have been erected outside Westminster Hall; and prints of Titus Oates in the pillory seem to have been produced quite commonly in and after 1685. There is little reason to suppose, therefore, that the painting does not represent Oates; whether it is an actual record of the scene is open to considerably more doubt. The treatment of the architectural detail is very generalised, and of little archaeological value.

The painting generally, and the very idiosyncratic stylised clouds, suggest that the painter was a close follower of Jan Wyck, and the handling is identical with a view of the Frost Fair of 1683-4 attributed to Jan Wyck, now in the collection of Mr. and Mrs. Paul Mellon.

Portraits and Theatrical Pictures

It has not been the policy of the Museum to collect portraits of eminent Londoners, as this task is to a large extent fulfilled by the National Portrait Gallery, and most of the portraits acquired have entered the Museum as part of the theatrical collections.

JAMES ARCHER (1823-1904)

Portrait, history and genre painter. Born in Edinburgh, the son of a dentist. Studied at the Edinburgh Trustees Academy. A.R.S.A. 1850; R.S.A. 1858. Settled in London 1862, and lived in Kensington; spent his last years at Haslemere.

113 SIR HENRY IRVING (1838-1905) AS *MATHIAS* IN *THE BELLS* (38.41/6)
Canvas. $20\frac{3}{4} \times 27\frac{1}{4}$ inches (50.2 × 76.9 cms.) (oval). Painted 1871-2.

Provenance: The Lyceum Theatre (Beefsteak Room); Weedon Grossmith; Red Cross Sale, Christie's, 23 April 1915 Lot 1440 (presented by W. Grossmith) bt. Mrs. Barton; lent by E. Temple (pseudonym) in 1938, and afterwards presented.

Exhibited: Royal Academy 1872 (275); *Relics of Sir Henry Irving*, London Museum, February-April 1938 (33); Irving Commemorative Exhibition, Saville Theatre, December 1955-April 1956.

Reference: Laurence Irving, *Henry Irving The Actor and His World*, London, 1951, p. 211.

Three quarter length seated in an armchair, facing half left, and wearing a reddish brown suit with a reddish brown and yellow striped waistcoat.

The part of the Burgomaster *Mathias* in *The Bells*, a man racked by remorse for a murder he had committed many years before, was perhaps Irving's most famous rôle, and certainly the one he performed most frequently. The scene depicted here is the

196

Plate 113 Sir Henry Irving as *Mathias* in *The Bells* by James Archer. Painted in 1871-2

moment at the end of Act I when *Mathias*, on the anniversary (and at the very hour) of his crime, suddenly hears the bells of the murdered man's sledge ringing in his ears, and sinks back into his chair, transfixed.

The Bells, a play by Leopold Lewis based on a French original, held a place of particular significance in Irving's career, as it was the play which established his reputation on the London stage. The young actor had just joined H. L. Bateman's company at the Lyceum, and things were not going well; he entreated Bateman to try *The Bells*, which would give him the chance to play a tragic rôle, instead of the comic and character parts for which he was actually engaged. Despite the fears of the company, and a thin audience on the opening night, 25 November 1871, Irving's gamble was triumphantly justified; the critics were unanimous in their acclaim, and the play was kept in the bill for fully six months. In 1892, when Irving's own company wanted to show their affection for their master, they did so by presenting him with a bronze to mark the 21st anniversary of his appearance as *Mathias*.

Costumes worn by Irving as *Mathias* are in the Museum's collection (Nos. 24-6 and 31 in the Catalogue of Stage Costume and Accessories published in 1968). The latter on permanent loan from the Governors of the Royal Shakespeare Theatre, Stratford-upon-Avon. Accessories from the play are also in the collection (Nos. 27-30 in the Stage Costume Catalogue).

Other portraits of Irving in oils, by Partridge (No. 122) and Eves (No. 117), are in the Museum. Archer also painted Irving as *Charles I* (Russell Cotes Art Gallery, Bournemouth).

HENRY BARRAUD (1811-74)
Portrait and animal painter, best known for his large group portraits (in which his brother, William Barraud (1810-50), sometimes painted the backgrounds). Pupil of J. J. Middleton. Lived first in Camberwell, and afterwards in Mayfair and St. Marylebone.

114 PORTRAIT GROUP OF MEMBERS OF THE MARYLEBONE CRICKET CLUB OUTSIDE THE PAVILION AT LORD'S (A 25329)
Canvas. 28 × 60 inches (70 × 150 cms.). Painted about 1870-4.

Provenance: Henry Barraud sale, Christie's, 24 June 1875 Lot 112 bt. in; purchased in 1923 (without attribution).

About ninety members of the Marylebone Cricket Club and well-known patrons of cricket are shown grouped in the foreground, with other figures seen around and outside the Pavilion; among those who can be identified are Sir R. Ponsonby-Fane (fifteenth from the left), the Earl of Darnley (sixteenth from the left), the Prince of Wales, later Edward VII (twenty-first from the left), E. M. Grace (thirty-fifth from the left), R. A. Fitzgerald, then the Hon. Secretary (thirty-sixth from the left), and W. G. Grace (thirty-eighth from the left). The Pavilion, which is flying the Union Jack and the M.C.C. flag, is seen as enlarged by H. Newton in 1866; further improvements were

Plate 114 Portrait Group of Members of the Marylebone Cricket Club outside the Pavilion at Lord's by Henry Barraud. Painted about 1870-4

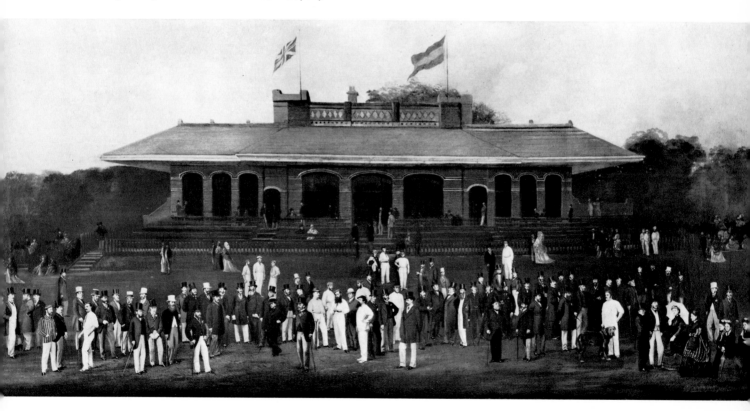

carried out in the 1880's, but the building was soon afterwards demolished, and the present Pavilion, by F. Verity, was built in 1889-90.

In the mid-eighteenth century, cricket matches in London were played first at the Artillery Ground in Finsbury Square, and then at White Conduit Fields, Islington. The latter, however, was used for amusements of all kinds, which proved a considerable inconvenience, and Thomas Lord, one of the employees of the White Conduit Club, was asked to find a new ground. Suitable quarters were found on the site of what is now Dorset Square, the Marylebone Cricket Club was formed, and the first match was played on 31 May 1787. The Club moved to its present home in 1814. By the date of this picture, the M.C.C. was well established as the premier club in Britain and the arbiter upon all matters relating to cricket, W. G. Grace was in full career, and the law permitting over-arm bowling (which laid the foundations of modern cricket) had been operative for a decade.

The Museum picture, the painting of *The London Season* (a view in Hyde Park) and *The Lobby of the House of Commons in* 1872, both of which were also in the Christie sale of 1875, were the three canvases by which Barraud was best known to his contemporaries.

The Museum picture is related to two other portrait groups by Barraud, both photographs. The first, which is signed, is substantially the same group, but taken from a different viewpoint, showing more of the ground and with the Pavilion on the right. The second is a different group, but with exactly the same background; this was published as an autotype photograph by Barraud and Jerrard 1 May 1874. In both these groups the foreground figures are separate photographs, and have been stuck on individually.

The costume indicates a date in the early 1870's.

GEORGINA A. BRACKENBURY (active 1927)
Miniature and portrait painter. Lived in Chelsea and Kensington.

115 PORTRAIT OF MRS. RICHARD MARSDEN PANKHURST, née EMMELINE GOULDEN (1858-1928) (50.82/1486)
Canvas. 29⅞ × 21½ inches (74.7 × 53.7 cms.). Painted about 1927.

Provenance: Presented by the Suffragette Fellowship in 1950.

This portrait was painted very shortly before Mrs. Pankhurst's death. She is shown at half length, facing the spectator, with her head turned upwards and slightly to right, wearing a black dress and a loose fur trimmed coat and holding a pair of spectacles in her left hand; plain background.

Mrs. Pankhurst's husband had been an advocate of women's suffrage long before she knew him, and, after marrying, she at once became deeply involved in work for the cause. Successively a member of the Liberal and the Independent Labour Parties,

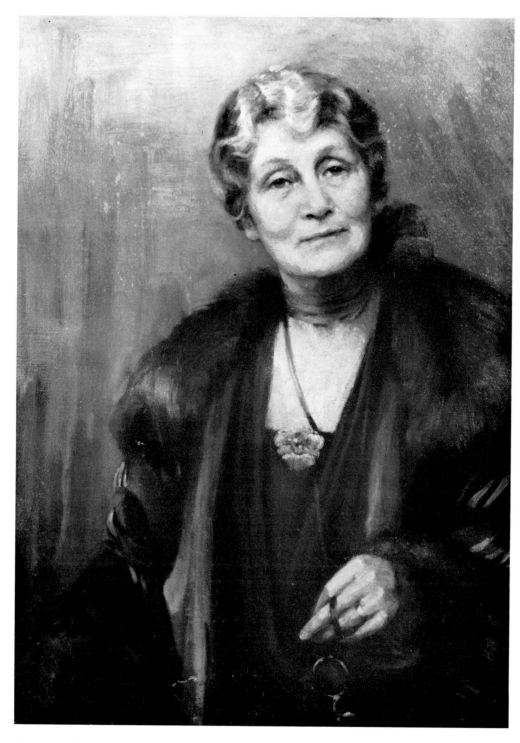

Plate 115 Portrait of Mrs. Richard Marsden Pankhurst, *née* Emmeline Goulden by Georgina Brackenbury. Painted about 1927

neither of which proved sufficiently sympathetic to her aims, she founded the Women's Social and Political Union in 1903. As orthodox political methods achieved no results, she adopted a policy of violence and sensationalism; arrested and imprisoned several times, and ruining her constitution by protracted hunger strikes in gaol, Mrs. Pankhurst only gave up the militant campaign for women's suffrage with the outbreak of war in 1914. The vote was finally won, largely as a result of the part women had played during the war, by the Acts of 1918 and 1928.

Another slightly larger version of this picture is in the National Portrait Gallery (No. 2360), and the artist stated in a letter dated 9 March 1929 (in the N.P.G. archives) that this canvas was painted from life some two years before.

This picture forms part of the large collection of relics of the Suffragette Movement, books, pamphlets, letters, photographs, personalia and other objects, presented by the Suffragette Fellowship in 1950.

CHARLES A. BUCHEL (active 1901-14)
Painter of nudes and portraits, chiefly theatrical portraits. Lived in Bloomsbury and Hampstead.

116 LIONEL BROUGH (1836-1909) AS *VERGES* IN *MUCH ADO ABOUT NOTHING* (56.169/30)

Canvas. 21¼ × 15⅝ inches (53.2 × 39.05 cms.). Signed bottom left: *CHAS. A. BUCHEL.* Painted about 1905.

Provenance: Presented by R. N. Green-Armytage in 1956.

Half length of Lionel Brough, facing half right and looking upwards, his arms folded in front of him, with plain background, in the part of *Verges* in Shakespeare's *Much Ado About Nothing*, which he played at the revival at His Majesty's Theatre, 24 January 1905. Lionel Brough made his first appearance on the stage at the Lyceum Theatre, London, in 1854, but he spent much of the next ten years in journalism, and did not begin to make a name for himself as an actor until he appeared in H. J. Byron's *Dearer than Life* in 1868. He was engaged almost exclusively for comic rôles, of which the best known was his *Tony Lumpkin* in *She Stoops to Conquer*, a part he played no less than 777 times. From 1894 till his death in 1909 Brough worked in Beerbohm Tree's company.

Plate 116 Lionel Brough as *Verges* in
Much Ado About Nothing by Charles
Buchel. Painted about 1905

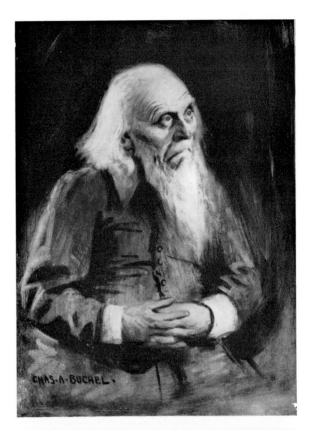

Plate 117 Portrait of Sir Henry Irving
by R. G. Eves. Painted about 1905-10

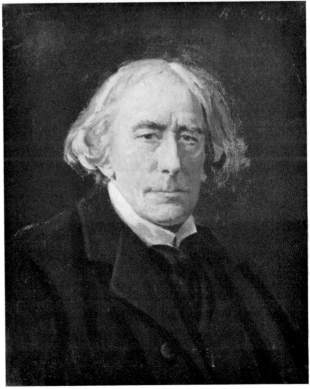

REGINALD GRANVILLE EVES (1876-1941)

Portrait, topographical and landscape painter. Born in Holborn, the son of a Justice of the Peace. Protegé of John Singer Sargent. Studied at the Slade School 1891-5. Settled in London as a portrait painter 1901, and painted many of the most prominent people in public life. Lived in Bloomsbury and St. John's Wood. A.R.A. 1933; R.A. 1939.

117 PORTRAIT OF SIR HENRY IRVING (1838-1905) (38.5/9)

Canvas. $24\frac{1}{8} \times 20$ inches (60.3 × 50 cms.). Signed top right: *R. G. Eves*. Painted about 1905-10.

Provenance: Fred Terry; presented by Miss Julia Neilson in 1938.

Exhibited: Relics of Sir Henry Irving, London Museum, February-April 1938 (2).

Head and shoulders facing slightly to right, with his head turned towards the spectator; plain background. Probably a posthumous portrait of the great actor, based on the photograph by William Crooke taken in Edinburgh in April 1904. For other portraits of Irving, see Nos. 113 and 122.

ARTHUR HACKER (1858-1919)

Painter of portraits, religious subjects, nudes and genre; also painted several views of London at night. Born in London, the son of an engraver. Studied at the Royal Academy Schools 1876-80, and in Paris at the Atelier Bonnat, 1880-1. A.R.A. 1894; R.A. 1910. Lived in St. Pancras, St. Marylebone and Kensington.

118 SIR JOHN MARTIN-HARVEY (1863-1944) AS *HAMLET* (50.3)

Canvas. $36\frac{1}{2} \times 30\frac{3}{4}$ inches (91.25 × 76.75 cms.). Signed and dated bottom right: *Arthur Hacker/1916*.

Provenance: Bequeathed by Lady Martin-Harvey in 1950.

Reproduced: ed. R. N. Green-Armytage, *The Book of Martin Harvey*, London, n.d. (=1928), facing p. xvi; Sir John Martin-Harvey, *Autobiography*, London, n.d. (=1933), facing p. 298.

Half length facing the spectator, his head turned half right, with his left hand at his brow and his right fingering his doublet. Martin-Harvey first played Hamlet at the Lyric Theatre in 1905, but mounted his own production at His Majesty's Theatre during the Shakespeare tercentenary celebrations of 1916. This picture was painted at the time of the 1916 production and represents the deranged Hamlet, but is probably not illustrative of any particular moment in the play.

Sir John Martin-Harvey, the distinguished actor-manager, began his career with fourteen years in Sir Henry Irving's company at the Lyceum Theatre, before founding his own company. His best known production was the play with which he began his career as an actor-manager in 1899, *The Only Way*, an adaptation of Dickens's *A Tale of Two Cities*. He was an early supporter of the idea of founding a national theatre.

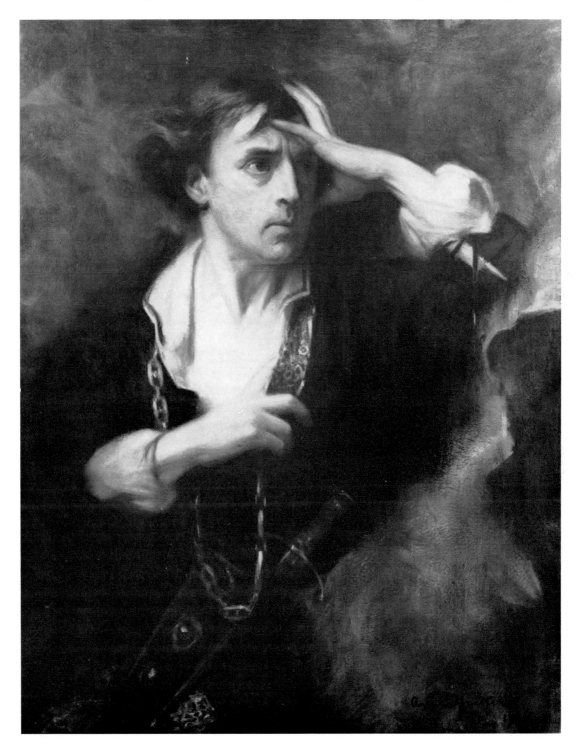

FRANCIS HAYMAN (1708-76)

Painter of history, portraits, conversation pieces, interiors, theatrical scenes and genre; and book illustrator. Best known for the large decorative canvases with genre subjects that he painted for Vauxhall Gardens during the 1730's and 1740's. Born at Exeter. Studied with Robert Brown, an Exeter portrait painter; came to London at an early age, and worked as a scene painter at Drury Lane Theatre. Played a leading part in forming the Society of Artists of Great Britain in 1760, and became its President 1766-8. Founder member of the Royal Academy 1768; appointed Librarian in 1771. One of the most versatile artists of his age.

119 DAVID GARRICK (1717-79) AND HANNAH PRITCHARD (1711-68) IN A SCENE FROM *THE SUSPICIOUS HUSBAND* (55.50)

Canvas. $25\frac{1}{2} \times 30\frac{5}{8}$ inches (63.75 × 76.6 cms.). Painted about 1747.

Provenance: Joseph Parkes; Parkes sale, Christie's, 8 May 1858 Lot 8 (as Zoffany) bt. Waters; Colonel the Honble. W. H. P. Carington; Carington sale, Christie's, 11 June 1887 Lot 50 (as Zoffany) bt. Parsons; T. Rogers and Co.; Rogers sale, Christie's, 23 July 1954 Lot 128 bt. Bernard; purchased out of the Joicey Trust Fund from Frank T. Sabin in 1955.

Exhibited: Francis Hayman, Iveagh Bequest, Kenwood, May-September 1960 (17); *David Garrick*, Abbey Dore Festival, September 1967.

Reproduced: R. Mander and J. Mitchenson, *A Picture History of the British Theatre*, London, 1957, pl. 69; Carola Oman, *David Garrick*, London, 1958, facing p. 96 (detail); *The Stage*, 27 November 1958 (detail); *The Illustrated London News*, 6 December 1958 (detail); Alec Clunes, *The British Theatre*, London, 1964, p. 92 (detail).

This picture shows David Garrick and Mrs. Pritchard as *Ranger* and *Clarinda* in Scene IV, Act IV of *The Suspicious Husband*, a comedy by Dr. Benjamin Hoadly which was first produced at Covent Garden on 12 February 1747, with Garrick and Mrs. Pritchard in the leading rôles. *Ranger* has been flirting with a masked lady, unaware that she is his cousin *Clarinda;* and Hayman has chosen the moment when *Clarinda* unmasks, and *Ranger*, much put out, declares, in an aside to the audience, 'I must brazen this out'.

Though only thirty at the time of this production, Garrick was already well-established as an actor of both Shakespearean and contemporary parts, having taken the town by storm in 1741 when he appeared as *Richard III* at Goodman's Fields. Mrs. Pritchard made her debut on the London stage in 1733; from 1744 until 1747 she appeared at Covent Garden, but she followed Garrick to Drury Lane when the latter took over the management of that theatre in 1747. She was one of Garrick's leading actresses for many years, and was held to be the greatest Lady Macbeth of her day.

Another (slightly larger) version of the Museum picture, inscribed in a contemporary hand as 'Painted by Mr Hayman 1747', is in the Garrick Club collection (Cat. No. 394): this was executed for Dr. Hoadly, the author of the play, and is identical except in one or two points of detail (e.g. Mrs. Pritchard is shown wearing a necklace), and in incorporating slightly more left, top and right. The fact that the Museum picture includes about

206

Plate 119 David Garrick and Hannah Pritchard in a Scene from *The Suspicious Husband* by
Francis Hayman. Painted about 1747

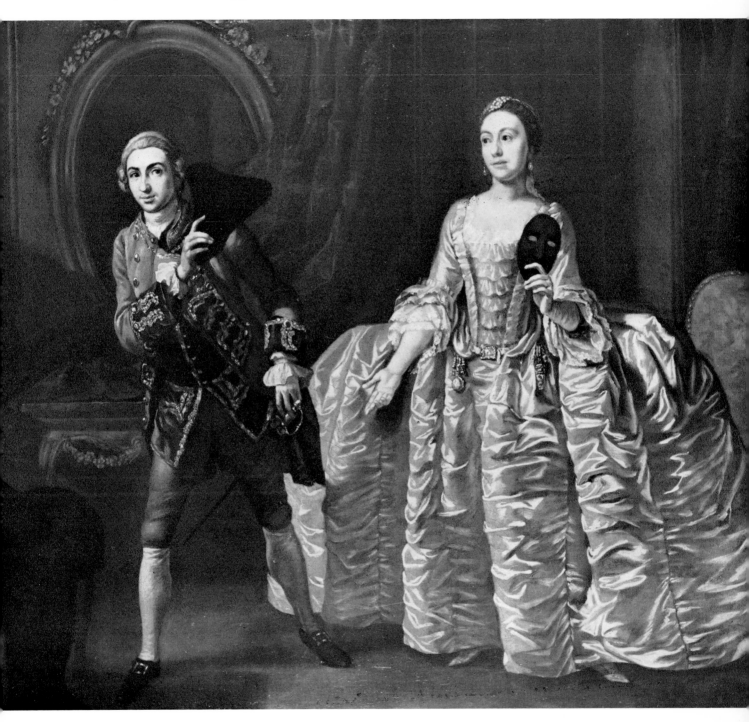

2 inches less of the composition on three sides, and in particular, loses part of Mrs. Pritchard's dress, suggests that it has been slightly reduced at some stage, and that it was originally a 28 × 36 inch canvas. At the time he did these pictures, Hayman was scene painter at Drury Lane.

WALTER H. LAMBERT (1870/1-1950)

Amateur painter of historical and genre pictures. Born in Jarrow. Studied at Harrogate Art School. Worked professionally on the stage as a female impersonator, under the name of Lydia Dreams.

120 POPULARITY: THE STARS OF THE EDWARDIAN MUSIC HALL (57.114)

Canvas. 64 × 150⅜ inches (160 × 375.9 cms.). Signed and dated bottom right: *Lydia Dreams. 1901-1903.*

Provenance: Peter Cannon (see below); A. Squires; A. Coleman, 1934; presented by Bernard Coleman in 1957.

This vast group portrait of the principal artistes of the Edwardian music hall includes no fewer than two hundred and thirty one performers, amongst them Harry Champion, Harry Lauder, Dan Leno, Marie Lloyd (on the right of the policeman), George Robey, Little Tich (bowler hatted in the foreground centre), Vesta Tilley (in male attire in the foreground right) and the artist himself (immediately above the sandwich board men in the foreground left, in his rôle as the female impersonator, Lydia Dreams: a self-portrait sketch of the artist signed and dated August 1900 is in an autograph book owned by Mr. Ellis Ashton). The first owner of the picture, Peter Cannon ('Bijou'), a friend of the artist, is seen with his partner 'Bella' on the left of the policeman.

The scene is the junction of Lower Marsh and the Cut with the Waterloo Road, the traditional meeting place of music hall artistes, and down which a couple of 'buses, a brougham and an open landau are seen. In the distance is the railway bridge constructed for the extension of the South Eastern Railway from London Bridge to Charing Cross in the early 1860's, and the tower and spire of St. John's, Waterloo Road, built in 1822-4. The Old Vic (formerly the Royal Victoria Music Hall) would have appeared just outside the picture, on the right.

Music hall, an essentially popular art form designed entirely to amuse, originated in the early years of Queen Victoria's reign; it started in the taverns and gin palaces of London as an entertainment which accompanied eating and drinking, and the first hall actually built as a music hall was the Canterbury, opened in 1852. The period from 1880 until 1914 was the heyday of the genre, and the principal London theatres which played it the Empire, the Palace, and the Coliseum. With the collapse of the Victorian way of life after the Great War, and the coming of the movies, music hall declined and the theatres themselves were turned into cinemas.

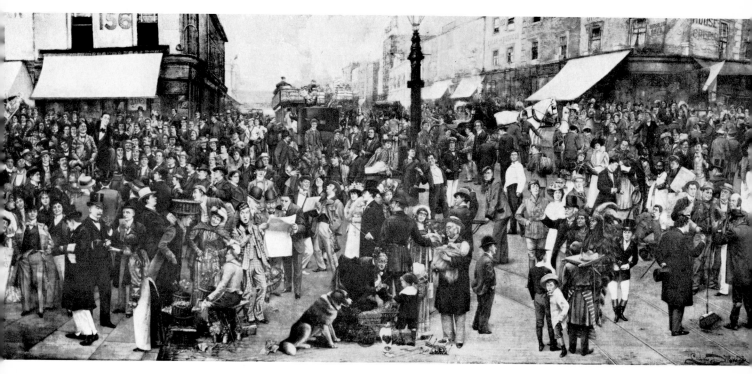

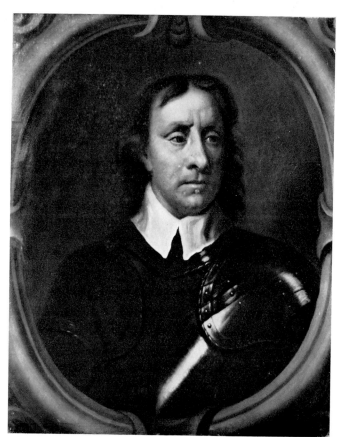

Plate 120 Popularity: The Stars of the Edwardian Music Hall by Walter Lambert. Signed and dated 1901-1903

Plate 121 Portrait of Oliver Cromwell (after Sir Peter Lely) Date uncertain

121 *AFTER SIR PETER LELY* (1618-80)
PORTRAIT OF OLIVER CROMWELL (1599-1658) (46.78/526)
Canvas. 28⅝ × 23½ inches (72.7 × 59.7 cms.). Date uncertain.

Provenance: Sir Richard Tangye (1833-1906); presented by Sir Harold Lincoln Tangye in 1913.

References: Catalogue of the Cromwellian Collection in the possession of Sir Richard Tangye, privately printed, 1905, p. 117; E. B. Powley, *The Cromwell Museum, Huntingdon,* Oxford, 1965, No. 4 (pp. 1-2).

Head and shoulders in armour in a feigned oval, facing the spectator, the head turned slightly to right; plain background. Replica, of uncertain date, of the portrait by Lely in the Birmingham City Art Gallery, which was probably painted in 1653-4 and in its turn derived from the unfinished miniature sketched from the life by Samuel Cooper, in the collection of the Duke of Buccleuch; a finished version of this miniature signed with initials and dated 1657 is on permanent loan to the Museum (37.17/1) from Viscount Harcourt. This picture forms part of the large collection of Cromwelliana, books, pamphlets, pictures and other objects, originally collected, from 1875 onwards, by Sir Richard Tangye, and presented to the Museum by his son in 1913.

SIR BERNARD PARTRIDGE (1861-1945)
Magazine and book illustrator and portrait painter; stained glass designer and decorative painter 1880-4. Born in London, the son of a distinguished surgeon. Joined the staff of *Punch* in 1891. Lived in West Kensington.

122 PORTRAIT OF SIR HENRY IRVING (1838-1905)
AT REHEARSAL (38.8/1)
Canvas. 24 × 17⅞ inches (60 × 42.7 cms.). Signed bottom right: *Bernard Partridge* Painted about 1903.

Provenance: Lent by the artist in 1938; presented by his niece, Mrs. Barbara Slater, in 1966.

Exhibited: Relics of Sir Henry Irving, London Museum, February-April 1938 (1).

Sir Henry Irving is shown here at full length, seated facing left, with his head turned to the spectator, wearing grey trousers, a thick brown overcoat and a felt hat, and clasping a stick in his right hand; he is seated on the stage, with a desk on the right. Irving's arrival in a felt hat was said to presage a long and arduous rehearsal; a top hat, on the other hand, signified that the rehearsal would probably be short.

Irving, whose original name was John Henry Brodribb, began his stage career at the Lyceum Theatre, Sunderland, in 1856; he spent the next ten years in the provinces,

Plate 122 Portrait of Sir Henry Irving at Rehearsal by Sir Bernard Partridge. Painted about 1903

playing at the Theatre Royal, Manchester, for five years, and it was not until 1871, after he had joined H. L. Bateman's company at the Lyceum Theatre, London, that he began to establish a serious reputation. In 1878 he took over the management of the Lyceum, and for nearly twenty-five years he reigned there, with a policy of alternating Shakespeare and popular melodrama, the acknowledged head of the English stage; Ellen Terry, whom he engaged as his leading lady, remained with him until 1902. Irving's strength as an actor lay in the thought and originality he brought to the parts he played, something entirely new in the Victorian theatre, when playgoers expected a performance to be cast in a traditional mould. Knighted in 1895, he died suddenly in 1905, and was buried in Westminster Abbey.

Partridge appeared as an actor in the early 1890's under the name of Bernard Gould; he was also *persona grata* as an artist at most London theatres, and drew and painted Irving in many of his rôles. A pencil sketch for the Museum picture is dated 1903, and this was used for the poster for Irving's farewell seasons in London and on tour.

Other portraits of Irving in oils, by Archer (No. 113) and Eves (No. 117), are also in the collection.

ROBERT PEAKE THE ELDER (active 1576-1616)
Portrait painter. On the staff of the Office of the Revels 1576-8. Serjeant Painter to the King (with John de Critz) from 1607.

123 PORTRAIT OF HENRY FREDERICK, PRINCE OF WALES
(1594-1612) (A 23271)
Panel. 22⅞ × 17½ inches (58.1 × 48 cms.). Painted about 1603-5.

Provenance: Bequeathed by J. G. Joicey in 1920 (as Charles I and without attribution).

Reference: Roy Strong, *Catalogue of Tudor and Jacobean Portraits in the National Portrait Gallery*, London, 1969, p. 164 and repr. pl. 318.

Half length facing slightly to left, with his left hand on his hip, wearing a silver slashed doublet, a falling lace collar, and the insignia of the Order of the Garter round his neck; plain background. Prince Henry, eldest son of James I, died suddenly of typhoid fever at the age of seventeen, and was succeeded as Prince of Wales by his younger brother, later Charles I. Robert Peake is known to have painted several portraits of Prince Henry, of which the most important surviving is the splendid double portrait in the Metropolitan Museum dated 1603; the Museum picture is closest in type and date to the half length in the Bodleian Library. The Prince was invested with the Order of the Garter on 2 July 1603, and the falling collar suggests a date of about 1603-5.

The attribution is due to Dr. Roy Strong.

Plate 123 Portrait of Henry Frederick, Prince of Wales by Robert Peake the Elder. Painted about 1603-5

SOLOMON JOSEPH SOLOMON (1860-1927)

Painter of portraits, classical and religious paintings, genre and nudes. Born in Southwark, the son of a leather merchant. Studied at Heatherley's School 1876, the Royal Academy Schools 1877-80, and with Cabanel at the École des Beaux Arts in Paris 1880 and 1882-3. A.R.A. 1896; R.A. 1906. Executed the murals in the Royal Exchange. Lived chiefly in West Kensington.

124 PORTRAIT OF LEWIS, FIRST VISCOUNT HARCOURT (1863-1922) (A 28579)

Fibreboard. 15¾ × 12⅞ inches (39.4 × 32.2 cms.). Signed in monogram bottom right: *SJS* Painted in 1922-3.

Provenance: Commissioned by the Trustees of the Museum in 1922.

Head and shoulders, facing right; plain background. Painted from a photograph. Lewis Harcourt (who was raised to the peerage in 1917) spent his early years as private secretary to his father, Sir William Harcourt; entering Parliament in 1904, he was First Commissioner of Works from 1905-10 and again from 1915-7, and Secretary of State for the Colonies from 1910-5. He was passionately interested in gardening, and made extensive improvements to the London parks while he was at the Office of Works. His other great interests were in art and archaeology, and for varying periods he was a Trustee of the British Museum, the Wallace Collection, and the National Portrait Gallery. With Reginald, 2nd Viscount Esher (1852-1930), he played a major part in founding the London Museum, which was opened to the public in the State Apartments of Kensington Palace in 1912, and he served until his death as a Trustee.

SAMUEL DE WILDE (1747-1824)

Painter of theatrical portraits and scenes. Born in Holland. Apprenticed to a carver in Soho. Student at the Royal Academy Schools 1769. Pupil of Zoffany. Portrayed nearly every leading actor and actress of the day in their principal rôles; many of these portraits were acquired by the collector, Charles Mathews, and purchased for the Garrick Club in 1835. Lived chiefly in Covent Garden.

125 JOSEPH GEORGE HOLMAN (1764-1817) AS *CHAMONT* IN OTWAY'S *THE ORPHAN* (A 7463)

Canvas. 16 × 12 inches (40 × 30 cms.). Painted about 1785.

Provenance: Purchased in 1912 (source unknown).

Full length, facing slightly to right, with his right arm outstretched; plain background. Joseph George Holman, one of the leading actors of his day, is portrayed here in the Windsor uniform, which he may have been entitled to wear on the stage as one of the King's Actors. This dress was instituted by George III as a private uniform for use at Court in or before 1779.

Plate 124 Portrait of Lewis, First Viscount Harcourt by S. J. Solomon. Painted in 1922-3

Holman made his first appearance on the stage as *Romeo* at the Theatre Royal, Covent Garden, in 1784, and continued to act there under Harris's management until the dispute which arose in the season of 1799-1800 over the increase in charges for a benefit and of fines for refusing a part, involving eight of the principal actors; Holman either resigned or was dismissed, and he ended his career in America. He first appeared as *Chamont* in Thomas Otway's play *The Orphan* (1680) at Covent Garden on 4 February 1785, and another portrait of him in this rôle, by de Wilde, is in the Garrick Club collection (Cat. No. 266).

The costume worn by Holman indicates a date of about 1785.

STUDIO OF WILLIAM WISSING (1656-87)

126 PORTRAIT OF MARY OF MODENA (1658-1718) (60.17)

Canvas. 29¾ × 25 inches (74.4 × 62.5 cms.). Inscribed bottom right: *Maria. Beatrix./ Dutchess of York.* Painted about 1676-85.

Provenance: Presented by H.R.H. Princess Alice, Countess of Athlone, in 1960.

Half length facing the spectator, with her head turned slightly to left; plain background. Mary of Modena, who was married by proxy to James, Duke of York (later James II) in her native city on 30 September 1673, is portrayed here as Duchess of York. The date of the Museum picture must lie between Wissing's arrival in this country in 1676 and the Duchess's accession to the throne as Queen Consort in 1685. Wissing was much employed by James both before and after his accession, and he is known to have painted several portraits of Mary of Modena, most of them following this pattern down to the ear-ring and the fall of the hair; the version in the National Portrait Gallery (Cat. No. 214) is an exact repetition of the design, but extended to three quarter length. No original is extant which shows the sitter as Duchess of York.

The state bed of James II and Mary of Modena is also in the Museum (36.239).

Plate 125 Joseph George Holman as
Chamont in Otway's *The Orphan*
by Samuel de Wilde. Painted about 1785

Plate 126 Portrait of Mary of Modena
(studio of William Wissing). Painted
about 1676-85

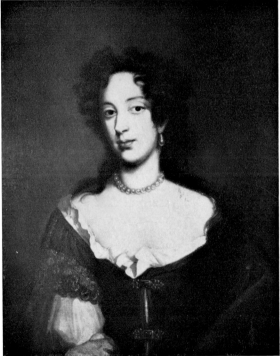

Reserve Collection

127 *FRANCIS DONKIN BEDFORD* (1864 — ?). Book illustrator. Born in London, the son of a solicitor. Studied at South Kensington, and the Royal Academy Architectural Schools; articled to Sir Arthur Blomfield. Lived in Wimbledon. BIRD'S-EYE VIEW OF KENSINGTON PALACE AND GARDENS FROM ABOVE THE SERPENTINE (64.155). *Tempera on canvas.* 19⅝ × 29⅛ inches (49.1 × 72.8 cms.). *Provenance:* presented by A. D. Royce in 1964. Amongst the principal buildings depicted are, from left to right, the Albert Memorial, the Kensington Palace Hotel, St. Mary Abbot's church, Kensington Palace, and the water tower on Campden Hill; ornamental floriated border, with birds and animals, and the arms of the Royal Borough of Kensington top centre.

128 *ROSAMUND BORRADAILE* (active 1925-30). GEORGE COURT, ADELPHI (A 28558). *Canvas.* 16¾ × 11¼ inches (41.9 × 28.1 cms.). Signed bottom left: *R. Borradaile.* Painted in 1925. *Provenance:* presented by the artist in 1926. A view looking northwards, towards the Strand; two fishmongers are seen at the doorway of a shop in the centre, in front of a flight of steps. George Court, the continuation of York Buildings, north of John Adam Street, has now been completely rebuilt, and only the flight of steps leading into the Strand remains.

129 *BRITISH SCHOOL*, eighteenth century. CHARING CROSS AND NORTHUMBERLAND HOUSE FROM SPRING GARDENS (30.70). *Canvas.* 24 × 41 inches (60 × 102.5 cms.). *Provenance:* J. O. Halliwell-Phillips; by descent to his niece, Miss Grace Baker, who presented it in 1930. *Reference: The Connoisseur*, April 1902, p. 56 (repr.). On the left is seen the Golden Cross Inn, in the centre Northumberland House, and on the right Hubert le Sueur's equestrian statue of Charles I. A copy of Canaletto's view, executed for the Earl of Northumberland, which was engraved in 1753 (see also Nos. 13 and 164).

130 *BRITISH SCHOOL*, eighteenth century. LAMBETH PALACE WITH A DISTANT VIEW OF THE CITY (c 1256). *Panel.* 13 × 22 inches (32.5 × 55 cms.). *Provenance:* Purchased from Richard Phillips in 1914 (as Scott). A bird's-eye view of Lambeth Palace, with the Thames in the foreground, looking north-eastwards over Lambeth Marsh, as yet unbuilt on, towards a panorama of the City from St. Paul's to the Tower. The evidence of costume and the inclusion of the west towers of St. Paul's indicates a date of about 1710.

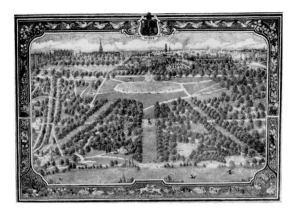

Plate 127 Bird's-eye View of Kensington Palace and Gardens from above the Serpentine by F. D. Bedford. Painted in the mid-twentieth century

Plate 128 George Court, Adelphi by Rosamund Borradaile. Painted in 1925

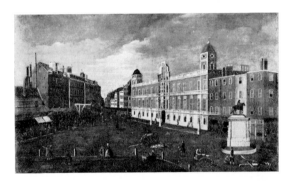

Plate 129 Charing Cross and Northumberland House from Spring Gardens (British School). Date uncertain

Plate 130 Lambeth Palace with a distant View of the City (British School). Painted about 1710

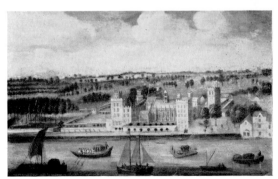

131 *BRITISH SCHOOL*, eighteenth century. WESTMINSTER BRIDGE FROM THE RIVER, LOOKING SOUTH (A 24667). *Canvas.* 24¾ × 29¾ inches (61.9 × 74.4 cms.). *Provenance:* purchased in 1922 (as after Scott). A feeble version of a popular composition better represented in the Museum by No. 20. The hills between Camberwell and Dulwich are seen, in rather exaggerated form, in the distance left.

132 *BRITISH SCHOOL*, nineteenth century. BLACKFRIARS BRIDGE AND ST. PAUL'S FROM THE RIVER (A 22242). *Canvas.* 10½ × 15¾ inches (26.25 × 39.4 cms.). *Provenance:* presented by Queen Mary in 1921 (as Sir A. W. Callcott). The north end of Blackfriars Bridge is seen in the middle distance, with St. Paul's Cathedral beyond; barges, a paddle steamer, and other craft are shown on the river.

133 *BRITISH SCHOOL*, nineteenth century. JESSIE BOND AS *IOLANTHE* RISING FROM THE STREAM (64.84). *Canvas.* 34 × 46¼ inches (86.4 × 117.5 cms.). Inscribed on the tree trunk centre right: *IOLANTHE Provenance:* Given to Jessie Bond by Sir William Gilbert; F. A. Sotham; presented by Ernest J. Tytler in 1960. *Iolanthe* is shown in the foreground right rising from the woodland stream in which she was confined, spotlit by the rays of the sun, and facing the spectator, with her head and the upper part of her body turned half left and upwards, her right arm shielding her face from the sun and her left arm outstretched, standing on a water-lily; a scene from the beginning of the Gilbert and Sullivan opera, first produced on 25 November 1882. Jessie Bond (1852/3-1942) was the original *Iolanthe*, and one of Gilbert's favourites. The picture was probably painted in 1882 or soon after.

134 *BRITISH SCHOOL*, nineteenth century. A BUTCHER'S BOY RACING WITH A POST-MAN IN THE MALL (31.38). *Canvas.* 16¼ × 23 inches (40.6 × 57.5 cms.). *Provenance:* Presented by Messrs. Pawsey and Payne in 1931. A butcher's boy dressed in a blue smock, riding a white horse, racing with a postman riding a brown horse, in the centre; a soldier and his wife, and a man holding a placard, in the middle distance left; a policeman and an early type of four-wheeled cab (a Clarence cab, later better known as the 'growler'), with the cabman on the box seat, in the middle distance right; Lancaster (then known as Stafford) House is seen between the trees in the distance right. The costume of the figures indicates a date of about 1845-55.

135 *BRITISH SCHOOL*, nineteenth century. THE CHRISTENING PROCESSION OF THE PRINCE OF WALES LEAVING BUCKINGHAM PALACE, 1842 (A 23092a). *Canvas.* 23½ × 34½ inches (58.75 × 76.25 cms.). *Provenance:* Presented by Alan F. Hooke in 1920 (as Henry Bright). The procession is shown emerging from the forecourt of Buckingham Palace, which is seen on the left; trumpeters of the band of the Household Brigade are in the foreground right. Piccadilly is visible in the distance, beyond Green Park. The Prince of Wales, later Edward VII (1841-1910), was christened Albert Edward at St. George's Chapel, Windsor, on 25 January 1842.

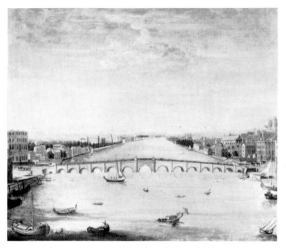

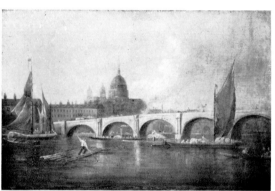

Plate 131 Westminster Bridge from the River, looking South (British School). Date uncertain

Plate 132 Blackfriars Bridge and St. Paul's from the River (British School). Painted in the first half of the nineteenth century

Pate 133 Jessie Bond as *Iolanthe* rising from the Stream (British School). Painted about 1882

Plate 134 A Butcher's Boy racing with a Postman in the Mall (British School). Painted about 1845-55

Plate 135 The Christening Procession of the Prince of Wales leaving Buckingham Palace, 1842 (British School). Painted about 1842

221

136 *BRITISH SCHOOL*, nineteenth century. A DREDGER ON THE THAMES (A 17588). *Panel.* $8\frac{7}{8}$ × $12\frac{1}{16}$ inches (28.2 × 30.1 cms.). *Provenance:* presented by J. G. Joicey in 1916. A dredger is shown at work in the foreground; the Tower of London is seen in the middle distance right.

137 *BRITISH SCHOOL*, nineteenth century. THE FROZEN THAMES AT GREENWICH (53.73). *Linoleum.* 6 × $8\frac{7}{8}$ inches (15 × 22.2 cms.). Signed and dated in monogram bottom left: *AH/12.2.95 Provenance:* Mrs. W. W. Hewitt; presented by Miss G. S. M. de Montmorency in 1953. This picture was painted on the last occasion when the Thames froze over, in February 1895; a tug and barges are shown icebound in the middle distance centre, and some buildings are silhouetted in the distance left and right.

138 *BRITISH SCHOOL*, nineteenth century. PORTRAIT OF WILLIAM SHAKESPEARE (1564-1616) (64.61/1). *Panel.* $10\frac{11}{16}$ × $8\frac{5}{16}$ inches (26.7 × 20.6 cms.). Inscribed top left: *W.S./ AEt.. 38/..10. Provenance:* Samuel Phelps; presented by Mrs. D. Brooke-Booth in 1964. Head and shoulders in an olive costume, facing slightly to left; plain background. Innumerable portraits of Shakespeare exist, most of them later copies or variants of one or other of the seventeenth century portraits purporting to represent the great poet. This portrait is derived from the authentic likeness engraved by Martin Droeshout for the First Folio edition of the *Plays*, 1623, but using the costume from the Chandos portrait in the National Portrait Gallery (No. 1).

139 *BRITISH SCHOOL*, nineteenth century. TEMPLE BAR ILLUMINATED FOR THE MARRIAGE OF THE PRINCE OF WALES, 11 MARCH 1863 (55.79). *Canvas.* 16 × 12 inches (40.6 × 30.5 cms.). *Provenance:* Purchased from R. W. Jack in 1955. Temple Bar is seen at night, richly decorated in red and gold hangings, with people and vehicles thronging the Strand. Edward, Prince of Wales, later Edward VII (1841-1910), married Princess Alexandra of Denmark (1844-1925) in St. George's Chapel, Windsor, on 10 March 1863.

140 *BRITISH SCHOOL*, nineteenth century. PORTRAIT OF AN UNKNOWN MAN (A 7462). *Panel.* $9\frac{1}{2}$ × $8\frac{7}{8}$ inches (24.1 × 22.5 cms.). *Provenance:* purchased in 1912 (as a portrait of John Liston, the actor, by Roberts); source unknown. Half length without hands wearing a grey topcoat, facing half left, the head turned towards the spectator; sky background. The costume indicates a date of about 1830-5.

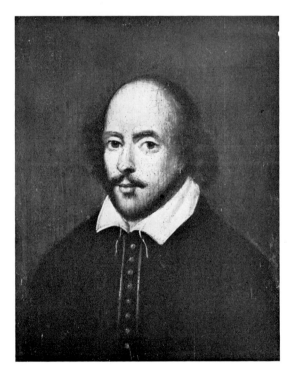

Plate 136 A Dredger on the Thames (British
School). Painted in the mid-nineteenth century

Plate 137 The Frozen Thames at Greenwich
(British School). Signed and dated 1895
Plate 138 Portrait of William Shakespeare
(British School). Date uncertain
Plate 139 Temple Bar illuminated for the
Marriage of the Prince of Wales, 11 March
1863 (British School). Painted about 1863
Plate 140 Portrait of an Unknown Man
(British School). Painted about 1830-5

141 *BRITISH SCHOOL*, nineteenth century. A WEST INDIAN SUGAR SALE (52.78). *Canvas.* 13 × 19⅛ inches (33 × 48.6 cms.). *Provenance:* Andrew Barron (1824-74), and thence by descent to Professor W. B. Stevenson, who presented it to the Museum in 1952. An auctioneer is shown on the rostrum presiding over a sale; on the table are samples of the sugar being sold and a sheet of paper inscribed: *Auction/Cork/IDAS/....../Hall Esq.* (which suggests that the sale depicted was held in Cork). A number of the merchants included are obviously portraits, and Andrew Barron, the first owner of the picture, a partner in a London sugar importing firm, is seen on the extreme left. The costume, and comparison with photographs of Barron, indicate a date of about 1860.

142 *BRITISH SCHOOL*, nineteenth century. WESTMINSTER FROM LAMBETH (A 17589). *Panel.* 8¹⁵⁄₁₆ × 12 inches (20.2 × 30 cms.). *Provenance:* presented by J. G. Joicey in 1916. A distant view of Westminster showing, from left to right, the church of St. John's, Smith Square, Westminster Abbey, Westminster Hall and part of Westminster Bridge; four figures are seen on the shore in the foreground right, with a barge moored close by. A copy by the same hand as No. 136 of the drawing by Samuel Prout, executed from the engraving published by George Cooke in 1827.

143 *REV. SEPTIMUS BUSS* (active 1854-9). Genre and topographical painter. Born in London, the son of an engraver and enameller. Lived in Camden Town with his brother, Robert William Buss, the well-known genre and humorous painter. A FUNERAL BEARER (A 9251). *Tinplate.* 14½ × 11 inches (36.25 × 27.5 cms.). *Provenance:* Presented by Gerald M. Burn in 1912 (without attribution). Whole length of a funeral bearer, facing half right and looking slightly downwards, in a feigned oval; plain interior background, with a column on the left. The bearer is wearing a black suit, with a top hat covered in black, and a black sash, and holding a staff draped in black in his right hand. Funeral bearers, or mutes, customarily preceded a funeral procession, and were a common sight in nineteenth century London. The costume indicates a date of about 1830-40.

144 *REV. SEPTIMUS BUSS.* A FUNERAL BEARER (A 9252). *Tinplate.* 14½ × 11 inches (36.25 × 27.5 cms.). *Provenance:* Presented by Gerald. M. Burn in 1912 (without attribution). Whole length of a funeral bearer, facing half left and looking slightly downwards, in a feigned oval; plain interior background, with a column on the right. The bearer is wearing a grey suit, with a top hat covered in white, and a white sash, and holding a staff draped in white in his left hand. The use of white indicates that the bearer, or mute, is dressed to precede the funeral procession of a child. The costume indicates a date of about 1830-40.

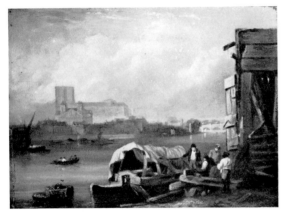

Plate 141 A West Indian Sugar Sale (British School). Painted about 1860

Plate 142 Westminster from Lambeth (British School). Painted in the mid-nineteenth century.

Plate 143 A Funeral Bearer by the Rev. Septimus Buss. Painted about 1830-40

Plate 144 A Funeral Bearer by the Rev. Septimus Buss. Painted about 1830-40

145 *WILLIAM J. CALLCOTT* (active late nineteenth century). Painter of coastal and river scenes. Lived in various parts of London. BARGES ON THE THAMES (28.100/1). *Canvas.* 7 × 9 inches (17.5 × 22.5 cms.). Inscribed in pencil on the stretcher: *Thames Barges* Signed bottom left: *W J Callcott. Provenance:* given to the donor's father by the artist in about 1878; presented by Herbert K. Rooke in 1928. Several barges and other craft are shown drawn up on the banks of the river in the foreground; the Thames is seen on the right.

146 *WILLIAM J. CALLCOTT.* THE CRAB TREE INN, FULHAM, FROM THE SURREY SHORE (28.100/2). *Canvas.* 7 × 9 inches (17.5 × 22.5 cms.). Signed bottom right: *W J Callcott.* Inscribed in pencil on the stretcher: *The Crab tree on the Thames evening. Provenance:* given to the donor's father by the artist in about 1878; presented by Herbert K. Rooke in 1928. The Crab Tree Inn is seen in the distance centre, with some malthouses to its left; a rowing boat is shown on the river, which stretches across the foreground, and two Thames barges are drawn up on the bank in the middle distance centre.

147 *SIR ARTHUR TEMPLE FELIX CLAY, BT.* (1842-1928). Painter of portraits, landscapes and genre. Lived in Guildford. THE YEOMEN OF THE GUARD SEARCHING THE CRYPT OF THE HOUSES OF PARLIAMENT (27.147). *Canvas.* $50\frac{1}{8}$ × $40\frac{1}{4}$ inches (125.3 × 100.6 cms.). Signed and dated bottom left: *ARTHUR-CLAY/1894. Provenance:* presented by the artist in 1927. A party of Yeomen of the Guard, three officers, a serjeant major, and eleven men, are shown searching the crypt of the Houses of Parliament for possible explosives; this ceremony, which takes place annually at the opening of the Parliamentary session, was initiated after the Gunpowder Plot of 1605, when Guy Fawkes and his fellow conspirators nearly succeeded in blowing up the building with King, Lords and Commons assembled inside.

148 *S. B. CULL* (active early nineteenth century). THE STATE BARGE OF GEORGE IV (A 27043). *Canvas.* 15 × $25\frac{1}{2}$ inches (37.5 × 63.75 cms.). Signed bottom right: *S·B·CULL* Painted about 1820-30. *Provenance:* presented by A. T. Barber in 1924 (without attribution). *Exhibited: 19th Century English Art,* New Metropole Arts Centre, Folkestone, May-June 1965(96). Two views of King George IV's state barge, painted probably from a model. The upper view is taken from the side and shows the green canopy in place and the Royal Standard flying at the bows; the lower view is taken from slightly on top, and shows the seating arrangements, with the canopy and Royal Standard removed.

Plate 145 Barges on the Thames by W. J. Callcott. Painted in the third quarter of the nineteenth century

Plate 146 The Crab Tree Inn, Fulham from the Surrey Shore by W. J. Callcott. Painted in the third quarter of the nineteenth century

Plate 147 The Yeomen of the Guard searching the Crypt of the Houses of Parliament by Sir Arthur Clay. Signed and dated 1894

Plate 148 The State Barge of George IV by S. B. Cull . . . Painted about 1820-30

149 *THOMAS CANTRELL DUGDALE* (1880-1952). Portrait, topographical and genre painter. Born at Blackburn, Lancashire, the son of an engineer. Studied at the Manchester School of Art, the Royal College of Art, the City and Guilds School, Kennington, the Académie Julian and the Atelier Colarossi in Paris. A.R.A. 1936; R.A. 1943. Lived in Chelsea. A STREET SCENE IN CHELSEA (A 17003). *Canvas.* 24¼ × 20¼ inches (60.6 × 50.6 cms.). Signed bottom left: *T. C. DUGDALE. Provenance:* Red Cross Sale, Christie's, 16 April 1915 Lot 730 (presented by the artist) bt. Sir Guy Laking for the Museum. *Exhibited:* Royal Glasgow Institute, 1911 (501). A bird's-eye view of the junction of King's Road and Glebe Place, Chelsea, showing the group of early eighteenth century houses, Nos. 213-7 King's Road, which still stand there; the premises on the right are now an antique shop. An open yellow car, a van, and an early motor bus with open upper deck serving Route 11, are seen in the foreground. The costume indicates a date of about 1907.

150 *ENGLISH SCHOOL*, sixteenth century. PORTRAIT OF SIR ROWLAND HILL (1492?-1561) (51.67). *Panel (rebacked).* 25½ × 18¼ inches 63.75 × 45.6 cms.). *Provenance:* bequeathed by Miss Mildred Aldrich Cotton in 1951. Half length facing the spectator, wearing a black costume trimmed with brown fur, a black hat, and a mayoral chain; green background, with a coat of arms set in a cartouche top right; a long inscription in Latin on the parapet at the bottom. Copy of the panel, size 25¼ × 19¾ inches, in an Anon. sale, Sotheby's, 19 July 1961 Lot 129 (attributed to Holbein). Sir Rowland Hill, a wealthy merchant, was Lord Mayor of London in 1549-50, the first Protestant to hold that office.

151 *AFTER JAN GRIFFIER THE ELDER.* THE GREAT FIRE OF LONDON, 1666 (27.142). *Canvas.* 35½ × 47¼ inches (88.75 × 123.1 cms.). *Provenance:* presented by Reginald, 2nd Viscount Esher in 1927 (without attribution). An inferior version of No. 48.

152 *AFTER JAN GRIFFIER THE ELDER.* THE GREAT FIRE OF LONDON, 1666 (27.142). *Canvas.* 41¼ × 66 inches (103.1 × 165 cms.). Inscribed on the back of the canvas: *Burning of London, by Lgi . . . A.D. Sept. 2ⁿᵈ 1666. Provenance:* Mr. Hollister, Cheltenham, c. 1830-40; Hollister sale, Assembly Rooms, Cheltenham, c. 1886 (no bid); acquired from the auctioneers in 1910 by William Jones, who presented it to the Museum in 1927 (without attribution). A version of No. 48, in which St. Paul's has become almost unrecognisable.

153 *JAMES HAMILTON HAY* (1875-1916). Landscape and marine painter, and etcher; trained in Liverpool. AN EVENING SCENE IN GREEN PARK (A 19841). *Canvas.* 14 × 18 inches (35 × 45 cms.). Signed bottom left: *Hamilton Hay. Provenance:* presented by A. E. Anderson in 1918. *Exhibited:* Royal Glasgow Institution, 1911 (505); *Memorial Exhibition of Works by the late J. Hamilton Hay,* Goupil Gallery, March 1917 (85). *Reference: The Daily Telegraph,* 5 March 1917 (where it was described by Sir Claude Phillips as the best piece in the exhibition). Two paths in the foreground left and centre, with a number of figures; other figures seated under the trees in the foreground right. The exact location is difficult to determine. The costume indicates a date of about 1905, and the picture belongs to Hay's latter years, when he was trying to evolve a landscape style based on decorative patterns.

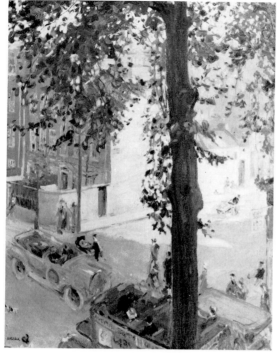

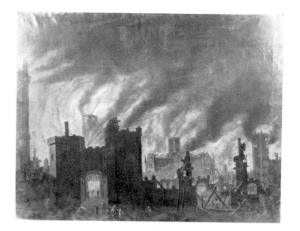

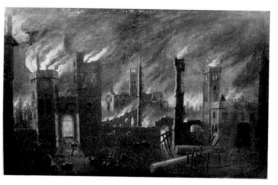

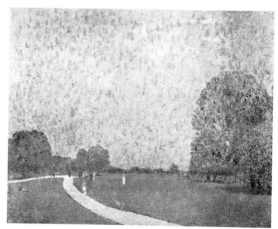

Plate 149 A Street Scene in Chelsea by
T. C. Dugdale. Painted about 1907
Plate 150 Portrait of Sir Rowland Hill
(English School). Painted in the mid-sixteenth
century
Plate 151 The Great Fire of London, 1666
(after Jan Griffier the Elder). Date uncertain
Plate 152 The Great Fire of London, 1666
(after Jan Griffier the Elder). Date uncertain
Plate 153 An Evening Scene in Green Park
by Hamilton Hay. Painted about 1905

154 *ERNEST DUDLEY HEATH* (active c. 1890-1940). Painter of portraits and genre, and book illustrator. Son of Henry Charles Heath, Miniature Painter to Queen Victoria. Studied at the Royal Academy Schools. Principal of the Hampstead Garden Suburb School of Arts and Crafts 1914-26. Lived in Hendon. PICCADILLY CIRCUS AT NIGHT (41.28/1). *Board.* 12 × 15⅞ inches (30 × 39.8 cms.). Signed bottom right: *Dudley Heath. Provenance:* presented by the artist in 1941. A view from outside the County Fire Office, looking towards Haymarket, showing, from left to right, the London Pavilion, opened 1885, Sir Alfred Gilbert's Shaftesbury Memorial Fountain (Eros), unveiled on 29 June 1893, and the Criterion Restaurant and Theatre, built in 1873-4; two 'buses and a number of hansom cabs are seen. The costume indicates a date in the early 1890's, and the picture was probably painted soon after the unveiling of Eros in 1893.

155 *ARCHIBALD S. HENNING* (active second quarter of the nineteenth century). Genre painter. Lived in Tulse Hill and Belgravia. PORTRAIT OF RENTON NICHOLSON (1809-61), WITH ALLEGORICAL SCENES AND FIGURES (34.272). *Canvas.* 35⅞ × 44 inches (89.7 × 110 cms.). Painted about 1841-61. *Provenance:* presented by C. Reginald Grundy through the National Art-Collections Fund in 1934. *Reference: 31st Annual Report of the National Art-Collections Fund 1934,* London, 1935, p. 26. Renton Nicholson, a well-known publican and popularly known as the Lord Chief Baron, was the founder (in 1841) of the Judge and Jury Society. This Society held mock trials at the Garrick's Head, Bow Street and later at the Coal Hole, Fountain Court and the Cider Cellar, Maiden Lane, which were attended by many eminent and fashionable people; intended primarily as an entertainment, the trials also admitted of serious eloquence, though cases of a political or theological nature were eschewed. Nicholson is shown here in Judge's robes holding a volume entitled *Comic BLACKSTONE* and standing between a jester and the personification of Justice (his motto was *Ecce Incorporo Hilaritatem cum Lege*); inset are roundel portraits of judges, and representations of putti dressing up as barristers, the birth of Venus, Andromeda chained to the rock, and putti conducting a mock trial; at the top is an imitation of the Royal Arms. The picture probably hung over Nicholson's chair at meetings of the Society.

156 *LADY ROSE L. HENRIQUES.* Self taught artist. Specialised in views of Stepney and scenes of Stepney life. Warden of the Bernhard Baron St. George's Jewish Settlement 1914-48. Lives in Stepney. MORNING TOILET IN STEPNEY (47.37/1). *Canvas.* 21¾ × 17¾ inches (54.4 × 44.4 cms.). Signed with initials top left: *R.L.H. Provenance:* purchased from the Whitechapel Art Gallery in 1947. *Exhibited: Stepney in War & Peace,* Whitechapel Art Gallery, June 1947 (10). Painted about 1930-40. Many houses in the poorer parts of Stepney still had little in the way of interior plumbing even in the period just before the Second World War, and this picture shows four or five women washing in their backyards. The yards, separated by wooden fences, occupy the centre of the canvas, and the backs of the two rows of two-storey terrace houses are seen left and right; taller buildings are seen beyond and to the right.

157 *TOM HESLEWOOD* (1868-1959). Amateur artist. THE QUADRANGLE OF STAPLE INN (38.209/1). *Canvas board.* 11¹⁵⁄₁₆ × 15¹⁵⁄₁₆ inches (27.7 × 37.7 cms.). Painted about 1900. *Provenance:* presented by the artist in 1938. A view of the north-east corner of the quadrangle

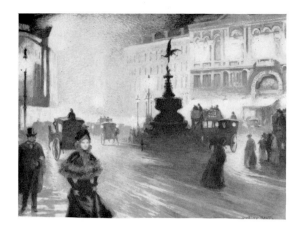

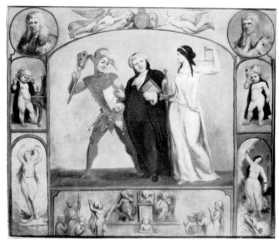

Plate 154 Piccadilly Circus at Night by
Dudley Heath. Painted about 1893

Plate 155 Portrait of Renton Nicholson with
Allegorical Scenes and Figures by Archibald
Henning. Painted about 1841-61

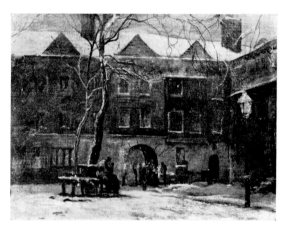

Plate 156 Morning Toilet in Stepney by
Lady Rose Henriques. Painted about 1930-
40

Plate 157 The Quadrangle of Staple Inn by
Tom Heslewood. Painted about 1900

231

of Staple Inn, Holborn, under snow. The range of gabled buildings shown here was faced with brick in 1826; the north front, facing Holborn, is still Elizabethan half-timbered, having been carefully reconstructed in 1937. Part of an early eighteenth century block, dated 1734, is seen on the right. None of the buildings depicted here survives today. The archway and north range were altered in the rebuilding of 1937, and most of the rest of the Inn was destroyed during the Second World War, being rebuilt in 1954-5.

158 *AFTER SIR THOMAS LAWRENCE* (1769-1830). PORTRAIT OF MRS. SARAH SIDDONS, née SARAH KEMBLE (1755-1831), AS *MRS. HALLER* IN KOTZEBUE'S *THE STRANGER* (56.169/3). *Canvas.* $28\frac{3}{4} \times 24\frac{3}{4}$ inches (71.9 × 61.9 cms.). *Provenance:* purchased at the Goldney House, Clifton, sale; presented by R. N. Green-Armytage in 1956 (as Lawrence). Half length facing the spectator; plain background. Copy of the portrait by Lawrence in the Tate Gallery (No. 785), which shows Mrs. Siddons in the rôle she created at Drury Lane Theatre on 24 March 1798, one of her most famous parts.

159 *J. LEWIS* (active late nineteenth century). A professional photographer in Richmond, who was an amateur artist and seems to have specialised in local views. RICHMOND BRIDGE (59.2/1). *Canvas.* $10 \times 13\frac{15}{16}$ inches (25 × 32.8 cms.). Signed bottom right: *J. LEWIS. Provenance:* Anon. sale, Sotheby's, 14 January 1959 Lot 141 bt. London Museum. The view shows the stone bridge (which still stands, though widened in 1937), that was built in 1774-7 to the designs of Kenton Couse and James Paine, and replaced the ferry service between Richmond and Twickenham. The viewpoint is from the Richmond side, and shows the pair of toll-houses, with the keeper collecting the toll from a couple in a gig. On the left is seen the gate of Miss Taylor's boarding house. The picture is a copy, excluding the dogs in the foreground and the figures on the right, of the engraving by W. B. Cooke from the original drawing by J. D. Harding, published in Mrs. Barbara Hofland's *Richmond and its surrounding scenery*, 1832.

160 *YOSHIO MARKINO* (1874- c.1938). Painter of genre scenes, and specialised in illustrations of British life. Born in Koromo, Mikawa. Came to London in 1897, and lived in Fulham. HYDE PARK CORNER FROM ROTTEN ROW AT NIGHT (29.73). *Canvas.* $20\frac{1}{8} \times 30\frac{1}{8}$ inches (50.3 × 75.3 cms.). Signed bottom left: *Yoshio Markino.* Painted in 1928. *Provenance:* presented by the artist in 1929. The Hyde Park Corner screen is seen on the left, with the quadriga on Constitution Arch in the middle distance centre; numerous cars and figures in the foreground.

161 *ALFRED MILLER* (active mid-twentieth century). Amateur artist. A BAKERY IN FLORAL STREET, COVENT GARDEN (59.53). *Fibreboard.* $19 \times 24\frac{1}{8}$ inches (47.5 × 60.3 cms.). Signed and dated bottom right: *ALFRED/MILLER/1959. Provenance:* presented by the artist in 1959. Interior of a bakery, with two bakers at work. The bakery was destroyed in 1941, and the picture, painted from memory, shows its appearance in 1934.

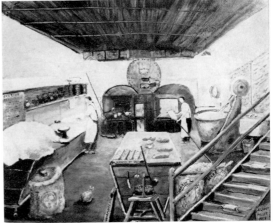

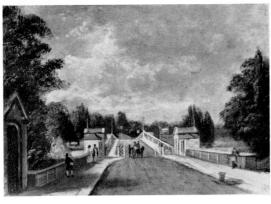

Plate 160 Hyde Park Corner from Rotten
Row at Night by Yoshio Markino. Painted in
1928

Plate 161 A Bakery in Floral Street, Covent
Garden by Alfred Miller. Signed and dated
1959

Plate 158 Portrait of Mrs. Sarah Siddons,
née Sarah Kemble as *Mrs. Haller* in Kotzebue's
The Stranger (after Sir Thomas Lawrence).
Date uncertain

Plate 159 Richmond Bridge by J. Lewis.
Copy of an engraving published 1832

17

162 *W. R. NOBLE* (active mid-nineteenth century). Amateur artist. PORTRAIT OF A ROYAL BARGEMAN (38.246). *Canvas.* 13⅞ × 10 inches (34.3 × 25 cms.). Signed and dated bottom left: *W. R. Noble/1843. Provenance:* presented by Alexandre Yakovleff in 1938. Three quarter length, facing slightly to left, and holding a top hat in his left hand; plain background. The bargeman is wearing the scarlet uniform of his profession, with the monogram *VR* and the Royal Arms surmounted by a crown embroidered on his breastplate.

163 *JAMES LYNWOOD PALMER* (1868-1941). Painter of horses, coaches and equestrian portraits. Born in Linwood, Lincolnshire, the son of a clergyman. Educated at King's College, London. Self-taught artist. Lived at Heston, Middlesex. A DOG CART AND STAGE COACH AT OLYMPIA (44.6/1). *Canvas.* 40¼ × 46¼ inches (100.6 × 115.6 cms.). *Provenance:* E. K. Fownes; presented by the Misses Fownes in 1944. A donkey cart with the initials *J.K.* on the back, and a coster and a woman seated inside, entering the ring at Olympia, on the left; leaving the ring on the right is a red stage coach, without markings, drawn by four horses, with the well-known coachman, E. K. Fownes (1850/1-1943), on the box and a guard standing at the back; plain background. A good example of vehicle portraiture, by a distinguished amateur coachman and collector. The costume indicates a date of about 1900. A portrait of E. K. Fownes is also in the Museum (No. 170).

164 *JOHN PAUL* (1804-87). Topographical painter, and copyist. CHARING CROSS AND NORTHUMBERLAND HOUSE (c 2389). *Canvas.* 29½ × 39⅜ inches (93.75 × 97.4 cms.). *Provenance:* lent by J. G. Joicey in 1917 (as after Scott), and afterwards bequeathed in 1919. A variant of the painting by Canaletto, engraved in 1753. The equestrian statue of Charles I by Hubert le Sueur, and Northumberland House, are seen in the centre; a man is filling a barrel from a pump in the foreground. For other versions of this subject, see Nos. 13 and 129.

165 *R. PEMBERY* (active second half of the nineteenth century). Landscape and topographical painter. An amateur artist, whose known pictures all suffer from extensive cracking. SEARLE'S BOAT BUILDING YARD, LAMBETH, FROM THE RIVER (b 732). *Canvas.* 24¼ × 42¼ inches (60.6 × 105.6 cms.). Signed and dated bottom right: *R. Pembery./1890* Inscribed in ink on the back of the canvas: *This Sketch was taken in 1851 by R. Pembery/and Painted by R. Pembery 1890/Now Sᵗ Thomas's Hospital. Provenance:* lent by Theodore Lumley in 1917, and afterwards purchased from his executors in 1923. Searle's yard is shown in the middle distance centre, with two ceremonial barges in dock; other wharves are shown on the right; Westminster Bridge, with Big Ben, and St. Paul's Cathedral beyond, appears on the left; and two barges, one of them bearing the City arms, and several other craft, are seen on the river; the artist is seen in the foreground centre right sketching the scene from a rowing boat. This part of the Lambeth riverfront is now occupied by St. Thomas's Hospital. The picture is very crudely painted.

Plate 164 Charing Cross and Northumberland House by John Paul. Date uncertain

Plate 165 Searle's Boat Building Yard, Lambeth from the River by R. Pembery. Signed and dated 1890

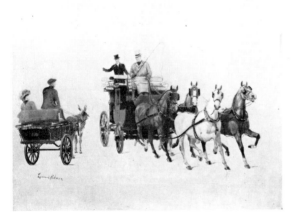

Plate 162 Portrait of a Royal Bargeman by W. R. Noble. Signed and dated 1843

Plate 163 A Dog Cart and Stage Coach at Olympia by Lynwood Palmer. Painted about 1900

166 *FREDERICK ROE* (1864-1947). Painter of portraits, landscapes, historical subjects and genre. Born in London, the son of an engraver. Studied at Heatherley's School, London. Lived in various parts of London. THE TAP ROOM OF THE BAPTIST'S HEAD INN, CLERKEN-WELL (A 25674). *Canvas.* 18 × 20⅞ inches (45 × 52.2 cms.). Signed and dated bottom left: *Fred Roe. April 1891. Provenance:* presented by the artist's son, Frederick Gordon Roe, in 1923. A view showing the Jacobean mantelpiece embodying the arms of Forster and Radclyffe, in the taproom; the picture of which a small part can be seen top left depicted a Dutch wake, and was attributed to Egbert van Heemskerk. The old Baptist's Head, now replaced, which was situated at No. 30, St. John's Lane, Clerkenwell, was part of the former mansion of Sir Thomas Forster (died 1612). Goldsmith and Dr. Johnson were regular customers there in the days when *The Gentleman's Magazine* was published at St. John's Gate.

167 *M. J. RORSNIGER* (active late nineteenth century). Nothing is known about this painter, who was presumably an amateur. PORTRAIT OF MRS. FANNY STIRLING, née ANNE MARY KEHL (1813-95) (56.169/31). *Fibreboard.* 12 × 10 inches (30 × 25 cms.). *Provenance:* presented by R. N. Green-Armytage in 1956. Head and shoulders facing half right and looking downwards; plain background. Mrs. Stirling was a well-known actress, who appeared on the London stage from 1832 until 1885; she played Cordelia to Macready's Lear, and her greatest rôle was as Peg Woffington in *Masks and Faces.* The hair style suggests a date of about 1860-70.

168 *GEORGE HARCOURT SEPHTON* (active 1895-1938). Painter of portraits, landscapes and genre. Lived in Bloomsbury, Campden Hill, and later, West Kensington. PORTRAIT OF QUEEN VICTORIA (1819-1901) (60.44/1). *Canvas.* 44½ × 35½ inches (111.25 × 88.75 cms.). Inscribed on the back of the canvas in pencil: *painted by/GEORGE SEPHTON/AFTER WINTERHALTER/1909. Provenance:* the Marquess of Carisbrooke; presented by Queen Victoria Eugenie of Spain in 1960. Three quarter length seated, facing the spectator, wearing Coronation robes and the crown of state especially made for her coronation; the Imperial State Crown on a table on the right, with a view of the Houses of Parliament through a window behind; a column top left. Copied from the central part of the full length by Winterhalter at Buckingham Palace.

169 *GEORGE HARCOURT SEPHTON.* PORTRAIT OF PRINCE ALBERT (1819-61). 60.44/2. *Canvas.* 44½ × 35½ inches (111.25 × 88.75 cms.). Inscribed on the back of the canvas in pencil: *1909* and *painted by/George Sephton/after WINTERHALTER. Provenance:* the Marquess of Carisbrooke; presented by Queen Victoria Eugenie of Spain in 1960. Three quarter length facing left, with his head turned towards the spectator, wearing a blue uniform; columns and curtain, and discarded robes and insignia, behind. Copied from the upper right part of the full-length by Winterhalter at Buckingham Palace.

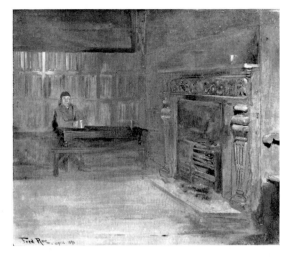

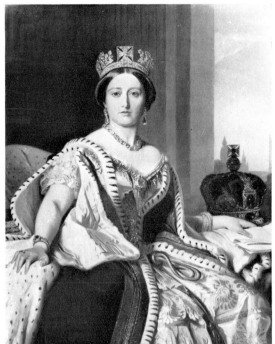

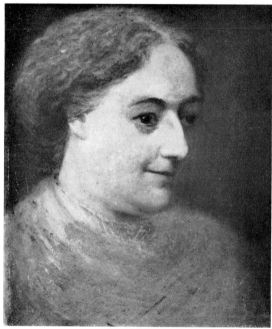

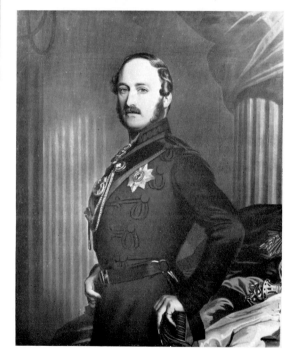

Plate 166 The Tap Room of the Baptist's
Head Inn, Clerkenwell by Frederick Roe.
Signed and dated 1891

Plate 167 Portrait of Mrs. Fanny Stirling,
née Anne Mary Kehl by M. J. Rorsniger.
Painted about 1860-70

Plate 168 Portrait of Queen Victoria by
G. H. Sephton. Inscribed 1909

Plate 169 Portrait of Prince Albert by
G. H. Sephton. Inscribed 1909

237

170 *THOMAS FREDERICK MASON SHEARD* (1866-1921). Painter of landscapes, portraits and genre, best known for his Oriental subjects. Born in Oxford. Studied in Paris under Courtois and others. Professor of Art at Queen's College, London, from 1915. Lived in Chelsea and Kensington. PORTRAIT OF E. K. FOWNES (1850/1-1943) (51.16). *Canvas.* $48\frac{1}{4} \times 36\frac{1}{4}$ inches (120.6 × 90.6 cms.). Signed bottom right: *TFM Sheard.* Painted about 1911-21. Inscribed on the back of the stretcher in pencil: *E. K. Fownes/Brighton &/London/Coaches/Old Times/1900/Nimrod/1911. Provenance:* E. K. Fownes; purchased from the Misses Fownes, daughters of the sitter, in 1950. Fownes is shown at three quarter length, facing half right, with his head turned to the spectator, wearing a brown overcoat and grey top hat; a coach and four is seen on the open road in the middle distance right; landscape background. Fownes, universally known as Ted Fownes, was born into a coaching family, and his three younger brothers were all coachmen; he was recognised as the best professional of his day, from the death of James Selby in 1888 until the 1900's. He drove the *Old Times* coach for Lord Leconfield, and the *Nimrod* for Captain John Spicer.

171 *FREDERICK P. SHUCKARD* (active early twentieth century). Painter of portraits, topographical subjects and genre. Lived chiefly in Peckham. QUEEN VICTORIA RECEIVING THE NEWS OF HER ACCESSION AT KENSINGTON PALACE, 20 JUNE 1837 (A 25317). *Canvas.* $36\frac{1}{4} \times 28\frac{1}{8}$ inches (90.6 × 70.3 cms.). Signed and dated bottom left: *F. P. SHUCKARD /1909/AFTER WELLS. Provenance:* Presented by the artist in 1923. The young Queen is shown at three quarter length, facing half right, standing in her nightgown, with the Lord Chamberlain, Lord Conyngham, kneeling before her and kissing her hand, bottom right. The scene is copied from the central part of H. T. Wells's painting in the Tate Gallery (No. 1919).

172 *FRANK MARKHAM SKIPWORTH* (died 1929). Genre and portrait painter. Lived in Chelsea. AN UNKNOWN MAN DRESSED AS *FABIEN DEI FRANCHI* IN *THE CORSICAN BROTHERS* (A 28582). *Canvas.* 30 × $17\frac{1}{4}$ inches (75 × 43.3 cms.). Signed and dated top left: *F. M. Skipworth/1883. Provenance:* unknown. The pose does not suggest a professional actor, and it is probable that the picture represents someone dressed for a ball in the costume for this part; Irving produced *The Corsican Brothers* at the Lyceum in 1883, and this season was followed by a highly successful tour in the provinces – the Victorians loved being portrayed in fancy dress, and the part of Fabien would clearly have been a popular rôle at this date.

173 *ERNEST STAMP* (1869-after 1937). Portrait painter and mezzotint engraver. Born at Sowerby, Yorkshire, the son of a leather merchant. Studied under Sir Hubert Herkomer. Lived at Bushey, and later in Hampstead. PERRIN'S COURT, HAMPSTEAD (37.212). *Panel.* $17\frac{1}{8} \times 12$ inches (42.8 × 30 cms.). Inscribed on the back of the panel in pencil: *Perrins Court/Hampstead London/ Ernest Stamp June 1931/ARE. Provenance:* presented by the artist in 1937. A view looking east. Perrin's Court, rebuilt shortly after this picture was painted, is an alley-way lying between Fitzjohn's Avenue and Hampstead High Street, east of Church Row, which has now become a locale for boutiques.

238

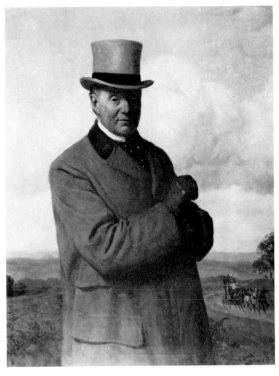

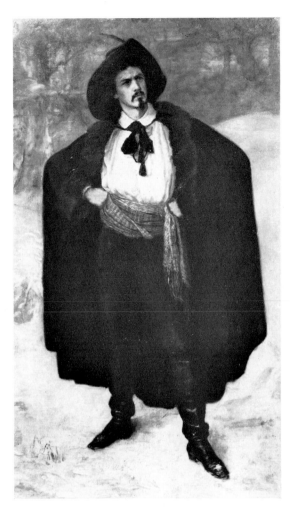

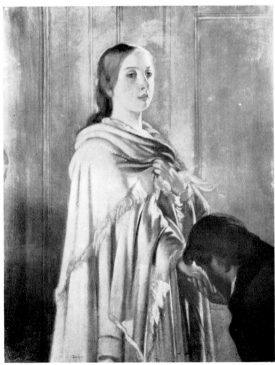

Plate 170 Portrait of E. K. Fownes by
T. F. M. Sheard. Painted about 1911-21

Plate 171 Queen Victoria receiving the News
of her Accession at Kensington Palace,
20 June 1837 by F. P. Shuckard. Signed and
dated 1909

Plate 172 An Unknown Man dressed as
Fabien Dei Franchi in *The Corsican Brothers* by
F. M. Skipworth. Signed and dated 1883

174 *ROBERT WRIGHT STEWART* (active 1906-41). Painter and etcher. Studied at the Edinburgh School of Art c. 1906, in London and in Paris. Lived in Chelsea. HYDE PARK CORNER FROM ROTTEN ROW (66.52). *Canvas.* 20⅛ × 24⅛ inches (50.3 × 60.3 cms.). Signed bottom right: *R. W. Stewart.* Painted in 1918. *Provenance:* lent by the artist in 1919, and given by his sister, Miss Ann Scott Stewart, in 1966. Exhibited Royal Academy, 1919 (454). The buildings shown are, from left to right, part of Apsley House, the quadriga on Constitution Arch, the Hyde Park Corner screen, and St. George's Hospital; numerous figures in the foreground and middle distance.

175 *WILLIAM STEWART* (born 1886). Press artist, illustrator and scene painter; principally known for his theatrical and London subjects, more particularly London types and characters. Born in Greenwich, the son of a journalist. Studied at the Lambeth Art School. Lived in Stockwell; retired to Ditchling, Sussex. INTERIOR OF A COFFEE SHOP (65.96/2). *Board.* 12⅜ × 16½ inches (30.9 × 41.25 cms.). *Provenance:* purchased out of the Mackenzie Bell Trust Fund from the artist in 1965. *Exhibited: William Stewart: London life, past and present,* Towner Art Gallery, Eastbourne, February-March 1962 (50). Painted about 1960 from sketches made about 1900-14. Six lorry drivers are shown having a meal in a coffee shop; on the right, a waiter is taking an order. Cheap eating houses of this type, with back to back seating, and the slogan *Good pull up for carmen* displayed outside, were common in Victorian and Edwardian London; they have now been superseded by transport cafés.

176 *WILLIAM STEWART.* INTERIOR OF A STEPNEY DOSS-HOUSE (65.96/1). *Board.* 15 × 21 inches (37.5 × 52.5 cms.). *Provenance:* purchased out of the Mackenzie Bell Trust Fund from the artist in 1965. *Exhibited: William Stewart: London life, past and present,* Towner Art Gallery, Eastbourne, February-March 1962 (24). Painted about 1960 from sketches made about 1900-14. Seven down and outs are shown inside a doss-house, where beds could be had for fourpence a night; three of the men are resting on the simple bunks.

177 *DANIEL TURNER* (active 1782-1806). Landscape, marine and portrait painter and engraver. Pupil of John Jones, the mezzotint engraver. Lived in Millbank. Sometimes known as David Turner. BLACKFRIARS BRIDGE, THE CITY, AND THE FUNERAL PROCESSION OF LORD NELSON, SEEN FROM SOUTHWARK (A 8081). *Panel.* 6½ × 9⅞ inches (16.25 × 24.7 cms.). Signed bottom right: *Dᴸ TURNER.* Painted about 1806. *Provenance:* purchased from Leggatt Brothers in 1912. The north end of Blackfriars Bridge is seen on the left, with St. Paul's Cathedral and many of the City churches in the distance right; the flotilla of ceremonial barges and other craft which accompanied the body of Lord Nelson to the lying-in-state at Greenwich Hospital on 8 January 1806 is seen stretching across the middle distance; the view is taken from Bankside, but it is not possible to identify which of the many wharves and stairs along this river frontage is seen in the foreground here. One of a number of paintings of Nelson's funeral which Turner did from different viewpoints.

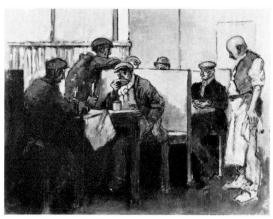

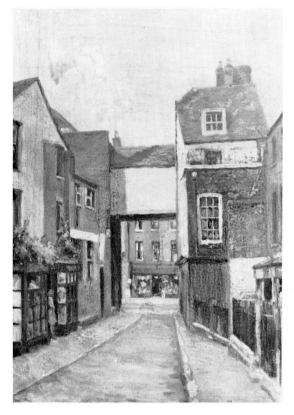

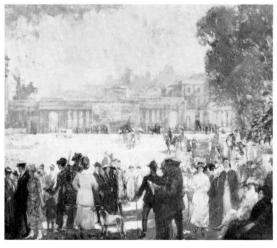

Plate 173 Perrin's Court, Hampstead by
Ernest Stamp. Inscribed 1931

Plate 174 Hyde Park Corner from Rotten
Row by R. W. Stewart. Painted in 1918

Plate 175 Interior of a Coffee Shop by
William Stewart. Painted about 1960

Plate 176 Interior of a Stepney Doss-house
by William Stewart. Painted about 1960

Plate 177 Blackfriars Bridge, the City, and
the Funeral Procession of Lord Nelson seen
from Southwark by Daniel Turner. Painted
about 1806

178 *DANIEL TURNER.* BLACKFRIARS BRIDGE AND ST. PAUL'S FROM THE RIVER (A 8082). *Panel.* $6\frac{5}{16} \times 9\frac{3}{16}$ inches (15.8 \times 23 cms.). Signed bottom left: *D TURNER.* Painted about 1800-10. *Provenance:* purchased from Leggatt Brothers in 1912. The north end of Blackfriars Bridge is seen in the middle distance, with St. Paul's Cathedral beyond; two small craft are shown in the foreground. A familiar composition deriving ultimately from Marlow, and of which Luny did several versions; a variant by Daniel Turner showing only two arches and taken from closer to, signed and dated 1803, is in the collection of Colonel Astor.

179 *AFTER DANIEL TURNER.* 'THE ADELPHI AND THE CITY FROM THE RIVER, WITH THE FUNERAL PROCESSION OF LORD NELSON (27.5). *Canvas (laid down on panel).* $15\frac{7}{8} \times 22\frac{3}{8}$ inches (39.7 \times 55.9 cms.). *Provenance:* Thomas Hellyer Foord; Foord sale, Holman's, Rochester, 1927, bt. Wheatley; presented by the Rev. Sydney W. Wheatley in 1927 (without attribution). A view looking eastwards down the river from a point close to the York Water Gate, and showing the funeral procession of Lord Nelson (see also No. 177). The York Water Gate and the Adelphi can be distinguished on the left, and beyond are St. Paul's surrounded by the City churches and Blackfriars Bridge, with part of the Lambeth shore and a square shot tower on the right. The quality is so poor that most of the features are difficult to make out, and the complete misrepresentation of the front of Somerset House suggests that the artist was unfamiliar with London itself. Copy of the picture by Daniel Turner in the National Maritime Museum.

180 *THOMAS WATERS* (active mid-nineteenth century). Amateur artist. TRAFALGAR SQUARE FROM SPRING GARDENS (29.132). *Canvas.* $19\frac{1}{4} \times 71$ inches (48.1 \times 177.5 cms.). Signed bottom right: *T. Waters. Provenance:* unknown. The view shows, from left to right, part of the Union Club, the National Gallery, the church of St. Martin-in-the-Fields, Morley's Hotel (now replaced by South Africa House), and the corner of Spring Gardens. The layout of Trafalgar Square, with the central fountain, is not shown as actually executed by Sir Charles Barry in 1840-50 (see No. 92), and evidently represents a plan which was not carried out. A carriage, a phaeton, several cavalrymen, and a number of gaily dressed onlookers are seen in the foreground. The picture is a copy, excluding some of the figures, of the engraving by Sands after Allom. The costume indicates a date of about 1830-5, and the inclusion of Morley's Hotel (built in 1830) and the National Gallery (built in 1832-8) suggests the end of this period. A watercolour by Edmund Walker, about 1845, taken from a similar viewpoint, but showing the square as built, with the Nelson Monument and Landseer's lions, is also in the Museum (64.153).

181 *KIRBY WATFORD* (active late nineteenth century). Amateur artist. THE GREEN MAN INN, WEMBLEY (53.137). *Canvas.* 10 \times 18 inches (25 \times 47 cms.). Inscribed on the back of the stretcher in pencil: *KIRBY WATFORD 1899. Provenance:* presented by C. Burgin in 1953. This picture shows the inn as it appeared before it was destroyed by fire in 1899; the garden is seen on the left.

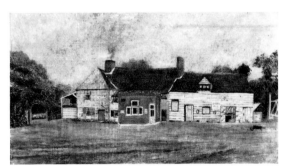

Plate 178 Blackfriars Bridge and St. Paul's from the River by Daniel Turner. Painted about 1800-10

Plate 179 The Adelphi and the City from the River, with the Funeral Procession of Lord Nelson (after Daniel Turner). Date uncertain

Plate 180 Trafalgar Square from Spring Gardens by Thomas Waters. Painted about 1835

Plate 181 The Green Man Inn, Wembley by Kirby Watford. Inscribed 1899

Plate 182 Portrait of David Garrick (manner of Joseph Wright of Derby). Painted about 1770

243

182 *MANNER OF JOSEPH WRIGHT OF DERBY* (1734-97). PORTRAIT OF DAVID GARRICK (1717-79) (56.169/2). *Canvas.* 30 × 24⅞ inches (75 × 62.2 cms.). *Provenance:* presented by R. N. Green-Armytage in 1956 (as Hudson). The costume indicates a date of about 1770. A very poor portrait, and presumably a provincial work; there is nothing to suggest the style of Hudson or his school, nor is any portrait known of which this might be a copy. Another portrait of Garrick is in the collection (No. 119).

Concordance

Accession Numbers	Catalogue Number	Source
A 6392	95	Purchased
A 7462	140	Purchased
A 7463	125	Purchased
A 7466	1	Purchased
A 7545	86	Purchased
A 7928	42	Charles Welch
A 8069	111	Purchased
A 8070	70	Purchased
A 8072	72	Purchased
A 8076	5	Purchased
A 8078	99	Purchased
A 8079	20	Purchased
A 8081	177	Purchased
A 8082	178	Purchased
A 8083	19	Purchased
A 8084	105	Purchased
A 8088	16	Purchased
A 9251	143	Gerald M. Burn
A 9252	144	Gerald M. Burn
A 13264	6	Purchased
A 13265	7	Purchased
A 13437	89	Theodore Lumley
A 15491	59	Purchased
A 16492	98	J. G. Joicey
A 17003	149	Purchased
A 17004	25	Purchased
A 17452	45	Miss M. C. Ford Smith
A 17588	136	J. G. Joicey
A 17589	142	J. G. Joicey
A 19092	24	Norman J. Byers
A 19841	153	A. E. Anderson
A 20709	55	Oliver, 3rd Viscount Esher
A 20710	31	Anonymous donor
A 20760	64	Purchased
A 20964	27	Cecil B. Harmsworth (through the N.A. - C.F.)
A 22242	130	Queen Mary
A 23092a	135	Alan F. Hooke
A 23271	123	J. G. Joicey
A 23976	28	Purchased
A 24289	29	Purchased
A 24298	9	Purchased

Accession Numbers	Catalogue Number	Source
A 24381	39	Miss Edith Durham
A 24382	37	Miss Edith Durham
A 24383	38	Miss Edith Durham
A 24667	131	Purchased
A 25317	171	Frederick P. Shuckard
A 25323	11	Dermot, 7th Earl of Mayo
A 25327	68	Purchased
A 25328	67	Purchased
A 25329	114	Purchased
A 25332	65	Purchased
A 25674	166	Frederick Gordon Roe
A 25874	74	J. Pierpont Morgan, Jr.
A 25910	3	P. A. S. Phillips
A 27043	149	A. T. Barber
A 28558	128	Miss Rosamond Borradaile
A 28575	10	Messrs. Leggatt
A 28576	13	Unknown
A 28577	15	Purchased
A 28578	44	Miss Evelyn Forster
A 28579	124	Commissioned
A 28580	103	Purchased
A 28581	106	Unknown
A 28582	172	Unknown
A 28583	21	Unknown
B 732	165	Purchased
C 352	14	Sir Arthur Fitzgerald
C 355	33	A. L. Nicholson (through the N.A.-C.F.)
C 358	84	Purchased
C 407	85	Purchased
C 1004	53	The Tate Gallery
C 1256	130	Purchased
C 2385	88	J. G. Joicey
C 2389	164	J. G. Joicey
C 2399	94	J. G. Joicey
27.5	179	Rev. Sydney W. Wheatley
27.69	151	Reginald, 2nd Viscount Esher
27.142	152	William Jones
27.147	147	Sir Arthur Clay, Bt.
28.35	35	John Scrimgeour
28.100/1	145	Herbert K. Rooke
28.100/2	146	Herbert K. Rooke
28.160	78	R. Just Boyd (through the N.A.-C.F.)
29.73	160	Yoshio Markino
29.132	180	Unknown
29.166	60	Miss Rosalind B. Joy
30.70	129	Miss Grace Baker
30.167	79	Anonymous donor
31.38	134	Messrs. Pawsey and Payne
34.54	112	The National Art-Collections Fund
34.272	155	C. Reginald Grundy (through the N.A.-C.F.)

Accession Numbers	Catalogue Number	Source
35.190	56	The National Art-Collections Fund and Owen H. Smith
37.205	54	Lady Holmes
37.212	173	Ernest Stamp
38.5/9	117	Miss Julia Neilson
38.8/1	122	Miss Barbara Slater
38.41/6	113	E. Temple (pseudonym)
38.109/1	4	The Misses Robson
38.209/1	157	Tom Heslewood
38.246	162	Alexandre Yakovleff
38.292	23	Bernard, 8th Earl of Granard
39.45/1	2	Unknown
39.166/3	107	S. H. Dowson
41.28/1	154	Ernest Dudley Heath
42.50/1	17	Marcus R. Samuel
42.50/2	18	Marcus R. Samuel
44.6/1	163	The Misses Fownes
46.78/526	121	Sir Harold Lincoln Tangye
47.26/5	32	H.M. Government (through the Imperial War Museum)
47.26/15	93	H.M. Government (through the Imperial War Museum)
47.37/1	156	Purchased
49.80	57	Purchased
50.3	118	Lady Martin-Harvey
50.31	73	Purchased
50.82/1486	115	The Suffragette Fellowship
51.16	170	Purchased
51.53	48	The National Art-Collections Fund
51.55	52	Purchased
51.67	150	Miss Mildred Aldrich Cotton
52.78	141	Professor W. B. Stevenson
52.87	87	Purchased
52.137	62	Purchased
53.28	58	Purchased
53.29	108	Purchased
53.73	137	Miss G. S. M. de Montmorency
53.137	181	C. Burgin
54.96	49	Purchased
54.131	96	Purchased
55.50	119	Purchased
55.72	30	Ernest E. Cook (through the N.A.-C.F.)
55.79	139	Purchased
56.167	41	London County Council
56.169/2	182	R. N. Green-Armytage
56.169/3	158	R. N. Green-Armytage
56.169/30	116	R. N. Green-Armytage
56.169/31	167	R. N. Green-Armytage
57.54	40	Purchased (with the aid of the N.A.-C.F. and an anonymous donor)
57.68/1	90	Mrs. Victor Bonney

Accession Numbers	Catalogue Number	Source
57.114	120	Bernard Coleman
59.2/1	159	Purchased
59.39	75	Purchased
59.53	161	Alfred Miller
59.99/140	77	A. D. Power (through the N.A.-C.F.)
59.99/143	80	A. D. Power (through the N.A.-C.F.)
59.99/144	81	A. D. Power (through the N.A.-C.F.)
59.99/145	82	A. D. Power (through the N.A.-C.F.)
59.105/1	71	Purchased
60.17	126	H.R.H. Princess Alice, Countess of Athlone
60.44/1	168	Queen Victoria Eugenie of Spain
60.44/2	169	Queen Victoria Eugenie of Spain
60.50	91	Purchased
60.58/2	46	Purchased
60.58/3	47	Purchased
60.90	63	Purchased
60.114/1	66	Purchased
60.114/2	101	Purchased
60.171	102	Purchased
61.7/1	76	Purchased
61.7/2	22	Purchased
61.62	51	Purchased
61.78	8	Purchased
61.121	34	Purchased
61.142/1	109	Purchased
62.32	61	Purchased (with the aid of the N.A.-C.F.)
62.118	36	Purchased
62.187	110	Purchased
63.61	97	Purchased
63.62	69	Purchased
63.145	104	Purchased
64.52	43	Purchased (with the aid of the N.A.-C.F. and an anonymous donor)
64.61/1	138	Mrs. D. Brooke-Booth
64.77	12	The Royal National Pension Fund for Nurses
64.84	133	Enrest J. Tytler
64.150	83	Purchased
64.155	127	A. D. Royce
65.84	100	George Fraser
65.93	50	Purchased
65.96/1	176	Purchased
65.96/2	175	Purchased
66.44	92	Purchased
66.52	114	Miss Anne Scott Stewart
66.68	26	Purchased

List of Previous Owners

The numbers refer to the catalogue entries

Abbott and Holder, 22 76
Agnew, Thomas and Sons, 14
Alice, Princess, Countess of Athlone, 126
Anderson, A. E., 153
Appleby, J. G., 109

Babington, 66 101
Bacon, John Henry Frederick, 6 7
Baker, A., 9
Baker, Miss Grace, 129
Barber, A. T., 148
Barraud, Henry, 114
Barron, Andrew, 141
Barton, Mrs., 113
Batsford, B. T., 1 14
Bernard, M., 49 102 119
Bevan, Robert Polhill, 8
Bischoffsheim, Mrs. C. W., 14
Bond, Jessie, 133
Bonney, Victor, 90
Bonney, Mrs. Victor, 90
Boorman, G. W., 67 68
Borradaile, Rosamund, 128
Boyd, R. Just, 78
Brooke-Booth, Mrs. D., 138
Burgin, C., 181
Burn, Gerald M., 143 144
Byers, Norman J., 24

Callcott, W. J., 145 146
Cannon, Peter, 120
Carington, Col. the Honble. W. H. P., 119
Carisbrooke, Marquess of, 168 169
Cartwright, Rev. Anson, 72
Cartwright, William, 72
Chambers, Sir William, 73
Clay, Sir Arthur Temple Felix, Bt., 147
Coleman, A., 120
Coleman, Bernard, 120
Colnaghi, P. and D., 8 46 47 74
Cook, Ernest E., 30
Cotton, Miss Mildred Aldrich, 150

Creasy, B. C., 64
Cresner, H. R., 87
Crowe, Stanley, 71

Dowson, S. H., 107
Dugdale, Thomas Cantrell, 149
Dunstan, Bernard, 36
Durham, Mary Edith, 37 38 39

Eglinton, Janet, Countess of, 43
Elbourne, Miss Gertrude, 71
Esher, Reginald, 2nd Viscount, 151
Esher, Oliver, 3rd Viscount, 55

Fenwick, Noel, 98
Fitzgerald, Sir Arthur, Knight of Kerry, 14
Foord, Thomas Hellyer, 179
Forster, Miss Evelyn, 44
Fownes, E. K., 9 163 170
Fownes, The Misses, 163 170
Frank, Robert, 58
Fraser, George, 100

Gilbert, Sir William, 133
Girling, S., 89
Glen, John, 98
Granard, 8th Earl of, 23
Green, Richard (Fine Paintings), 26 83 92
Green-Armytage, R. N., 116 158 167 182
Grossmith, Weedon, 113
Grundy, C. Reginald, 155

Hall, Christopher, 50
Hall, Clifford Eric, 52
Halliwell-Phillips, J. O., 129
Halls, F., 22
Hamilton, 67 68
Harmsworth, Cecil B., 27
Harmsworth, G. & Co., 103
Harvard, Michael, 34
Heath, Ernest Dudley, 154
Heslewood, Tom, 157

Index

References are made solely to the subject matter of the paintings catalogued. The numbers refer to pages

Statues:
 Charles I (Hubert le Sueur), 37 164 218 234
 George I (John Nost), 40
 George IV (Sir Francis Chantrey), 164
 Havelock, General (W. Behnes), 164
 Napier, General (G. G. Adams), 164
 Nelson, Lord (E. H. Baily), 48 162
 Achilles (Sir Richard Westmacott), 106
 Percy Lion, the, 37
 Victory in a Quadriga, 104 232 240
Stepney, backyards in, 230; doss-house in, 240
Stirling, Mrs. Fanny, 236
Strand, 37 48 180
 Buckingham Street, 36 138 148; steps, 154
 Duncannon Street, 48
 Riverfront, 154 162
 St. Clement Danes, 64 118 132 180
 St. Mary-le-Strand, 64 132 180 188
 Savoy Street, 180
 Wellington Street, 180
 See also Temple Bar
Strand Bridge. See Waterloo Bridge
Street musician. See Musicians
Street-seller. See Seller, street-
Sugar, auction of, 224
Sun-dial (Covent Garden), 22

Taverns. See Inns
Tavistock Row, 176
Tea-garden, 168
Telegraph poles, 72
Telegraph wires, 146
Temple, Middle, Hall, 110
Temple Bar (1863, illuminated), 222
Temple Church, 110
Temple Stairs, 110
Thames. See localities
Thames, frozen, 108 110 222
Theatres:
 Criterion, 230
 Drury Lane (on fire), 132
 Grecian Saloon, Hoxton, 34
 London Pavilion, 230
 Opera House, proposed new, Leicester Square, 38
 Tolmer Cinema, 98
 See also Music Hall, and actors by name
Tilley, Vesta, 208
Timber-yards. See Lambeth, river bank at
Toll-house:
 at Fulham, 42
 at Richmond, 232
Tolmers Square, St. Pancras, 98
Tombs:
 Henry VII, 56

Dd. 134912 K28

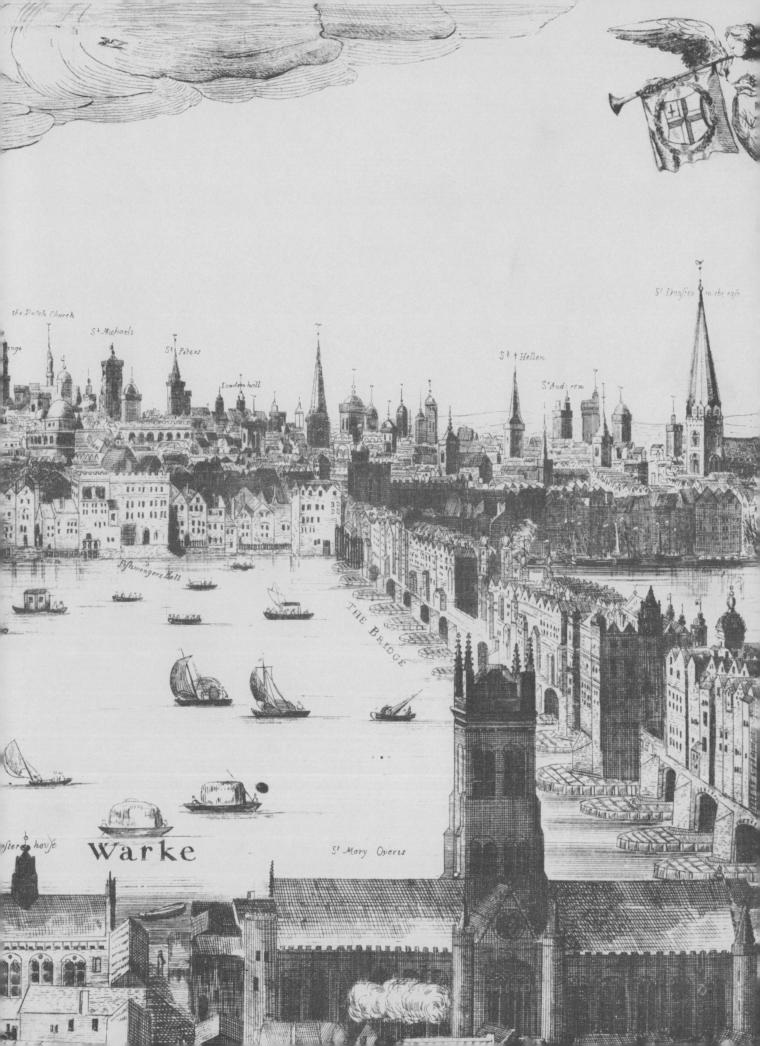

the Dutch Church

St Michaels

St Peters

Leadenhall

St † Hellen

St Andrew

St Dunsten in the east

Fishmongers Hall

THE BRIDGE

...ster house

Warke

St Mary Overis